£25.95

Trick Cinematography

Trick Cinematography

The Oscar Special-Effects Movies

by
R.M. Hayes

McFarland & Company, Inc., Publishers
Jefferson, North Carolina, and London

Library of Congress Cataloguing-in-Publication Data

Hayes, R.M., 1947–
 Trick cinematography.

 Includes index.
 1. Cinematography, Trick—Awards. 2. Cinematography
—Special effects—Awards. 3. Academy awards (Moving-
pictures) I. Title.
TR858.H38 1986 791.43'024 84-43219

ISBN 0-89950-157-5 (acid-free natural paper)

Printed in the United States of America.

McFarland Box 611 Jefferson NC 28640

To the memory of MARCEL DELGADO, whose creative talents added immeasurably to the wonders and excitement of these and other motion pictures: *Annie Get Your Gun; The Bells of Saint Mary's; The Bird of Paradise; The Birds; Cobra; Days of Glory; Dinosaurus!; Fantastic Voyage; The Farmer's Daughter; Flying Down to Rio; Goliath and the Dragon; It's a Mad, Mad, Mad, Mad World; Jack the Giant Killer; King Kong; The Last Days of Pompeii; The Lost World; Mary Poppins; Master of the World; Maytime; Mighty Joe Young; Miracle of the Bells; The Most Dangerous Game; The Road to Rio; Robinson Crusoe on Mars; Saratoga Trunk; The Shaggy Dog; Sister Kenny; The Son of Kong; Strike Up the Band; Sundown; Thirty Seconds Over Tokyo; Twenty Thousand Leagues Under the Sea; The War of the Worlds; The Wizard of Oz.*

Acknowledgments

I would like to thank Bill Warren, a writer of extreme talent and taste, for the special help he gave in supplying additional credits for several films; Robert E. Carr for supplementing considerably the credits of *Dragonslayer* and *2010*; the publicity personnel at Universal City Studios for providing information on *1941*; and the staff (particularly Barbara) at Columbia Pictures Industries for material on *Ghostbusters*.

Thanks are also in order to Daisy, whose "creative input" was rewarding in many small ways.

This book came to be because a beautiful person named Carol said "do it." She deserves the biggest "thank you" possible.

Table of Contents

Introduction

The Academy of Motion Picture Arts and Sciences was formed on January 11, 1927. On May 16, 1929, the first annual presentation of awards—"Oscars," as they were later dubbed—took place. This book chronicles one of those awards from the beginning through 1984.

Though there are a number of books detailing how movie special effects are created, none have specifically concerned the Oscar-nominated features nor concentrated on who was actually responsible for executing the effects. The intention here is to acknowledge the many craftspersons who have received Academy recognition over the years as well as bring to notice the various other individuals who have done so much with seldom a mention in the screen billing. All special effects nominations as well as scientific, technical and special awards are covered. Each film is represented with as complete credit listing as I could research. Most of the credits contained herein have never been published anywhere. Most of the credit lists are substantially longer than the official billing issued by the distributors. Occasionally I have been forced to print credits somewhat shorter than I would like. Any reader who can supplement these credits in any way, please do so. Likewise, if there are errors—and such unfortunately seems unavoidable in any reference work—that any reader is aware of, please advise me so that corrections may appear in future editions.

Some of the comments contained herein will surprise some readers. These are the opinions of the author and are not necessarily meant to detract from the work of others. It was not my intention to unfairly criticize any individual or film. Like everyone, I have my likes and dislikes. Often a technically bad film is more enjoyable than the near-perfect production. So, readers, when you find yourself disagreeing mightily with me, remember there is no personal affront intended.

For the general movie fan, dedicated buff and researcher, here is the complete reference guide to the Oscar special-effects movies.

Pictures

The following is an alphabetical listing of films nominated for Special Effects Oscars (* denotes winner). After each title the technician(s) who qualified for the statuette is credited.

The Absent Minded Professor (1961)
 Robert A. Mattey, Eustace Lycett
The Adventures of Mark Twain (1944)
 Paul Detlefsen, John Crouse
Air Force (1943)
 Hans Koenekamp, Rex Wimpy
Alien (1979)*
 Carlo Rambaldi, Brian Johnson, Nick Allder, Denys Ayling
Aloma of the South Seas (1941)
 Farciot Edouart, Gordon Jennings
Bedknobs and Broomsticks (1971)*
 Alan Maley, Eustace Lycett, Danny Lee
Ben-Hur: A Tale of The Christ (1959)*
 A. Arnold Gillespie, Robert MacDonald
The Birds, Alfred Hitchcock's (1963)
 Ub Iwerks
The Black Hole (1979)
 Peter Ellenshaw, Art Cruickshank, Eustace Lycett, Danny Lee, Harrison Ellenshaw, Joe Hale
The Black Swan, Rafael Sabatini's (1942)
 Fred Sersen
Blade Runner (1982)
 David Dryer, Douglas Trumbull, Richard Yuricich
"Blithe Spirit," Noel Coward's (1946)*
 Thomas Howard
The Blue Bird (1940)
 Fred Sersen
Bombardier (1943)
 Vernon L. Walker
Boom Town (1940)
 A. Arnold Gillespie

The Boys From Syracuse (1940)
 John P. Fulton
The Bridges at Toko-Ri (1955)*
 John P. Fulton
Captain Eddie (1945)
 Fred Sersen, Sol Halprin
Cleopatra, Joseph L. Mankiewicz' (1963)*
 Emil Kosa, Jr.
Close Encounters of the Third Kind (1977)
 Roy Arbogast, Douglas Trumbull, Matthew Yuricich, Gregory Jein,
 Richard Yuricich
Crash Dive (1943)*
 Fred Sersen
The Dam Busters (1955)
 George Blackwell
Days of Glory (1944)
 Vernon L. Walker
Deep Waters (1948)
 Ralph Hammeras, Fred Sersen, Edward Snyder
Desperate Journey (1942)
 Byron Haskin
Destination Moon (1950)*
 Lee Zavitz
Dr. Cyclops (1940)
 Farciot Edouart, Gordon Jennings
Doctor Dolittle (1967)*
 L.B. Abbott
Dragonslayer (1981)
 Dennis Muren, Phil Tippett, Ken Ralston, Brian Johnson
E.T. the Extra-Terrestrial (1982)*
 Dennis Muren, Carlo Rambaldi, Kenneth F. Smith
Earthquake (1974)*
 Frank Brendel, Glen Robinson, Albert Whitlock
The Empire Strikes Back (Star Wars Episode V) (1980)*
 Richard Edlund, Dennis Muren, Ken Ralston, Phil Tippet
Fantastic Voyage (1966)*
 Art Cruickshank
Flight Command (1941)
 A. Arnold Gillespie
Flying Tigers (1942)
 Howard Lydecker
Forbidden Planet (1956)
 A. Arnold Gillespie, Irving Ries
Foreign Correspondent, Alfred Hitchcock's (1940)
 Paul Eagler

Ghostbusters (1984)
 Richard Edlund, John Bruno, Mark Vargo, Chuck Gaspar
Gone with the Wind (1939)
 John R. Cosgrove
The Greatest Story Ever Told (1965)
 J. McMillan Johnson
Green Dolphin Street (1947)*
 A. Arnold Gillespie, Warren Newcombe
The Guns of Navarone (1961)*
 Bill Warrington
Hawaii (1966)
 Linwood G. Dunn
Hell and High Water (1954)
 Ray Kellogg
The Hindenburg (1975)*
 Albert Whitlock, Glen Robinson
I Wanted Wings (1941)*
 Farciot Edouart, Gordon Jennings
Ice Station Zebra (1968)
 Hal Millar, J. McMillan Johnson
*Indiana Jones and the Temple of Doom (1984)**
 Dennis Muren, Michael McAlister, Lorne Peterson, George Gibbs
Invisible Agent (1942)
 John Fulton
The Invisible Man Returns (1940)
 John P. Fulton
The Invisible Woman (1941)
 John Fulton
The Jazz Singer (1927–28)
 Nugent Slaughter
Journey to the Center of the Earth, Jules Verne's (1959)
 L.B. Abbott, James B. Gordon
Jungle Book, Rudyard Kipling's (1942)
 Lawrence Butler
King Kong (1976)*
 Carlo Rambaldi, Glen Robinson, Frank van der Veer
Krakatoa East of Java (1969)
 Eugene Lourie, Alex Weldon
The Last Voyage (1960)
 A.J. Lohman
Logan's Run (1976)*
 L.B. Abbott, Glen Robinson, Matthew Yuricich
The Long Voyage Home (1940)
 R.T. Layton, R.O. Binger

The Longest Day, Daryl F. Zanuck's (1962)*
 Robert MacDonald
Marooned (1969)*
 Robie Robertson
Mary Poppins (1964)*
 Peter Ellenshaw, Hamilton Luske, Eustace Lycett
Mighty Joe Young (1949)*
 Willis H. O'Brien, Harold Stine, Bert Willis
Moonraker (1979)
 Derek Meddings, Paul Wilson, John Evans
Mrs. Miniver (1942)
 A. Arnold Gillespie, Warren Newcombe
Mutiny on the Bounty (1962)
 A. Arnold Gillespie
The Navy Comes Through (1942)
 Vernon L. Walker
1941 (1979)
 William A. Fraker, A.D. Flowers, Gregory Jein
The North Star (1943)
 Clarence Slifer, R.O. Binger
One Million B.C. (1940)
 Roy Seawright
"...One of Our Aircraft is Missing" (1942)
 Ronald Neame
Only Angels Have Wings (1939)
 Roy Davidson
Patton (1970)
 Alex Weldon
Plymouth Adventure (1952)*
 A. Arnold Gillespie
Poltergeist (1982)
 Richard Edlund, Bruce Nicholson, Michael Wood
Portrait of Jennie (1948)*
 Paul Eagler, J. McMillan Johnson, Russell Shearman, Clarence Slifer,
 James G. Stewart
The Poseidon Adventure (1972)*
 L.B. Abbott, A.D. Flowers
The Pride of the Yankees (1942)
 Jack Cosgrove, Ray Binger
The Private Life of Helen of Troy (1927–28)
 Ralph Hammeras
The Private Lives of Elizabeth and Essex (1939)
 Byron Haskin

Raiders of the Lost Ark (1981)*
 Richard Edlund, Kit West, Bruce Nicholson, Joe Johnston
The Rains Came (1939)*
 Fred Sersen
The Rains of Ranchipur (1955)
 Ray Kellogg
Reap the Wild Wind, Cecil B. De Mille's (1942)*
 Farciot Edouart, Gordon Jennings, William L. Pereira
Rebecca, Alfred Hitchcock's (1940)
 Jack Cosgrove
Return of the Jedi (Star Wars Episode VI) 1983*
 Richard Edlund, Dennis Muren, Ken Ralston, Phil Tippet
Samson and Delilah (1950)
 Gordon Jennings
The Sea Hawk (1940)
 Byron Haskin
The Sea Wolf (1941)
 Byron Haskin
Secret Command (1944)
 David Allen, Ray Cory, Robert Wright
7 Faces of Dr. Lao (1964)
 Jim Danforth
Since You Went Away (1944)
 John R. Cosgrove
So Proudly We Hail (1943)
 Farciot Edouart, Gordon Jennings
Spawn of the North (1938)*
 Gordon Jennings, Jan Domela, Dev Jennings, Irmin Roberts, Art Smith,
 Farciot Edouart, Loyal Griggs
Spellbound, Alfred Hitchcock's (1945)
 Jack Cosgrove
The Spirit of St. Louis (1957)
 Louis Lichtenfield
Stand by for Action (1943)
 A. Arnold Gillespie, Donald Jahraus
Star Trek (1979)
 Douglas Trumbull, John Dykstra, Richard Yuricich, Robert Swarthe,
 Dave Stewart, Grant McCune
Star Wars (1977)*
 John Dykstra, Richard Edlund, Grant McCune, Robert Blalack
A Stolen Life (1946)
 William McGann
The Story of Dr. Wassel (1944)
 Farciot Edouart, Gordon Jennings

Superman (1978)*
 Les Bowie, Colin Chilvers, Denys Coop, Roy Field, Zoran Perisic, Derek Meddings
Swiss Family Robinson (1940)
 Vernon L. Walker
The Ten Commandments (1956)*
 John Fulton
That Hamilton Woman (1941)
 Lawrence Butler
Them! (1954)
 Ralph Ayres
They Were Expendable (1945)
 A. Arnold Gillespie, Donald Jahraus, R.A. MacDonald
The Thief of Bagdad (1940)*
 Lawrence Butler
Thirty Seconds Over Tokyo (1944)*
 A. Arnold Gillespie, Donald Jahraus, Warren Newcombe
A Thousand and One Nights (1945)
 L.W. Butler
Thunderball, Ian Fleming's (1965)*
 John Stears
The Time Machine (1960)*
 Gene Warren, Tim Barr
Tobruk (1967)
 Howard A. Anderson, Jr., Albert Whitlock
tom thumb (1958)*
 Tom Howard
Topper Returns (1941)
 Roy Seawright
Topper Takes a Trip (1939)
 Roy Seawright
Tora! Tora! Tora! (1970)*
 A.D. Flowers, L.B. Abbott
Torpedo Run (1958)
 A. Arnold Gillespie
Tulsa (1949)
 John P. Fulton
Twenty Thousand Leagues Under the Sea, Jules Verne's (1954)*
 Ub Iwerks
2001: A Space Odyssey (1968)*
 Stanley Kubrick
2010 (1984)
 Richard Edlund, Neil Krepela, George Jensen, Mark Stetson
Typhoon (1940)
 Farciot Edouart, Gordon Jennings

Unconquered (1947)
 Farciot Edouart, Devereaux Jennings, Gordon Jennings, Wallace Kelley,
 Paul Lerpae
Union Pacific (1939)
 Farciot Edouart, Gordon Jennings
The War of the Worlds (1953)*
 Gordon Jennings, W. Wallace Kelley, Paul K. Lerpae, Irmin Roberts,
 Jan Domela, Chesley Bonestell, Ivyl Burks, George Ulrick, Lee Vasque
When Dinosaurs Ruled the Earth (1971)
 Jim Danforth, Roger Dicken
When Worlds Collide (1951)*
 Gordon Jennings, Paul K. Lerpae, J. Devereaux Jennings, Irmin
 Roberts, Harry Barndollar, Jan Domela, Chesley Bonestell, Ivyl Burks
Wilson (1944)
 Fred Sersen
Wings (1927–28)*
 Roy Pomeroy
The Wizard of Oz (1939)
 A. Arnold Gillespie
Women in War (1940)
 Howard J. Lydecker, Ellis J. Thackery, William Bradford
Wonder Man (1945)*
 John Fulton
A Yank in the R.A.F. (1941)
 Fred Sersen

Technicians

The following is an alphabetical listing of all Oscar nominated special effects personnel and their features (* denotes winner). Scientific or Technical and Special Awards are also listed.

F.R. Abbott
 Scientific or Technical (1939)*
L.B. Abbott
 Jules Verne's *Journey to the Center of the Earth* (1959); *Doctor Dolittle* (1967)*; *Tora! Tora! Tora!* (1970)*; *The Poseidon Adventure* (1972)*; *Logan's Run* (1976)*
Hal Adkins
 Scientific or Technical (1946)*
Nick Allder
 Alien (1979)*
David Allen
 Secret Command (1944)
Louis Ami
 Scientific or Technical (1974)*
Howard A. Anderson, Jr.
 Tobruk (1967)
Roy Arbogast
 Close Encounters of the Third Kind (1977)
Denis Ayling
 Alien (1979)*
Ralph Ayres
 Scientific or Technical (1951)*; *Them!* (1954)
Tim Barr
 The Time Machine (1960)*
Roger W. Banks
 Scientific or Technical (1973)*; Scientific or Technical (1975)*
Harry Barndollar
 When Worlds Collide (1951)*
Robert Bealmear
 Technical Achievement (1984)*
Haller Belt
 Scientific or Technical (1939)*
Raymond O. Binger
 The Long Voyage Home (1940); *The Pride of the Yankees* (1942); *The North Star* (1943)

George Blackwell
 The Dam Busters (1955)
Robert Blalack
 Star Wars (1977)*
Chesley Bonestell
 When Worlds Collide (1951)*; *The War of the Worlds* (1953)*
Lesley Bowie
 Superman (1978)*
Conrad Boye
 Scientific or Technical (1958)*
William Bradford
 Women in War (1940)
Frank Brendel
 Earthquake (1974)*
Herbert E. Britt
 Scientific or Technical (1946)*; Scientific or Technical (1949)*
George Brown
 Scientific or Technical (1951)*; Scientific or Technical (1958)*
Russell Brown
 Scientific or Technical (1944)*
John Bruno
 Ghostbusters (1984)
Paul Burk
 Technical Achievement (1984)*
Ivyl Burks
 When Worlds Collide (1951)*; *The War of the Worlds* (1953)*
Lawrence W. (Larry) Butler
 The Thief of Bagdad (1940)*; *That Hamilton Woman* (1941); Rudyard Kip-
 ling's *Jungle Book* (1942); *A Thousand and One Nights* (1945); Scientific or
 Technical (1975)*
H.G. Cartwright
 Scientific or Technical (1947)*
Colin Chilvers
 Superman (1978)*
Carroll Clark
 Scientific or Technical (1942)*
Charles Galloway Clarke
 Scientific or Technical (1943)*
Alan Cook
 Scientific or Technical (1939)*
Denys Coop
 Superman (1978)*
Hal Corl
 Scientific or Technical (1947)*; Scientific or Technical (1955; two awds.)*
Ray Cory

Secret Command (1944)
John R. (Jack) Cosgrove
 Gone with the Wind (1939); Alfred Hitchcock's *Rebecca* (1940); *The Pride of the Yankees* (1942); *Since You Went Away* (1944); Alfred Hitchcock's *Spellbound* (1945)
John Crouse
 The Adventures of Mark Twain (1944)
Art Cruickshank
 Fantastic Voyage (1966)*; *The Black Hole* (1979)
Dr. Charles R. Dailey
 Scientific or Technical (1947)*; Scientific or Technical (1956)*
James (Jim) Danforth
 7 Faces of Dr. Lao (1964); *When Dinosaurs Ruled the Earth* (1971)
E. Roy Davidson
 Only Angels Have Wings (1939)
Elizabeth D. De La Mare
 Scientific or Technical (1983)*
Gary Demos
 Scientific or Engineering (1984)*
Paul Detlefsen
 The Adventures of Mark Twain (1944)
Roger Dicken
 When Dinosaurs Ruled the Earth (1971)
Jan Domela
 Spawn of the North (1938)*; *When Worlds Collide* (1951)*; *The War of the Worlds* (1953)*
Roger Dorney
 Scientific or Technical (1983)*
David Dryer
 Blade Runner (1982)
Linwood G. Dunn
 Scientific or Technical (1944)*; *Hawaii* (1966); Medal of Commendation (1980)*; Scientific or Technical (1980); Gordon E. Sawyer Award (1984)*
John C. Dykstra
 Star Wars (1977)*; Scientific or Technical (1977)*; *Star Trek* (1979)
Paul Eagler
 Alfred Hitchcock's *Foreign Correspondent* (1940); *Portrait of Jennie* (1948)*
Richard Edlund
 Star Wars (1977)*; *The Empire Strikes Back (Star Wars Episode V)* (1980)*; *Raiders of the Lost Ark* (1981)*; Scientific or Engineering (1981; two awards)*; *Poltergeist* (1982); *Return of the Jedi (Star Wars Episode VI)* (1983)*; *Ghostbusters* (1984); *2010* (1984)
Farciot Edouart
 Scientific or Technical (1937)*; *Spawn of the North* (1938)*; *Union Pacific* (1939); Scientific or Technical (1939)*; *Dr. Cyclops* (1940); *Typhoon* (1940);

Aloma of the South Seas (1941); *I Wanted Wings* (1941)*; Cecil B. De Mille's *Reap the Wild Wind* (1942)*; *So Proudly We Hail* (1943); Scientific or Technical (1943; two awards)*; *The Story of Dr. Wassell* (1944); *Unconquered* (1947); Scientific or Technical (1947)*; Scientific or Technical (1955; two awards)*

Peter Ellenshaw
 Mary Poppins (1964)*; *Bedknobs and Broomsticks* (1971)*; *The Black Hole* (1979)

P.S. (Harrison) Ellenshaw
 The Black Hole (1979)

Clifford H. Ellis
 Scientific or Technical (1973)*

Jonathan Erland
 Scientific or Technical (1938)*; Technical Achievement (1984; two awards)*

Orien Ernest
 Scientific or Technical (1954)*

John Evans
 Moonraker (1979)

Bran Ferren
 Technical Achievement (1982)*

Roy Field
 Superman (1978)*

A.D. Flowers
 Tora! Tora! Tora! (1970)*; *The Poseidon Adventure* (1972)*; *1941* (1979); Scientific or Technical (1979)*

Robert M. Flynn
 Scientific or Technical (1969)*

Stephen Fog
 Technical Achievement (1984)*

William A. Fraker
 1941 (1979)

Logan R. Frazee
 Scientific or Technical (1979)*

Douglas Fries
 Scientific or Technical (1983)*

John P. Fulton
 The Boys From Syracuse (1940); *The Invisible Man Returns* (1940); *The Invisible Woman* (1941); *Invisible Agent* (1942); *Wonder Man* (1945)*; *Tulsa* (1949); *The Bridges at Toko-Ri* (1955)*; *The Ten Commandments* (1956)*

Edward Furer
 Scientific or Technical (1980)*

Charles (Chuck) Gaspar
 Ghostbusters (1984)

Jack Gaylord
 Scientific or Technical (1951)*

George Gibbs
 Indiana Jones and the Temple of Doom (1984)*
A. Arnold Gillespie
 The Wizard of Oz (1939); *Boom Town* (1940); *Flight Command* (1941); *Mrs. Miniver* (1942); *Stand By For Action* (1943); *Thirty Seconds Over Tokyo* (1944)*; *They Were Expendable* (1945); *Green Dolphin Street* (1947)*; *Plymouth Adventure* (1952)*; *Forbidden Planet* (1956); *Torpedo Run* (1958); *Ben-Hur: A Tale of The Christ* (1959)*; *Mutiny on the Bounty* (1962); Scientific or Technical (1963)*
James B. Gordon
 Jules Verne's *Journey to the Center of the Earth* (1959)
Loyal C. Griggs
 Spawn of the North (1938)*
Anton Grot
 Scientific or Technical (1940)*
Joe Hale
 The Black Hole (1979)
Sol Halprin
 Captain Eddie (1945)
Ralph Hammeras
 The Private Life of Helen of Troy (1927–28); *Deep Waters* (1948); Jules Verne's *Twenty Thousand Leagues Under the Sea* (1954)*
Charles Handley
 Scientific or Technical (1939)*
Byron Haskin
 Scientific or Technical (1938)*; *The Private Lives of Elizabeth and Essex* (1939); *The Sea Hawk* (1940); *The Sea Wolf* (1941); *Desperate Journey* (1942)
Robert Henderson
 Scientific or Technical (1942)*
Russell Hessy
 Scientific or Technical (1969)*
Ray Hinsdale
 Scientific or Technical (1944)*
Winton C. Hoch
 Scientific or Technical (1939)*
David Stanley Horsley
 Scientific or Technical (1954)*
Thomas Howard
 Blithe Spirit (1946)*; *tom thumb* (1958)*
Ub Iwerks
 Jules Verne's *Twenty Thousand Leagues Under the Sea* (1954)*; Scientific or Technical (1959)*; Alfred Hitchcock's *The Birds* (1963); Scientific or Technical (1964)*
Fred Jackman, Sr.
 Scientific or Technical (1932–33)*
Donald Jahraus

Stand by for Action (1943); *Thirty Seconds over Tokyo* (1944)*; *They Were Expendable* (1945)
Jerry L. Jeffress
Scientific or Technical (1977)*
Gregory Jein
Close Encounters of the Third Kind (1977); *1941* (1979)
Gordon Jennings
Spawn of the North (1938)*; *Union Pacific* (1939); *Dr. Cyclops* (1940); *Typhoon* (1940); *Aloma of the South Seas* (1941); *I Wanted Wings* (1941)*; Cecil B. De Mille's *Reap the Wild Wind* (1942)*; *So Proudly We Hail* (1943); *The Story of Dr. Wassell* (1944); *Unconquered* (1947); *Samson and Delilah* (1950); *When Worlds Collide* (1951)*; Scientific or Technical (1951); *The War of the Worlds* (1953)*
J. Devereaux Jennings
Spawn of the North (1938)*; *Unconquered* (1947); *When Worlds Collide* (1951)*
George Jensen
2010 (1984)
Brian Johnson (né Johncock)
Alien (1979)*; *The Empire Strikes Back (Star Wars Episode VI)* (1980)*; *Dragonslayer* (1981)
Joseph McMillan Johnson
Portrait of Jennie (1948)*; *The Greatest Story Ever Told* (1965); *Ice Station Zebra* (1968)
Joe Johnston
Raiders of the Lost Ark (1981)*
David Joy
Scientific or Technical (1939)*
Nick Kalten
Scientific or Technical (1948)*
W. Wallace Kelley
Unconquered (1947); *The War of the Worlds* (1953)*
Ray Kellogg
Hell and High Water (1954); *The Rains of Ranchipur* (1955)
Fred Knoth
Scientific or Technical (1954)*
Hans F. Koenekamp
Air Force (1943)
Emil Kosa, Jr.
Joseph L. Mankiewicz's *Cleopatra* (1963)*
Neil Krepela
2010 (1984)
Stanley Kubrick
2001: A Space Odyssey (1968)*
John Lacey
Scientific or Technical (1983)*

Jack Lannon
 Scientific or Technical (1948)*
R.T. Layton
 The Long Voyage Home (1940)
Danny Lee
 Bedknobs and Broomsticks (1971)*; *The Black Hole* (1979)
Paul K. Lerpae
 Scientific or Technical (1944)*; *Unconquered* (1947); *When Worlds Collide* (1951)*; *The War of the Worlds* (1953)*
Louis Lichtenfield
 The Spirit of St. Louis (1957)
August J. (Augie) Lohman
 The Last Voyage (1960)
Eugene Lourie
 Krakatoa East of Java (1969)
Cecil D. Love
 Scientific or Technical (1944)*; Scientific or Technical (1980)*
Hamilton Luske
 Mary Poppins (1964)*
Eustace Lycett
 The Absent Minded Professor (1961); *Mary Poppins* (1964)*; *Bedknobs and Broomsticks* (1971)*; *The Black Hole* (1979)
Howard J. Lydecker
 Women in War (1940); *Flying Tigers* (1942)
Robert A. MacDonald, Sr.
 They Were Expendable (1945); *Ben-Hur: A Tale of The Christ* (1959)*; *The Longest Day* (1962)*
Alan Maley
 Bedknobs and Broomsticks (1971)*
Marty Martin
 Scientific or Technical (1946)*; Scientific or Technical (1948)*
Robert A. Mattey
 The Absent Minded Professor (1961)
Michael McAlister
 Indiana Jones and the Temple of Doom (1984)*
Grant McCune
 Star Wars (1977)*; *Star Trek* (1979)
William McGann
 A Stolen Life (1946)
Derek Meddings
 Superman (1978)*; *Moonraker* (1979)
Dr. Herbert Meyer
 Scientific or Technical (1968)*
Hal Millar
 Ice Station Zebra (1968)

Alvah J. Miller
 Scientific or Technical (1977)*
Earle Morgan
 Scientific or Technical (1943)*
Dennis Muren
 The Empire Strikes Back (Star Wars Episode V) (1980)*; *Dragonslayer* (1981); Tech.
 Achievement (1981)*; *E. T. the Extra-Terrestrial* (1982)*; *Return of the Jedi (Star
 Wars Episode VI)* (1983)*; *Indiana Jones and the Temple of Doom* (1984)*
Ronald Neame
 "...One of Our Aircraft Is Missing" (1942)
Warren Newcombe
 Mrs. Miniver (1942); *Thirty Seconds over Tokyo* (1944)*; *Green Dolphin Street*
 (1947)*
Bruce Nicholson
 The Empire Strikes Back (Star Wars Episode V) (1980)*; *Raiders of the Lost Ark*
 (1981)*; *Poltergeist* (1982)
Eugene Nottingham
 Technical Achievement (1980)*
Willis Harold O'Brien
 Mighty Joe Young (1949)*
Anthony Paglia
 Scientific or Technical (1960)*; Scientific or Technical (1964)*
George Pal
 Special Award (1943)*
Philip V. Palmquist
 Scientific or Technical (1968)*
M.B. Paul
 Scientific or Technical (1949)*
William L. Pereira
 Cecil B. De Mille's *Reap the Wild Wind* (1942)*
Zoran Perisic
 Superman (1978)*; Scientific or Technical (1979)*
Lorne Peterson
 Indiana Jones and the Temple of Doom (1984)*
Wadsworth E. Pohl
 Scientific or Technical (1964)*
Roy Pomeroy
 Wings (1927–28)*
Fred Ponedel
 Scientific or Technical (1947)*; Scientific or Technical (1951)*; Scientific
 or Technical (1958)*
Ken Ralston
 Dragonslayer (1981); *Return of the Jedi (Star Wars Episode VI)* (1983)*
Carlo Rambaldi
 King Kong (1976)*; *Alien* (1979)*; *E. T. the Extra-Terrestrial* (1982)*

Peter A. Regla
 Technical Achievement (1980)*
Irving G. Ries
 Forbidden Planet (1956)
Joseph E. Robbins
 Scientific or Technical (1939)*; Scientific or Technical (1944)*
Irmin Roberts
 Spawn of the North (1938)*; *When Worlds Collide* (1951)*; *The War of the Worlds*
 (1953)*
Robie Robertson
 Marooned (1969)
Glen E. Robinson
 Earthquake (1974)*; *The Hindenberg* (1975)*; *King Kong* (1976)*; *Logan's Run*
 (1976)*
William Rudolph
 Scientific or Technical (1939)*
Sidney Sanders
 Scientific or Technical (1932–33)*
Gunther Schaidt
 Scientific or Engineering (1984)*
Harold A. Scheib
 Scientific or Technical (1973)*
Roy Seawright
 Topper Takes a Trip (1939); *One Million B.C.* (1940); *Topper Returns* (1941)
Fred Sersen
 The Rains Came (1939)*; *The Blue Bird* (1940); *A Yank in the R.A.F.*
 (1941); Rafael Sabatini's *The Black Swan* (1942); *Crash Dive* (1943)*; *Wilson*
 (1944); *Captain Eddie* (1945); *Deep Waters* (1948)
Russell Shearman
 Portrait of Jennie (1948)*; Scientific or Technical (1948)*
Michael Sicrist
 Scientific or Technical (1983)*
Wilbur Silvertooth
 Scientific or Technical (1941)*
Dan Slater
 Technical Achievement (1980)*
Nugent Slaughter
 The Jazz Singer (1927–28)
Clarence W.D. Slifer
 The North Star (1943); *Portrait of Jennie* (1948)*
Arthur Smith
 Spawn of the North (1938)*
Kenneth F. Smith
 E.T. the Extra-Terrestrial (1982)*

Edward Snyder
 Deep Waters (1948)
Charles D. Staffell
 Scientific or Technical (1968)*
S.L. Stancliffe
 Scientific or Technical (1951)*
John Stears
 Ian Fleming's Thunderball (1965)*; *Star Wars* (1977)*
Mark Stetson
 2010 (1984)
Dave Stewart
 Star Trek (1979)
James G. Stewart
 Portrait of Jennie (1948)*
Roy C. Stewart
 Scientific or Technical (1956)*
Harold Stine
 Mighty Joe Young (1949)*
Robert Swarthe
 Star Trek (1979)
Ross Taylor
 Scientific or Engineering (1980)*
Ellis J. (Bud) Thackery
 Women in War (1940)
Barton Thompson
 Scientific or Technical (1943)*
F. Thomas Thompson
 Scientific or Technical (1942)*
Phil Tippett
 Dragonslayer (1981); *Return of the Jedi (Star Wars Episode VI)* (1983)*
Donald Trumbull
 Technical Achievement (1984)*
Douglas Trumbull
 Close Encounters of the Third Kind (1977); *Star Trek* (1979); *Blade Runner* (1982)
George Ulrick
 The War of the Worlds (1953)*
Frank van der Veer
 King Kong (1976)*
Mark Vargo
 Ghostbusters (1984)
Lee Vasque
 The War of the Worlds (1953)*
Charles Vaughn
 Technical Achievement (1980)*

Petro Vlahos
 Scientific or Technical (1964)*
Vernon L. Walker
 Swiss Family Robinson (1940); *The Navy Comes Through* (1942); *Bombardier* (1943); *Days of Glory* (1944)
Gene Warren, Sr.
 The Time Machine (1960)*
William (Bill) Warrington
 The Guns of Navarone (1961)*
Alex C. Weldon
 Krakatoa East of Java (1969); *Patton* (1970)
Kit West
 Raiders of the Lost Ark (1981)*
Joseph Westheimer
 Scientific or Technical (1975)*
Jon Whitney, Jr.
 Scientific or Engineering (1984)*
Albert J. Whitlock
 Tobruk (1967); *Earthquake* (1974)*; *The Hindenburg* (1975)*
Bert Willis
 Mighty Joe Young (1949)*
Paul Wilson
 Moonraker (1979)
Rex Wimpy
 Air Force (1943)
Louis J. Witti
 Scientific or Technical (1948)*
Michael Wood
 Poltergeist (1982)
Robert Wright
 Secret Command (1944)
Matthew Yuricich
 Logan's Run (1976)*; *Close Encounters of the Third Kind* (1977)
Richard Yuricich
 Close Encounters of the Third Kind (1977); *Star Trek* (1979); *Blade Runner* (1982)
Lee Zavitz
 Destination Moon (1950)*
Stuart Ziff
 Technical Achievement (1981)*

1927-28

Engineering Effects Nominations

The Jazz Singer (Warner Bros.) Nugent Slaughter
The Private Life of Helen of Troy
 (First National) Ralph Hammeras
* *Wings* (Paramount) Roy Pomeroy

Comments

For the first annual Oscar presentations there were twelve award groups of which "Engineering Effects" was interestingly one. Not until 1939 would a special effects category be listed again as a regular award. As in future situations, the features nominated were quite a mixture. *The Jazz Singer*, shot partly on the West Coast and completed on the East Coast, featured a few good matte shots but was certainly not a spectacular technical display. *The Private Life of Helen of Troy* also featured numerous mattes as well as model shots and seemed more effects-oriented; but *Wings* got the statuette. It featured full size and miniature devastation that even today is quite impressive. Roy Pomeroy, who was in charge of Paramount's technical department, supervised not only the pyrotechnics and miniatures but also the sound mixing. Unfortunately, he was not well liked, and his career nosedived in the early thirties after a short period as Paramount's recording supervisor. Though turning out some epic work during the twenties — notably *The Ten Commandments* (1923) and *Old Ironsides* (1928) — he is seldom acknowledged by even the most devoted effects fans.

Credits

The Jazz Singer
(Warner Bros.; October 6, 1927)

Producers Sam Warner, Jack L. Warner *Associate Producer* Darryl F. Zanuck *Director* Alan Crosland *Screenplay* Alfred A. Cohn *Subtitles* Jack Jarmuth *Based on the Stage Play by* Samson Raphaelson *Cinematographer* Hal Mohr *Musical Director* Louis Silvers *conducting* the Vitaphone Orchestra *Film Editor* Harold McCord *Sound Supervisor* Nathan Levinson *Production Mixer* George R.

Groves *Art Directors* Ben Carre, Esdras Hartley *Art Titles* Victor Vance *Electrical Department Supervisor* F.N. Murphy *Gaffer* Ralph Owen *Publicity Supervisor* Hal B. Wallis *Casting* Frank Kingsley, George Leonard Taylor *Property Department Supervisor* Albert C. "Whitey" Wilson *Property Master* Herbert "Limey" Plews *Costume Designer* Alpharette *Technical Adviser* Benjamin Warner *Assistant Director* Gordon Hollingshead *Choral Supervisor and Vocal Coach* Paul Lamkoff *Technical Director* R. Lewis Geib *Songs* "Blue Skies" by Irving Berlin; "Mammy" by Sam Lewis, Joe Young, Walter Donaldson; "Toot Toot Tootsie, Goodbye" by Gus Kahn, Ernie Erdman, Dan Russo; "Dirty Hands, Dirty Face" by Edgar Leslie, Grant Clarke, Al Jolson, Jimmy Monaco; "Mother I Still Have You" by Al Jolson, Louis Silvers; "Yahrzeit," traditional; Vocals, Al Jolson; "Kol Nidre," traditional; *Vocal Dubbing* Joseph Diskay *Special Effects* Fred Jackman Sr., Nugent Slaughter

A Warner Bros.-Vitaphone Picture. Made at Warner Bros. Studios and Vitaphone Studios and on location in New York City. Copyright October 6, 1927 by Warner Bros. Pictures Inc. Western Electric Vitaphone Recording. 89 minutes.

The Players: *Jack Robin/Jakie Rabinowitz* Al Jolson *Mary Dale* Mary McAvoy *Cantor Rabinowitz* Warner Oland *Sara Rabinowitz* Eugenie Besserer *Moisha Yudleson* Otto Lederer *Jakie at Age 13* Bobbie Gordon *Harry Lee* Richard Tucker *Cantor Josef Rosenblatt* Himself *Levi* Nat Carr *Buster Billings* William Demarest *Dillings* Anders Randoff *Chorus Girls* Myrna Loy, Audrey Ferris *Doctor* Will Wallington, Sr. *Agent* Roscoe Karns *Band Pianist* Louis Silvers *Coffee Dan's Atmosphere Girls* Jane Arden, Violet Bird, Marie Stapleton, Edna Gregory, Margaret Oliver

Additional Oscar Nominations: *Writing—Adaptation* (Alfred Cohn); Special Award (Warner Bros. for producing the outstanding pioneer talking picture which has revolutionized the industry)*

Note: Remade by Warner Bros. in 1953 and by ITC in 1980.

The Private Life of Helen of Troy
(First National; December 9, 1927)

Executive Producer Richard A. Rowland *Producer* Carey Wilson *Director* Alexander Korda *Screenplay* Carey Wilson *Subtitles* Ralph Spence, Gerald Duffy, Casey Robinson *Based on the Novel by* John Erskine *and the stage play* The Road to Rome *by* Robert Sherwood *Cinematographers* Lee Garmes, Sydney Hickox *Muscial Score* Carl Edouarde *Film Editor* Harold Young *Assistant Film Editor/ Foreign Version Editor* Barbara P. McLean *Costume Designer* Max Ree *Special Effects* Ralph Hammeras

A Richard A. Rowland Production. Made at First National Studios. Copyright December 23, 1927 by First National Pictures, Inc. 86 minutes.

The Players: *Helen* Maria Corda *Menelause* Lewis Stone *Paris* Ricardo Cortez *Eteoneus* George Fawcett *Malapokitoreadetos* Charles Puffy *Adraste* Alice White *Telemachus* Gordon (Wild Bill) Elliott *Ulysses* Tom O'Brien *Achilles* Bert Sprotte *Ajax* Mario Carillo *Hector* George Kotsonaros *Aeneas* Constantin Romanoff *Sarpedon* Emilio Borgato *Aphrodite* Alice Adair *Athena* Helen Fairweather *Hera* Virginia Thomas *Bit* Gus Partos

Additional Oscar Nomination: *Writing — Title Writing* (Gerald Duffy)

Note: Remade by Warner Bros. in 1955 as *Helen of Troy*.

Wings

(Paramount Pictures; August 12, 1927)

Executive Producers Adolph Zukor, Jesse L. Lasky, Sr. *Producer* Lucien Hubbard *Director* William A. Wellman, Sr. *Screenplay* Hope Loring, Louis D. Lighton *Subtitles* Julian Johnson *Story* John Monk Saunders *Chief Cinematographer* Harry F. Perry *Cinematographers* Paul Perry, E. Burton Steene, Alfred "Buddy" Williams, Russell Harlan, Bert Baldridge, L.B. Abbott, Cliff Blackston, Faxon M. Dean, Frank Cotner, Herman Schoop, L. Guy Wilky, Al Lane, Ray Olsen, Sergeant Ward, Gene O'Donnell, Harry Mason, Albert Meyers, William H. Clothier, Guy Bennett, Ernest Lazell [Laszlo] *Music* John S. Zamecnik *Supervising Film Editor* E. Sheldon Lloyd *Film Editor* Lucien Hubbard *Sound Effects Editor* Merrill C. White *Associate Producer* Benjamin P. Schulberg *Sound Supervisor* Roy Pomeroy *Assistant Directors* Richard Johnston, Norman Z. McLeod *Costume Designer* Edith Head *Property Master* Charles T. Barton *Still Photographer* Otto Dyer *Air Supervisors* S.C. Campbell, Ted Parson, Carl Von Hartmann, James A. Healy, Capt. Bill Taylor, Lt. Cmdr. Harry Reynolds, Brig. Gen. F.P. Lahm, F.M. Andrews *Troop Maneuvers Supervisor* Maj. A.M. Jones *Ordnance Supervisor* Capt. Robert Mortimer *Communications Officer* Capt. Walter Ellis *Ground Operations Technical Supervisor* Capt. E.P. Ketchum *Title Song* John S. Zamecnik, Ballard MacDonald *Special Effects* Roy Pomeroy, Paul Perry

An Adolph Zukor–Jesse L. Lasky Presentation. A Lucien Hubbard Production. A Paramount Famous Lasky Corporation Picture. Copyright January 5, 1929 by Paramount Famous Lasky Corporation. Magnascope. Color Tints. General Electric Kinegraphone Recording. Made at Paramount Studios and on location at Camp Stanley Army Reserve, Brooks Field and Kelly Field, San Antonio, Texas. 141 minutes plus intermission.

The Players: *Mary Preston* Clara Bow *Jack Powell* Charles "Buddy" Rogers *David Armstrong* Richard Arlen *Sylvia Lewis* Jobyna Ralson *Air Cadet White* Gary Cooper *Celeste* Arlette Marchal *Patrick O'Brien* El Brendel *Sergeant* Gunboat Smith *Air Commander* Richard Tucker *Mrs. Armstrong* Julia Swayne Gordon *Mr. Armstrong* Henry B. Walthall *Mr. Powell* George Irving *Mrs. Powell* Hedda Hopper *French Peasants* Nigel De Brulier, Margery Wellman, Gloria Wellman *Lt. Cameron* Roscoe Karns *Military Policeman* James Pierce *Herman Schwimpf* Carl Von Hartmann *Capt. Kellerman* Frank Clarke *Flyers* Capt. Bill Taylor, Lt. Cmdr. Harry Reynolds, Hoyt Vanderberg, Frank Andrews, Hal George, Earl E. Patridge, Capt. Sterling R. Stribling, Clarence Irvine, Rod Rogers, Omer Locklear, Leo Nomis, Dick Grace, Lt. E.H. Robinson, John Monk Saunders *Soldiers* U.S. Army Second Division *Air Personnel* Brooks Field Air Service, Ground School Cadets, Kelly Field Servicemen, First Pursuit Group *Soldier Struck by Ambulance* Charles Barton *Soldier killed at St. Mihiel* William Wellman, Sr.

Note: Dedicated "to those young warriors of the sky, whose wings are forever folded about them." All sources list Paul Mantz as one of the pilots; however, in his autobiography he corrected that error. John Monk Saunders expanded his story into a novel after the release of the feature. Originally released silent with a music and sound effects track added in 1929. General Electric Kinegraphone Sound was renamed RCA Photophone (see Glossary). The home video version does not have the original soundtrack as all original preprint material no longer exists.

1930–31

Scientific or Technical Award (New Category)

Class II Fox Film Corporation
For effective use of synchroprojection composite photography
graphy

Comments

During the fourth year of Oscar presentations, the Academy Board of Governors established the Scientific or Technical category. Under this grouping, companies and individuals were given either statuettes (for Class I), plaques (for Class II) or citations (for Class III) for developing new or improved industry equipment or procedures. Fox Studios was the first to receive an award under this heading for Special Effects related work.

1932–33

Scientific or Technical Award

Class III Fox Film Corporation,
Fred Jackman, Warner
Bros. Pictures, Inc., Sidney
Sanders and RKO Studios, Inc.

For their development and effective use of the translucent
cellulose screen in composite photography

1936

Scientific or Technical Award

Class III United Artists Studio Corporation
For the development of a practical, efficient, and quiet wind
machine

1937

Scientific or Technical Award

Class II Farciot Edouart and
Paramount Pictures, Inc.

For the development of the Paramount dual screen transparency camera setup

1938

Special Award (Plaques)

For outstanding achievement in creating special photographic and sound effects in the Paramount production *Spawn of the North: Special Effects by* Gordon Jennings, *assisted by* Jan Domela, Dev Jennings, Irmin Roberts and Art Smith; *Transparencies by* Farciot Edouart, *assisted by* Loyal Griggs; *Sound Effects by* Loren Ryder, *assisted by* Harry Mills, Louis H. Mesenkop and Walter Oberst.

Scientific or Technical Award

Class III Byron Haskin and the Special
Effects Department of
Warner Bros. Studio

For pioneering the development and for the first practical application to motion picture production of the triple head background projector

Comments

For the first time since the 1927–28 presentation, a feature was given an award for Special Effects. As with most nominations under the Special Effects category through 1962, visual and audible effects were senselessly grouped together. This practice has over the years led to much confusion, as various film books, when crediting Special Effects and using the Oscar nominations as source material, have billed the sound technicians as part of the trick crew. We have here corrected the billing on all dual nominations. As *Spawn of the North* was given a Special Award, the specific credits were clearly defined. Well, almost! Actually, Loren Ryder was the studio's sound department head, Harry Mills was the unit recordist, and Louis Mesenkop and Walter Oberst were the re-recordists. The actual sound effects cutter was left unacknowledged! Until 1963, when Sound Effects became a separate category for a brief time — and occasionally a Special Award thereafter — the audible nominations were almost never given to the sound effects personnel.

Spawn of the North dealt with Canadian deep sea fishermen and featured a great deal of process and miniature work. The rousing climax — incorporating models and actual location footage — had an iceberg crumble and destroy one of the trawlers. This was pretty impressive stuff in 1938, but looks rather phony today.

Credits

Spawn of the North
(Paramount; August 26, 1938)

Producer Albert Lewin *Director* Henry Hathaway *Associate Director* Richard Talmadge *Screenplay* Jules Furthman, Talbot Jennings, Dale Van Every *Story* Barrett Willoughby *Cinematographer* Charles B. Lang, Jr. *Musical Score* Dimitri Tiomkin *Musical Director* Boris Morros *Film Editor* Ellsworth Hoagland *Art Directors* Hans Dreier, Roland Anderson *Set Decorator* A.E. Freudeman *Makeup* Wally Westmore *Hair dressing* Nellie Manley *Costume Designer* Edith Head *Songs* Frank Loesser, Burton Lane *Sound Supervisor* Loren L. Ryder *Production Mixer* Harry Mills *Dubbing Mixers* Louis H. Mesenkop, Walter Oberst *Unit Publicist* Kenny Carter *Special Effects Director* Gordon Jennings *Special Effects Cinematographers* J. Devereaux Jennings, Irmin Roberts *Matte Artist* Jan Domela *Miniatures* Art Smith *Optical Cinematography* Paul K. Lerpae *Process Cinematography* Farciot Edouart, Loyal C. Griggs

Made at Paramount Studios and on location in the North Seas. Copyright 1938 by Paramount Pictures Inc. Western Electric Mirrophonic Recording. 110 minutes.

The Players: *Tyler Dawson* George Raft *Jim Kimmerlee* Henry Fonda *Nicky Duval* Dorothy Lamour *Red Skain* Akim Tamiroff *Windy* John Barrymore *Diane* Louise Platt *Jackson* Lynne Overman *Lefty Jones* Fuzzy Knight *Dimitri* Vladimir Sokoloff *Ivan* Duncan Renaldo *Dr. Sparks* John Wray *Indian Dancer* Michio Ito *Partridge* Stanley Andrews *Tom* Richard Ung *Slicker the Seal Himself* *Gregory* Alex Woloshin *Fishermen* Archie Twitchell, Lee Shumway, Wade Boteler, Galan Galt, Arthur Aylesworth, Rollo Lloyd *Grant* Guy Usher *Davis* Henry Brandon *Erickson* Egon Brecher *David* Robert Middlemass *Vashia* Adia Kuznetzoff *Red's Gang* Eddie Marr, Frank Puglia, Leonid Snegoff *Minister* Edmund Elton *Purser* Harvey Clark *Cannam Officials* Monte Blue, Irving Bacon

Note: Re-edited from 130 minutes. Remade in 1954 by Paramount as *Alaska Seas* and incorporating stock footage from this version.

1939

Special Effects (New Category) Nominations

Gone with the Wind (Selznick, MGM) John R. Cosgrove
Audible: Fred Albin, Arthur Johns
Only Angels Have Wings (Columbia) Roy Davidson
Audible: Edwin C. Hahn
*The Private Lives of Elizabeth
and Essex* (Warner Bros.) Byron Haskin
Audible: Nathan Levinson
**The Rains Came* (20th Century–Fox) Fred Sersen
Audible: E.H. Hansen
Topper Takes a Trip (Roach, UA) Roy Seawright
Union Pacific (Paramount) Farciot Edouart,
Gordon Jennings
Audible: Loren Ryder
The Wizard of Oz (MGM) A. Arnold Gillespie
Audible: Douglas Shearer

Scientific or Technical Awards

Class III Farciot Edouart, Joseph E.
Robbins, William Rudolph and
Paramount Pictures, Inc.
For the design and construction of a quiet portable treadmill
Class III Multiple award for important
contributions in cooperative
development of new improved Process
Projection Equipment
F.R. Abbott, Haller Belt, Alan Cook and Bausch & Lomb
Optical Company for faster projection lenses; Mitchell
Camera Company for a new type process projection head;
Mole-Richardson Company for a new type automatically
controlled projection arc lamp; Charles Handley, David Joy
and National Carbon Company for improved and more stable
high-intensity carbons; Winton Hoch and Technicolor
Motion Picture Corporation for an auxiliary optical system

Comments

Starting this year, Special Effects became a regular Oscar category. This year's winner, *The Rains Came*, dealt with the love of an Indian for an Englishwoman. Fred Sersen created a spectacular earthquake using miniatures and animated mattes. Shot in California, the sets were "locationized" with extensive use of matte art. Studio sound head Edmund Hansen shared the nomination for the loud soundtrack.

Jack Cosgrove's mattes in *Gone with the Wind* ran the full range: poor to excellent. Much of the lushness and location feel were courtesy of him. So was some of the phoniness. The process shots were generally poor. Rerecordists Fred Albin and Arthur Johns received the audible effects nomination.

Only Angels Have Wings made extensive use of models, all too obviously! Edwin Hahn was the supervising sound effects cutter on this aviation adventure.

The Technicolor spectacular *The Private Lives of Elizabeth and Essex* featured mattes of London to add epic proportions to a generally stage-bound story about history's platonic lovers. Col. Nathan Levinson was recording supervisor for Warner Bros.

The Roach Studios' visual effects supervisor, Roy Seawright, handled the multiple exposures necessary to "ghost-in" the heroine of *Topper Takes a Trip*. No sound effects nomination was included. This was one of a series; all featured elementary but well executed optical illusions.

Westerns have seldom been noted for Special Effects even though they often included such work, as a viewing of *Union Pacific* reveals. The action-packed retelling of the UPRR's building of the transcontinental rail line featured two well-staged train wrecks and far too many process shots. The noisy soundtrack of gunshots, war whoops and hoof beats was recorded under the overall control of studio department head Loren Ryder.

A wondrous musical fantasy, *The Wizard of Oz* had the best cyclone sequence ever shot. This and many Technicolor-photographed matte paintings added to the visual beauty of this classic. Some of the process shots were noticeable, as was the model castle, a large but apparent miniature. MGM's sound director, Douglas Shearer, was nominated for the audio portions, which did employ some rather unusual sounds.

Credits

Gone with the Wind
(Loew's, Inc.; December 15, 1939)

Producer David O. Selznick *Directors* Victor Fleming, George Cukor, Sam Wood *Screenplay* Sidney Howard, Oliver H.P. Garrett, David O. Selznick,

Howard Hawks, John L. Balderston, F. Scott Fitzgerald, Michael Foster, Charles MacArthur, John Lee Mahin, Edwin Justus Mayer, Donald Ogden Stewart, Jo Swerling, Sr., John van Druten *Subtitles* Ben Hecht *Montage Scenario* Val Lewton, Winston Miller, Wilbur G. Kurtz *Adaptation* Sidney Howard *Based on the Novel by* Margaret Mitchell *Cinematographers* Ernest Haller, Lee Garmes, Joseph Ruttenberg, Paul Ivano, Hal Rosson *Associate Cinematographers* Ray Rennahan, Wilfred M. Cline, Winton C. Hoch *Musical Score* Max Steiner *Additional Music* Franz Waxman, Adolph Deutsch, Hugo Friedhofer, Heinz Roemheld, Daivd Axt *Production Designer* William Cameron Menzies *Art Director* Lyle Reynolds Wheeler *Assistant Musical Director* Louis Forbes *Costume Designer* Walter Plunkett *Scarlett's hats* John Frederics *Interior Design* Joseph B. Platt *Set Decorators* Edward G. Boyle, Hobe Erwin *Film Editor* Hal C. Kern Sr. *Associate Film Editor* James E. Newcom *Scenario Assistant* Barbara Keon *Makeup Supervisor* Monty Westmore *Makeup* Percy Westmore, Ben Nye, Paul Stanhope, Stanley Campbell, Eddie Allen *Hairdressing Supervisor* Hazel Rogers *Hairdressing* Martha Acker, Sydney Guilaroff *Sound Supervisor* Thomas T. Moulton *Sound* Samuel Goldwyn Studios *Production Mixers* Frank Maher, Lucho Navarro *Boom Operator* Antonio Samamiego *Dubbing Mixers* Fred Albin, Arthur W. Johns, Gordon E. Sawyer *Choreography* Frank Floyd, Eddie Prinz *Historian* Wilbur G. Kurtz *Assistant Historian* Annie Laurie Fuller Kurtz *Technical Advisers and Dialogue Coaches* Susan Myrick, Will Price *Studio Teacher* Priscilla Brader *Medical Adviser* Dr. Reuben D. Chier *Research* Lillian K. Deighton *Research Assistant* Ruth Leone *Production Manager* Raymond A. Klune *Technicolor Director* Natalie Kalmus *Technicolor Consultants* Henri Jaffa, Richard Mueller *Technicolor Technician* Paul Hill *Technicolor Timers* Bob Riley, Dave Johnson, Giff Chamberlain, Gerald McKenzie *Assistant Directors* Eric G. Stacey, Edward Woehler, Harvey Foster, Ralph Stosser *Second Assistant Directors* Ridgeway Callow, William McGarry, G. Cecil Barker *Script Supervisors* Lydia Schiller, Connie Earle, George Bernard McNutly, Jerry Wright, Naomi "Dillie" Thompson *Mechanical Engineers* R. Donald Musgrave, Oskar Jarosch, Hal Corl *Construction Superintendent* Harold Fenton *Key Grip* Fred Williams *Electrical Department Superintendent* Wally Oettel *Gaffer* James Potevin *Wardrobe Supervisor* Edward P. Lambert *Wardrobe Mistress* Marian Dabney *Wardrobe Master* Elmer Ellsworth *Wardrobe Assistants* Helen Henley, Mary Madden, Catherine Causey, Julie Kinetter, Basia Bassett *Clark Gable's Tailor* Eddie Schmidt *Casting* Charles Richards, Fred Schuessler *Casting Assistants* John Darrow, Maxwell Arnow *Casting Tests Directors* George Cukor, Anthony Mann *Location Manager* Mason Litson *Scenic Department Superintendent* Henry J. Stahl *Property Master* Harold Coles *Property Man* Arden Cripe *Greensman* Roy A. McLaughlin *Drapesman* James Forney *Special Property Maker* Ross B. Jackman *Landscaper* Florence Yoch *Still Photographers* Fred Parrish, Clarence Bull *Camera Operators* Arthur E. Arling, Vincent Farrar, Roy Clark *Assistant Cameramen* Harry Wolf, Al Cline, Bob Carney, Howard Nelson *Stunt Coordinator* Yakima Canutt *Second Unit Directors* Chester Franklin, William Cameron Menzies, John R. Cosgrove, B. Reeves

Eason, James A. Fitzpatrick, Hal C. Kern, Sr. *Second Unit Cinematographer* Glenn R. Kershner *Production Illustrators* Joseph McMillan Johnson, Dorothea Holt Redman, Howard Richman *Assistant Film Editors* Richard L. van Enger, Ernest Leadley, Hal C. Kern, Jr., Stuart Freye *Publicity Supervisors* Howard Dietz, Howard Strickling *Unit Publicists* Russell Birdwell, Victor M. Shapiro *Assistant Publicists* John Flinn, Neville Reay, George Glass *Handwritten Inserts* Jack Connors *Scarlett's portrait* Helen Carlton *Montage Opening for Act Two* Peter Ballbush *Wranglers* Tracy Lane, Art Hudkins *Horse Trainer* Dick Smith *Production Executive* Henry Ginsberg *Producer's Secretary* Betty Baldwin *George Cukor's Secretary* Dorothy Dawson *Executive Assistant to the Producer* Marcella Rabwin *Production Secretary* Harriet Flagg *Legal Affairs* Daniel T. O'Shea *Unit Doctor* Dr. Gilbert Stone *Chorale* The Hall Johnson Choir *Orchestration* Hugo Friedhofer, Bernard (Bernhard) Kaun, Adolph Deutsch, Reginald H. Bassett, Maurice de Pakh *Titles* Pacific Title & Art Studio *Story Editors* Val Lewton, Katharine Brown *Visual Effects Supervisor* John R. Cosgrove *Visual Effects Cinematographer* Clarence W.D. Slifer *Matte Artists* Fitch Fulton, Albert Maxwell Simpson, Byron Crabbe, Jack Shaw *Process Equipment* George Teague *Visual Effects Assistant Cameramen* William Neumann, Russell Hoover, Bert Willis *Visual Effects Technicolor Technicians* Rube Boyce, John Hamilton, Dave Jordan, Nelson Cordes *Process Projectionist* Bob Creso *Mechanical Effects* Lee Zavitz

A David O. Selznick Production. A Selznick International Picture. A Selznick International Pictures Presentation in Association with Metro-Goldwyn-Mayer Corporation. Made at Selznick International Studios and Metro-Goldwyn-Mayer Studios and on location in Busch Gardens, Pasadena, Reuss Ranch, Chico, Lasky Mesa, Agoura, Calabasas and on the Stockton River, California, and in Oregon. Copyright December 31, 1939 by Selznick International Pictures Inc. Technicolor. Western Electric Mirrophonic Recording. 225 minutes plus intermission.

The Players: *Capt. Rhett Butler* Clark Gable *Scarlett O'Hara* Vivien Leigh *Melanie Hamilton Wilkes* Olivia De Havilland *Ashley Wilkes* Leslie Howard *Gerald O'Hara* Thomas Mitchell *Belle Watling* Ona Munson *Aunt Pittypat Hamilton* Laura Hope Crews *Suellen O'Hara* Evelyn Keyes *Careen O'Hara* Ann Rutherford *Jonas Wilkerson* Victor Jory *Ellen O'Hara* Barbara O'Neil *India Wilkes* Alicia Rhett *Mammy* Hattie McDaniel *Prissy* Butterfly McQueen *Brent Tarleton* Frederic Crane *Stuart Tarleton* George Reeves *Big Sam* Everett Brown *Elijah* Zack Williams *Pork* Oscar Polk *Tara House Servants* D. Bufford, N. Pharr, Ruth Byers, F. Driver *Hezekiah* Clinton C. Rosemond *Pickaninnie* Ivy Gaines *Jeems* Ben Carter *John Wilkes* Howard Hickman *Charles Hamilton* Rand Brooks *Frank Kennedy* Carrol Nye *Cathleen Calvert* Marcella Martin *Lady Guest at Twelve Oaks Barbeque* Marjorie Reynolds *Young Gentleman Guest at Twelve Oaks Barbeque* Selmer Jackson *Gentlemen Guests at Twelve Oaks Barbeque* James Bush, Bryant Washburn, Jr., Carlyle Blackwell, Jr., Edward De Butts *Little Girl at Twelve Oaks Barbeque* Diane Fisher *Tony Fontaine* Tom Seidel

Cade Calvert David Newell *Rafe Calvert* Eric Alden *Twelve Oaks House Servants* Sarah Whitley, Marina Cortina, Inez Hatchett, Azarene Rogers *Lady Wedding Guest* Frances McCardell *Dr. Meade* Harry Davenport, Sr. *Mrs. Meade* Leona Roberts *Mrs. Merriweather* Jane Darwell *Rene Picard* Albert Morin *Maybelle Merriwether* Mary Anderson *Fanny Elsing* Terry Shero *Old Levi* William McClain *One-Arm Soldier Collecting for the Cause at the Bazaar* Harry Davenport, Jr. *Soldier at the Bazaar* Revel Freeman *Lieutenant General at the Bazaar* Wayne Castle *Officer at the Bazaar* Col. Tim Longeran *Uncle Peter* Eddie "Rochester" Anderson *Phil Meade* Jackie Moran *Elderly Band Leader Outside "The Examiner" Office* Luke Cosgrove *Elderly Band Leader's Wife* Louise Carter *Mother Reading Casualty List* Laura B. Treadwell *General's Wife Outside "The Examiner" Office* Edythe Elliott *Reminiscent Hospital Patient* Cliff Edwards *Sergeant at the Hospital* Edward Chandler *Hospital Patient in Pain* George Hackathorne *Convalescing Hospital Patient* Roscoe Ates *Hospital Amputation Case* Eric Linden *Dr. Wilson* Claude King *Dying Soldier in Hospital* John Arledge *Card-Playing Hospital Patient* Guy Wilkerson *Hospital Nurses* Joan Drake, Jean Heker *Colored Woman at the Hospital* Hattie Noel *Hospital Patient Calling for his Mammy* Clay Mercer *Hospital Patients* James Mason, Charles "Jockey" Haefeli *Elderly Men at the Train Depot* Josef Swickard, Emmett King *Elderly Officer at the Train Depot* Allen Cavin *Elderly Officer's Wife* Mary Carr *Women at the Train Depot* Nell Carlo, Raida Rae *Rig Driver During the Evacuation* Hank Bell *Townswoman During the Evacuation* Marian Montgomery *Townsman During the Evacuation* Fred Behrle *Commanding Officer During the Evacuation* Tom Tyler *Colored Man During the Evacuation* Jesse Clark *Medical Aide at the Railway Station* Frank Faylen *Nurse at the Railway Station* E. Livingston *Mounted Officer During the Siege* William Bakewell *Belle's Bartender* Lee Phelps *Belle's Girls* Shirley Chambers, Yola D'Avril *Belle's Maids* Ivy Parsons, Libby Taylor *Baby Beauregard Wilkes* Patrick Curtis *Young Soldier Who Collapses During the Retreat* Frank Coghlan, Jr. *Officer During the Retreat* Sam Garrett *Yankee Deserter at Tara* Paul Hurst *Colored Carpetbagger* Ernest Whitman *One-Legged Returning Veteran* John Wallace *Bearded Returning Veteran* Philip Trent *Veterans Eating at Tara* William Stelling, Al Kunde *Hungry Soldier at Tara* Louis Jean Heydt *Beau at Age 11 Months* Ricky Holt *Emmy Slattery* Isabel Jewell *Beau at Age 1½ Years* Gary Carlson *Yankee Major at the Stable Jail* Robert Elliott *Poker-Playing Captains at the Stable Jail* George Meeker, Wallis Clark *Corporal at the Stable Jail* Irving Bacon *Carpetbagger Orator* Adrian Morris *Townswomen During Reconstruction* Mrs. Bowker, Aline Goodwin *Johnny Gallegher* J.M. Kerrigan *Kennedy Store Clerk* Fred Warren *Kennedy Store Customer* Frances Goodall *Yankee Businessman* Olin Howard *White Renegade Hobo at Shanty Town* Yakima Canutt *Colored Renegade Hobo at Shanty Town* Edgar "Blue" Washington *Capt. Tom* Ward Bond *Tom's Sergeant* Harry Strang *Tom's Troopers* C. Hamilton, H. Nellman, Kernan Cripps, W. Kirby *Yankee on Street During Reconstruction* Si Jenks *New Orleans Can-Can Dancers* Evelyn Harding, Jolane Reynolds, Suzanne Ridgeway *Bonnie Blue Butler at Age 6 Months* Julia Ann Tuck *Bonnie at Age 2½ Years* Phyllis Callow *Bonnie at Age 4 Years* Cammie (Eleanor) King *Bonnie's London Nurse* Lillian Kemble-

Cooper *Rhett's Stable Boy* D. Goff *Young Beau* Mickey Kuhn *Photo Doubles and Standins* Fay Helm, Pearl Adams, Yakima Canutt, Earl Dobbins, Cary Harrison, Aline Goodwin, Joan Rogers, Mozelle Miller, Richard Smith, Arthur Roland Tovey, Edward L. Davenport, Anne Robinson Miller, Gwen Kenyon, Tony Beard, Jr. *Ashley's Horse* Rebel *Rhett's Horse* Black Chief *Bonnie's Pony* Bobby

Additional Oscar Nominations: *Picture* (Selznick, MGM, David O. Selznick)*; *Actor* (Clark Cable)*; *Actress* (Vivien Leigh)*; *Supporting Actress* (Olivia De Havilland); *Supporting Actress* (Hattie McDaniel)*; *Direction* (Victor Fleming)*; *Film Editing* (Hal C. Kern, James E. Newcom)*; *Art Direction* (Lyle Wheeler)*; *Music — Original Score* (Max Steiner)*; *Sound Recording* (Thomas T. Moulton); *Writing — Screenplay* (Sidney Howard)*; *Cinematography — Color* (Ernest Haller, Ray Rennahan)*; *Special Award* (William Cameron Menzies, for outstanding achievement in the use of color for the enhancement of dramatic mood)*; *Irving G. Thalberg Memorial Award* (David O. Selznick)*; *Scientific or Technical Award — Class III* (Don Musgrave and Selznick International Pictures, Inc., for pioneering in the use of coordinated equipment in production)*

Note: Winton C. Hoch was cinematographer for the dual-screen fire sequence that was shot but never used. Robert Glecker died of a heart attack during production and was replaced as Jonas Wilkerson by Victor Jory. Mary Young as Mrs. Elsing and Bruce Lane as Hugh Elsing had been in footage shot by George Cukor; however, after he was fired as director, these scenes were rewritten and reshot by Victor Fleming, and the two performers' parts were eliminated. Cut prior to release were Margaret Seddon as Grandma Tarleton, George Reed as the Tarleton Family Coachman, and John Wray as the Provost Marshal. Re-released in 1954 in Perspecta stereophonic sound and reframed for 1.75 × 1 Wide-Vision projection. The new soundtrack, in Western Electric Movietone system, was engineered under the supervision of Douglas Shearer and Wesley C. Miller at Metro-Goldwyn-Mayer Studios. That company had bought all rights to the production from Selznick. For the Civil War Centennial, new Metrocolor prints were struck for re-issue. These were available only in Western Electric Mirrophonic sound even though some older Technicolor prints with Perspecta stereo sound were still in use. The new prints were for wide screen projection. In 1963 a 140-minute version was released but quickly withdrawn due to patron complaints. These Metrocolor prints were issued with Westrex mono soundtracks only. A roadshow re-release in 1967 offered 70mm prints blownup to a 2.05x1 aspect ratio with Westrex six-channel stereophonic sound. The blowup was poorly reframed, had a new and unpleasing main title and very poor Metrocolor.

During the years it was discovered that several original Technicolor reels had disappeared and it was necessary to produce some of the new pre-

print material from original release prints. While it had been necessary to supplement the original soundtrack with additional sound effects for the 1954 re-issue, these were deemed unsatisfactory for the 70mm edition, and new audio tracks were made. Franklin E. Milton supervised the re-recording, and Merle Chamberlin supervised the optical conversion to the giant wide screen format. In addition to the reworked sound, Max Steiner re-scored some parts of the action, including new recording of the main title music. An overture and entr'acte were added. Though the feature had always been presented with an intermission, there had never been an announcement card for such on the prints, so one was attached. On most prints this announcement card had no musical accompaniment, but on some an organ-based score of music by Stephen Foster could be heard. Those prints had music through the entire intermission, and as it was not from the original Steiner score, it simply did not fit well with the rest of the orchestration.

Starting with the 1967 re-issue the credits had been altered. In addition to replacing the majestic sweeping title with a lesser one, Technicolor was removed from the presentation card, though it did remain in the roll up technical credits. The Loew's, Inc., distribution credit was changed to acknowledge Metro-Goldwyn-Mayer, one time subsidiary of that firm but by then a seperate company. The copyright credit was supplemented with a renewed credit also to Metro-Goldwyn-Mayer. All advertising boasted Metrocolor.

In 1968 new 35mm Metrocolor prints were issued on a non-roadshow basis. These had the new credits and were reframed for 1.85x1 wide screen projection. They were available with Westrex mono sound or magnetic stereo sound. The stereo version was mixed down from the 70mm edition and was four-channel separation. The print quality was poor. Prints contained the overture, intermission announcement and entr'acte. After initial engagements the overture was removed. For its network television premiere, one of the new reframed prints was shown. After CBS-TV secured exclusive rights, they had a dupe made from an original 1.33x1 Technicolor print with the original main titles, and they have since televised it.

In the late 1970s, the Zanuck/Brown Company developed a sequel with Metro-Goldwyn-Mayer to be based on a novel which would be published prior to the release of the new production. The studio, however, did not like the finished book, and no acceptable rewrites could be done. The sequel rights expired and the project was shelved.

Only Angels Have Wings
(Columbia; May 25, 1939)

Executive Producer Harry Cohn *Producer and Director* Howard Hawks *Screenplay* Jules Furthman, William Rankin, Eleanor Griffin, Howard Hawks *Story* Howard Hawks *Cinematographer* Joseph Walker *Musical Score* Dimitri

Tiomkin *Musical Director* Morris W. Stoloff *Film Editor* Viola Lawrence *Sound Supervisor* John P. Livadary *Supervising Sound Editor* Edwin C. Hahn *Art Director* Lionel Banks *Assistant Director* Arthur Black *Technical Adviser and Chief Pilot* Paul Mantz *Aerial Cinematographer* Elmer Dyer *Costume Designer* Robert Kalloch *Guitar Solos* Manuel Maciste *Special Effects* E. Roy Davidson *Matte Artist* Chesley Bonestell

Made at Columbia Studios and on location in St. George, Utah. Copyright May 11, 1939 by Columbia Pictures Corporation of California. Sepia. Western Electric Mirrophonic Recording. 121 minutes.

The Players: *Jeff Carter* Cary Grant *Bonnie Lee* Jean Arthur *Bat McPherson* Richard Barthelmass *Judith* Rita Hayworth *Kid Dabb* Thomas Mitchell *Dutchman* Sig Ruman *Sparks* Victor Kilian *Gent Sheldon* John Carroll *Les Peters* Allyn Josyn *Tex Gordon* Donald "Red" Barry *Joe Souther* Noah Beery, Jr. *Lily* Melissa Sierra *Dr. Lagorio* Lucio Villegas *Hartwood, Sr.* Forbes Murray *Guitarist* Manuel Maciste *Mike* Pat Flaherty *Pancho* Pedro Regas *Baldy* Pat West *Musician* Candy Candido *Mechanics* Lew Davis, Al Rhein, James Millican, Bud Wolfe, Curly Dresden, Ed Randolph, Ky Robinson, Eddie Foster *Lily's Agent* Inez Palange *Purser* Rafael Corio *Servant* Charles Moore *Cook* Sammee Tong *Plantation Owners* Victor Travers, Francisco Maran *Assistant Purser* Wilson Benge *Ship's Captain* Vernon Dent *Banana Foreman* Jack Lowe *Second Foreman* Tex Higginson *Tourists* Enrique Acosta, Raoul Lechuga, Dick Botiller, Harry Bailey, Amora Navarro, Tessie Murray *Felice* Cecilia Callejo *Blonde Spanish Girl* Elana Duran *First Mate* Budd Fine *Hartwood, Jr.* Stanley Brown

Note: Working title was *Plane No. 4.*

The Private Lives of Elizabeth and Essex
(Warner Bros.; November 11, 1939)

Executive Producer Hal B. Wallis *Producer* Robert Lord *Director* Michael Curtiz *Screenplay* Norman Reilly Raine, Aeneas MacKenzie *Based on the Stage Play* "Elizabeth the Queen" *by* Maxwell Anderson *as Produced by* The Theatre Guild, Inc. *Cinematographer* Sol Polito *Associate Cinematographer* W. Howard Greene *Musical Score* Erich Wolfgang Korngold *Musical Director* Leo F. Forbstein *Film Editor* Owen Marks *Sound Supervisor* Nathan Levinson *Production Mixer* Clare A. Riggs *Dialogue Coach* Stanley Logan *Art Director* Anton Grot *Costume Designer* Orry-Kelly *Makeup* Perc Westmore *Orchestration* Hugo Friedhofer, Milan Roder *Production Manager* Tenny Wright *Unit Manager* Frank Mattison *Assistant Director* Sherry Shourds *Technical Adviser* Ali Hubert *Technicolor Director* Natalie Kalmus *Technicolor Consultant* Morgan Padelford *Special Effects Director* Byron Haskin *Special Effects Cinematographer* Hans F. Koenekamp

A Warner Bros.-First National Picture. Made at Warner Bros. Studios. Copyright November 11, 1939 by Warner Bros. Pictures Inc. Technicolor. RCA Photophone Recording. 106 minutes.

Players: *Queen Elizabeth* Bette Davis *Earl of Essex* Errol Flynn *Lady Penelope Gray* Olivia De Havilland *Francis Bacon* Donald Crisp *Earl of Tyrone* Alan Hale, Sr. *Sir Walter Raleigh* Vincent Price *Lord Burghley* Henry Stephenson *Sir Robert Cecil* Henry Daniell *Sir Thomas Egerton* James Stephenson *Mistress Margaret Redcliffe* Nanette Fabares (Fabray) *Lord Mountjoy* Robert Warwick *Sir Edward Coke* Leo G. Carroll *Lord Charles Howard* Guy Bellis with Rosella Towne, Maris Wrixon, John Sutton, Doris Lloyd, Forrester Harvey, I. Stanford Jolley

Additional Oscar Nominations: *Art Direction* (Anton Grot); *Music — Scoring* (Erich Wolfgang Korngold); *Sound Recording* (Nathan Levinson); *Cinematography — Color* (Sol Polito, W. Howard Greene)

Note: Execution sequence was edited from some current prints. Working titles: *Elizabeth the Queen, The Knight and the Lady* and *Elizabeth and Essex.*

The Rains Came

(20th Century-Fox; September 15, 1939)

Producer Darryl F. Zanuck *Associate Producer* Harry Joe Brown *Director* Clarence Brown *Screenplay* Philip Dunne, Julien Josephson *Based on the Novel by* Louis Bromfield *Cinematographer* Arthur Miller *Musical Score* Alfred Newman *Film Editor* Barbara McLean *Art Directors* William S. Darling, George Dudley *Set Decorator* Thomas Little *Costume Designer* Gwen Wakeling *Sound Supervisor* Edmund H. Hansen *Production Mixer* Alfred Bruzlin *Dubbing Mixer* Roger Heman *Camera Operator* Joseph La Shelle *Still Photographer* Cliff Maupin *Songs* "The Rains Came" *by* Mack Gordon, Harry Revel; "Hindu Song of Love" by Lal Chand Mehra *Visual Effects Supervisor* Fred Sersen *Matte Artist* Ray Kellogg *Mechanical Effects* Louis Witte

Made at 20th Century-Fox Studios and on location in Southern California. Copyright September 15, 1939 by 20th Century-Fox Film Corporation. Sepia. Western Electric Mirrophonic Recording. 103 minutes.

The Players: *Lady Edwina Esketh* Myrna Loy *Maj. Rama Safti* Tyrone Power *Tom Ransome* George Brent *Fern Simon* Brenda Joyce *Lord Albert Esketh* Nigel Bruce *Maharani* Maria Ouspenskaya *Bannerjee* Joseph Schildkraut *Miss Mac-David* Mary Nash *Aunt Phoebe Smiley* Marjorie Rambeau *Rev. Homer Smiley* Henry Travers *Maharajah* H.B. Warner *Lily Hoggett-Egbury* Laura Hope Crews *Raschid Ali Khan* William Royle *Gen. Keith* Montague Shaw *Rev. Elmer Simon* Harry Hayden *Bates* Herbert Evans *John the Baptist* Abner Biberman

Mrs. Bannerjee Mara Alexander *Das* William Edmunds *Princesses* Adele Labansat, Sonia Charsky *Maid* Rita Page *Nurses* Rosina Galli, Connie Leon *Official* Pedro Regas *Indian* Lal Chand Mehra *Engineer* Frank Lackteen *Rajput* George Regas *Doctor* Leyland Hodgson *Hindu Woman* Fern Emmett *Durga* Guy D'Emery *Aide-de-Camp* Jamiel Hasson *Officer* Maj. Sam Harris

Additional Oscar Nominations: *Film Editing* (Barbara McLean); *Art Direction* (William Darling, George Dudley); *Music — Original Score* (Alfred Newman); *Sound Recording* (E.H. Hansen)

Note: Remade by 20th Century–Fox as *The Rains of Ranchipur.* See 1955.

Topper Takes a Trip

(United Artists; January 12, 1939)

Producer Hal Roach, Sr. *Associate Producer* Milton H. Bren *Director* Norman Z. McLeod *Screenplay* Eddie Moran, Jack Jevne, Corey Ford *Based on Characters Created by* Thorne Smith *Cinematographer* Norbert Brodine *Musical Score* Edward Powell, Hugo Friedhofer *Musical Director* Marvin Hartley *Film Editor* William Terhune *Sound Supervisor* Elmer Raguse *Art Director* Charles D. Hall *Set Decorator* William L. Stevens *Costume Designers* Irene, Omar Kiam *Assistant to the Producer* Hal Roach, Jr. *Production Manager* Sidney S. Van Keuran *Orchestration* Edward Powell, Herbert Spencer *Special Effects* Roy Seawright

A Hal Roach Production. Made at Hal Roach Studios. Copyright February 1, 1939 by Hal Roach Studios, Inc. Western Electric Mirrophonic Recording. 85 minutes.

The Players: *Marion Kerby* Constance Bennett *Cosmo Topper* Roland Young *Clara Topper* Billie Burke *Wilkins* Alan Mowbray *Nancy Parkhurst* Veree Teasdale *Louis* Franklin Pangborn *Baron de Rossi* Alexander D'Arcy *Mr. Atlas* Skippy *Bartender* Paul Hurst *Jailer* Eddy Conrad *Judge Wilson* Spencer Charters *Prosecutor* Irving Pichel *Defense Attorney* Paul Everton *Gorgan* Duke York *Bellhop* Leon Belasco *Magistrate* Georges Renavent *Waiters* George Humbert, Alphonse Martell *Bailiff* James Morton *Doorman* Torben Meyer *Porter* George Davis *Clerk* Armand Kaliz *George Kerby* Cary Grant

Note: Second in the Roach trilogy, preceded by *Topper* (MGM, 1937) and followed by *Topper Returns* (United Artists, 1941). The studio produced a television series that ran from October 1953 to September 1955. A revised TV pilot was produced in 1974, and another pilot, this time a feature, was made in 1979. Neither resulted in another series. Cary Grant's scenes were stock footage from *Topper.*

Union Pacific
(Paramount; April 28, 1939)

Executive Producer William LeBaron *Producer and Director* Cecil B. De Mille *Associate Producer* William H. Pine *Screenplay* Walter DeLeon, C. Gardner Sullivan, Jesse L. Lasky, Jr., Jeanie Macpherson *Adaptation* Jack Cunningham *Based on the Novel* Trouble Shooter *by* Ernest Haycox *Cinematographer* Victor Milner *Second Unit Cinematographer* Dewey Wrigley *Musical Score* Sigmund Krumgold, John Leipold *Film Editor* Anne Bauchens *Second Unit Directors* Arthur Rosson, James Hogan, Jesse L. Lasky, Jr. *Art Directors* Hans Dreier, Roland Anderson *Production Illustrator* Dan Sayre Groesbeck *Set Decorator* A.E. Freudeman *Costume Designer* Natalie Visart *Indian Technical Supervisors* Iron Eyes Cody, J.W. Silvermoon Cody *Production Cooperation* Union Pacific Railroad *Dialogue Coach* Edwin Maxwell *Wrangler* Hosea Steelman *Choreography* LeRoy Prinz *Research* Frank Calvin, Waldo Twitchell *Unit Publicist* Robert Gillham *Production Manager* Roy Burns *Assistant Director* Edward Salven *Production Secretary* Gladys Rosson *Makeup* Wally Westmore *Hairdressing* Nellie Manley *Camera Operator* Haskell Boggs *Sound Supervisor* Loren L. Ryder *Production Mixer* Harry M. Lindgren *Dubbing Mixer* John Cope *Special Effects Director* Gordon Jennings *Special Effects Cinematographer* Irmin Roberts *Matte Artist* Jan Domela *Optical Cinematography* Paul K. Lerpae *Process Cinematography* Farciot Edouart, Dewey Wrigley

A Cecil B. De Mille Productions Inc. Picture. Made at Paramount Studios and on location in Canab, Utah and Canoga Park, California. Copyright March 5, 1939 by Paramount Pictures Inc. Western Electric Mirrophonic Recording. 133 minutes.

The Players: *Mollie Monahan* Barbara Stanwyck *Jeff Butler* Joel McCrea *Fiesta* Akim Tamiroff *Dick Allen* Robert Preston *Leach Overmile* Lynne Overman *Sid Campeau* Brian Donlevy *Jack Cordray* Anthony Quinn *Mrs. Calvin* Evelyn Keyes *Duke Ring* Robert Barrat *Casement* Stanley Ridges *Asa M. Barrows* Henry Kolker *Grenville M. Dodge* Francis J. McDonald *Oakes Ames* Willard Robertson *Calvin* Harold Goodwin *Sam Reed* Richard Lane *Dusky Clayton* William Haade *Paddy O'Rourke* Regis Toomey *Monahan* J.M. Kerrigan *Cookie* Fuzzy Knight *Al Brett* Harry Woods *Dollarhide* Lon Chaney, Jr. *Gen. Ulysses S. Grant* Joseph Crehan *Mame* Julia Faye *Rose* Sheila Darcy *Shamus* Joseph Sawyer *Bluett* Earl Askam *Dr. Durant* John Marston *Andrew Whipple* Byron Fougler *Jerome* Selmer Jackson *Sen. Smith* Morgan Wallace *Sergeant* Russell Hicks *Mrs. Hogan* Mary Beatty *Gen. Philip Sheridan* Ernest S. Adams *Oliver Ames* William J. Worthington *Gov. Stanford* Guy Usher *Mills* James McNamara *Gov. Sofford* Gus Glassmire *Dr. Harkness* Stanley Andrews *Rev. Dr. Todd* Paul Everton *Harmonica Player* Jack Pennick *Gamblers* Richard Alexander, Max Davidson, Oscar G. Hendrian, Jim Pierce *Irishman* Walter Long *Laborer* John Merton *Paddy* Jim Farley *Fireman* Buddy Roosevelt

Reporters Richard Denning, David Newell *Warriors* Artie Ortega, Chief Thundercloud, Ray Mala, Iron Eyes Cody, Sonny Chorre, Greg Whitespear, Richard Robles, Tony Urchel, Noble Johnson, Monte Blue, J.W. Silvermoon Cody, Navaho and Cheyenne Tribesmen *Conductor* Lane Chandler *Women* Mary MacLaren, Jane Keckley, Maude Fealy *Men* Jack Richardson, William Pawley, Emory Parnell, Frank Shannon, Elmo Lincoln, Edward J. LeSaint, Nestor Paiva, Ed Brady, Stanhope Wheatcroft *Barker* Sid Sailor

The Wizard of Oz

(Metro-Goldwyn-Mayer; August 18, 1939)

Producer Mervyn LeRoy *Directors* Victor Fleming, King Vidor, Richard Thorpe, George Cukor *Screenplay* Noel Langley, Florence Ryerson, Edgar Allan Woolf, E.Y. Harburg, John Lee Mahin *Adaptation* Noel Langley *Based on the "Oz" Books by* L. Frank Baum *Cinematographer* Harold Rosson *Associate Cinematographer* Allen Davey *Musical Score* Harold Arlen *Additional Music* George Bassman, George Stoll, Herbert Stothart, Robert Stringer, Roger Edens, Van Alstyne *Musical Adaptation* Herbert Stothart, Roger Edens *Musical Director* Herbert Stothart *Associate Musical Director* George Stoll *Lyrics* E.Y. Harburg *Orchestration and Vocal Arrangements* George Bassman, Ken Darby, Murray Cutter, Paul Marquardt, Roger Edens *Film Editor* Blanche Sewell *Sound Supervisor* Douglas Shearer *Production Mixer* Conrad Kahn *Assistant Sound Supervisor* Wesley C. Miller *Assistant to the Producer* Arthur Freed *Choreography* Bobby Connolly *Art Director* Cedric Gibbons *Associate Art Director* William A. Horning *Assistant Art Directors* Randall Duell, Malcolm Brown *Set Decorator* Edwin B. Willis *Property Master* Billy H. Scott *Costume Designer* Adrian *Makeup Supervisor and Character Makeups Designer* Jack Dawn *Makeup* Jack Young, Charles Schram, Howard Smit, William Tuttle, Josef Norin, Gustav Norin, Emile LaVigne, Jack Kevan, Lee Steinfield *Technicolor Director* Natalie Kalmus *Technicolor Consultant* Henri Jaffa *Casting* Billy Grady, Henry Kramer, Leonard Murphy *Publicity Supervisors* Howard Dietz, Howard Strickling *Unit Publicist* Mary Mayer *Vocal Coach* Roger Edens *Production Manager* Joseph S. Cohn *Unit Manager* Keith Weeks *Assistant Director* Al Shoenberg *Wardrobe* John B. Scura, Marie Wharton, Marian Parker, Sheila O'Brien, Rose Meltzer, Vera Mordaunt, Marie Rose *Camera Operator* Henry Imus *Construction Supervisor* Lorey "Easy" Yzuel *Plaster Supervisor* Henny Greutert *Scenic Supervisor* George Gibson *Scenic Artist* Ben Carre *Assistant Choreographer* Dona Massin *Dog Trainer* Carl Spitz *Special Effects Supervisor* A. Arnold Gillespie *Assistant Special Effects Supervisor* Warren Newcomb *Special Effects* Marcel Delgado, Jack McMasters, Franklin E. Milton, Glen Robinson, Hal Millar

A Victor Fleming Production. Produced by Loew's, Inc. Made at MGM

Studios. Copyright August 7, 1939 by Loew's, Inc. Technicolor. Western Electric Mirrophonic Recording. 102 minutes.

The Players: *Dorothy Gale* Judy Garland *The Wizard/Prof. Marvel/Carriage Driver/Palace Guard* Frank Morgan *The Scarecrow/Huke* Ray Bolger *The Cowardly Lion/Zeke* Bert Lahr *The Tin Woodsman/Hickory* Jack Haley, Sr. *Good Witch Glinda* Billie Burke *The Wicked Witch of the West/Almira Gulch* Margaret Hamilton *Uncle Henry Gale* Charles Grapewin *Auntie Em Gale* Clara Blondick *Nikko* Pat Walshe *Mayor of Munchkinland* Billy Curtis *Munchkins* Jerry Marenghi (Maren), Charlie Becker, Hazel Resmundo, Margaret Pellegrini, Dolly Kramer, Grace Williams, Angelo Rossitto, Harry Monty, Tommy Cottonaro, Harvey Williams & His Little People, The Leo Singer Midgets *Toto* Terry *Stuntwoman* Betty Danko *Stand-in* Bobbie Koshay

Additional Oscar Nominations: *Picture* (MGM, Mervyn LeRoy); *Art Direction* (Cedric Gibbons, William A. Horning); *Music — Song* ("Over the Rainbow" by Harold Arlen, E.Y. Harburg)*; *Music — Original Score* (Herbert Stothart)*; *Special Award — miniature statuette* (Judy Garland for her outstanding performance as a screen juvenile during the past year)*

Note: Previously made in 1913 by Oz Film Company and in 1924 by Chadwick. Remakes include *The Wonderful Land of Oz* (Childhood Productions, 1969); *20th Century Oz* (Inter Planetary Pictures, 1976), an Australian production; *The Wiz* (Universal Pictures, 1978), adapted from an all-black stage musical; *The Wizard of Oz* (Toho, 1981), an animated version from Japan; and *The Wizard of Oz* (1982), a videotaped stage version made for direct sales on videocassette. An animated sequel, *Journey Back to Oz* (Filmation Associates, 1964), featuring the voice of Liza Minnelli as Dorothy, was made for television and released theatrically in 1974; and a live action sequel, *Return to Oz* (Buena Vista, 1985) was produced by the Disney studio in England. *Under the Rainbow* (Orion Pictures, 1981) was a fictional telling of the little people's comic antics during the making of the 1939 classic.

1940

Special Effects Nominations

The Blue Bird . Fred Sersen
(20th Century-Fox) *Audible:* E.H. Hansen
Boom Town (MGM) A. Arnold Gillespie
 Audible: Douglas Shearer
The Boys From Syracuse John P. Fulton
(Universal) *Audible:* Bernard B. Brown, Joseph Lapis
Dr. Cyclops (Paramount) Farciot Edouart,
 Gordon Jennings
Alfred Hitchcock's *Foreign Correspondent* Paul Eagler
(Wanger, UA) *Audible:* Thomas T. Moulton
The Invisible Man Returns John P. Fulton
(Universal) *Audible:* Bernard B. Brown,
 William Hedgecock
The Long Voyage Home R.T. Layton, R.O. Binger
(Wanger, UA) *Audible:* Thomas T. Moulton
One Million B.C. Roy Seawright
(Roach, UA) *Audible:* Elmer Raguse
Alfred Hitchcock's *Rebecca* Jack Cosgrove
(Selznick, UA) *Audible:* Arthur Johns
The Sea Hawk . Byron Haskin
(Warner Bros.) *Audible:* Nathan Levinson
Swiss Family Robinson Vernon L. Walker
(RKO Radio) *Audible:* John O. Aalberg
**The Thief of Bagdad* Lawrence Butler
(Korda, UA) *Audible:* Jack Whitney
Typhoon (Paramount) Farciot Edouart,
 Gordon Jennings
 Audible: Loren Ryder
Women in War (Republic) Howard J. Lydecker,
William Bradford, Ellis J. Thackery
 Audible: Herbert Norsch

Scientific or Technical Awards

Class III Warner Bros. Art Department
and Anton Grot

For the design and perfecting of the Warner Bros. water ripple
and wave illusion machine

Comments

This year there was considerable ill feeling generated over the Special
Effects award. It would not be the last. Larry Butler, an American special-
izing at that time in mechanical devices, and Jack Whitney, head of General
Service Studios' sound department in Hollywood, were nominated and
received the Oscar for *The Thief of Bagdad*. Yet the actual craftsmen principal-
ly responsible for the work were all Englishmen: Percy Day, Wally Veevers,
Tom Howard, Stanley Sayer and Johnny Mills, visual effects; Tony Watkins
and Denham Studios Sound Department, recording. Only Day received
screen credit! The United Kingdom crew was just justifiably irked. As is so
often the case, there was no reasoning to this credit. Though completed in
the United States, almost all Special Effects work—indeed almost all prin-
cipal photography—was done in England. This remarkable fantasy about a
youth, aided by a gigantic djinni, who outwits an evil sorcerer featured
numerous traveling and painted mattes and miniatures. Many of these were
extremely spectacular. Butler did contribute some large mechanical props.
These, however, were the least effective illusions employed and were rather
poor in some scenes.

In *The Blue Bird* a little girl sought the mythical Bird of Happiness amid
Technicolor miniatures and matte art. Lushly produced, these created a
totally engrossing fantasy world that excelled even *Thief of Bagdad's* Arabian
Nights atmosphere. The climax was a blazing inferno as the miniature forest
burned with the appropriate thrills before Fred Sersen's cameras. As with all
early color productions, the transparencies were noticably pale.

MGM's usual washed-out process shots provided most of the
backgrounds for *Boom Town*, a popular tale of wildcatters and oil boomers.
The models and mattes weren't bad.

John P. Fulton was a master of multiple exposure work, and *The Boys
From Syracuse* and *The Invisible Man Returns* featured plenty. The former also
included numerous mattes depicting the ancient world. The miniature work
varied. Fulton's traveling mattes, though often fringed noticeably, still were
impressive. Sound supervisor Bernard Brown shared audio effects nomina-
tion with the production recordists on each show.

Process supervisor Farciot Edouart and trick photographer Gordon
Jennings ramrodded *Dr. Cyclops* and *Typhoon*. The first feature told of an in-
sane scientist in South America who was able to shrink people and animals.
Almost all the illusions were accomplished via oversize props and rear
screens. Jennings' contributions weren't even acknowledged with a screen
credit. The second production offered a shipwreck, tidal wave, forest fire,
and the title storm, all in miniature. This film was also nominated for sound
effects.

A pre–World War II spy thriller directed by Alfred Hitchcock and

dealing with kidnapping, *Foreign Correspondent* almost appeared devoid of visual effects other than the obvious back projection. However, it had incredible models and mattes that expanded some soundstage scenes to wide vistas. An impressive process shot involved a plane crash viewed through the cockpit. As the sea projected on the screen rushed toward the plane, dump tanks released a deluge of water that tore through the process screen and flooded the cockpit. Simple and hugely effective.

The Long Voyage Home, derived from several short stage plays, was a talky bore using a great deal of process work. About the crew of a trawler, it was shot entirely within the studio, and the marine work included the usual model shots. Studio sound department head Thomas Moulton supervised the recording for this and *Foreign Correspondent*.

This year was heavy with fantasies, and the best was *One Million B.C.*, a super adventure of primeval man and his struggles against himself, nature, and monstrous beasts. Employing every type of Special Effects, most notably rear projection and models, the story was historically inaccurate, but so enhanced by the trick photography and illusions that no one cared. There were several animal fights employing live creatures and costumed performers, a terrific volcanic eruption and earthquake, a landslide, forest fire, and many miniature vistas of jungle and desert. Roach Studios' Special Effects Department was headed by Roy Seawright, and their sound department by Elmer Raguse.

Rebecca, another Hitchcock thriller, made use of some very large and badly photographed miniatures, but did have a few good matte paintings by Jack Cosgrove. Arthur Johns, the dubbing recordist, was nominated for audible effects.

Though *The Sea Hawk* had some good model marine work, so much of it was lifted from earlier Warner Bros.-owned features that its nomination seems strange indeed. An enjoyable swashbuckler, it really had no place in this awards category.

RKO shot *Swiss Family Robinson* entirely in California, but the lost island atmosphere was obtained thanks to Verne Walker, Lin Dunn and Albert Simpson and their models, opticals and matte art. The best and most notable work was the opening storm sequence. The various nature sounds were attributed to studio sound director John Aalberg.

The bombing of a miniature village and an air attack on channel-crossing ships highlighted *Women in War*, an obscure Republic production. Howard Lydecker, who had turned out some really bad models for Mascot Pictures in the early thirties, headed the miniature and mechanical effects unit at the studio until they ceased production in the late fifties. He worked freelance for a while before taking over the Model Department at 20th Century-Fox. Despite his poor early efforts, he established at Republic the industry's finest miniature shop and developed some of the best model control systems. Unfortunately, Bud Thackery's process cinematography never equaled the studio's miniature work. At this time Republic was not screen-

billing soundmen; nevertheless, production mixer Herbert Norsch was acknowledged with a nomination for his audio contributions.

Credits

The Blue Bird
(20th Century-Fox; March 22, 1940)

Producer Darryl F. Zanuck *Associate Producer* Gene Markey *Director* Walter Lang *Screenplay* Ernest Pascal *Additional Dialogue* Walter Bullock *Based on the Stage Play by* Maurice Maeterlinck *Cinematographer* Arthur Miller *Associate Cinematographer* Ray Rennahan *Musical Score* Alfred Newman *Film Editor* Robert Bischoff *Technicolor Director* Natalie Kalmus *Technicolor Consultant* Henri Jaffa *Sound Supervisor* Edmund H. Hansen *Production Mixer* E. Clayton Ward *Dubbing Mixer* Roger Heman *Art Directors* Richard Day, Wiard B. Ihnen *Set Decorator* Thomas Little *Costume Designer* Gwen Wakeling *Choreography* Genva Sawyer *Special Effects* Fred Sersen *Matte Artist* Ray Kellogg

A Darryl F. Zanuck Production. Made at 20th Century-Fox Studios. Copyright January 19, 1940 by 20th Century-Fox Film Corporation. Technicolor. Western Electric Mirrophonic Recording. 88 minutes.

The Players: *Mytyl* Shirley Temple *Mummy Tyl* Spring Byington *Luxury* Nigel Bruce *Tylette* Gale Sondergaard *Tylo* Eddie Collins *Angela Berlingot* Sybil Jason *Fairy Berylune* Jessie Ralph *Light* Helen Erickson *Tyltyl* Johnny (John) Russell *Mrs. Luxury* Laura Hope Crews *Daddy Tyl* Russell Hicks *Granny Tyl* Cecilia Loftus *Grandpa Tyl* Al Shean *Studious Boy* Gene Reynolds *Mrs. Berlingot* Leona Roberts *Wilhelm* Stanley Andrews *Cypress* Dorothy Dearing *Roll Caller* Frank Dawson *Nurse* Claire DuBrey *Wild Plum* Sterling Holloway *Father Time* Thurston Hall *Oak* Edwin Maxwell *Footmen* Herbert Evans, Brandon Hurst *Royal Forester* Dewey Robinson *Major Domo* Keith Hitchcock *Boy Inventor* Buster Phelps *Lovers* Tommy Baker, Dorothy Joyce *Boy Chemist* Billy Cook *Children* Scotty Beckett, Juanita Quigley, Payne Johnson *Little Sister* Ann Todd *Little Girl* Dianne Fisher

Additional Oscar Nomination: *Cinematography — Color* (Arthur Miller, Ray Rennahan)

Note: The first sequences were in sepiatone with the story going to Technicolor as the fantasy section began. This was a remake of the 1918 Artcraft feature. Remade in 1976 by 20th Century-Fox in association with Lenfilm Studio.

Boom Town
(Metro-Goldwyn-Mayer; August 30, 1940)

Producer Sam Zimbalist *Director* Jack Conway *Screenplay* John Lee Mahin *Based on the Story "A Lady Comes to Burknurnet" by* James Edward Grant *Cinematographers* Harold Rosson, Elwood Bredell *Art Director* Cedric Gibbons *Associate Art Director* Eddie Imazu *Musical Score* Franz Waxman *Montage Director* John Hoffman *Sound Supervisor* Douglas Shearer *Film Editor* Paul Landers *Second Unit Director* John Waters *Stunt Coordinator* Yakima Canutt *Set Decorator* Edwin B. Willis *Makeup* Jack Dawn *Hairdressing* Sydney Guilaroff *Costume Designers* Adrian, Gile Steele *Assistant Director* Horace Hough *Publicity Supervisors* Howard Dietz, Howard Strickling *Assistant Sound Supervisor* Wesley C. Miller *Special Effects* A. Arnold Gillespie, Warren Newcombe

A Loew's Inc. Production. Made at MGM Studios and on location in California. Copyright August 5, 1940 by Loew's Inc. Western Electric Mirrophonic Recording. 116 minutes.

The Players: *Big John McMasters* Clark Gable *Square John Sand* Spencer Tracy *Betsy Bartlett* Claudette Colbert *Karen Van Meer* Hedy Lamarr *Luther Aldrich* Frank Morgan *Harry Compton* Lionel Atwill *Harmony Jones* Chill Wills *Whitey* Marion Martin *Spanish Eva* Minna Gombell *Ed Murphy* Joe Yule *Tom Murphy* Horace Murphy *McCreery* Roy Gordon *Assistant District Attorney* Richard Lane *Little Jack* Casey Johnson *Baby Jack* Baby Quintanilla *Judge* George Lessey *Miss Barnes* Sara Haden *Barber* Frank Orth *Deacon* Frank McGlynn, Jr. *Ferdie* Curt Bois *Hiring Boss* Dick Curtis

Additional Oscar Nominations: *Cinematography — Black-and-White* (Harold Rosson)

The Boys from Syracuse
(Universal; August 9, 1940)

Producer Jules Levy *Director* A. Edward Sutherland *Screenplay* Leonard Spiegelglass, Charles Grayson, Paul Gerard Smith *Based on the Musical Play: Book by* George Abbott *Lyrics by* Lorenz Hart *Music by* Richard Rodgers *From the Stage Play* "A Comedy of Errors" *by* William Shakespeare *Cinematographer* Joseph Valentine *Musical Director* Charles Previn *Film Editor* Milton Carruth *Art Director* John Otterson *Set Decorator* Russell A. Gausman *Choreography* Dave Gould *Makeup* Jack P. Pierce *Sound Supervisor* Bernard B. Brown *Production Mixer* Joseph Lapis *Special Effects* John P. Fulton, David Stanley Horsley *Miniatures* Charlie Baker

A Mayfair Production. Made at Universal City Studios. Copyright July 18, 1940 by Universal Pictures Company, Inc. Western Electric Mirrophonic Recording. 73 minutes.

The Players: *Antipholus of Ephesus/Antipholus of Syracuse* Allan Jones *Dromio of Ephesus/Dromio of Syracuse* Joe Penner *Duke of Ephesus* Charles Butterworth *Luce* Martha Raye *Phyllis* Rosemary Lane *Adriana* Irene Harvey *Pinch* Eric Blore *Angelo* Alan Mowbray *Aegeon* Samuel S. Hinds *Octavious* Tom Dugan *Turnkey* Spencer Charters *First Woman* Doris Lloyd *Announcer* Larry Blake *Taxi Driver* Eddie Acuff *Bartender* Matt McHugh *Jury Foreman* Joe Cunningham *Messenger* David Oliver *Man* Malcolm Waite *Second Woman* Alaine Branes *Secretary* June Wilkins *Conductor* Charles Sherlock *Policeman* Charles Sullivan *Newsboy* Gerald Pierce *Girl* Julie Carter *Third Woman* Bess Flowers *Guard* Cyril Ring *Driver* William Desmond

Additional Oscar Nomination: *Art Direction — Black-and-White* (John Otterson)

Dr. Cyclops

(Paramount; April 12, 1940)

Producer Dale Van Every *Director* Ernest B. Schoedsack *Screenplay* Tom Kilpatrick *Based on the Story by* Henry Kuttner *Cinematographer* Henry Sharp *Associate Cinematographer* Winton C. Hoch *Musical Score* Ernest Toch, Gerard Carbonara, Albert Hay Malotte *Film Editor* Ellsworth Hoagland *Technicolor Director* Natalie Kalmus *Technicolor Consultant* Henri Jaffa *Art Directors* Hans Dreier, Earl Hedricks *Set Decorator* A.E. Freudeman *Makeup* Wally Westmore *Hairdressing* Nellie Manley *Sound Supervisor* Loren L. Ryder *Production Mixer* Harry M. Lindgren *Dubbing Mixer* Richard Olson *Special Effects Director* Gordon Jennings *Special Effects Cinematographer* Irmin Roberts *Matte Artist* Jan Domela *Optical Cinematography* Paul K. Lerpae *Process Cinematography* Farciot Edouart, W. Wallace Kelley

Made at Paramount Studios. Copyright April 12, 1940 by Paramount Pictures Inc. Technicolor. Western Electric Mirrophonic Recording. 75 min.

The Players: *Dr. Alexander Thorkel* Albert Dekker *Dr. Mary Mitchell* Janice Logan *Bill Stockton* Thomas Coley *Dr. Rupert Bullfinch* Charles Halton *Steve Baker* Victor Kilian *Pedro* Frank Yaconelli *Silent Indian* Bill Wilkerson *Taxi Driver* Allen Fox *Dr. Mendoza* Paul Fix *Prof. Kendall* Frank Reicher

Note: Henry Kuttner, using the pseudonym Will Garth, expanded the short story into a novel after the film became a success.

Alfred Hitchcock's *Foreign Correspondent*

(United Artists; August 16, 1940)

Producer Walter Wanger *Director* Alfred Hitchcock *Screenplay* Charles Bennett, Joan Harrison *Dialogue* James Hilton, Robert Benchley *Adaptation* John Howard Lawson, Budd Schulberg, Harold Clurman, John Lay, John Meehan *Based on the Autobiography* "Personal History" *by* Vincent Sheehan *and the Novel* "The Thirty-Nine Steps" *by* John Buchan *Cinematographer* Rudolph Mate *Musical Score* Alfred Newman *Supervising Film Editor* Otho Lovering *Film Editor* Dorothy Spencer *Assistant Director* Edmond F. Bernoudy *Production Designer* William Cameron Menzies *Art Director* Alexander Golitzen *Associate Art Director* Richard Irvine *Set Decorator* Julia Heron *Costumes* I. Magnin & Co. *Air Scenes* Paul Mantz *Camera Operator* Burnett Guffey *Publicity Supervisors* Monroe Greenthal, John Leroy Johnston *Sound Supervisor* Thomas T. Moulton *Sound* Samuel Goldwyn Studios *Production Mixer* Frank Maher *Dubbing Mixers* Gordon E. Sawyer, Arthur W. Johns *Second Unit Cinematographer* Roy Overbaugh *Visual Effects* Paul Eagler *Mechanical Effects* Lee Zavitz

A Walter Wanger Presentation. An Alfred Hitchcock Production. Made at Samuel Goldwyn Studios. Copyright August 29, 1940 by Walter Wanger Productions Inc. Western Electric Mirrophonic Recording. 120 minutes.

The Players: *Jonny Jones/Huntley Haverstock* Joel McCrea *Carol Fisher* Laraine Day *Stephen Fisher* Herbert Marshall *Herbert Ffolliott* George Sanders *Van Mear* Albert Basserman *Stebbins* Robert Benchley *Krug* Eduardo Cianelli *Rowley* Edmund Gwenn *Powers* Harry Davenport *Tramp* Martin Kosleck *Latvian Diplomat* Eddie Conrad *Mrs. Benson* Gertrude W. Hoffman *Miss Benson* Jane Novak *Benson* Ken Christy *Toast Master* Crauford Kent *Capt. Lanson* Louis Borell *Doreen* Barbara Pepper *Assassin* Charles Wagenheim *Mrs. Spraque* Frances Carson *Valet* Alexander Granach *Mrs. Jones* Dorothy Vaughn *Donald* Jack Rice *Sophie* Rebecca Bohannen *Clipper Captain* Martin Lamont *Miss Pimm* Hilda Plowright *Brood* Roy Gordon *Insp. McKenna* Leonard Mudie *Com. Ffolliott* Holmes Herbert *John Martin* Emory Parnell *Dutch Peasant* James Finlayson *Bradley* Charles Halton *Jones' Sister* Joan Brodel (Leslie) *Dr. Williamson* Paul Irving *Jones* Ferris Taylor *Clark* John T. Murray *Stiles* Ian Wolfe *Italian Waiter* Gino Corrado *English Cashier* Eily Malyon *English Radio Announcer* John Burton *Naismith* E.E. Clive *Man with Newspaper* Alfred Hitchcock

Additional Oscar Nominations: *Picture* (Wanger, UA; Walter Wanger); *Supporting Actor* (Albert Basserman); *Writing — Original Screenplay* (Charles Bennett, Joan Harrison); *Cinematography — Black-and-White* (Rudolph Mate); *Art Direction — Black-and-White* (Alexander Golitzen)

Note: Working title was *Personal History* . Hitchcock replaced William Dieterle as director during preproduction.

The Invisible Man Returns
(Universal; January 12, 1940)

Producer Kenneth Goldsmith *Director* Joe May *Screenplay* Curt Siodmak, Joe May *Based on Characters Created by* H.G. Wells, R.C. Sherriff, Philip Wylie *Cinematographer* Milton Krasner *Musical Score* Hans J. Salter, Frank Skinner *Musical Director* Charles Previn *Film Editor* Frank Gross *Art Director* Jack Otterson *Associate Art Director* Martin Obzina *Set Decorator* Russell A. Gausman *Makeup* Jack P. Pierce *Costume Designer* Vera West *Sound Supervisor* Bernard B. Brown *Production Mixer* William Hedgecock *Assistant Director* Phil Karlstein *Special Effects* John P. Fulton, David Stanley Horsley *Miniatures* Charlie Baker

Made at Universal City Studios. Copyright January 12, 1940 by Universal Pictures Company Inc. Western Electric Mirrophonic Recording. 81 minutes.

The Players: *Richard Cobb* Cedric Hardwicke *Geoffrey Radcliffe* Vincent Price *Dr. Frank Griffin* John Sutton *Helen Manson* Nan Grey *Insp. Sampson* Cecil Kellaway *Willis Spears* Alan Napier *Ben Jenkins* Forrester Harvey *Nurse* Francis Robinson *Cotton* Ivan Simpson *Prison Governor* Edward Fielding *First Policeman* Harry Stubbs *Second Policeman* Matthew Boulton *Third Policeman* Rex Evans *Fourth Policeman* Cyril Thornton *Fifth Policeman* Ed Brady *Chaplain* Bruce Lester *Detective* Paul England *Cook* Mary Gordon *First Woman* Mary Field *Second Woman* Clare Blore *Fingerprint Man* Eric Wilton *First Miner* Ellis Irving *Second Miner* Dennis Tankard *Third Miner* George Lloyd *Fourth Miner* George Kirby *Fifth Miner* Harry Cording *Sixth Miner* George Hyde *Chauffeur* Leyland Hodgson *Bob* Dave Thursby *First Plainsclothesman* Jimmy Aubrey *Second Plainclothesman* Colin Kenny *Griffin's Secretary* Louise Brien *Man* Ernest S. Adams *Bill* Frank Hagney *Policeman at Colliery* Frank O'Connor *Policeman Attending Cobb* Frank Hill *Prison Warden* Billy Bevan *Secretary* Hugh Huntley *Photograph of John Griffin* Claude Rains

Note: Sequel to *The Invisible Man* (Universal, 1933). Others in the Universal series were *The Invisible Woman* (1941), *The Invisible Agent* (1942), *The Invisible Man's Revenge* (1944), *Bud Abbott and Lou Costello Meet Frankenstein* (1948) and *Bud Abbott and Lou Costello Meet the Invisible Man* (1951). Universal also produced two television features, *The Invisible Man* (1975) and *The Gemini Man* (1975), based on the property. Both of these became very short-lived series during the 1975–76 season on NBC. The character was the basis of several foreign features, mostly of Mexican origin, and a British television series

starting in 1958. Numerous derivative features, including *Now You See Him, Now You Don't* (Disney, 1972) and *Mister Superinvisible* (Edo/Carsten, 1969; U.S. K-tel International, 1974), have been made.

The Long Voyage Home
(United Artists; November 11, 1940)

Executive Producer Walter Wanger *Producers* John Ford, Merian C. Cooper *Director* John Ford *Screenplay* Dudley Nichols *Based on the One-Act Stage Plays "The Moon of the Caribbees," "In the Zone," "Bound East for Cariff" and "The Long Voyage Home" by* Eugene O'Neill *Cinematographer* Gregg Toland *Musical Score* Richard Hageman *Musical Director* Edward Paul *Film Editor* Sherman Todd *Art Director* James Basevi *Set Decorator* Julia Heron *Sound Supervisor* Thomas T. Moulton *Sound* Samuel Goldwyn Studios *Production Mixer* Jack Noyes *Dubbing Mixers* Gordon E. Sawyer, Arthur W. Johns *Sound Editor* Robert Parrish *Key Grip* Ralph Hege *Production Manager* Lowell Farrell *Assistant Director* Wingate Smith *Second Assistant Director* Bernard F. McEveety *Script Supervisor* Meta Stern *Special Effects* Ray O. Binger, R.T. Layton

A Walter Wanger Productions Presentation. An Argosy Corporation Production. Made at Samuel Goldwyn Studios. Copyright October 21, 1940 by Walter Wanger Productions Inc. Western Electric Mirrophonic Recording. 105 minutes.

The Players: *Aloysius Driscoll* Thomas Mitchell *Ole Olsen* John Wayne *Thomas "Smitty" Fenwick* Ian Hunter *Cocky* Barry Fitzgerald *Captain* Wilfred Lawson *Freda* Mildred Natwick *Axel Swanson* John Qualen *Yank* Ward Bond *Davis* Joe Sawyer *Donkeyman* Arthur Shields *Crimp* J.M. Kerrigan *Scotty* David Hughes *Joe* Billy Bevan *Mate* Cyril McLaglen *Paddy* Robert E. Perry *Johnny Bergman* Jack Pennick *Narvey* Constantin Frenke *Big Frank* Constantin Romanoff *Tim* Danny Borzage *Max* Harry Tenbrook *Daughter of the Tropics* Raphaela Ottiano *Second Lieutenant* Douglas Walton *Cook* Edgar "Blue" Washington *Clifton* Lionel Pape *Kate* Jane Crowley *Mag* Maureen Roden-Ryan *Amindra Captain* Arthur Miles *Amindra First Mate* Harry Woods *British Naval Officer* Wyndham Standing *Dock Policemen* James Flavin, Lee Shumway *Bumboat Girls* Carmen Morales, Carmen D'Antonio, Tina Menard, Judith Linden, Elena Martinez, Lita Cortez, Soledad Gonzales *Bald Man* Lowell Drew *Seaman* Sammy Stein

Additional Oscar Nominations: *Picture* (Wanger, UA; John Ford); *Writing—Screenplay* (Dudley Nichols); *Film Editing* (Sherman Todd); *Cinematography—Black-and-White* (Gregg Toland); *Music—Original Score* (Richard Hageman)

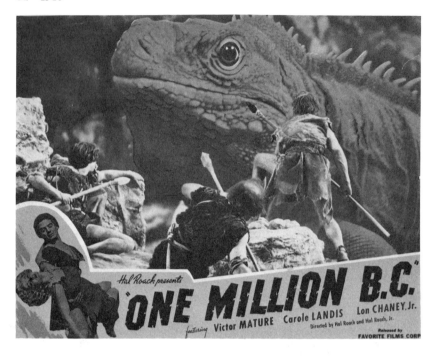

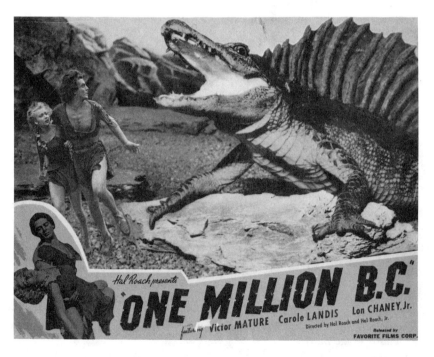

One Million B.C.

(United Artists; April 5, 1940)

Producer Hal Roach, Sr. *Directors* Hal Roach, Sr., Hal Roach, Jr., D.W. Griffith *Original Screenplay* Mikell Novak, George Baker, Joseph Fricket *Narration* Grover Jones *Cinematographer* Norbert Brodine *Musical Score* Werner R. Heymann *Film Editor* Ray Snyder *Sound Supervisor* Elmer A. Raguse *Production Mixer* William Randall *Art Director* Charles D. Hall *Associate Art Director* Nicolai Remisoff *Set Decorator* William L. Stevens *Costume Supervisor* Harry Black *Makeup* Paul Stanhope *Stunt Coordinator* Yakima Canutt *Production Manager* Sidney S. Van Keuren *Assistant Director* Bernard Carr *Special Effects Supervisor* Roy Seawright *Special Effects Cinematographer* Frank William Young *Miniatures* Fred Knoth *Matte Artist* Jack Shaw *Animal Supervisor* Charles Oelze

A Hal Roach Production. Made at Hal Roach Studios and on location at Vasque Rocks, California. Copyright April 12, 1940 by Hal Roach Studios Inc. Western Electric Mirrophonic Recording. 80 minutes.

The Players: *Tumak/Mountain Climber* Victor Mature *Loana/Mountain Climber* Carole Landis *Akhoba* Lon Chaney, Jr. *Archaelogist/Narrator* Conrad Nagel *Ohtao* John Hubbard *Mountain Guide* Robert Kent *Nupondi* Mamo Clark *Wandi* Mary Gale Fisher *Peytow* Nigel De Brulier *Tohana* Inez Palange *Skakana* Edgar Edwards *Ataf* Jacqueline Dalya *Shell Tribe* Adda Gleason, Rosemary Theby, Aubrey Manners, Patricia Pope, Ed Coxen, Creighton Hale, Jimmy Boudwin, Chuck Stubbs, Boots LeBaron, Dick Simons, Jean Porter, Katherine Frye, Ora May Carlson *Klang Tribe* Ricca Allen, Harry Wilson, John Northpole, Harold Howard, Henry Sylvester, Norman Budd, Lorraine Rivero, Aida Hernandez, Betty Greco, Frank Tinajero, James Coppedge

Additional Oscar Nomination: *Music — Original Score* (Werner Heymann)

Note: Re-issued as *Man and His Mate* and *Caveman*. Remade as *One Million Years B.C.* (20th Century–Fox, 1966) and *Caveman* (United Artists, 1981). D.W. Griffith was discharged from the production and may not have shot any footage.

Opposite top: A hand painted re-release lobby card for "One Million B.C." This is an actual frame blowup, something very rare for publicity stills and even rarer for Special Effects scenes. Bottom: This lobby card is a publicity pasteup and the action in the film does not occur in this manner, though such a scene is depicted in the story. The finned alligator, representing a dimetrodon, is larger in the film.

Alfred Hitchcock's *Rebecca*

(United Artists; April 10, 1940)

Producer David O. Selznick *Director* Alfred Hitchcock *Screenplay* Michael Hogan, Robert E. Sherwood, Joan Harrison *Adaptation* Philip MacDonald, Michael Hogan, Alma Reville Hitchcock, Joan Harrison, Martin Buckley *Based on the Novel by* Daphne du Maurier *Cinematographers* George Barnes, Harry Stradling, Sr. *Second Unit Cinematographer* Lloyd Knechtel *Musical Score* Franz Waxman, Max Steiner *Musical Associate* Louis Forbes *Supervising Film Editor* Hal C. Kern *Film Editor* James E. Newcom *Production Manager* Raymond A. Klune *Camera Operators* John F. Warren, Irving Rosenberg, Arthur E. Arling, Vincent J. Farrar *Art Director* Lyle Reynolds Wheeler *Interior Designer* Joseph B. Platt *Set Decorator* Howard Bristol *Production Executive* Henry Ginsberg *Scenario Assistant* Barbara Keon *Construction Supervisor* Harold Fenton *Costume Designers* Irene, Elmer Ellsworth *Makeup* Monty Westmore, Frank Westmore, Ben Nye *Hairdressing* Hazel Rogers *Assistant to the Director* Joan Harrison *Script Supervisor* Lydia Schiller *Executive Assistant to the Producer* Marcello Rabwin *Second Unit Director* Eric G. Stacey *Assistant Directors* Eric G. Stacey, Edmund F. Bernoudy *Second Assistant Director* Ridgeway Callow *Casting Tests Directors* Anthony Mann, John Cromwell *Still Photographer* Fred Parrish *Publicity Supervisors* Russell Birdwell, Monroe Greenthal, Whitney Bolton *Sound Superviser* Thomas T. Moulton *Sound* Samuel Goldwyn Studios *Production Mixer* Jack Noyes *Dubbing Mixers* Arthur W. Johns, Gordon E. Sawyer *Visual Effects Supervisor* John R. Cosgrove *Matte Artist* Albert Maxwell Simpson *Process Cinematography* Clarence W.D. Slifer *Mechanical Effects* Lee Zavitz

A Selznick Studio Production. A Selznick International Picture. Made at The Selznick Studio and on location in Carmel, Catalina and Del Monte, California. Copyright April 16, 1940 by Selznick International Pictures Inc. Western Electric Mirrophonic Recording. 130 minutes.

The Players: *Maxim de Winter* Laurence Olivier *Daphne de Winter* Joan Fontaine *Jack Favell* George Sanders *Mrs. Danvers* Judith Anderson *Maj. Giles Lacey* Nigel Bruce *Col. Julyan* C. Aubrey Smith *Frank Crawley* Reginald Denny *Beatrice Lacey* Gladys Cooper *Robert* Philip Winter *Frith* Edward Fielding *Mrs. Van Hopper* Florence Bates *Dr. Baker* Leo G. Carroll *Chalcroft* Forrester Harvey *Tabbs* Lumsden Hare *Ben* Leonard Carey *Woman* Edith Sharpe *Coroner* Melville Cooper *Telephone Booth Passer-by* Alfred Hitchcock

Additional Oscar Nominations: *Picture* (Selznick, UA; David O. Selznick)*; *Actor* (Laurence Olivier); *Actress* (Joan Fontaine); *Supporting Actress* (Judith Anderson); *Writing — Screenplay* (Robert E. Sherwood, Joan Harrison); *Film Editing* (Hal C. Kern); *Cinematography — Black-and-White* (George Barnes)*; *Art Direction — Black-and-White* (Lyle Wheeler); *Music — Original Score* (Franz Waxman)

Note: Selznick was displeased with portions of Waxman's score, but the composer was under contract to MGM and unavailable to do revisions. At the producer's insistence, Louis Forbes integrated selections from Max Steiner's *A Star Is Born* score. Both Waxman and Steiner were very displeased.

The Sea Hawk

(Warner Bros.; August 31, 1940)

Executive Producer Jack L. Warner *Producer* Hal B. Wallis *Associate Producer* Henry Blanke *Director* Michael Curtiz *Screenplay* Seton I. Miller, Howard W. Koch *Adaptation* Seton I. Miller *Based on the Novel by* Rafael Sabatini *Cinematographer* Sol Polito *Musical Score* Erich Wolfgang Korngold *Musical Director* Leo F. Forbstein *Film Editor* George Amy *Sound Supervisor* Nathan Levinson *Production Mixer* Francis J. Scheid *Production Manager* Tenny Wright *Assistant Director* Jack Sullivan *Dialogue Coach* Jo Graham *Art Director* Anton Grot *Production Illustrator* Harper Goff *Costume Designer* Orry-Kelly *Makeup* Perc Westmore *Orchestration* Hugo Friedhofer, Milan Roder, Ray Heindorf, Simon Bucharoff *Technical Advisers* Ali Hubert, Thomas Manners, William Kiel *Fencing Master* Fred Cavens *Still Photographer* Elmer Fryer *Special Effects Director* Byron Haskin *Special Effects Cinematographer* Hans F. Koenekamp

A Warner Bros.–First National Picture. Made at Warner Bros. Studios and on location in Southern California. Copyright September 3, 1940 by Warner Bros. Pictures Inc. RCA Photophone Recording. 126 minutes.

The Players: *Capt. Geoffrey Thorpe* Errol Flynn *Donna Maria* Brenda Marshall *Don Jose Alvarez de Cordoba* Claude Rains *Sir John Burleson* Donald Crisp *Queen Elizabeth* Flora Robson *Carl Pitt* Alan Hale, Sr. *Lord Wolfingham* Henry Daniell *Miss Latham* Una O'Connor *Abbott* James Stephenson *Capt. Lopez* Gilbert Roland *Danny Logan* William Lundigan *Oliver Scott* Julien Mitchell *King Philip II* Montagu Lowe *Eli Matson* J.M. Kerrigan *Martin Burke* David Bruce *William Tuttle* Clifford Brooke *Walter Boggs* Clyde Cook *Inquisitor* Fritz Leiber *Monty Preston* Ellis Irving *Kroner* Francis McDonald *Capt. Mendoza* Pedro de Cordoba *Peralta* Ian Keith *Lt. Ortega* Jack LaRue *Astronomer* Halliwell Hobbes *Chart Maker* Alec Craig *Gen. Aguirre* Victor Varoni *Capt. Frobisher* Robert Warwick *Slave Masters* Harry Cording, Nestor Paiva *Martin Barrett* Frank Wilcox *Eph Winters* Herbert (Guy) Anderson *Arnold Cross* Charles Irwin *Ben Rollins* Edgar Buchanan *Capt. Ortiz* Frank Lackteen *Palace Lieutenant* Lester Matthews *Darnell* Frederic Worlock *Officers* Leonard Mudie, Leyland Hodgson, Colin Kenny *Driver* David Thursby *Sea Hawk* Michael Harvey *Spanish Officer* Gerald Mohr *Lieutenant* Crauford Kent *Maids of Honor* Elizabeth Sifton, Mary Anderson *Stuntmen* Don Turner, Ned Davenport, Ralph Faulkner

Additional Oscar Nominations: *Sound Recording* (Nathan Levinson); *Art Direction — Black-and-White* (Anton Grot); *Music — Score* (Erich Wolfgang Korngold)

Note: Working title was *Beggars of the Sea*. Remake of the 1924 First National production and containing stock footage from it as well as from *Captain Blood* (Vitagraph, 1923) and *Captain Blood* (First National, 1935). Fred Jackman, Sr. directed the Special Effects sequences for *The Sea Hawk* and the 1935 *Captain Blood* and probably worked on the 1923 version. Re-edited to 116 minutes in 1947.

Swiss Family Robinson

(RKO Radio; February 16, 1940)

Producers Gene Towne, Graham Baker *Director* Edward Ludwig *Screenplay* Gene Towne, Graham Baker, Walter Ferris *Based on the Novel* "The Swiss Family Robinson" *by* Johann David Rudolf Wyss, Johann Wyss the Younger, Baroness de Montholieu, W.H.G. Kingston *Cinematographer* Nicholas Musuraca *Musical Score* Anthony Collins *Film Editor* George Crone *Sound Supervisor* John O. Aalberg *Production Mixer* John E. Tribby *Dubbing Mixers* Earl Mounce, Terry Kellum, James G. Stewart *Art Director* Van Nest Polglase *Set Decorator* Darrell Silvera *Costume Designer* Edward Stevenson *Makeup* Mel Berns *Assistant Director* Sam Ruman *Special Effects Supervisor* Vernon L. Walker *Matte Artist* Albert Maxwell Simpson *Optical Cinematography* Linwood G. Dunn

A Gene Towne Presentation. A Towne and Baker Production. A The Play's the Thing Productions Picture. Made at RKO Radio Studios and on location in Southern California. Copyright February 16, 1940 by RKO Radio Pictures Inc.; Applied Author: The Play's the Thing Productions. RCA Photophone Recording. 93 minutes.

The Players: *William Robinson* Thomas Mitchell *Elizabeth Robinson* Edna Best *Jack Robinson* Freddie Bartholomew *Fritz Robinson* Tim Holt *Ernest Robinson* Terry Kilburn *Francis Robinson* Baby Bobby Quillan *Thoren* Christian Rub *Ramsay* John Wray *Ship's Captain* Herbert Rawlinson *Narrator* Orson Welles

Note: Remade in 1960 by Disney and in 1975 by 20th Century–Fox. An ABC-TV series from September 14, 1975 to April 11, 1976 was made by 20th Century–Fox. There was also a Canadian-produced television series and a ten-chapter serial, *Perils of the Wild* (Universal, 1925), based on the novel.

The Thief of Bagdad
(United Artists; December 25, 1940)

Producer Alexander Korda *Associate Producers* Zoltan Korda, William Cameron Menzies *Directors* Ludwig Berger, Michael Powell, Tim Whelan, Zoltan Korda, William Cameron Menzies, Alexander Korda *Screenplay* Miles Malleson *Story* Lajos Biro *Cinematographer* Georges Perinal *Associate Cinematographer* Osmond H. Borradaile *Musical Score and Lyrics* Miklos Rozsa *Musical Director* Muir Mathieson *Sound Supervisors* Anthony W. Watkins, Jack Whitney *Sound* Denham Studios, General Service Studios *Supervising Film Editor* William Hornbeck *Film Editor* Charles Crichton *Art Directors* Vincent Korda, William Cameron Menzies *Assistant Art Director* Elliot Scott *Associate Art Directors* Frederick Pussey, Ferdinand Pullen *Assistant to the Producer and Second Unit Director* Andre de Toth *Assistant Directors* Geoffrey Boothby, Charles David *Second Assistant Director* Jack Clayton *Costume Designers* Oliver Messell, John Armstrong, Marcel Vertes *Makeup* Chris Mueller *Technicolor Director* Natalie Kalmus *Camera Operator* Robert Krasker *Production Manager* David B. Cunynghame *Aerial Sequences* Paul Mantz *Aerial Cinematographer* Elmer Dyer *Matte Artists* W. Percy Day, Wally Veevers *Traveling Mattes* Thomas Howard, Stanley Sayer *Miniatures* Johnny Mills *Mechanical Effects* Lawrence W. Butler

An Alexander Korda Films Presentation. A London Film Production. Made at Denham Studios and General Service Studios and on location in Cornwall, England and St. George, Utah. Copyright November 11, 1940 by Alexander Korda Films Inc. Technicolor. Western Electric Mirrophonic Recording. 106 minutes.

The Players: *Jaffar* Conrad Veidt *Abu* Sabu Dastagir *Princess* June Duprez *Halima* Mary Morris *Ahmad* John Justin *Djinni* Rex Ingram *Sultan* Miles Malleson *Astrologer* Hay Petrie *Singer* Adelaide Hall *Old King* Morton Selten *Merchant* Bruce Winston *Jailer* Ray Emerton *Storyteller* Allan Jeays *Stuntman* David Sharpe

Additional Oscar Nominations: *Cinematography—Color* (Georges Perinal)*; *Art Direction—Color* (Vincent Korda)*; *Music—Original Score* (Miklos Rozsa)

Note: Previously made in 1924 by United Artists. Remade in 1961 by Titanus and C.C. Lux (released in the U.S. by MGM) and in 1978 by Palm Films.

Typhoon
(Paramount; May 17, 1940)

Producer Anthony Veiller *Director* Louis King *Screenplay* Allen Rivkin *Story*

Steve Fisher *Cinematographer* William C. Mellor *Associate Cinematographer* Allen M. Davey *Musical Score* Frederick Hollander *Film Editor* Alma Macrorie *Sound Supervisor* Loren L. Ryder *Technicolor Director* Natalie Kalmus *Art Directors* Hans Dreier, John B. Goodman *Set Decorator* A.E. Freudeman *Makeup* Wally Westmore *Hairdressing* Nellie Manley *Songs* Frederick Hollander, Frank Loesser *Assistant Director* Russell Matthews *Still Photographer* Jack Koffman *Special Effects Director* Gordon Jennings *Special Effects Cinematographer* Irmin Roberts *Matte Artist* Jan Domela *Optical Cinematography* Paul K. Lerpae *Process Cinematography* Farciot Edouart, W. Wallace Kelley

Made at Paramount Studios. Copyright May 17, 1940 by Paramount Pictures, Inc. Technicolor. Western Electric Mirrophonic Recording. 70 minutes.

The Players: *Dea* Dorothy Lamour *Johnny Potter* Robert Preston *Skipper Joe* Lynne Overman *Mekaike* J. Carroll Naish *Kehi* Chief Thundercloud *Mate* Jack Carson *Doctor* Frank Reicher *Barkeeper* John Rogers *Dea's Father* Paul Harvey *Dea as a Child* Norma Nelson *Cook* Al Kikume *Kehi's Bodyguards* Angelo Cruz, Paul Singh

Women in War
(Republic; June 6, 1940)

Executive Producer Herbert J. Yates *Producer* Sol C. Siegel *Director* John H. Auer *Screenplay* F. Hugh Herbert, Doris Anderson *Cinematographer* Jack Marta *Musical Director* Cy Feuer *Supervising Film Editor* Murray Seldeen *Film Editor* Edward Mann *Art Director* John Victor McKay *Costume Supervisors* Adele Palmer, Robert Ramsey *Makeup* Robert Mark *Production Manager* Allen Wilson *Sound Supervisors* Charles L. Lootens, Daniel J. Bloomberg *Production Mixer* Herbert Norsch *Still Photographer* Joe Walters *Special Effects Supervisors* Howard Lydecker, Theodore Lydecker *Special Effects Cinematographer* William Bradford *Process Cinematography* Ellis J. "Bud" Thackery

A Herbert J. Yates Presentation. Made at Republic Studios. Copyright July 3, 1940 by Republic Pictures Corporation; Applied Author: Republic Productions, Inc. RCA Photophone Recording. 71 minutes.

The Players: *O'Neil* Elsie Janis *Pamela Starr* Wendy Barrie *Lt. Larry Hall* Patric Knowles *Gail Halliday* Mae Clark *Ginger* Dennis Moore *Francis* Dorothy Peterson *Pierre* Billy Gilbert *Capt. Tedford* Colin Tapley *Col. Starr* Stanley Logan *Millie* Barbara Pepper *Phyllis* Pamela Randall *Gordon* Lawrence Grant *Sir Humphrey* Lester Matthews *Starr's Date* Marion Martin *Chief Justice* Holmes Herbert *Pierre's Wife* Vera Lewis *Freddie* Charles D. Brown *Capt. Evans* Peter Cushing

1941

Special Effects Nominations

Aloma of the South Seas	Farciot Edouart,
(Paramount)	Gordon Jennings
	Audible: Louis H. Mesenkop
Flight Command (MGM)	A. Arnold Gillespie
	Audible: Douglas Shearer
The Invisible Woman	John Fulton
(Universal)	*Audible:* John Hall
**I Wanted Wings*	Farciot Edouart,
(Paramount)	Gordon Jennings
	Audible: Louis H. Mesenkop
The Sea Wolf	Byron Haskin
(Warner Bros.)	*Audible:* Nathan Levinson
That Hamilton Woman	Lawrence Butler
(Korda, UA)	*Audible:* William H. Wilmarth
Topper Returns	Roy Seawright
(Roach, UA)	*Audible:* Elmer Raguse
A Yank in the R.A.F.	Fred Sersen
(20th Century–Fox)	*Audible:* E.H. Hansen

Scientific or Technical Award

Class III Wilbur Silvertooth and the Paramount Studio Engineering Department
For the design and computation of a relay condenser system applicable to transparency process projection, delivering considerably more usable light

Comments

I Wanted Wings followed the Army Air Corps training of three men and allowed the liberal use of noticeable process projection and model aircraft. Paramount's second nominee, *Aloma of the South Seas*, was considerably more spectacular in Technicolor with its volcanic eruption and destruction. Re-recordist Louis Mesenkop worked on both productions and received the audio nomination on each.

The "year of the airmen" continued with *Flight Command*, about a know-

it-all in a naval flight squadron, and *A Yank in the R.A.F.*, in which an American flier helped defend England. Both had good matte art, some interesting pyrotechnics, and laughable airplane miniatures.

The Invisible Woman was an amusing little comedy in the fading screwball vein and had more of John Fulton's interesting traveling mattes. Dubbing editor John Hall cut the soundtrack and was nominated for such. Less enjoyable but similar was the last of the Topper trilogy, *Topper Returns*, with its usual ghost sequences.

Marine work via studio tanks highlighted both *The Sea Wolf* and *That Hamilton Woman*. The latter was by far the more spectacular, with several model naval battles featuring photography by Eddie Linden and miniatures by Larry Butler. The story was a boring version of the notorious Nelson-Hamilton affair that scandalized upper class England. It was producer Alexander Korda's attempt to convey to the British that throughout history they overcame the odds and kept the Union Jack flying. *The Sea Wolf* related Jack London's tale of a savage ship's captain and his conflicts with a passenger. Warners' water scenes, as usual, were superior to other studios' marine models, except, of course, for Republic.

Credits

Aloma of the South Seas
(Paramount; August 29, 1941)

Executive Producer Buddy G. De Sylva *Producer* Monta Bell *Director* Alfred Santell *Screenplay* Frank Butler, Seena Owen, Lillian Hayward *Adaptation* Seena Owen, Curt Siodmak *Based on the Stage Play by* LeRoy Owen Clemens, John B. Hymer *Cinematographer* Karl Struss *Associate Cinematographers* Wilfred M. Cline, William Snyder *Musical Director* Andrea Setaro *Film Editor* Arthur Schmidt *Technicolor Director* Natalie Kalmus *Sound Supervisor* Loren L. Ryder *Art Directors* Hans Dreier, William L. Pereira *Costume Designer* Edith Head *Makeup* Wally Westmore *Hairdressing* Nellie Manley *Dubbing Mixer* Louis H. Mesenkop *Camera Operator* George T. Clemens *Still Photographer* Malcolm Bulloch *Special Effects Director* Gordon Jennings *Special Effects Cinematographer* Irmin Roberts *Matte Artist* Jan Domela *Optical Cinematography* Paul K. Lerpae *Process Cinematography* Farciot Edouart, W. Wallace Kelley

Made at Paramount Studios and on location in the South Seas. Copyright August 29, 1941 by Paramount Pictures Inc. Technicolor. Western Electric Mirrophonic Recording. 77 minutes.

The Players: *Aloma* Dorothy Lamour *Tanoa* Jon Hall *Corky* Lynne Overman *Revo* Philip Reed *Kari* Katherine DeMille *High Priest* Fritz Leiber *Nea* Dona

Drake *Tarusa* Esther Dale *Ramita* Pedro de Cordoba *Ilkali* John Barclay *Aloma as a Child* Norma Jean Nelson *Nea as a Child* Evelyn Del Rio *Tanoa as a Child* Scotty Beckett *Revo as a Child* Billy Roy *Moukali* Noble Johnson *Aloma's Handmaidens* Ella Neal, Dena Coaker, Emily LaRue, Patsy Mace, Dorothy Short, Paula Terry, Carmella Cansino, Esther Estrella *Man* John Bagni *Girls* Charlene Wyatt, Janet Dempsey *Toots* Nina Campana

Additional Oscar Nomination: *Cinematography — Color* (Wilfred M. Cline, Karl Struss, William Snyder)

Note: Remake of the 1926 Famous Players–Lasky production, which was released by Paramount.

Flight Command

(Metro-Goldwyn-Mayer; December 23, 1940)

Producer J. Walter Ruben *Director* Frank Borzage *Screenplay* Wells Root, Cmdr. Harvey Haislip U.S.N. *Story* Cmdr. Harvey Haislip U.S.N., John Sutherland *Cinematographer* Harold Rosson *Musical Score* Franz Waxman *Film Editor* Robert J. Kern *Sound Supervisor* Douglas Shearer *Art Directors* Cedric Gibbons, Urie McCleary *Set Decorator* Edwin B. Willis *Men's Costume Designer* Gile Steele *Women's Costume Designer* Dolly Tree *Makeup* Jack Dawn *Hairdressing* Sydney Guilaroff *Technical Adviser* Cmdr. Morton Seligman U.S.N. *Aerial Sequences* Paul Mantz *Assistant Sound Supervisor* Wesley C. Miller *Publicity Supervisors* Howard Dietz, Howard Strickling *Song "Eyes of the Fleet"* Lt. Cmdr. J.V. McElduff U.S.N. *Production Cooperation* U.S. Navy *Still Photographer* Frank Tanner *Special Effects* A. Arnold Gillespie, Warren Newcombe

A Frank Borzage Production. Produced by Loew's Inc. Made at MGM Studios and on location in San Diego, California. Copyright December 12, 1940 by Loew's Inc. Western Electric Mirrophonic Recording. 110 minutes.

The Players: *Ens. Alan Drake* Robert Taylor *Lorna Gray* Ruth Hussey *Sq. Cmdr. Bill Gary* Walter Pidgeon *Lt. Cmdr. Dusty Rhodes* Paul Kelly *C.P.O. Spike Knowles* Nat Pendleton *Lt. Jerry Banning* Shepperd Strudwick *Lt. Mugger Martin* Red Skelton *Lt. Stitchy Payne* Dick Purcell *Lt. Freddy Townsend* William Tannen *Lt. Bush* William Stelling *Lt. Frost* Stanley Smith *Vice Admiral* Addison Richards *First Duty Officer* Donald Douglas *Second Duty Officer* Pat Flaherty *Captain* Forbes Murray *Claire* Marsha Hunt

Note: Previewed at 113 minutes.

The Invisible Woman
(Universal; January 7, 1941)

Producer Burt Kelly *Director* A. Edward Sutherland *Screenplay* Robert Lees, Fred Rinaldo, Gertrude Purcell *Story* Curt Siodmak, Joe May *Based on the Character Created by* H.G. Wells *Cinematographer* Elwood Bredell *Musical Director* Charles Previn *Film Editor* Frank Gross *Sound Supervisor* Bernard B. Brown *Sound Editor* John Hall *Art Director* Jack Otterson *Set Decorator* Russell A. Gausman *Costume Designer* Vera West *Makeup* Jack P. Pierce *Assistant Director* Joseph McDonough *Special Effects* John P. Fulton, David Stanley Horsley, Ross Hoffman *Miniatures* Charlie Baker

Made at Universal City Studios. Copyright December 1, 1940 by Universal Pictures Company, Inc. Western Electric Mirrophonic Recordings. 72 minutes.

The Players: *Kitty Carroll* Virginia Bruce *Prof. Gibbs* John Barrymore *Richard Russell* John Howard *George* Charlie Ruggles *Blackie Cole* Oscar Homolka *Bill* Edward Brophy *Foghorn* Donald MacBride *Mrs. Jackson* Margaret Hamilton *Hammerhead Frankie* Shemp Howard *Jean* Anne Nagel *Peggy* Kathryn Adams *Marie* Maria Montez *Growley* Charles Lane *Mrs. Bates* Mary Gordon *Hudson* Thurston Hall *Hernandez* Eddie Conrad *Model* Kay Leslie *Mrs. Patten* Kitty O'Neil *Buyers* Kay Linaker, Sarah Edwards *Want Ad Man* Harry C. Bradley *Mailman* Kernan Cripps

Note: See the note for *The Invisible Man Returns* (1940). Remade by Universal in 1983.

I Wanted Wings
(Paramount; March 27, 1941)

Producer Arthur Hornblow, Jr. *Directors* Mitchell Leisen, Theodore Reed *Screenplay* Richard Maibaum, Lt. Beirne Lay Jr., Sid Herzig *Adaptation* Eleanore Griffin, Cmdr. Frank W. Wead *Based on the Novel by* Lt. Beirne Lay Jr. *Cinematographer* Leo Tover *Aerial Cinematographer* Elmer Dyer *Musical Score* Victor Young *Film Editor* Hugh Bennett *Sound Supervisor* Loren L. Ryder *Production Mixer* Gene Merritt *Dubbing Mixers* Richard Olsen, Louis H. Mesenkop *Aerial Coordinator* Paul Mantz *Art Directors* Hans Dreier, Robert Usher *Makeup* Wally Westmore *Hairdressing* Nellie Manley *Songs* "Spirit of the Air Corps" Capt. William J. Clinch "Born to Love" Victor Young, Ned Washington *Assistant Director* Arthur Jacobson *Second Assistant Director* Francisco Alonzo Day *Dialogue Coach* Phyllis Loughton *Mitchell Leisen's Secretary* Eleanor Broder *Costume Designer* Edith Head *Special Effects Director* Gordon

Jennings *Special Effects Cinematographer* Irmin Roberts *Matte Artist* Jan Domela *Optical Cinematography* Paul K. Lerpae *Process Cinematography* Farciot Edouart, W. Wallace Kelley

Made at Paramount Studios and on location at Randolph Field and Kelly Field in San Antonio, Texas. Copyright May 30, 1941 by Paramount Pictures, Inc. Western Electric Mirrophonic Recording. 130 minutes.

The Players: *Jeff Young* Ray Milland *Al Ludlow* William Holden *Tom Cassidy* Wayne Morris *Capt. Mercer* Brian Donlevy *Carolyn Bartlett* Constance Moore *Sally Vaughn* Veronica Lake *Sandbags Riley* Harry Davenport *Jimmy Masters* Phil Brown *Court President* Edward Fielding *Judge Advocate* Willard Robertson *Flight Commander* Richard Lane *Flight Surgeon* Addison Richards *Mickey* Hobart Cavanaugh *Lt. Hopkins* Douglas Aylesworth *Lt. Ronson* John Trent *Lt. Clankton* Archie Twitchell *Cadet Captain* Richard Webb *Radio Announcer* John Hiestand *Montgomery* Harlan Warde *Ranger* Lane Chandler *Cadets* Jack Chaplin, Charles Drake, Alan Hale, Jr., Renny McEvoy *Mechanic* Arthur Gardner *Mechanic Corporal* Lane Allan *First Crew Chief* Jack Shea *Sergeants* Emory Johnson, Tom Quinn *Detectives* Edward Peil, Sr., Frank O'Connor *Corporals* Michael Gale, James Millican *Supply Sergeant* Russ Clark *Privates* George Turner, Hal Brazeale *Cadet Adjutant* Warren Ashe *Meteorology Instructor* Charles A. Hughes *Buzzer Class Instructor* George Lollier *Flight Dispatcher* John Sylvester *Court Martial Majors* John McEvoy, Boyd Irwin, Ralph Emerson *Court Martial Captains* Anthony Nace, Jack Luden *Defense Captain* Gilbert Wilson *Captain Computer* George Eldredge *Bombardier* Gaylord (Steve) Pendleton *Navigator* John Beach *Randolph Field Colonel* Frank H. LaRue *Kelly Field Colonel* Henry Hall *Surgeon* Gladden M. James *Gas Station Attendant* Jimmy Lucas *Patrolman* Lee Shumway *Policeman* Charles Hamilton *Voice of Officer* Keith Richards *Voice of Lieutenant* John Ellis *Voice Over Loud Speaker* Rod Cameron *Radio Operator* Phillip Terry *Lieutenant* Edward Peil, Jr. *Young Herbert* Rawlinson *Mrs. Young* Hedda Hopper *Fire Chief* James Farley *Evaluating Officer* Lester Dorr *Commanding General* Charles D. Waldron *Vocal Dubbing for Veronica Lake* Martha Mears

Note: Mitchell Leisen replaced J. Theodore Reed, who was removed for not shooting spectacular enough footage. Little or nothing of his scenes appears in the released version. Paramount's *Hold Back the Dawn* (1941) includes a behind-the-scenes visit to the set of *I Wanted Wings*.

The Sea Wolf

(Warner Bros.; March 1941)

Executive Producer Jack L. Warner *Producer* Hal B. Wallis *Associate Producer*

Henry Blanke *Director* Michael Curtiz *Screenplay* Robert Rosson *Based on the Novel by* Jack London *Cinematographer* Sol Polito *Musical Score* Erich Wolfgang Korngold *Musical Director* Leo F. Forbstein *Film Editor* George Amy *Art Director* Anton Grot *Makeup* Perc Westmore *Orchestration* Ray Heindrof, Hugo Friedhofer *Production Manager* Tenny Wright *Assistant Director* Sherry Shrouds *Dialogue Coach* Jo Graham *Sound Supervisor* Nathan Levinson *Production Mixer* Oliver S. Garretson *Dubbing Mixer* George R. Groves *Assistant Art Director* Leo Kuter *Still Photographer* Mac Julian *Special Effects Director* Byron Haskin *Special Effects Cinematographer* Hans F. Koenekamp

A Warner Bros.–First National Picture. Made at Warner Bros. Studios. Copyright February 22, 1941 by Warner Bros. Pictures Inc. RCA Photophone Recording. 100 minutes.

The Players: *Wolf Larsen* Edward G. Robinson *George Leach* John Garfield *Ruth Webster* Ida Lupino *Humphrey Van Weyden* Alexander Knox *Dr. Louie Prescott* Gene Lockhart *Cooky* Barry Fitzgerald *Johnson* Stanley Ridges *Svenson* Francis McDonald *Young Sailor* David Bruce *Harrison* Howard Da Silva *Smoke* Frank Lackteen *Agent* Ralf Harolde *Crewmen* Louis Mason, Dutch Hendrian *Indian* Iron Eyes Cody *First Detective* Cliff Clark *Second Detective* William Gould *First Mate* Charles Sullivan *Pickpocket* Ernest S. Adams *Helmsman* Wilfred Lucas *Singer* Jeane Cowan

Note: Previously made in 1913 by Bosworth, 1920 by Paramount, 1926 by P.D.C. and 1930 by Fox. Remade as *Barricade* (Warner Bros., 1950), *Wolf Larsen* (Allied Artists, 1958) and *The Legend of Sea Wolf* (Cougar, 1978). Hans F. Koenekamp worked on *Barricade*, which may have employed stock footage. All current prints run 90 minutes.

That Hamilton Woman
(United Artists; April 30, 1941)

Producer and Director Alexander Korda *Screenplay* Walter Reisch, R.C. Sherriff, Alexander Korda *Cinematographer* Rudolph Mate *Musical Score* Miklos Rozsa *Supervising Film Editor* William Hornbeck *Production Designer* Vincent Korda *Art Director* Lyle Reynolds Wheeler *Set Decorator* Julia Heron *Costume Designer* Rene Hubert *Makeup* Blagoe Stephanoff *Production Manager* Raymond A. Klune *Assistant Director* Walter Mayo *Sound Supervisor* Jack Whitney *Sound* General Service Studios *Production Mixer* William H. Wilmarth *Camera Operator* Burnett Guffey *Assistant Cameraman* Cliff King *Second Assistant Cameraman* Jimmy Murray *Laboratory* Consolidated Film Industries *Special Effects Supervisor* Lawrence J. Butler *Special Effects Cinematographer* Edwin Linden *Special Effects Camera Operator* Vincent J. Farrar

An Alexander Korda Production. Made at General Service Studios. Copyright March 27, 1941 by Alexander Korda Films Inc. Western Electric Mirrophonic Recording. 128 minutes.

The Players: *Lady Emma Hart Hamilton* Vivien Leigh *Lord Horatio Nelson* Laurence Olivier *Sir William Hamilton* Alan Mowbray *Mrs. Cadogan-Lyon* Sara Allgood *Lady Frances Nelson* Gladys Cooper *Capt. Hardy* Henry Wilcoxon *Mary Smith* Heather Angel *Rev. Nelson* Halliwell Hobbes *Lord Spencer* Gilbert Emery *Lord Keith* Miles Mander *Josiah* Ronald Sinclair *King of Naples* Luis Alberni *Queen of Naples* Norma Drury *French Ambassador* George Renavent *Hotel Manager* Leonard Carey *Orderly* Alec Craig *Gendarme* George Davis *Lady Spencer* Juliette Compton *Cavin* Olaf Hytten *Capt. Troubridge* Guy Kingsford

Additional Oscar Nominations: *Cinematography — Black-and-White* (Rudolph Mate); *Art Direction — Interior Decoration — Black-and-White* (Vincent Korda, Julia Heron); *Sound Recording* (Jack Whitney, General Service)*

Note: Originally 125 minutes, but the Hayes Office demanded a scene be added with Nelson denouncing his affair with Emma. Some U.S. prints do not contain this scene, nor do foreign prints. Nelson's speech to the Admiralty was reputedly written by Winston Churchill, though he denied it. Remade as *Lady Hamilton* (German-French, 1968) and as *The Nelson Affair* (Universal, 1973).

Topper Returns

(United Artists; March 21, 1941)

Producer Hal Roach, Sr. *Associate Producer* Hal Roach, Jr. *Director* Roy Del Ruth *Screenplay* Jonathan Latimer, Gordon Douglas *Additional Dialogue* Paul Guard Smith *Based on the Characters Created by* Thorne Smith *Cinematographer* Norbert Brodine *Musical Score* Werner R. Heymann *Musical Director* Irvin Talbot *Film Editor* James E. Newcom *Art Director* Nicolai Remisoff *Set Decorator* William L. Stevens *Costume Designer* Lewis Royer Hastings *Production Manager* Sidney S. Van Keuran *Assistant Director* Bernard Carr *Sound Supervisor* Elmer Raguse *Production Mixer* William Randall *Special Effects* Roy Seawright

A Hal Roach Production. Made at Hal Roach Studios. Copyright April 14, 1941 by Hal Roach Studios Inc. Western Electric Mirrophonic Recording. 85 minutes.

The Players: *Gail Richards* Joan Blondell *Cosmo Topper* Roland Young *Ann Carrington* Carole Landis *Clara Topper* Billie Burke *Bob* Dennis O'Keefe *Maid*

Patsy Kelly *Chauffeur* Eddie "Rochester" Anderson *Carrington* H.B. Warner *Dr. Jervis* George Zucco *Sgt. Roberts* Donald MacBride *Lillian* Rafaela Ottiano *Rama* Trevor Bardette

Additional Oscar Nomination: *Sound Recording* (Elmer Raguse)

Note: See footnote for *Topper Takes a Trip* (1939).

A Yank in the R.A.F.
(20th Century-Fox; October 3, 1941)

Producer Darryl F. Zanuck *Associate Producer* Lou Edelman *Director* Henry King *Screenplay* Darrell Ware, Karl Tunberg *Story* Melville Grossman (Darryl F. Zanuck) *Cinematographer* Leon Shamroy *Musical Score* Alfred Newman *Film Editor* Barbara McLean *Art Directors* Richard Day, James Basevi *Set Decorator* Thomas Little *Costume Designer* Travis Banton *Aerial Coordinator* Paul Mantz *Makeup* Guy Pearce *Songs* "Hi-Ya Love," "Another Little Dream Won't Do Us Any Harm" Leo Robin, Ralph Rainger *Sound Supervisor* Edmund H. Hansen *Production Mixer* Bernard Freericks *Dubbing Mixer* Roger Heman *Assistant Cameraman* Lee "Red" Crawford *Aerial Director* Herbert Mason *Aerial Cinematographers* Ronald Neame, Jack Whitehead, Otto Kantuch *Production Cooperation* Royal Air Force *Special Effects* Fred Sersen *Matte Artist* Ray Kellogg

Made at 20th Century-Fox Studios and on location in England. Copyright October 3, 1941 by 20th Century-Fox Film Corporation. Western Electric Mirrophonic Recording. 98 minutes.

The Players: *Tim Baker* Tyrone Power *Carol Brown* Betty Grable *Wing Cmdr. Morley* John Sutton *Roger Pillby* Reginald Gardiner *Cpl. Harry Baker* Donald Stuart *Thorndyke* Richard Fraser *F/Lt. Redmond* Denis Green *F/Lt. Richardson* Bruce Lester *Mrs. Fitzhugh* Ethel Griffies *Al* Ralph Byrd *Regency Head Waiter* Fortunio Bonanova *Wales* Gilchrist Stuart *Canadian Major* Frederick Worlock *Group Captain* Lester Matthews *Instructor* James Craven *Officer* Claude Allister *Squadron Leader* G.P. Huntley, Jr. *Intelligence Officers* Stuart Robinson, Denis Hoey *Nurse at Boat* Lynne Roberts *Gerry Pilots* Otto Reichow, Kurt Kreuger *Chorus Girl* Lillian Porter *Gerry Sergeant* Hans Von Morhart *Taxi Driver* Bobbie Hale *Captain* Crauford Kent *Barmaid* Maureen Roden-Ryan *Sergeant* Gil Perkins

1942

Special Effects Nominations

Rafael Sabatini's *The Black Swan* Fred Sersen
(20th Century–Fox) *Audible:* Roger Heman,
 George Leverett
Desperate Journey Byron Haskin
(Warner Bros.) *Audible:* Nathan Levinson
Flying Tigers Howard Lydecker
(Republic) *Audible:* Daniel J. Bloomberg
Invisible Agent . John Fulton
(Universal) *Audible:* Bernard B. Brown
Rudyard Kipling's *Jungle Book* Lawrence Butler
(Korda, UA) *Audible:* William H. Wilmarth
Mrs. Miniver (MGM) A. Arnold Gillespie,
 Warren Newcombe
 Audible: Douglas Shearer
The Navy Comes Through Vernon L. Walker
(RKO Radio) *Audible:* James G. Stewart
"*...One of Our Aircraft Is Missing*" Ronald Neame
(Powell, UA) *Audible:* C.C. Stevens
The Pride of the Yankees Jack Cosgrove,
(Goldwyn, RKO Radio) Ray Binger
 Audible: Thomas T. Moulton
Cecil B. De Mille's *Reap the Wild Wind* Farciot Edouart,
(De Mille, Paramount) Gordon Jennings
 William L. Pereira
 Audible: Louis Mesenkop

Scientific or Technical Awards

Class II Carroll Clark, F. Thomas Thompson
 and the RKO Radio Studio Art
 and Miniature Departments
For the design and construction of a moving cloud and
horizon machine
Class III Robert Henderson and the Para-
 mount Studio Engineering and
 Transparency Departments

For the design and construction of adjustable light bridge and
screen frames for transparency process photography

Comments

Despite its Technicolor prettiness, occasionally exciting sequences and
big budget for a wartime effort, Cecil B. De Mille's *Reap the Wild Wind* was
so soundstage phony throughout that its potential was almost destroyed.
Dealing with South Florida shipwreck salvagers in the 1840s, the film treated
viewers to storms, wrecks, diving in a sunken vessel, a giant squid, etc. All
this was good action stuff but poor Special Effects work. The models looked
small, and color only washed out the rear screens. Some of the matte art was
quite good however.

Better sea sequences were in *The Black Swan* and *The Navy Comes
Through*. A Technicolor swashbuckler about a pirate and the woman he
loves, *The Black Swan* had better tank work (including live action matted onto
a moving ship) than *Reap the Wild Wind* and made far more of its story. Pro-
duction mixer George Leverett and re-mixer Roger Heman soundtracked
the action. Merchant marines were called to action in *The Navy Comes
Through*. With its low budget, it still looked more real than De Mille's show.
James G. Stewart was dubbing mixer.

Desperate Journey, a lighthearted adventure about downed Allied fliers
behind Nazi lines, had so much action it was like watching a condensed
serial. Good model work was displayed throughout.

Howard Lydecker's miniature aircraft aren't quite up to his later stan-
dards in the fictionalized *Flying Tigers*, and the film now has an undeserved
reputation for quality that just isn't there. Almost all of the full size aircraft,
including those seen taxiing, were mockups built under Lydecker's supervi-
sion. Like A. Arnold Gillespie at MGM, he was in charge of literally all
Special Effects work, except process photography. Sound effects nominee
Daniel Bloomberg was Republic's studio sound chief.

The Invisible Man went to war with everybody else in *Invisible Agent*.
Optically there was nothing new, and the story was too ridiculous to be really
enjoyed by today's audiences. This should have been a comedy, but wasn't.

Jungle Book featured an exciting and well-staged miniature forest fire in
"blazing" Technicolor. Other Larry Butler effects included a mechanical
cobra and crocodile. This stagebound production worked because of the ex-
cellent matte paintings and models. The matte art came the closest ever in
a color film to the feel of *King Kong* (1933). Even though the jungle noises were
dubbed in post-production, unit mixer William Wilmarth was given the
audio nomination.

British residents were given morale boosts with the U.S.-made *Mrs.
Miniver* and the homemade *"...One of Our Aircraft Is Missing."* MGM decked
their American production with their usual high-gloss mounting; conse-
quently, the matte work was topnotch, as were the model Blitz scenes. The

British effort was another situation. Like *Desperate Journey*, "...*One of Our Aircraft Is Missing*" concerned a downed air crew attempting to escape the enemy. Unlike the Warner Bros. film, it was done almost in a documentary fashion. The trick work was generally poor throughout. The opening sequence showing the bomber crash into a tower had the guidewires clearly visible. Most of the matte paintings looked like drawings; some of the cloud effects were acceptable, but only a few. Lighting cameraman Ronald Neame and sound recordist C.C. Stevens were nominated for visual and audible effects.

Lou Gehrig's tragic life unreeled in *The Pride of the Yankees*, shot principally in Los Angeles. Via matte and process shots most of the baseball action was accomplished with star Gary Cooper. The rear screen scenes were always detectable.

Credits

Rafael Sabatini's *The Black Swan*
(20th Century-Fox; December 4, 1942)

Executive Producer Darryl F. Zanuck *Producer* Robert Bassler *Director* Henry King *Screenplay* Ben Hecht, Seton I. Miller *Adaptation* Seton I. Miller *Based on the Novel by* Rafael Sabatini *Cinematographer* Leon Shamroy *Musical Score* Alfred Newman *Film Editor* Barbara McLean *Technicolor Director* Natalie Kalmus *Technicolor Consultant* Henri Jaffa *Art Directors* Richard Day, James Basevi *Set Decorator* Thomas Little *Costume Designer* Earl Luick *Makeup* Guy Pearce, Lee Greenway *Orchestration* Hugo Friedhofer *Sound Supervisor* Edmund H. Hansen *Production Mixer* George Leverett *Dubbing Mixer* Roger Heman *Assistant Cameraman* Lee "Red" Crawford *Special Effects Supervisor* Fred Sersen *Special Effects Cinematographer* Winton C. Hoch

Made at 20th Century-Fox Studios. Copyright December 4, 1942 by 20th Century-Fox Film Corporation. Technicolor. Western Electric Mirrophonic Recording. 85 minutes.

The Players: *James Waring* Tyrone Power *Margaret Denby* Maureen O'Hara *Capt. Henry Morgan* Laird Cregar *Tommy Blue* Thomas Mitchell *Capt. Billy Leech* George Sanders *Wogan* Anthony Quinn *Lord Denby* George Zucco *Roger Ingram* Edward Ashley *Don Miguel* Fortunio Bonanova *Capt. Graham* Stuart Robertson *Fenner* Charles McNaughton *Speaker* Frederick Worlock *Cook* Willie Fung *Capt. Higgs* Charles Francis *Bishop* Arthur Shields *Major Domo* Keith Hitchcock *Capt. Blaine* John Burton *Capt. Jones* Cyril McLaglen *Daniel* Clarence Muse *Clerk* Olaf Hytten *Sea Captains* Charles Irwin, David

Thursby, Frank Leigh *Assemblymen* Arthur Gould-Porter, C. Montague Shaw, Boyd Irwin, George Kirby *Dancer* Rita Christiani *Women* Bryn Davis, Jody Gilbert *Town Crier* Billy Edmunds

Additional Oscar Nominations: *Cinematography — Color* (Leon Shamroy)*; *Music — Scoring of a Dramatic or Comedy Picture* (Alfred Newman)

Desperate Journey
(Warner Bros.; September 26, 1942)

Executive Producer Hal B. Wallis *Producer* Jack Saper *Director* Raoul Walsh *Story and Screenplay* Arthur T. Horman *Cinematographer* Bert Glennon *Musical Score* Max Steiner *Musical Director* Leo F. Forbstein *Film Editor* Rudi Fehr *Art Director* Carl Jules Weyl *Costume Designer* Milo Anderson *Makeup* Perc Westmore *Orchestration* Hugo Friedhofer *R.A.F. Technical Adviser* Sq. Ldr. Owen Cathcart-Jones *R.C.A.F. Production Executive* Jack L. Warner *Production Manager* Tenny Wright *Assistant Director* Russell Saunders *Dialogue Coach* Hugh MacMullan *Sound Supervisor* Nathan Levinson *Production Mixer* Clare A. Riggs *Dubbing Mixer* George R. Groves *Special Effects* Edwin P. DuPar, Byron Haskin

A Warner Bros.–First National Picture. Made at Warner Bros. Studios and on location in Southern California. Copyright September 26, 1942 by Warner Bros. Pictures Inc. RCA Photophone Recording. 107 minutes.

The Players: *Flight Lt. Terence Forbes* Errol Flynn *Flight Ofr. Johnny Hammond* Ronald Reagan *Kaethe Brahms* Nancy Coleman *Maj. Otto Baumeister* Raymond Massey *Flight Sgt. Kirk Edwards* Alan Hale Sr. *Flight Ofr. Jed Forrest* Arthur Kennedy *Flight Sgt. Lloyd Hollis* Ronald Sinclair *Dr. Mather* Albert Basserman *Preuss* Sig Rumann *Sq. Ldr. Lane Ferris* Patrick O'Moore *Dr. Herman Brahms* Felix Basch *Frau Brahms* Ilka Gruning *Frau Raeder* Elsa Basserman *Capt. Coswick* Charles Irwin *Sq. Ldr. Clark* Richard Fraser *Kruse* Robert O. Davis *Heinrich Schwartzmuller* Henry Victor *Assistant Plotting Officer* Bruce Lester *Wing Commander* Lester Matthews *Hesse* Kurt Katch *Gestapo Men* Hans Schumm, Robert Stevenson *Nazi Co-Pilot* Helmut Dantine *Squadron Commander* Barry Bernard *Warwick* Walter Brooke *Aircraftsman* William Hopper *Sergeant* Rolf Lindau *Pvt. Koenig* Otto Reichow *Pvt. Rasek* Sigfried Tor *Nazi Soldiers* Philip Van Zandt, Harold Daniels *Unteroffizier* Roland Varno *Mechanic* Sven Hugo Borg *Capt. Eggerstedt* Victor Zimmerman *British Officer* Douglas Walton *Motorcycle Scout* Henry Rowland *Nazi Sentries* Walter Bonn, Ferdinand Schumann-Heink *Lieutenant* Frank Alten *Feldwebel Gertz* Louis Arco *Pvt. Trecha* Arno Frey *Polish Boy* Gene Garrick *Telephone Repairman* Carl Ekberg *Driver* Lester Sharpe *Pharmacist* Ludwig Hardt *Magnus* Jack Lomas

Note: Working title was *Forced Landing*.

Flying Tigers
(Republic; October 8, 1942)

Executive Producer Herbert J. Yates *Producer* Edmund Grainger *Director* David Miller *Screenplay* Kenneth Gamet, Barry Trivers *Story* Kenneth Gamet *Cinematographer* Jack Marta *Musical Score* Victor Young *Musical Director* Walter Scharf *Film Editor* Ernest Nims *Sound Supervisors* Daniel J. Bloomberg, Charles L. Lootens *Art Director* Russell Kimball *Set Decorator* Otto Siegel *Aerial Sequences* Paul Mantz *Technical Adviser* William Pawley, American Volunteers Group *Costume Supervisors* Adele Palmer, Robert Ramsey *Makeup* Robert Mark *Production Supervisor* Max Schoenberg *Titles, Opticals, Processing and Prints* Consolidated Film Industries *Production Cooperation* Curtis-Wright Corporation *Special Effects* Howard Lydecker, Theodore Lydecker *Process Cinematography* Ellis J. Thackery

Made at Republic Studios and on location in Southern California. Copyright October 8, 1942 by Republic Pictures Corporation; Applied Author: Republic Productions Inc. RCA Photophone Recording. 102 minutes.

The Players: *Jim Gordon* John Wayne *Woody Jason* John Carroll *Brooke Elliott* Anna Lee *Hap Davis* Paul Kelly *Alabama Smith* Gordon Jones *Verna Bates* Mae Clarke *Col. Lindsay* Addison Richards *Blackie Bales* Edmund MacDonald *Dale* Bill Shirley *Reardon* Tom Neal *McIntosh* James Dodd *Tex Norton* Gregg Barton *Selby* John James *Mike* Chester Gan *Lt. Barton* David Bruce *McCurdy* Malcolm McTaggert *Airport Official* Charles Lane *Barratt* Tom Seidel *Doctor* Richard Loo *Airfield Radioman* Richard Crane *Jim* Willie Fung

Additional Oscar Nominations: *Sound Recording* (Daniel Bloomberg); *Music — Scoring of a Dramatic or Comedy Picture* (Victor Young)

Invisible Agent
(Universal; July 31, 1942)

Producer Frank Lloyd *Associate Producer* George Waggner *Director* Edwin L. Marin *Screenplay* Curtis Siodmak *Based on Characters Created by* H.G. Wells *Cinematographer* Lester White *Musical Director* Charles Previn *Film Editor* Edward Curtis *Sound Supervisor* Bernard B. Brown *Art Director* Jack Otterson *Set Decorator* Russell A. Gausman *Costume Designer* Vera West *Makeup* Jack P. Pierce *Assistant Director* Vernon Keays *Special Effects* John P. Fulton, David Stanley Horsley, Ross Hoffman *Miniatures* Charlie Baker

A Frank Lloyd Production Inc. Picture. Made at Universal City Studios. Copyright July 11, 1942 by Universal Pictures Company Inc. Western Electric Mirrophonic Recording. 81 minutes.

The Players: *Maria Sorenson (Goodrich)* Ilona Massey *Frank Raymond (Griffin)* Jon Hall *Baron Ikito* Peter Lorre *Conrad Stauffer* Cedric Hardwicke *Karl Heiser* J. Edward Bromberg *John Gardiner* John Litel *Arnold Schmidt* Albert Basserman *Sir Alfred Spencer* Holmes Herbert *Surgeon* Keye Luke *Nazi SS Men* Philip Van Zandt, Eddie Dunn, Hans Schumm *Nazi Assassin* Matt Willis *Maid* Mabel Colcord *Spencer's Secretary* John Holland *Killer* Marty Faust *Free Frenchman* Alberto Morin *Storm Troopers* Henry Guttman, Victor Zimmerman, Billy Pagan *Von Porten* Wolfgang Zilzer *Bartender* Ferdinand Munier *RAF Flier* Lee Burton *Gen. Chin Lee* Lee Tung-Foo *Nazi Sergeant* Milburn Stone *Verichen* Michael Visaroff *Newsboy* Walter Tetley *German Taxi Driver* Leslie Denison *German* Pat McVey *Housekeeper* Mabel Conrad *Brigadier General* Lee Shumway *Col. Kelenski* Henry Zynder *German Telephone Operator* Ferdinand Schumann-Heink *Ordnance Car Driver* Charles Regan *Nazi Captain* Sven Hugo Borg *Ship Radio Operator* James Craven *Gestapo Agents* William Ruhl, Otto Reichow *English Tommies* Wally Scott, Bobby Hale *Nazi Soldiers* Charles Flynn, Phil Warren, Paul Bryar, John Merton *Nazi Sentries* Lane Chandler, Duke York, Donald Curtis

Note: See the footnote for *The Invisible Man Returns* (1940).

Rudyard Kipling's *Jungle Book*
(United Artists; April 3, 1942)

Producer Alexander Korda *Director* Zoltan Korda *Screenplay* Laurence Stallings *Based on* "The Jungle Books" *by* Rudyard Kipling *Cinematographers* W. Howard Greene, Lee Garmes *Musical Score* Miklos Rozsa *Film Editor* William Hornbeck *Technicolor Director* Natalie Kalmus *Technicolor Consultant* Morgan Padelford *Production Designer* Vincent Korda *Art Directors* Jack Okey, Joseph McMillan Johnson *Set Decorator* Julia Heron *Makeup* Gordon Bau, Chris Mueller, Frank Westmore, Ern Westmore *Production Manager* Walter Mayo *Assistant to the Producer* Charles David *Second Unit Director* Andre de Toth *Assistant Director* Lowell Farrell *Sound Supervisor* Jack Whitney *Sound* General Service Studios *Camera Operator* Vincent J. Farrar *Still Photographer* Robert Coburn *Production Mixer* William H. Wilmarth *Special Effects* Lawrence W. Butler

An Alexander Korda Films Presentation. A Zoltan Korda Film. Made at General Service Studios. Copyright April 13, 1942 by Alexander Korda Films Inc. Technicolor. Western Electric Mirrophonic Recording. 109 minutes.

The Players: *Mowgli* Sabu Dastagir *Buldeo* Joseph Calleia *Barber* John Qualen *Pundit* Frank Puglia *Messua* Rosemary De Camp *Mahala* Patricia O'Rourke *Durga* Ralph Byrd *Rao* John Mather *English Girl* Faith Brook *Sikh* Noble Johnson *Shere Khan* Roger the Tiger

Additional Oscar Nominations: *Cinematography — Color* (W. Howard Greene); *Art Direction — Interior Decoration — Color* (Vincent Korda, Julia Heron); *Music — Scoring of a Dramatic or Comedy Picture* (Miklos Rozsa)

Note: Remade in 1967 by Walt Disney Productions. Also the basis for several animated television specials.

Mrs. Miniver

(Metro-Goldwyn-Mayer; May 1942)

Producer Sidney Franklin *Director* William Wyler *Screenplay* George Froeschel, James Hilton, Claudine West, Arthur Wimperis *Based on the Novel by* Jan Struther *Cinematographer* Joseph Ruttenberg *Musical Score* Herbert Stothart *Film Editor* Harold F. Kress *Sound Supervisor* Douglas Shearer *Song "Midsummer's Day"* Gene Lockhart *Art Director* Cedric Gibbons *Associate Art Director* Urie McCleary *Set Decorator* Edwin B. Willis *Costume Designers* Robert Kalloch, Gile Steele *Makeup* Jack Dawn *Hairdressing* Sydney Guilaroff *Publicity Supervisors* Howard Dietz, Howard Strickling *Second Unit Director* Andrew Marton *Assistant Sound Supervisor* Wesley C. Miller *Special Effects* A. Arnold Gillespie, Warren Newcombe *Miniatures* Maximilian Fabian

A William Wyler Production. Produced by Loew's Inc. Made at MGM Studios. Copyright May 15, 1942 by Loew's Inc. Western Electric Mirrophonic Recording. 134 minutes.

The Players: *Kay Miniver* Greer Garson *Clem Miniver* Walter Pidgeon *Lady Beldon* May Whitty *Carol Beldon* Teresa Wright *Foley* Reginald Owen *Ballard* Henry Travers *Vin Miniver* Richard Ney *Vicar* Henry Wilcoxon *Toby Miniver* Christopher Severn *Gladys* Brenda Forbes *Judy Miniver* Clare Sanders *Ada* Marie de Becker *Gerry Flier* Helmut Dantine *Fred* John Abbott *Simpson* Connie Leon *Horace* Rhys Williams *Singers* St. Luke's Choristers *Miss Spriggins* Mary Ford *Nobby* Paul Scardon *Ginger* Ben Webster *George* Aubrey Mather *Huggins* Forrester Harvey *Conductor* Billy Bevan *Saleswoman* Ottola Nesmith *Car Dealer* Gerald Oliver Smith *Joe* Alec Craig *Mrs. Huggins* Clara Reid *William* Harry Allen *Halliday* John Burton *Beldon's Butler* Leonard Carey *Marston* Eric Lonsdale *Mac* Charles Irwin *Dentist* Ian Wolfe *Sir Henry* Arthur Wimperis *Carruthers* David Clyde *Bickles* Colin Campbell *Doctor* Herbert Clifton *Man in Tavern* Walter Byron *Verger* Thomas Louden *Pilot* Peter Lawford *Voice of Gerry Agent* Miles Mander

Additional Oscar Nominations: *Picture* (MGM; Sidney Franklin); *Actor* (Walter Pidgeon); *Actress* (Greer Garson)*; *Supporting Actor* (Henry Travers); *Supporting Actress* (Dame May Whitty); *Supporting Actress* (Teresa Wright)*; *Direction* (William Wyler)*; *Writing — Screenplay* (George Froeschel, James Hilton, Claudine West, Arthur Wimperis)*; *Cinematography — Black-and-White* (Joseph Ruttenberg)*; *Sound Recording* (Douglas Shearer); *Film Editing* (Harold F. Kress)

Note: Sequel was *The Miniver Story* (MGM, 1950).

The Navy Comes Through

(RKO Radio; October 30, 1942)

Producer Islin Auster *Director* A. Edward Sutherland *Screenplay* Roy Chandler, Aeneas MacKenzie *Adaptation* Earl Baldwin, John Twist *Based on the Story* *"Pay to Learn" by* Borden Chase *Cinematographer* Nicholas Musuraca *Musical Score* Roy Webb *Musical Director* Constantin Bakaleinikoff *Film Editor* Samuel E. Beetley *Art Directors* Albert S. D'Agostino, Carroll Clark *Set Decorator* Darrell Silvera *Costume Designer* Renie *Makeup* Mel Burns *Sound Supervisor* John O. Aalberg *Dubbing Mixer* James G. Stewart *Special Effects Supervisor* Vernon L. Walker *Special Effects Cinematographer* Paul Eagler *Optical Cinematography* Linwood G. Dunn

Made at RKO Radio Studios. Copyright October 6, 1942 by RKO Radio Pictures Inc. RCA Photophone Recording. 82 minutes.

The Players: *Mallory* Pat O'Brien *Sande* George Murphy *Myra* Jane Wyatt *Babe* Jackie Cooper *Kroner* Carl Esmond *Berringer* Max Baer, Sr. *Tarriba* Desi Arnaz *Capt. McCall* Ray Collins *Kovac* Lee Bonnell *Sampter* Frank Jenks *Bayliss* John Maguire *Hodum* Frank Fenton *Dennis* Joey Ray *Doctor* Marten Lamont *Officer* Cyril Ring

"...One of Our Aircraft Is Missing"

(United Artists; October 16, 1942)

Production, Screenplay and Direction Michael Powell, Emeric Pressberger *Story* Emeric Pressberger *Associate Producer* Stanley Haynes *Cinematographer* Ronald Neame *Film Editor* David Lean *Art Director* David Rawnsley *Unit Production Manager* Sydney Streeter *Costume Designer* Rahvis *Associate Cinematographer* Robert Krasker *Camera Operator* Guy Green *Assistant Director* John Seabourne *Script Supervisor* Betty Curtis *Production Secretary* Jane Bayes *Assistant Film Editor* Thelma Myers *Sound Supervisor* Anthony W. Watkins *Sound* Denham Studios

Production Mixer C.C. Stevens *Production Cooperation* Royal Air Force, Air Ministry, London Branch Royal Netherlands Government

An Alexander Korda Films Inc. Presentation. A Michael Powell–Emeric Pressberger–The Archers Production. A British National Films Ltd. Picture. Made at Denham Studios and on location in England. Copyright May 10, 1942 by Manhattan Films Inc.; Applied Author: Emeric Pressberger. Western Electric Mirrophonic Recording. 90 minutes.

The Players: *Sir George Corbett* Godfrey Tearle *Tom Earnshaw* Eric Portman *Frank Shelley* Hugh Williams *Else Meertens* Pamela Browne *Jo de Vries* Googie Withers *Priest* Peter Ustinov *Naval Officer* Roland Culver *Geoff Hickman* Bernard Miles *John Glyn Haggard* Hugh Burden *Bob Ashley* Emrye Jones *Jet van Dieren* Joyce Redman *Burgomeister* Hay Petrie *Burgomeister's Wife* Selma Vaz Dias *Pieter Slwp* Arnold Marle *De Jong* Robert Helpmann *Organist* Alec Clunes *Commander* Stewart Rome *Len Martin* David Evans *First Gerry Airman* Davis Ward *Second Gerry Airman* Robert Duncan *With* Hector Abbas, James Carson, Bill Akkerman, Joan Akkerman, Valerie Moon, Peter Schenke, John Salew, William D'Arcy

Additional Oscar Nomination: *Writing—Original Screenplay* (Michael Powell, Emeric Pressberger)

Note: The Oscar nomination under the specific writing category was incorrect, as the screenplay was based on an original story treatment by Pressberger. Released in May 1942 in England by Anglo Film Distributors with a 100 minute running time, though some prints may have been 106 minutes. The B.B.F.C. certificate was U.

The Pride of the Yankees
(RKO Radio; July 16, 1942)

Producer Samuel Goldwyn *Director* Sam Wood *Screenplay* Jo Swerling, Sr., Herman J. Mankiewicz *Story* Paul Gallico *Cinematographer* Rudolph Mate *Musical Score* Leigh Harline *Film Editor* Daniel Mandell *Production Designer* William Cameron Menzies *Art Director* Perry Ferguson *Associate Art Director* McClure Capps *Set Decorator* Howard Bristol *Song "Always"* Irving Berlin *Assistant Director* John Sherwood *Costume Designer* Rene Hubert *Publicity Supervisor* William Herbert *Sound Supervisor* Thomas T. Moulton *Production Mixer* Frank Maher *Dubbing Mixer* Gordon E. Sawyer *Consultant* Eleanor Gehrig *Casting* Robert B. McIntyre *Production Manager* Walter Mayo *Production Auditor* A.R. Evans *Wardrobe Supervisor* W.C. McClenaghan *Production*

Cooperation Ed Barrows *and* The New York Yankees *by Arrangement with* Christy Walsh *Still Photographer* Hal McAlpin *Special Effects* John R. Cosgrove *Matte Artist* Albert Maxwell Simpson *Process Cinematography* Ray O. Binger

A Samuel Goldwyn Production. Made at Samuel Goldwyn Studios and on location in Los Angeles and New York City. Copyright July 15, 1942 by Samuel Goldwyn. Western Electric Mirrophonic Recording. 128 minutes.

The Players: *Lou Gehrig* Gary Cooper *Eleanor Gehrig* Teresa Wright *Sam Blake* Walter Brennan *Hank Hanneman* Dan Duryea *Mom Gehrig* Elsa Janssen *Pop Gehrig* Ludwig Stossel *Myra* Virginia Gilmore *Mike Huggins* Ernie Adams *Twitchell* Pierre Watkin *Joe McCarthy* Harry Harvey *Babe Ruth, Bill Dickey, Robert W. Meusel, Mark Koenig, Bill Stern, Veloz & Yolanda, Ray Noble & His Orchestra* Themselves *Coach* Addison Richards *Van Tuyl* Hardie Albright *Clinic Doctor* Edward Fielding *New Rochelle Mayor* George Lessey *Lou as a Child* Douglas Croft *Laddie* Rip Russell *Third Base Coach* Frank Faylen *Hammond* Jack Shea *Wally Pip* George McDonald *Billy at Age 8* Gene Collins *Billy at Age 17* David Holt *Mayor La Guardia* David Manley *Colletti* Max Willenz *Sasha* Jimmy Valentine *Sasha's Mother* Anita Bolster *Murphy* Robert Winkler *Larsen* Spencer Charters *Mrs. Fabini* Rosina Galli *Joe Fabini* Billy Roy *Mrs. Roberts* Sarah Padden *Tessie* Janet Chapman *Mrs. Worthington* Eva Dennison *Worthington* Montague Shaw *Ed Barrows* Jack Stewart *Christy Mathewson* Fay Thomas *Fraternity Boys* Jack Arnold, John Kellogg, Bernard Zanville (Dane Clark), Tom Neal *Doctor in Gehrig Home* Vaughan Glaser *Baseball Player in Locker Room* Lane Chandler *Hospital Doctor* Edgar Barrier *Freshman* George Offerman, Jr. *Clinic Nurse* Lorna Dunn *Policeman* Emory Parnell *Landlady* Dorothy Vaughan *Scrubwoman* Patsy O'Byrne *Strength Machine Operator* Matt McHugh *Newsboy* William Chaney *Baseball Player* Pat Flaherty *Maid* Mary Gordon *Taxi Driver* Francis Sayles

Additional Oscar Nominations: *Picture* (Goldwyn, RKO Radio; Samuel Goldwyn); *Actor* (Gary Cooper); *Actress* (Teresa Wright); *Writing — Original Story* (Paul Gallico); *Writing — Screenplay* (Herman J. Mankiewicz, Jo Swerling); *Cinematography — Black-and-White* (Rudolph Mate); *Art Direction — Interior Decoration — Black-and-White* (Perry Ferguson, Howard Bristol); *Sound Recording* (Thomas Moulton); *Film Editing* (Daniel Mandell)*; *Music — Scoring of a Dramatic or Comedy Picture* (Leigh Harline)

Note: Remade as *A Love Affair: The Eleanor and Lou Gehrig Story* (Fries/Stonehedge, 1978)

Cecil B. De Mille's *Reap the Wild Wind*

(Paramount; March 12, 1942)

Executive Producer Buddy G. DeSylva *Producer and Director* Cecil B. De Mille *Associate Producer* William H. Pine *Screenplay* Alan LeMay, Charles Bennett, Jesse L. Lasky, Jr. *Based on the Novel by* Thelma Strabel *Cinematographers* Victor Milner, William V. Skall *Underwater Cinematographer* Dewey Wrigley *Musical Score* Victor Young *Film Editor* Anne Bauchens *Sound Editor* John M. Woodcock *Art Directors* Hans Dreier, Roland Anderson *Production Illustrator* Dan Sayre Groesbeck *Set Decorator* George Sawley *Costume Designer* Natalie Visart *Research* Marion Crist *Assistant Director* Edward Salven *Second Assistant Director* Francisco Day *Dialogue Coaches* Edwin Maxwell, Phyllis Loughton *Camera Operator* Haskell Boggs *Songs "Sea Chanty" by* Frank Loesser, Victor Young *"Tis But a Little Faded Flower" by* J.R. Thomas, Troy Sanders *Second Unit Director* Arthur Rosson *Unit Publicist* Theodore Bonnet *Marine Technical Adviser* Capt. Fred F. Ellis *Unit Production Manager* Roy Burns *Production Secretary* Gladys Rosson *Producer-Director's Secretaries* Berenice Mosk, Florence Cole *Technicolor Director* Natalie Kalmus *Sound Supervisor* Loren L. Ryder *Production Mixer* Harry M. Lindgren *Dubbing Mixers* John Cope, Louis H. Mesenkop *Makeup* Wally Westmore *Hairdressing* Nellie Manley *Special Effects Directors* Gordon Jennings, William L. Pereira *Special Effects Cinematographer* Irmin Roberts *Matte Artist* Jan Domela *Optical Cinematography* Paul K. Lerpae *Process Cinematography* Farciot Edouart, W. Wallace Kelley

A Cecil B. De Mille Productions Inc. Picture. Made at Paramount Studios. Copyright January 30, 1942 by Paramount Pictures, Inc. Technicolor. Western Electric Mirrophonic Recording. 124 minutes.

The Players: *Stephen Tolliver* Ray Milland *Capt. Jack Stuart* John Wayne *Loxi Claiborne* Paulette Goddard *King Cutler* Raymond Massey *Dan Cutler* Robert Preston *Drusilla Alston* Susan Hayward *Capt. Phillip Philpott* Lynne Overman *Tyfib Mate* Charles Bickford *Com. Devereaux* Walter Hampden *Maum Maria* Louise Beavers *Mrs. Claiborne* Elizabeth Risdon *Mrs. Mottram* Janet Beecher *Aunt Henrietta Beresford* Hedda Hopper *Ivy Devereaux* Martha O'Driscoll *Nathias Widgeon* Victor Kilian *Saltmeat* Oscar Polk *Chinkapin* Ben Carter *Lamb* William "Wee Willie" Davis *Sam* Lane Chandler *Judge Marvin* Davidson Clark *Pelican Captain* Lou Merrill *Dr. Jepson* Frank M. Thomas *Capt. Carruthers* Keith Richards *Lubbock* Victor Varconi *Port Captain* J. Farrell MacDonald *Mace* Harry Woods *Master Shipwright* Raymond Hatton *Lt. Farragut* Milburn Stone *Claiborne Lookout* Dave Wengren *Cadge* Tom Paton *Charleston Ladies* Barbara Britton, Julia Faye, Ameda Lambert *Charleston Beaux* D'Arcy Miller, Bruce Warren *Pete* Constantin Romanoff *Jake* Fred Graham *Stoker Boss* Richard Alexander *Lady Dancer* Mildred Harris *Deveraux Agent* John Saint Polis *Dr. Jepson's Boy* Eugen Jackson *Girls' Father* James Flavin *Officer at*

Tea Monte Blue *Ettie* Claire McDowell *Devereaux Secretary* Stanhope Wheatcroft *Man with Suspenders* Nestor Paiva *Bixby* Byron Fougler *Woman in Ballroom* Dorothy Sebastian *Southern Gentleman at Tea* Jack Luden *Falcon Crewman* Dale Van Sickel *Jailer* Stanley Andrews *Jurymen* Leo Sulky, Cap Anderson, Sam Appel, Harry Dean, Billy Elmer *Cutler Men in Barrel Room* Frank Lackteen, Alan Bridge, Al Ferguson *Cutler's Co-Counsel* Frank Ferguson *Seaman from First Wreck* William Haade *Mottram Servant* George Reed *Narrator* Cecil B. De Mille *With* Forrest Taylor, George Melford, Ed Brady, Frank C. Shannon, Buddy Pepper, Tom Chatterton, Frank Richards, Hayden Stevenson, Emory Parnell, William Cabanne, Hope Landin, Ottola Nesmith, Max Davidson, Gertrude Astor, Maurice Costello

Additional Oscar Nominations: *Cinematography — Color* (Victor Milner, William V. Skall); *Art Direction — Interior Decoration — Color* (Hans Dreier, Roland Anderson, George Sawley)

1943

Special Effects Nominations

Air Force . Hans Koenekamp,
(Warner Bros.) Rex Wimpy
 Audible: Nathan Levinson

Bombardier . Vernon L. Walker
(RKO Radio) *Audible:* James G. Stewart,
 Roy Granville

**Crash Dive* . Fred Sersen
(20th Century-Fox) *Audible:* Roger Heman

The North Star . Clarence Slifer,
(Goldwyn, RKO Radio) R.O. Binger
 Audible: Thomas T. Moulton

So Proudly We Hail Farciot Edouart,
(Paramount) Gordon Jennings
 Audible: George Dutton

Stand by for Action A. Arnold Gillespie,
(MGM) Donald Jahraus
 Audible: Michael Steinore

Special Award (Plaque)

To George Pal for the development of novel methods and techniques in the production of short subjects known as Puppetoons.

Scientific or Technical Awards

Class II Farciot Edouart, Earle Morgan
Barton Thompson and the Paramount
Studio Engineering and Trans-
parency Departments

For the development and practical application to motion picture production of a method of duplicating and enlarging natural color photographs, transferring the image emulsions to glass plates and projecting these slides by especially designed stereopticon equipment

Class III Charles Galloway Clarke and the
 20th Century–Fox Studio Camera Department
For the development and practical application of a device for
composing artificial clouds into motion picture scenes during
production photography

Class III Farciot Edouart and the
 Paramount Studio Transparency Department
For an automatic electric transparency cueing timer

Comments

What you can say about one of this year's nominees, you can say about
them all: They were rousing patriotic war adventures. All employed
numerous process shots, miniatures and matte art. The work in each feature
ran from poor to excellent. One's favorite film would probably be decided
more on story than actual effectiveness of the trick illusions, or maybe ac-
cording to your preference for land, sea or air action. Probably the most in-
teresting aspect of the winner was that it was the only Technicolor nominee.
Pyrotechnics always look better — or at least prettier! — in three colors.

Crash Dive dealt with a submarine mission.

Air Force featured the heroics of a bomber crew in the South Pacific.

Bombardier was concerned with the training of fliers. Re-recordists
James G. Stewart and Roy Granville were nominated for sound effects.

The North Star showed the determination of the Russians to withstand
the Nazis.

So Proudly We Hail! saluted the military nurses stationed in the South
Pacific. Audio nomination was given to dubbing mixer George Dutton.

Stand by for Action highlighted the Navy and their valiant officers and
seamen. Appropriately, supervising sound effects editor Michael Steinore
was nominated.

The Army apparently was not in favor this year.

Credits

Air Force

(Warner Bros.; March 20, 1943)

Executive Producer Jack L. Warner *Producer* Hal B. Wallis *Director* Howard
Hawks *Screenplay* Dudley Nichols, Arthur Horman, Howard Hawks *Addi-
tional Dialogue* William Faulkner *Cinematographer* James Wong Howe *Aerial
Cinematographers* Elmer Dyer, Charles Marshall *Musical Score* Franz Waxman
Musical Director Leo F. Forbstein *Film Editor* George Amy *Air Technical Adviser
and Chief Pilot* Paul Mantz *Military Technical Advisers* Capt. Hewett T.

Wheless, Capt. Sam Triffy *Art Director* John Hughes *Set Decorator* Walter F. Tilford *Costume Designer* Milo Anderson *Sound Supervisor* Nathan Levinson *Production Mixer* Oliver S. Garretson *Makeup* Perc Westmore *Production Manager* Tenny Wright *Second Unit Director* B. Reeves Eason *Assistant Director* Jack Sullivan *Special Effects Director* E. Roy Davidson *Special Effects Cinematographers* Rex Wimpy, Hans F. Koenekamp

A Howard Hawks Production. A Warner Bros.–First National Picture. Made at Warner Bros. Studio and on location in Santa Barbara, California and at Hickham Field and Drew Field in Tampa, Florida. Copyright March 20, 1943 by Warner Bros. Pictures Inc. RCA Photophone Recording. 124 minutes.

The Players: *Sgt. Joe Winocki* John Garfield *Capt. Mike "Irish" Quinncannon* John Ridgley *Lt. Bill Williams* Gig Young *Lt. Tommy McMartin* Arthur Kennedy *Lt. Munchauser* Charles Drake *Sgt. Robby White* Harry Carey, Sr. *Cpl. Weinberg* George Tobias *Cpl. Peterson* Ward Wood *Pvt. Chester* Ray Montgomery *Lt. Tex Rader* James Brown *Maj. Mallory* Stanley Ridges *Colonel* Willard Robertson *Col. Blake* Moroni Olsen *Sgt. J.J. Callahan* Edward S. Brophy *Maj. W.G. Roberts* Richard Lane *Lt. P.T. Moran* Bill Crago *Susan McMartin* Faye Emerson *Maj. Daniels* Addison Richards *Maj. A.M. Bagley* James Flavin *Mary Quinncannon* Ann Doran *Mrs. Chester* Dorothy Peterson *Marine with Dog* James Millican *Group Cmdr. Jack Harper* William Forrest *Demolition Squad Corporal* Murray Alper *Hickham Field Officer* George Neise *Marine* Tom Neal *Quinncannon's Son* Henry Blair *Control Officers* James Bush, Warren Douglas *First Nurse* Ruth Ford *Second Nurse* Leah Baird *Sergeants* William Hopper, Sol Gorss *Ground Crewman* George Offerman, Jr. *Sgt. Joe* Walter Sande *Nurses* Lynn Baggett, Marjorie Hoshelle *First Lieutenant* Theodore von Eltz *Second Lieutenant* Ross Ford *Co-Pilot* Rand Brooks

Additional Oscar Nominations: *Writing — Original Screenplay* (Dudley Nichols); *Cinematography — Black-and-White* (James Wong Howe, Elmer Dyer, Charles Marshall); *Film Editing* (George Amy)

Bombardier
(RKO Radio; May 13, 1943)

Producer Robert Fellows *Director* Richard Wallace *Screenplay* John Twist *Story* John Twist, Martin Rackin *Cinematographer* Nicholas Musuraca *Musical Score* Roy Webb *Musical Director* Constantin Bakaleinikoff *Film Editor* Robert Wise *Art Directors* Albert S. D'Agostino, Al Herman *Set Decorators* Darrell Silvera, Claude Carpenter *Assistant Director* Edward Killy *Second Assistant Director* Robert Aldrich *Montage Director* Douglas Travers *Songs* M.K. Jerome, Jack

Scholl *Makeup* Mel Berns *Sound Supervisor* John O. Aalberg *Production Mixer* Bailey Fesler *Dubbing Mixers* James G. Stewart, Roy Granville *Still Photographer* Fred Hendrikson *Special Effects Supervisor* Vernon L. Walker *Special Effects Cinematographer* Paul Eagler *Optical Cinematography* Linwood G. Dunn *Miniature Construction Supervisor* Marty Martin

Made at RKO Radio Studios. Copyright May 16, 1943 by RKO Radio Pictures Inc. RCA Photophone Recording. 99 minutes.

The Players: *Maj. Chick Davis* Pat O'Brien *Capt. Buck Oliver* Randolph Scott *Burt Hughes* Anne Shirley *Tom Hughes* Eddie Albert *Jim Carter* Walter Reed *Joe Connor* Robert Ryan *Sgt. Dixon* Barton MacLane *Chito Rafferty* Richard Martin *Paul Harris* Russell Wade *Capt. Rand* James Newill *Lt. Ellis* Bruce Edwards *Chaplain Craig* John Miljan *Pete Jordan* Harold Landon *Mamie* Margie Stewart *Gen. Barnes* Joe King *Nip Officer* Leonard Strong *Nip Sergeant* Abner Biberman *Photographer* Russell Hoyt *Instructors* Wayne McCoy, Charles Russell *Sergeant* Bud Geary *Co-Pilots* Warren Mace, George Ford, Mike Lally *Colonels* Neil Hamilton , Lloyd Ingraham *Officers* Lee Shumway, Edward Peil, Sr., Robert Middlemass *Capt. Driscoll* Paul Parry *Doctor* Larry Wheat *Maj. Morris* James Craven *Capt. Randall* Cy Ring *Man* Marty Faust *Woman* Joan Barclay *Illusionist* John Calvert *Pilots* Eddie Dew, Kirby Grant *Soldier* Hugh Beaumont *Navigators* Dick Winslow, Joey Ray *Congressmen* Bert Moorhouse, Stanley Andrews, John Sheehan, Walter Fenner *Big Guy* Paul Fix *Lieutenant* John James *Clerk* Allen Wood *Mayer* Erford Gage *Radio Operator* Charles Flynn

Crash Dive

(20th Century-Fox; May 14, 1943)

Executive Producer Darryl F. Zanuck *Producer* Milton Sperling *Director* Archie Mayo *Screenplay* Jo Swerling, Sr. *Story* W.R. Burnett *Cinematographer* Leon Shamroy *Musical Score* David Buttolph *Musical Director* Emil Newman *Film Editors* Walter Thompson, Ray Curtis *Technicolor Director* Natalie Kalmus *Technicolor Consultant* Henri Jaffa *Art Directors* Richard Day, Wiard B. Ihnen *Set Decorator* Thomas Little *Associate Set Decorator* Paul S. Fox *Costume Designer* Earl Luick *Technical Adviser* Cmdr. M.K. Kirkpatrick U.S.N. *Assistant Director* John Johnston *Sound Supervisor* Edmund H. Hansen *Production Mixer* Bernard Freericks *Dubbing Mixer* Roger Heman *Assistant Cameraman* Lee "Red" Crawford *Special Effects Supervisor* Fred Sersen *Special Effects Cinematographer* Winton C. Hoch

Made at 20th Century-Fox Studios. Copyright May 14, 1943 by 20th Century-Fox Film Corporation. Technicolor. Western Electric Mirrophonic Recording. 105 minutes.

The Players: *Lt. Ward Stewart* Tyrone Power *Jean Hewlitt* Anne Baxter *Lt. Cmdr. Dewey Connors* Dana Andrews *McDonnell* James Gleason *Pop* Charley Grapewin *Grandmother* May Whitty *Brownie* Henry (Harry) Morgan *Oliver Cromwell Jones* Ben Carter *Hammond* Charles Tannen *Capt. Bryson* Frank Conroy *Doris* Florence Lake *Curley* John Archer *Crewman* George Holmes *Adm. Bob Stewart* Minor Watson *Miss Bromley* Kathleen Howard *Lieutenant* David Bacon *Captain* Stanley Andrews *Henry* Frank Dawson *Crony* Edward McWade *Simmons* Paul Burns *Sailor* Gene Rizzi *Texas Senator* Thurston Hall *Telephone Operator* Trudy Marshall *Lee Wong* Chester Gan *Waiter* Bruce Wong *Woman* Cecil Weston *Q Boat Captain* Lionel Royce *Kraut Officer* Hans Moebus

The North Star
(RKO Radio; October 13, 1943)

Producer Samuel Goldwyn *Associate Producer* William Cameron Menzies *Director* Lewis Milestone *Story and Screenplay* Lillian Hellman *Cinematographer* James Wong Howe *Musical Score* Aaron Copland *Film Editor* Daniel Mandell *Art Director* Perry Ferguson *Associate Art Director* McClure Capps *Set Decorator* Howard Bristol *Choreography* David Lichine *Songs* Aaron Copland, Ira Gershwin *Production Manager* Walter Mayo *Assistant Director* Sam Nelson *Makeup* Robert Stephanoff *Russian Technical Adviser* Zina Voynow *Sound Supervisor* Thomas T. Moulton *Production Mixer* Fred Lau *Dubbing Mixers* Gordon E. Sawyer, Arthur W. Johns *Still Photographer* Hal McAlpin *Special Effects* Ray O. Binger, Clarence W.D. Slifer

A Samuel Goldwyn Presentation. A Crescent Production. Made at Samuel Goldwyn Studios. Copyright November 4, 1943 by Crescent Productions Inc. Western Electric Mirrophonic Recording. 105 minutes.

The Players: *Marina* Anne Baxter *Kolya* Dana Andrews *Dr. Kurin* Walter Huston *Sophia* Ann Harding *Dr. Otto von Harden* Erich von Stroheim *Claudia* Jane Withers *Damian* Farley Granger *Karp* Walter Brennan *Rodion* Dean Jagger *Grisha* Eric Roberts *Boris* Carl Benton Reid *Olga* Ann Carter *Anna* Esther Dale *Nadya* Ruth Nelson *Iakin* Paul Guilfoyle *Dr. Max Richter* Martin Kosleck *Nazi Captain* Tonio Stewart *Nazi Lieutenant* Peter Pohlenz *Red Pilot* Robert Lowery *Red Gunner* Gene O'Donnell *Petrov* Frank Wilcox *Woman on Hospital Cot* Loudie Claar *Guerilla Girl* Lynn Winthrop *Petya* Charles Bates *Nazi Pilot* George Lynn *Old Woman in Wagon* Minna Phillips *Farmers* Edmund Cobb, Martin Faust, Jack Perrin, Bill Nestel, Al Ferguson, Henry Hall, John Judd *Wife* Grace Cunard *Son* Jerry Mickelson *Young Men in Wagon* Bill Walker, Clarence Straight *Accordion Player in Wagon* Bill Borzage *Old Ladies* Emma Dunn, Sarah Padden *Little Stinker* Teddy Infuhr *Woman on Bridge* Grace Leonard *Little Girl in Hospital* Joyce Tucker *Guard at Desk* John Bagni

Orderly John Beverly *Doctor's Aide* Ferdinand Schumann-Heink *Sonya* Patricia Parks *Nazi Motorcycle Officers* Frederick Brunn, Ray Teal *Nazi Soldier* Crane Whitney *Guerillas* Lane Chandler, Harry Strang *Boris' Aide* Constant Franke *Accordion Players* Serge Protzendo, Ilia Khmara *Dancers* Tommy Hall, Ronn Harvin, George Kole, Jack Vlaskin, William Sabbot, Clair Freeman, Eric Braunsteiner, Tamara Laub, Marie Vlaskin, Inna Gest *Farm Woman* Florence Auer

Additional Oscar Nominations: *Writing — Original Screenplay* (Lillian Hellman); *Cinematography — Black-and-White* (James Wong Howe); *Art Direction-Interior Decoration — Black-and-White* (Perry Ferguson, Howard Bristol); *Sound Recording* (Thomas Moulton); *Music — Scoring of a Dramatic or Comedy Picture* (Aaron Copland)

Note: Re-released as *Armored Attack* and re-edited to 82 minutes to de-emphasize the goodness of the Soviets.

So Proudly We Hail!

(Paramount; June 22, 1943)

Producer and Director Mark Sandrich *Story and Screenplay* Allan Scott *Cinematographer* Charles B. Lang *Musical Score* Miklos Rozsa *Film Editor* Ellsworth Hoagland *Art Directors* Hans Dreier, Earl Hedrick *Set Decorator* Stephen Seymour *Assistant Director* Joe Youngerman *Makeup* Wally Westmore *Hairdressing* Nellie Manley *Song "Loved One"* Miklos Rozsa, Edward Heyman *Technical Advisers* Col. Thomas W. Doyle, Lt. Eunice Hatchitt *Sound Supervisor* Loren L. Ryder *Production Mixer* Harold Lewis *Dubbing Mixers* John Cope, George Dutton, Walter Oberst *Production Cooperation* U.S. Army, U.S. Army Nursing Corps, American Red Cross *Special Effects* Gordon Jennings *Optical Cinematography* Paul K. Lerpae *Process Cinematography* Farciot Edouart

A Mark Sandrich Production. Made at Paramount Studios. Copyright June 22, 1943 by Paramount Pictures Inc. Western Electric Mirrophonic Recording. 126 minutes.

The Players: *Lt. Janet Davidson* Claudette Colbert *Lt. Joan O'Doul* Paulette Goddard *Lt. Olivia D'Arcy* Veronica Lake *Lt. John Summers* George Reeves *Lt. Rosemary Larsen* Barbara Britton *Chaplain* Walter Abel *Kansas* Sonny Tufts *Capt. "Ma" McGregor* Mary Servoss *Dr. Jose Bardia* Ted Hecht *Dr. Harrison* John Litel *Ling Chee* Dr. Hugh Ho Chang *Lt. Sadie Schwartz* Mary Treen *Lt. Ethel Armstrong* Kitty Kelly *Lt. Elsie Bollenbacher* Helen Lynd *Lt. Toni Dacolli* Lora Gray *Lt. Irma Emerson* Dorothy Adams *Lt. Betty Peterson* Ann Doran *Lt.*

Carol Johnson Jean Wiles *Lt. Fay Leonard* Lynn Walker *Lt. Margaret Stevenson*
Joan Tours *Lt. Lynne Hopkins* Jan Wiley *Nurses* Mimi Doyle, Frances Morris,
Julia Faye, Hazel Keener *Col. White* James Bell *Flight Lt. Archie McGregor*
Dick Hogan *Capt. O'Rourke* Bill Goodwin *Capt. O'Brien* James Flavin *Larson*
Byron Fougler *Mrs. Larson* Elsa Janssen *Georgie Larson* Richard Crane *Col.
Mason* Boyd Davis *Col. Clark* Will Wright *Young Ensign* James Millican *First
Young Doctor* Damian O'Flynn *Ship's Captain* Roy Gordon *Steward* Jack Luden
Maj. Arthur Harry Strang *Capt. Lawrence* Edward Dow *Girl* Yvonne De Carlo
San Francisco Dock Major William Forrest *Filipino Nurses* Isabel Cooper,
Amparo Antenercrut, Linda Brent *Corporal* Victor Kilian, Jr. *Doctors* Ed-
ward Earle, Byron Shores *Captain* Hugh Prosser *Soldier* Charles Lester

Additional Oscar Nominations: *Supporting Actress* (Paulette Goddard);
Writing — Original Screenplay (Allan Scott); *Cinematography — Black-and-White*
(Charles Lang)

Stand by for Action

(Metro-Goldwyn-Mayer; May 11, 1943)

Producers Robert Z. Leonard, Orville O. Dull *Director* Robert Z. Leonard
Screenplay George Bruce, John L. Balderston, Herman J. Mankiewicz
Adaptation Capt. Harvey Haislip U.S.N., R.C. Sherriff *Based on the Story "A
Cargo of Innocents" by* Laurence Kirk *Cinematographer* Charles Rosher *Musical
Score* Lennie Hayton *Film Editor* George Boehmer *Sound Supervisor* Douglas
Shearer *Supervising Sound Editor* Michael Steinore *Art Director* Cedric Gibbons
Set Decorator Edwin B. Willis *Makeup* Jack Dawn *Hairdressing* Sydney
Guilaroff *Aerial Sequences* Paul Mantz *Scenic Artist* George Gibson *Assistant
Sound Supervisor* Wesley C. Miller *Special Effects* A. Arnold Gillespie, Warren
Newcombe *Miniatures* Donald Jahraus

A Loew's Inc. Production. Made at MGM Studios. Copyright December 8,
1942 by Loew's Inc. Western Electric Mirrophonic Recording. 109 minutes.

The Players: *Lt. Gregg Masterson* Robert Taylor *Lt. Cmdr. Martin J. Roberts*
Brian Donlevy *R. Adm. Stephen Thomas* Charles Laughton *Chief Yoeman Henry
Johnson* Walter Brennan *Audrey Carr* Marilyn Maxwell *Cmdr. Stone* Henry
O'Neill *Mary Collins* Marta Linden *Chief Boatswain's Mate Jenks* Chill Wills
Capt. Ludlow Douglass Dumbrille *Ens. Lindsay* Richard Quine *Flag Lt. Budley*
William Tannen *Ens. Martin* Douglas Fowley *Lt. Tim Ryan* Himself *Lt. (j.g.)
Royce* Dick Simmons *Pharmacist's Mate "Doc" Miller* Byron Fougler *Carpenter's
Mate Chips* Hobart Cavanaugh *Susan Garrison* Inez Cooper *Chief Quartermaster
Rankin* Ben Walden *Chief Signalman* Harry Fleischman

1944

Special Effects Nominations

The Adventures of Mark Twain Paul Detlefsen,
(Warner Bros.) John Crouse
 Audible: Nathan Levinson

Days of Glory Vernon L. Walker
(Robinson, RKO Radio) *Audible:* James G. Stewart,
 Roy Granville

Secret Command David Allen, Ray
(Columbia) Cory, Robert Wright
 Audible: Russell Malmgren,
 Harry Kusnick

Since You Went Away John R. Cosgrove
(Selznick, UA) *Audible:* Arthur Johns

The Story of Dr. Wassell Farciot Edouart,
(De Mille, Paramount) Gordon Jennings
 Audible: George Dutton

**Thirty Seconds over Tokyo* A. Arnold Gillespie,
(MGM) Donald Jahraus, Warren Newcombe
 Audible: Douglas Shearer

Wilson . Fred Sersen
(20th Century–Fox) *Audible:* Roger Heman

Scientific or Technical Awards

Class III Linwood Dunn, Cecil Love and
 Acme Tool Manufacturing Company
For the design and construction of the Acme-Dunn Optical
Printer

Class III Russell Brown, Ray Hinsdale
 and Joseph E. Robbins
For the development and production use of the Paramount
floating hydraulic boat rocker

Class III . Paul Lerpae
For the design and construction of the Paramount traveling
matte projection and photographing device

Comments

The Doolittle raid on Japan was the basis of MGM's *Thirty Seconds over Tokyo,* a topnotch war epic with extraordinary effects throughout. Some of this footage was tinted, converted to *Super*Scope 235 and interloped into the Sensurround spectacular *Midway* (Universal, 1976). Even when duped and optically enlarged by almost fifty percent the high quality came through. These were certainly some of the best war effects scenes ever produced.

The Adventures of Mark Twain gave a fairly accurate accounting of Samuel Clemens' colorful life. Many good scenes of fog-shrouded miniature riverboats highlighted this feature, yet the most striking scene, and one I've never seen duplicated, was a 360° camera pan around an Arabian town that incorporated live actors, miniatures, painted mattes, and process projection!

RKO had distributed Goldwyn's *The North Star* to very good box office, so they did their own Reds vs. Nazis saga entitled *Days of Glory.* It featured a slam-bang finale involving excellent miniature tanks and terrain.

Saboteurs plagued a California shipyard in *Secret Command,* one of Columbia's contributions to the war effort. It was highlighted by a great deal of process photography and mechanical work. The sound effects citation went to sound mixer Russell Malmgren and re-recording mixer Harry Kusnick.

Since You Went Away told of the war's effects on a middle class family and to most appeared devoid of any trickery. However, it included some fine perspective miniatures and numerous matte paintings. It was a tribute to Jack Cosgrove that all this work was unnoticed. Unfortunately, the rear screen scenes were anything but unnoticable.

The Story of Dr. Wassell, a fact-based De Mille Technicolor production about a South Seas military physician, had some flashy pyrotechnics and lush model jungles, trucks, boats, etc., but it all looked too phony to be taken seriously, especially when thrown on rear screens with actors in front.

Wilson, a big historical biography of the peace-minded president, used the Special Effects department to recreate its period atmosphere via much matte art.

Credits

The Adventures of Mark Twain
(Warner Bros.; May 6, 1944)

Executive Producer Jack L. Warner *Producer* Jesse L. Lasky, Sr. *Associate Producer* Julius Evans *Director* Irving Rapper *Screenplay* Alan LeMay *Additional Dialogue* Harry Chandlee *Adaptation* Harold M. Sherman, Alan LeMay *Based on the Stage Play* Mark Twain *by* Harold M. Sherman *and on biographical material*

owned and controlled by The Mark Twain Company *Cinematographer* Sol Polito *Musical Score* Max Steiner *Musical Director* Leo F. Forbstein *Film Editor* Ralph Dawson *Art Director* John J. Hughes *Set Decorator* Fred M. MacLean *Costume Designer* Orry-Kelly *Makeup* Perc Westmore *Dialogue Coach* Herschel Daugherty *Orchestration* Bernhard Kaun *Montage Directors* Donald Siegel, James Leicester *Sound Supervisor* Nathan Levinson *Production Mixer* Robert B. Lee *Special Effects Director* Lawrence W. Butler *Special Effects Cinematographer* Eddie Linden *Matte Artists* Paul Detlefsen, John Crouse

A Warner Bros.–First National Picture. Made at Warner Bros. Studios. Copyright May 13, 1944 by Warner Bros. Pictures Inc. RCA Photophone Recording. 130 minutes.

The Players: *Samuel Langhorne Clemens* Fredric March *Olivia Langdon* Alexis Smith *J.B. Pond* Donald Crisp *Steve Gillis* Alan Hale, Sr. *Oxford Chancellor* C. Aubrey Smith *Bret Harte* John Carradine *Billings* Percy Kilbride *Charles Langdon* William Henry *Horace E. Bixby* Robert Barrat *Jervis Langdon* Walter Hampden *Clara Clemens* Joyce Reynolds *Joe Goodwin* Whitford Kane *Mrs. Langdon* Nana Bryant *Sam at Age 15* Dickie Jones *Sam at Age 12* Jackie Brown *Orion Clemens* Russell Gleason *Pres. Ulysses S. Grant* Joseph Crehan *William Dean Howells* Douglas Wood *Jane Clemens* Kay Johnson *Huckleberry Finn* Eugene Holland *Tom Sawyer* Michael Miller *Prospector* Cliff Saum *Editor* Ronald Drew *Assistant Editor* Harry Tyler *George* Willie Best *Oliver Wendell Holmes* Burr Caruth *John G. Whittier* Harry Hilliard *Ralph Waldo Emerson* Brandon Hurst *Henry Wadsworth Longfellow* Davidson Clark *Captain* Monte Blue *Deck Boss* Paul Newlan *Stoker* Ernest Whitman *Repeater* Emmett Smith *Ship's Mate* Pat O'Malley *Judge* Chester Conklin *Henry H. Rogers* George Lessey *Kate Leary* Dorothy Vaughan *Susie* Lynn Baggett *Susie as a Child* Gloria Ann Crawford *Clara as a Child* Carol Joyce Coombs *Jean* Joyce Tucker *Jean as a Child* Charlene Salerno *Dr. Quintard* Charles Waldron *Rudyard Kipling* Paul Scardon *with* Dennis Donnelly, Hooper Atchley, George Reed, Sam McDaniel, Dudley Dickerson, Betty Roadman, Viola Callahan, Frank Wilcox, Libby Taylor, Lillian Randolph, Mildred Gover, Frederick Spencer, Victor Kilian, Christian Rub, Harry Woods, Eddie Waller, John "Skins" Miller, Willie Fung, Creighton Hale, Fred Kelsey, Oliver Prickett, Leo White, Walter Soderling, Sailor Vincent, Richard Kipling, Bill Edwards, Bill Kennedy, Stuart Holmes, Joan Winfield, Sarah Edwards, Leah Baird, Frank Reicher, George Haywood, Frank Drien, Harry Holman, Frank Dae, Henry Blair, Francis Pierlot, Jessie Grayson, Bobby Jordan, Earl Dewey, Lee Powell, Sammy McKim, Charles Peck, Bill Lechner, Jack Gargan, Francis Sayles, Charles Irwin, Ross Ford, Rosina Galli, Harry Worth, Lee "Lasses" White, Ernest S. Adams, William Gould, Arthur Aylesworth, Jack Mower, Frank Mayo, William Haade, Robert Homans, Lew Kelly, Paul Panzer, George Sherwood, Charles Marsh, Charles McAvoy, Jim Farley, Frank Pharr, Norman Willis, Dick Elliott,

Bud Osborne, Thurston Hall, George Humbert, Paul Lawford, Robert Herrick

Additional Oscar Nominations: *Art Direction-Interior Decoration — Black-and-White* (John J. Hughes, Fred MacLean); *Music — Scoring of a Dramatic or Comedy Picture* (Max Steiner)

Days of Glory

(RKO Radio; April 27, 1944)

Producer Casey Robinson *Director* Jacques Tourneur *Screenplay* Casey Robinson *Story* Melchior Lengyel *Cinematographer* Tony Gaudio *Musical Score* Daniele Amfitheatrof *Musical Director* Constantin Bakaleinikoff *Film Editor* Joseph Noriega *Production Designer* Mordecai Gorelik *Art Directors* Albert S. D'Agostino, Carroll Clark *Set Decorators* Darrell Silvera, Harley Miller *Costume Designer* Renie *Makeup* Mel Berns *Orchestration* Leonid Rabb *Assistant Director* William Dorfman *Sound Supervisor* John O. Aalberg *Production Mixer* Richard van Huessen *Dubbing Mixers* James G. Stewart, Roy Granville *Still Photographer* Alexander Kahle *Special Effects Supervisor* Vernon L. Walker *Special Effects Cinematographer* Paul Eagler *Optical Cinematography* Linwood G. Dunn *Miniatures* Marcel Delgado

A Casey Robinson Production. Made at RKO Radio Studios and on location in Oregon. Copyright April 19, 1944 by RKO Radio Pictures Inc. RCA Photophone Recording. 86 minutes.

The Players: *Nina* Tamara Toumananova *Vladimir* Gregory Peck *Sasha* Alan Reed *Yelena* Maria Palmer *Semyon* Lowell Gilmore *Fedor* Hugo Haas *Mitya* Glenn Vernon *Olga* Dena Penn *Dmitri* Igor Dolgoruki *Petrov* Edward L. Durst *Johann Staub* Lou Crosby *Duchenko* William Challee *Seminov* Joseph Vitale *Col. Prilenko* Erford Gage *Nazi Lieutenant* Ivan Triesault *Vera* Maria Bibikov *Anton* Edgar Licho *Mariya* Gretl Dupont *Von Rundholz* Peter Helmers

Secret Command

(Columbia; July 20, 1944)

Executive Producer Pat O'Brien *Producer* Phil L. Ryan *Director* A. Edward Sutherland *Screenplay* Roy Chanslor *Based on the Story "Pilebuck" (a.k.a. "The Saboteurs")* by John Hawkins *and* Ward Hawkins *Cinematographer* Franz F. Planer *Musical Score* Paul Sawtell *Musical Director* Morris W. Stoloff *Film Editor* Viola Lawrence *Art Director* Lionel Banks *Associate Art Director* Edward C. Jewell *Costume Designer* Jean Louis *Montage Director* Aaron Nibley *Production*

Manager Jack Murphy *Assistant Director* Rex Bailey *Sound Supervisor* John P. Livadary *Production Mixer* Russell Malmgren *Dubbing Mixer* Harry Kusnick *Process Cinematography* David Allen, Ray Cory *Mechanical Effects* Robert Wright

A Terneen Production. Made at Columbia Studios and on location in Southern California. Copyright June 15, 1944 by Columbia Pictures Corporation. Western Electric Mirrophonic Recording. 82 minutes.

The Players: *Sam Gallagher* Pat O'Brien *Jill McGann* Carole Landis *Jeff Gallagher* Chester Morris *Lea Damaron* Ruth Warwick *Miller* Wallace Ford *Red Kelly* Barton MacLane *Brownell* Tom Tully *Max Lessing* Howard Freeman *Ben Royall* Erik Rolf *Curly* Matt McHugh *Shawn* Frank Sully *Simms* Frank Fenton *James Thane* Charles D. Brown *Joan* Carol Nugent *Paul* Richard Lane *Men* George McKay, Cyril Ring

Since You Went Away

(United Artists; July 20, 1944)

Producer David O. Selznick *Director* John Cromwell *Screenplay* David O. Selznick *Additional Dialogue* F. Hugh Herbert *Adaptation* Margaret Buell Wilder *Based on the Book by* Margaret Buell Wilder *Cinematographers* Stanley Cortz, Lee Garmes, George Barnes *Musical Score* Max Steiner, Louis Forbes *Film Editor* Hal C. Kern, Sr. *Associate Film Editor* James E. Newcom *Assistant Film Editors* John D. Faure, Arthur Fellows, Wayland M. Hendry *Sound Editor* Charles L. Freeman *Production Designer* William L. Pereira *Assistant Director* Lowell J. Farrell *Second Assistant Director* Edward F. Muhl *Art Director* Mark Lee Kirk *Set Decorator* Victor A. Gangelin *Technical Adviser* Lt. Col. J.G. Taylor U.S.A. *Choreography* Charles Walters *Makeup* Robert Stephanoff *Costume Supervisors* Elmer Ellsworth, Adele Sadler *Camera Operator* Arthur E. Arling *Production Managers* Raymond A. Klune, Richard L. Johnson *Assistant Production Manager* Fred R. Ahern *Casting* Ruth Burch *Scenario Assistant* Lydia Schiller *Production Assistant* Barbara Keon *Construction Supervisor* Harold Fenton *Unit Publicist* Don King *Still Photographer* Marty Crail *Sound Supervisor* Thomas T. Moulton *Sound* Samuel Goldwyn Studios *Production Mixer* Percy Townsend *Dubbing Mixers* Gordon E. Sawyer, Arthur W. Johns *Story Editor* Margaret McDonnell *Special Effects* John R. Cosgrove *Process Cinematography* Clarence W.D. Slifer

A David O. Selznick Productions Inc. Presentation. A Vanguard Film. A Selznick International Picture. Made at The Selznick Studio and on location in Southern California. Copyright September 14, 1944 by Vanguard Films Inc. Western Electric Mirrophonic Recording. 172 minutes.

The Players: *Anne Hilton* Claudette Colbert *Jane Hilton* Jennifer Jones *Lt. Tony Willett* Joseph Cotten *Bridget Hilton* Shirley Temple *Col. William G. Smollett I* Monty Woolley *Clergyman* Lionel Barrymore *William G. Smollett II* Robert Walker, Sr. *Fidelia* Hattie McDaniel *Emily Hawkins* Agnes Moorehead *Harold Smith* Guy Madison *Danny Williams* Craig Stevens *Lt. Solomon* Keenan Wynn *Dr. Sigmund Gottlieb* Albert Basserman *Zosia Koslowska* Alla Nazimova *Mahoney* Lloyd Corrigan *Johnny Mahoney* Jackie Moran *Marine Officer* Gordon Oliver *Gladys Brown* Jane Devlin *Becky Anderson* Ann Gillis *Sugar* Dorothy (Cindy) Garner *Former Plowboy* Andrew V. McLaglen *Waitress* Jill Warren *Refugee Child* Helen Koford (Terry Moore) *Colored Officer* Robert Johnson *Colored Officer's Wife* Dorothy Dandridge *A.W.O.L. Soldier* Johnny Bond *Bartender* Irving Bacon *Taxi Driver* George Chandler *Maj. Sam Atkins* Addison Richards *Pin Girl* Barbara Pepper *Principal* Byron Fougler *Businessman* Edwin Maxwell *Hungry Woman* Florence Bates *Conductors* Harry Hayden, Jonathan Hale *Caroler* Jimmy Clemons, Jr. *Desk Clerk* Theodore von Eltz *Elderly Woman* Adeline de Walt Reynolds *Sergeant's Child* Eilene Janssen *Convalescent* Doodles Weaver *Patient at Finger Ladder* Warren Hymer *Tax Payer* William B. Davidson *Envious Girl* Ruth Roman *Girl* Rhonda Fleming *Tim Hilton* Neil Hamilton *W.A.C. Platoon Leader* Butterfly McQueen *with* Robert Anderson, Aileen Pringle, Charles Williams, Wallis Clark, Neila Hart, Leonide Mostovoy, James Carlisle, John A. James, Mary Ann Dorkin, Joyce Horne, Grady Sutton, Ruth Valmy, Buddy Gorman, Patricia Peters, George Lloyd, Russell Hoyt, Loudie Claar, Don Najarian, Conrad Binyon, Christopher Adams, Jimmy Dodd, Martha Outlaw, Verna Knopf, Robert Cherry, Kirk Bargon, Karl Jacobs, Cecil Ballerino, Jack Gardner, Dorothy Adams, James Westerfield, Paul Esbury, Richard C. Cood, Ralph Reed, Willard Jillson, Dorothy Mann, Peggy Maley, Shelby Bacon, Eddie Hall, Warren Burr, Lela Bliss, Harlan Miller, Mrs. Ray Feldman, Neyle Marx, Betsy Howard, Stephen Wayne, Tom Dawson, Marilyn Hare, Walter Baldwin, Eric Sinclair, Jerry Revell

Additional Oscar Nominations: *Picture* (Selznick, UA; David O. Selznick); *Actress* (Claudette Colbert); *Supporting Actor* (Monty Woolley); *Supporting Actress* (Jennifer Jones); *Cinematography — Black-and-White* (Stanley Cortez, Lee Garmes); *Art Direction-Interior Decoration — Black-and-White* (Mark Lee Kirk, Victor A. Gangelin); *Film Editing* (Hal C. Kern, James E. Newcom); *Music — Scoring of a Dramatic or Comedy Picture* (Max Steiner)*

Note: After first openings, Selznick recut to 147 minutes. For its re-issue he further edited to 132 minutes. In 1979, ABC purchased all rights and restored the original 172-minute version. Alexander Tansman prepared a musical score, but Selznick disliked it, and Max Steiner was commissioned to compose and conduct a new music track. Steiner left after a disagreement over the use of "The Emperor Waltz" and Selznick's music department head, Louis Forbes, finished the scoring.

The Story of Dr. Wassell

(Paramount; April 26, 1944)

Executive Producer Buddy G. De Sylva *Producer and Director* Cecil B. De Mille *Screenplay* Alan LeMay, Charles Bennett *Story* James Hilton *Cinematographers* Victor Milner, William Snyder *Musical Score* Victor Young *Film Editor* Anne Bauchens *Associate Producer* Sidney Biddell *Art Directors* Hans Dreier, Roland Anderson *Set Decorator* George Sawley *Second Unit Director* Arthur Rosson *Technicolor Director* Natalie Kalmus *Technicolor Consultant* Robert Brower *Costume Designer* Natalie Visart *Production Illustrator* Dan Sayre Groesbeck *Dialogue Coach* Edwin Maxwell *Makeup* Wally Westmore *Hairdressing* Nellie Manley *Assistant Directors* Edward Salven, Oscar Rudolph *Second Assistant Director* Francisco Day *Technical Consultant* Cmdr. Dr. Corydon M. Wassell *Technical Advisers* Lt. Cmdr. H.D. Smith U.S.N., Capt. Fred F. Ellis B.M.M. Rtd. *Research* Marion Crist *Unit Production Manager* Roy Burns *Production Secretary* Gladys Rosson *Producer-Director's Secretaries* Berenice Mosk, Florence Cole *Unit Publicists* Theodore Bonnet, Lou Harris *Camera Operator* Haskell Boggs *Stunt Coordinator* James Dundee *Sound Supervisor* Loren L. Ryder *Production Mixer* Hugo Grenzbach *Dubbing Mixers* John Cope, George Dutton *Special Effects* Gordon Jennings *Optical Cinematography* Paul K. Lerpae *Process Cinematography* Farciot Edouart, W. Wallace Kelley

A Cecil B. De Mille Productions Inc. Picture. Made at Paramount Studios and on location in Parangaricutiro, Mexico. Copyright April 1, 1944 by Paramount Pictures Inc. Technicolor. Western Electric Mirrophonic Recording. 140 minutes.

The Players: *Dr. Corydon M. Wassell* Gary Cooper *Madeline Day* Laraine Day *Bettina* Signe Hasso *Benjamin "Hoppy" Hopkins* Dennis O'Keefe *Tremartini* Carol Thurston *Lt. Dirk Van Daal* Carl Esmond *Murdock* Paul Kelly *William "Andy" Anderson* Elliott Reid *Cmdr. William B. (Bill) Goggins* Stanley Ridges *Johnny Leinwerber* Renny McEvoy *Alabam* Oliver Thorndike *Ping* Philip Ahn *Ruth* Barbara Britton *Robert Kraus* Joel Allen *Robert Elroy Whaley* James Millican *Melvin Francis* Himself *Thomas Borghetti* Mike Kilian *Harold Hunter* Doodles Weaver *Dr. Wei* Richard Loo *Dr. Holmes* Davidson Clark *Arkansas Mailman* Si Jenks *Lt. Bainbridge* Morton Lowry *Dr. Ralph Wayne* Lester Matthews *Capt. Carruthers* Richard Nugent *Dr. Vranken* Ludwig Donath *Australian Rear Admiral* Minor Watson *Capt. Ryk* Victor Varconi *Mrs. Wayne* Catherine Craig *English Mother* Edith Barrett *English Boy* Billy Severn *Capt. Balan* George Macready *Adm. Hart* Edward Fielding *Evacuation Captain* Harvey Stephens *Captain's Aide* Frank Wilcox *Rear Admiral's Aide* Edmund MacDonald *Javanese Temple Guide* Frank Puglia *Missionary* Irving Bacon *Missionary's Wife* Ottola Nesmith *Head Nurse* Jody Gilbert *Pharmacist's Mate* Anthony Caruso *Ensign* Louis Jean Heydt *Passengers* Ron Randall, Sarah

Edwards, Sam Flint, Milton Kibbee, Hazel Keener, Cecil Weston, Frances Morris *Companionway Passenger* Jack Norton *American Marine* Carlyle Blackwell *Praying Woman* Ann Doran *Adm. Hart's Aide* Hugh Beaumont *Lt. Smith* George Lynn *Fashta* Linda Brent *Nurse Anne* Julia Faye *Native Girl* Yvonne De Carlo *Javanese Girl* Sybil Merritt *Fat Javanese Girl* Marie Loredo *Pretty Javanese Girl* Loretta Luiz *Coolie Boatman* Luke Chan *Capt. Carruthers' Driver* Jack Luden *Captains on "Surabaya"* Charles Trowbridge, Gus Glassmire *Officers on "Surabaya"* Edward Earle, Allan Raye *Damage Control Officer* George Eldredge *Captain in Australia* Forbes Murray *Dutch Guard* Sven Hugo Borg *Javanese Conductor* Frank Lackteen *Bosum's Mate* Fred Kohler, Jr. *Evacees* Maxine Fife, Amanda Lambert, Carla Boehm, Phyllis Perry, Marion De Sydow *Javanese Nurses* Gloria Dee, Forrest Dickson, Geraldine Fisette *Coolie Wife* Oie Chan *Chinese Priest* Yu Feng Sung *Tea Vendor* Moy Ming *Naval Commander* Roy Gordon *Watch Officer* Ferdinand Schumann-Heink *English Woman* Mary Currier *Joyful Passenger* John Mylong *Sobbing Man* Stanley Price *Sailors* Eric Alden, Richard Barrett, John Benson, George Robinson, Edgar Caldwell, Tony Cirillo, James Cornell, James Courtney, Clint Dorrington, Reynold DuPont, Edward Howard, Henry Kraft, Buddy Messinger, Robert Wilbur *Civilian* Mike Lally *English Doctor* Frank Elliott *Javanese Orderlies* Rodd Redwing, Roque Espiritu, Joe Dominquez, Joe Bautista *Chief Petty Officer on "Marblehead"* Russ Clark *Narrator* Cecil B. De Mille *with* Douglas Fowley, Miles Mander, William Hall, Isabel Cooper, Olga Marie Thunis, Chuck Hamilton, Doris Lilly, Harvey Stephens, Philip Van Zandt, Gretl Dupont, Griff Barnett, Lane Chandler, Mildred Harris, June Kilgour, Beth Hartman, Isabel Lamal, Bruce Warren, Louis Borell, Frank Mayo, Gavin Muir, Ivan Triesault, Gordon Richards, Boyd Irwin, John Meredith, Greta Granstedt, William Forrest, Elmo Lincoln

Note: The original story was culled from events related by Wassell and fifteen of the seamen involved.

Thirty Seconds over Tokyo
(Metro-Goldwyn-Mayer; November 15, 1944)

Producer Sam Zimbalist *Director* Mervyn LeRoy *Screenplay* Dalton Trumbo *Based on the book by* Maj. Ted W. Lawson and Robert Considine *Cinematographers* Harold Rosson, Robert L. Surtees *Musical Score* Herbert Stothart *Film Editor* Frank Sullivan *Supervising Sound Editor* Michael Steinore *Sound Supervisor* Douglas Shearer *Assistant Sound Supervisor* Wesley C. Miller *Production Mixer* John F. Dullam *Art Directors* Cedric Gibbons, Paul Groesse *Set Decorator* Edwin B. Willis *Associate Set Decorator* Ralph S. Hurst *Makeup* Jack Dawn *Costume Designer* Irene *Associate Costume Designer* Kay Dean *Assistant Director* Wallace Worsley *Song "Sweetheart of All My Dreams"* Art Finch, Kay Fitch *Publicity Supervisors* Howard Dietz, Howard Strickling *Scenic Artist*

George Gibson *Special Effects* A. Arnold Gillespie, Warren Newcombe, A.D. Flowers *Miniatures* Donald Jahraus, Marcel Delgado

A Mervyn LeRoy Production. Produced by Loew's Inc. Made at MGM Studios. Copyright November 3, 1944 by Loew's Inc. Western Electric Mirrophonic Recording. 138 minutes.

The Players: *Lt. Ted W. Lawson* Van Johnson *David Thatcher* Robert Walker, Sr. *Lt. Col. James H. Doolittle* Spencer Tracy *Ellen Jones Lawson* Phyllis Thaxter *Dean Davenport* Tim Murdock *Davey Jones* Scott McKay *Bob Cleaver* Gordon MacDonald *Charles McClure* Don Defoe *Bob Gray* Robert Mitchum *Shorty Manch* John R. Reilly *Doc White* Horace (Stephen) McNalley *Lt. Randall* Donald Curtis *Lt. Miller* Louis Jean Heydt *Don Smith* William (Bill) Phillips *Brick Holstrom* Douglas Cowan *Capt. Ski York* Paul Langton *Cmdr. Jurrika* Leon Ames *Dr. Chan, Jr.* Benson Fong *Dr. Chan, Sr.* Dr. Hsin Kung Chuan Chi *Girls in Officers' Club* Myrna Dell, Peggy Maley, Hazel Brooks, Elaine Shepard, Kay Williams, Lorraine Miller, Lucille Casey, Noreen Nash *Jane* Dorothy Rush Morris *Mrs. Parker* Ann Shoemaker *Parker* Alan Napier *Foo Ling* Wah Lee *Guerrilla Charlie* Ching Wah Lee *Emmy York* Jacqueline White *Dick Joyce* Jack McClendon *Pilot* John Kellogg *Spike Henderson* Peter Varney *Military Policeman* Steve Brodie *Capt. Halsey* Morris Ankrum *Mrs. Jones* Selena Royle *Judge* Harry Hayden *Second Officer* Blake Edwards *Hoss Wyler* Will Walls *Hallmark* Jay Norris *Sailors* Wally Cassell, Mike Kilian, Charles King III, Ralph Brooks *Bud Felton* Bill Williams *Jig White* Robert Bice *Generals* Walter Sande, Moroni Olsen *Joe* Eddie Hall *Girls* Edith Leach, Katharine Booth *Deck Officer* Arthur Space *Chinese Runner* Luke Chan *School Teacher* Mary Chan

Additional Oscar Nominations: *Cinematography — Black-and-White* (Robert Surtees, Harold Rosson)

Wilson

(20th Century–Fox; August 2, 1944)

Producer Darryl F. Zanuck *Director* Henry King *Screenplay* Lamar Trotti *Based on the Stage Play* In Time to Come *by* John Houseman *Cinematographer* Leon Shamroy *Musical Score* Alfred Newman *Film Editor* Barbara McLean *Art Directors* Wiard Ihnen, James Basevi *Set Decorator* Thomas Little *Associate Set Decorator* Paul S. Fox *Assistant Director* Joseph Behm *Orchestration* Edward Powell *Makeup* Guy Pearce, Ben Nye *Technicolor Director* Natalie Kalmus *Technicolor Consultant* Richard Mueller *Technical Advisers* Ray Stannard Baker, Miles McCahill *Costume Designer* Rene Hubert *Sound Supervisor* Edmund H. Hansen *Production Mixer* E. Clayton Ward *Dubbing Mixer* Roger Heman *Camera Operator* Bud Mautino *Assistant Cameramen* Peter Clower, Lee

"Red" Crawford *Technicolor Technician* John Greer *Assistant Technicolor Technician* Edward Plante *Special Effects* Fred Sersen *Matte Artist* Ray Kellogg

Made at 20th Century–Fox Studios and on location in Washington, D.C. Copyright August 1, 1944 by 20th Century Fox–Film Corporation. Technicolor. Western Electric Mirrophonic Recording. 154 minutes.

The Players: *Pres. Woodrow Wilson* Alexander Knox *Prof. Henry Holmes* Charles Coburn *Edith Wilson* Geraldine Fitzgerald *Joseph Tumulty* Thomas Mitchell *Ellen Wilson* Ruth Nelson *Sen. Henry Cabot Lodge* Cedric Hardwicke *Sec. William Gibbs McAdoo* Vincent Price *George Felton* William Eythe *Eleanor Wilson McAdoo* Mary Anderson *Margaret Wilson* Ruth Ford *Josephus Daniels and Dockstader* Sidney Blackmer *Jessie Wilson* Madeleine Forbes *Adm. Grayson* Stanley Ridges *Eddie Foy, Sr.* Eddie Foy, Jr. *Col. House* Charles Halton *Sen. E.H. Jones* Thurston Hall *Jim Becker* Jammes Rennie *Helen Jones* Katherine Locke *Sec. Lansing* Stanley Logan *Clemenceau* Marcel Dalio *William Jennings Bryan* Edwin Maxwell *Lloyd George* Clifford Brooke *Von Bernstorff* Tonio Selwart *Sen. Watson* John Ince *Sen. Bromfield* Charles Miller *Jennie* Anne O'Neal *Sec. Lane* Arthur Loft *Sec. Colby* Russell Gage *Sec. Payne* Jameson Shade *Sec. Houston* George Anderson *Sec. Meredith* Robert Barrat *McCoombs* George Macready *Smith* Frank Orth *Barney Baruch* Francis X. Bushman, Sr. *Charles F. Murphy* Cy Kendall *Democratic Committee Chairman* Emory Parnell *Housekeeper* Isabel Randolph *Dancer* Jeffrey Sayre *German Delegates* William Yetter, Otto Reichow *Granddaughter* Phyllis Brooks *Senators* Emmett King, Gibson Gowland, Scott Seaton, George Carleton *Reporters* Jack Stoney, Ben Erway, Earle Dewey, Grandon Rhodes, Edward Earle, Carroll Nye, Griff Barnett, Ian Wolfe, James Forrest, Paul McVey *Orator* Forrest Taylor *Gen. Bliss* Maj. Sam Harris *Harry L. White* Montague Shaw *Sec. William B. Wilson* Larry McGrath *Secretaries* David Cavendish, Ray Cooper *Ike Hoover* Roy Roberts *Sec. Newton Baker* Reginald Sheffield *Sec. Harrison* Robert Middlemass *Sec. Burleson* Matt Moore *Champ Clark* Davidson Clark *Chief Justice White* Joseph J. Greene *Edward Sullivan* J.M. Kerrigan *Jeanette Rankin* Hilda Plowright *Usher* Reed Hadley *La Follette* Ralph Dunn

Additional Oscar Nominations: *Picture* (20th Century–Fox, Darryl F. Zanuck); *Actor* (Alexander Knox); *Direction* (Henry King); *Writing — Original Screenplay* (Lamar Trotti)*; *Cinematography — Color* (Leon Shamroy)*; *Art Direction-Interior Decoration — Color* (Wiard Ihnen, Thomas Little)*; *Film Editing* (Barbara McLean)*; *Sound Recording* (E. H. Hansen)*; *Music — Scoring of a Dramatic or Comedy Picture* (Alfred Newman)

Note: Original roadshow version was 154 minutes; general release edition and existing prints are about 120 minutes. Dwight Frye, cast as Sec. Newton Baker, died and was replaced by Reginald Sheffield. Lamar Trotti's Oscar for original screenplay is erroneous; the scenario was based on earlier material.

1945

Special Effects Nominations

Captain Eddie . Fred Sersen,
(20th Century–Fox) Sol Halprin
Audible: Roger Heman,
Harry Leonard
Alfred Hitchcock's Spellbound Jack Cosgrove
(Selznick, UA)
They Were Expendable A. Arnold Gillespie,
(MGM) Donald Jahraus, R.A. MacDonald
Audible: Michael Steinore
A Thousand and One Nights L.W. Butler
(Columbia) Audible: Ray Bomba
*Wonder Man . John Fulton
(Goldwyn, RKO Radio) Audible: A.W. Johns

Comments

John P. Fulton had left Universal after years of good trick work and
several Oscar nominations because he wanted to direct and the studio brass
refused him the opportunity. He signed on with Samuel Goldwyn when that
producer promised to give him a chance. It was a promise unfulfilled. In the
early fifties, Fulton left Goldwyn for Paramount, where he never got further
than some brief second unit efforts. He had a flare for setting up action, as
evidenced by such later work on The Bridges at Toko-Ri and The Ten Command-
ments, and one can only assume he would have been at least as good as fifty
percent of the working directors. Regrettably, he died without ever getting
an honest break. One of his first assignments at Goldwyn was Wonder Man,
a Technicolor "biggie" about twin brothers, one of whom is killed, forcing
the other to take his place as an entertainer. The Special Effects were of his
usual caliber and involved ghosts and models.

Hero Eddie Rickenbacker's exciting life story came to less than exciting
picturization in Captain Eddie, wherein Fred Sersen's miniature airplanes
added no production value. The audio nomination was shared by the two
re-recording mixers.

Jack Cosgrove's many mattes expanded the scenic vistas in Spellbound,
a Selznick-Hitchcock mystery of a very confused psychiatrist. The process
photography was too noticeable, and the film was not cited for sound effects.

A PT boat crew's South Pacific experiences were the basis of John Ford's *They Were Expendable*, his first post-war feature. The usual studio model work and rear screens were evident. This was another case of a fairly expensive production obtaining over the years an undeserved reputation for quality and entertainment. Actually, it was pretty dull goings-on.

Aladdin and his female Genie may not have had a thousand and one adventures in *A Thousand and One Nights*, but they did have a lot of silly fun. As always in these Arabian Nights yarns, most of the expansive settings were via the painted matte and miniature. The Technicolor rear screens were not up to par. The sound was re-mixed by Ray Bomba, who was nominated for audible effects.

Credits

Captain Eddie
(20th Century–Fox; September 1945)

Executive Producer Darryl F. Zanuck *Producer* Winfield R. Sheehan *Associate Producer* Christy Walsh *Director* Lloyd Bacon *Screenplay* John Tucker Battle *Cinematographer* Joseph MacDonald *Musical Score* Cyril J. Mockridge *Musical Director* Emil Newman *Film Editor* James B. Clark *Art Directors* Richard Day, Maurice Ransford *Set Decorator* Thomas Little *Associate Set Decorator* Walter M. Scott *Costume Designer* Rene Hubert *Makeup* Guy Pierce *Sound Supervisor* Edmund H. Hansen *Production Mixer* Eugene Grossman *Dubbing Mixers* Roger Heman, Harry M. Leonard *Assistant Director* Saul Wurtzel *Orchestration* Maurice De Packh *Special Effects* Fred Sersen, Sol Halprin *Matte Artist* Ray Kellogg

A Eureka Picture. Made at 20th Century–Fox Studios. Copyright August 1, 1945 by Eureka Pictures Inc. Western Electric Mirrophonic Recording. 107 minutes.

The Players: *Capt. Edward Rickenbacker* Fred MacMurray *Adelaide Frost* Lynn Bari *William Rickenbacker* Charles Bickford *Ike Howard* Thomas Mitchell *Lt. Whittaker* Lloyd Nolan *Tom Clark* James Gleason *Elise Rickenbacker* Mary Phillips *Eddie as a Boy* Darryl Hickman *Mrs. Frost* Spring Byington *Pvt. Bartek* Richard Conte *Sgt. Reynolds* Charles Russell *Capt. Cherry* Richard Crane *Col. Adamson* Stanley Ridges *Jabez* Clem Bevans *Lester Thomas* Grady Sutton *Lacey* Chick Chandler *Louis Rickenbacker* Dwayne Hickman *Mary Rickenbacker* Nancy June Robinson *Emma Rickenbacker* Winifred Glyn *Dewey Rickenbacker* Gregory Muradian *Albert Rickenbacker* David Spencer *Bill Rickenbacker* Elvin Field *Lt. De Angelis* George Mitchell *Mr. Frost* Boyd Davis *Sgt. Alex* Don

Garner *Mrs. Westrom* Mary Gordon *Dinkenspiel* Joseph J. Greene *Census Taker* Olin Howlin *Mr. Foley* Robert Malcolm *Mrs. Foley* Leila McIntyre *Simmons* Harry Shannon *Flo Clark* Virginia Brissac *Charlie* Peter Michael *Freddie* Peter Garcey *Prof. Montagne* Fred Essler *Mme. Montagne* Lotte Stein *Shelby* Franklin Parker *Doctor* William Forrest *French Captain* Paul Marion *Watson* Howard Negley *Heckler* George Chandler *Nurse* Dorothy Adams *Boy* Leon Tyler *Photographer* Ray Johnson *with* Earle Dewey, William Newell, Anne Loos, Tom Dillon, John Dehner, Georges Renavent, Joe Devlin, Walter Baldwin, Robert Homans

Alfred Hitchcock's *Spellbound*
(United Artists; December 28, 1945)

Producer David O. Selznick *Directors* Alfred J. Hitchcock, William Cameron Menzies *Screenplay* Ben Hecht, Alfred Hitchcock *Adaptation* Angus McPhail *Based on the Novel "The House of Dr. Edwards" by* Francis Beeding (Hilary Aidan St. George Saunders and John Leslie Palmer) *Cinematographer* George Barnes *Dream Sequences Cinematographer* Rex Wimpy *Musical Score* Miklos Rozsa *Supervising Film Editor* Julian D. Blaustein *Film Editor* Hal C. Kern, Sr. *Associate Film Editor* William Ziegler *Sound Editor* Charles L. Freeman *Art Director* James Basevi *Associate Art Director* John Ewing *Set Decorator* Emile Kuri *Dream Sequences Based on Designs by* Salvador Dali *Psychiatric Adviser* Dr. May E. Romm *Camera Operator* John F. Warren *Story Editor* Margaret McDonell *Production Executive* Charles Glatt *Production Manager* W. Argyle Nelson, Sr. *Unit Manager* Fred Ahern *Production Assistant* Barbara Keon *Scenario Assistant* Lydia Schiller *Assistant Director* Lowell Farrell *Costume Designer* Howard Greer *Unit Publicist* Paul MacNamara *Sound Supervisor* James G. Stewart *Production Mixer* Richard de Weese *Casting* Ruth Burch *Special Effects* John R. Cosgrove *Process Cinematography* Clarence W.D. Slifer

A David O. Selznick Presentation. A Vanguard Film. A Selznick International Picture. Made at The Selznick Studio. Copyright December 28, 1945 by Vanguard Films Inc. Western Electric Mirrophonic Recording. 111 minutes.

The Players: *Dr. Constance Peterson* Ingrid Bergman *John Ballantine* Gregory Peck *Matron* Jean Acker *Harry* Donald Curtis *Mary Carmichael* Rhonda Fleming *Dr. Fleurot* John Emery *Dr. Murchison* Leo G. Carroll *Garmes* Norman Lloyd *Dr. Alex Brulov* Michael Chekhov *Dr. Graff* Stephen Geray *Dr. Hanish* Paul Harvey *Dr. Galt* Erskine Sanford *Sheriff* Victor Kilian *Stranger at Empire State Hotel* Wallace Ford *House Detective* Bill Goodwin *Bellhop* Dave Willock *Norma* Janet Scott *Sgt. Gillespie* Regis Toomey *Police Captain* Addison Richards *Lt. Cooley* Art Baker *John's Brother* Teddy Infuhr *Railroad Clerk*

George Meador *Policeman at Railroad Station* Matt Moore *Gateman* Harry Brown *Police Secretary* Clarence Straight *John as a Child* Joel Davis *Dr. Edwards* Edward Fielding *Ticket Taker* Richard Bartell *Man Exiting Elevator with Violin* Alfred Hitchcock

Additional Oscar Nominations: *Picture* (Selznick, UA; David O. Selznick); *Supporting Actor* (Michael Chekhov); *Direction* (Alfred Hitchcock); *Cinematography — Black-and-White* (George Barnes); *Music — Scoring of a Dramatic or Comedy Picture* (Miklos Rozsa)*

Note: For its original release four frames of a gunshot were hand-painted red. Working title was *The House of Dr. Edwards.* William Cameron Menzies directed the dream sequences even though Hitchcock claimed full credit.

They Were Expendable
(Metro-Goldwyn-Mayer; December 7, 1945)

Executive Producer James Kevin McGuinness *Producer and Director* John Ford *Associate Producer* Cliff Reid *Screenplay* Lt. Cmdr. Frank W. Wead U.S.N. *Based on the Book by* William L. White *Cinematographer* Joseph H. August *Musical Score* Herbert Stothart *Film Editors* Frank E. Hull, Douglas Biggs *Supervising Sound Editor* Michael Steinore *Art Directors* Cedric Gibbons, Malcolm F. Brown *Set Decorator* Edwin B. Willis *Associate Set Decorator* Ralph S. Hurst *Second Unit Directors* James C. Havens, Robert Montgomery *Assistant Director* Edward O'Fearna *Makeup* Jack Dawn, Emile La Vigne *Technical Adviser* Jack Pennick *Song "To the End of the End of the World"* Earl Brent, Herbert Stothart *Sound Supervisor* Douglas Shearer *Assistant Sound Supervisor* Wesley C. Miller *Special Effects* A. Arnold Gillespie, Warren Newcombe, Robert A. MacDonald *Miniatures* Donald Jahraus

A John Ford Production. Produced by Loew's Inc. Made at MGM Studios and on location in Key Biscayne, Florida. Copyright November 16, 1945 by Loew's Inc. Western Electric Mirrophonic Recording. 136 minutes.

The Players: *Lt. John Brickley* Robert Montgomery *Lt. (j.g.) Rusty Ryan* John Wayne *2nd Lt. Sandy Davis* Donna Reed *Gen. Martin* Jack Holt *Boots Mulcahey* Ward Bond *Capt. Ohio Carter* Louis Jean Heydt *Ens. Snake Gardner* Marshall Thompson *Dad Knowland* Russell Simpson *Maj. James Morton* Leon Ames *Andy Andrews* Paul Langton *Jones* Arthur Walsh *Lt. (j.g.) Shorty Long* Donald Curtis *Ens. George Cross* Cameron Mitchell *Ens. Tony "Lefty" Aiken* Jeff York *Slug Mahan* Murray Alper *Cooky Squarehead Larsen* Harry Tenbrook *Doc Charlie* Jack Pennick *Adm Blackwell* Charles Trowbridge *General* Robert Barrat *Lt. Elder Thomas* Bruce Kellogg *Ens. Brant* Tim Murdock *Army Doctor* Vernon

Steele *Benny Lacoco* Alex Havler *Sailor* Wallace Ford *Priest* Pedro de Cordoba *Airport Captain* Tom Tyler *Gardner's Girl Friend* Trina Lowe *Sammy* Sammy Stein *Gunner* Blake Edwards *Silver Dollar Bartender* Robert Emmett O'Connor *Army Orderly* Phillip Ahn *Filipino Singer* Pacita Tod-Tod *Hotel Manager* William B. Davidson *Cebu Mayor* Max Ong *Sgt. Smith* Bill Wilkerson *Lt. James* John Carlyle *Nurses* Marjorie Davies, Eve Marsh *PT Boat Crewmen* Robert Shelby Randall, Art Foster, Larry Dods, Jack Stoney, Duke Green, Stubby Kruger, Phil Schumacher, Maj. Frank Pershing, Joey Fay, Danny Borzage, William Neff, Del Hill, Bill Barnum, Ted Lundigan, Michael Kirby, William McKeever Riley *Slim* Frank McGrath *Marine Orderly* Leslie Sketchley *Manila Hotel Bartender* Robert Homans *Navy Commander* Jack Cheatman *Navy Captain* Forbes Murray *Navy Doctor* Emmett Vogan *Marine Major* Sherry Hall *Navy Officers* Ernest Seftig, Stephen Barclay, Franklin Parker *Lt. Colonel* Alan Bridge *Navy Air Captain* Jack Luden *Submarine Commander* Jon Gilbreath *Personnel in Admiral's Office* Karl Miller, Len Stanford, George Bruggeman, Reginald Simpson, Dutch Schlickenmeyer, James Carlisle, Tony Carson, Jack Lorenz, Brad Towne, Charles Calhoun, Leonard Mellin, Frank Donahue, Dan Quigg, Clifford Rathjen, Dick Karl, Jack Lee, Wedgewood Nowell, Dick Thorne, Leonard Fisher, John Roy, Michael Kostrick, Jimmy Magrill, George Magrill, Sam Simone, Paul Kruger, Bruce Carruthers, Jack Semple, Roy Thomas, Bob Thom, Larry Steers, Gary Delmar *Airport Officers* Roger Cole, Fred Beckner, Jack Ross, Brent Shugar, Kermit Maynard, Bill Donahue, Frank Eldridge, Jack Carrington, Hansel Warner, Charles Ferguson, Jack Trent, Robert Strong, Jon Epper, Bill Nind, Don Lewis *Jeep Driver* Charles Murray, Jr. *Bartender's Wife* Margaret Morton *Filipino Orderly* Ralph Soncuya *Filipino School Teacher* Vincent Isla *Officer's Wives* Eleanor Vogel, Leota Lorraine, Almeda Fowler, Betty Blythe, Jane Crowley *Mate* Jim Farley *Filipino Boys* Ernest Dominquez, Henry Mirelez *Bartender* Lee Tung Foo *Lost Nurse* Mary Jane French *Pilot* Patrick Davis *Wounded Officer at Airport* William (Merrill) McCormick *Bartender's Children* George Economides, Michael Economides, Roque Yberra, Jr., Nino Pipitone, Jr. *Officer* Jack Mower

Additional Oscar Nominations: *Sound Recording* (Douglas Shearer)

A Thousand and One Nights
(Columbia; July 26, 1945)

Executive Producer Harry Cohn *Producer* Samuel Bischoff *Director* Alfred E. Green *Screenplay* Wilfred H. Pettitt, Richard English, Jack Henley *Story* Wilfred H. Pettitt *Cinematographer* Ray Rennahan *Musical Score* Marlin Skiles *Musical Director* Morris W. Stoloff *Film Editor* Gene Havelick *Technicolor Director* Natalie Kalmus *Technicolor Consultant* Morgan Padelford *Art Directors*

Stephen Gooson, Rudolph Sternad *Set Decorator* Frank Tuttle *Costume Designer* Jean Louis *Makeup* Clay Campbell *Assistant Director* Rex Bailey *Sound Supervisor* John P. Livadary *Production Mixer* Lambert Day *Dubbing Mixer* Ray Bomba *Special Effects* Lawrence W. Butler *Process Cinematography* Ray Cory

Made at Columbia Studios. Copyright June 11, 1945 by Columbia Pictures Corporation. Technicolor. Western Electric Mirrophonic Recording. 93 minutes.

The Players: *Aladdin* Cornel Wilde *Genie* Evelyn Keyes *Abdullah* Phil Silvers *Princess Armina* Adele Jergens *Novira* Dusty Anderson *Sultan Kamar Al-Kir and Prince Hadji* Denis Hoey *Giant* Rex Ingram *Grand Wazir Abu Hassan* Philip van Zandt *Jafar* Gus Schilling *Kahim* Nestor Paiva *Kofir the Sorcerer* Richard Hale *Exotic Girl* Vivian Mason *Hand Maidens* Carole Matthews, Pat Parrish, Shelley Winters *Hasson* Trevor Bardette *Ramud* Dick Botiller *Auctioneer* Cy Kendall *Innkeeper* Charles La Torre *Camel Drivers* Murray Leonard, Frank Lackteen *Dancer* Marie Jinishian *Retainers* Frank Scannell, Patric Desmond *Ali* John Abbott

Additional Oscar Nomination: *Art Direction-Interior Decoration—Color* (Stephen Gooson, Rudolph Sternad, Frank Tuttle)

Note: Variations of this story have appeared on the screen so often that a full listing here is impossible.

Wonder Man
(RKO Radio; April 25, 1945)

Producer Samuel Goldwyn *Director* H. Bruce Humberstone *Screenplay* Don Hartman, Melville Shavelson, Phillip Rapp *Adaptation* Jack Jevne, Eddie Moran *Story* Arthur Sheekman *Cinematographers* Victor Milner, William Snyder *Music and Lyrics* Sylvia Fine *Song "So In Love"* Leo Robin, David Rose *Musical Director* Louis Forbes *Musical Conductor and Orchestrator* Ray Heindorf *Film Editor* Daniel Mandell *Sound Supervisor* Gordon E. Sawyer *Production Mixer* Fred Lau *Dubbing Mixer* Arthur W. Johns *Choreography* John Wray *Art Director* Ernest Fegte *Associate Art Director* McClure Capps *Set Decorators* Julia Heron, Howard Bristol *Technicolor Director* Natalie Kalmus *Technicolor Consultant* Mitchell Kovaleski *Makeup* Robert Stephanoff *Hairdressing* Nina Roberts *Costume Designer* Travis Banton *Special Effects* John P. Fulton

A Samuel Goldwyn Presentation. A Beverly Production. Made at Samuel Goldwyn Studios. Copyright June 8, 1945 by Beverly Productions Inc. Technicolor. Western Electric Mirrophonic Recording. 98 minutes.

The Players: *Edwin Dingle and Buzzy Bellew* Danny Kaye *Ellen Shanley* Virginia Mayo *Midge Mallon* Vera-Ellen *Monte Rosson* Donald Woods *Schmidt* S.Z. Sakall *Chimp* Allen Jenkins *Torso* Ed Brophy *Ten Grand Jackson* Steve Cochran *District Attorney O'Brien* Otto Kruger *Assistant D.A. Grosset* Richard Lane *Mrs. Hume* Natalie Schafer *Sailor* Huntz Hall *Sailor's Girl Friend* Virginia Gilmore *Policeman* Ed Gargan *Prima Donna* Alice Mock *Mrs. Schmidt* Gisela Werbiseck *Prompter* Luis Alberni *Opera Conductor* Aldo Franchetti *Stage Manager* Maurice Cass *Beauties* The Goldwyn Girls: Ruth Valmy, Alma Carroll, Georgia Lange, Karen Gaylord, Mary Moore, Gloria Delson, Deannis Best, Margie Stewart, Mary Meade, Martha Montgomery, Ellen Hall, Phyllis Forbes, Mary Jane Woods, Katherine Booth, Chili Williams *Acrobatic Dancer* Barbara La Rene *Dancer* Carol Haney *Customer* Byron Fougler *Specialty Dancers* Al Ruiz, Willard Van Simons *Drunk at Table* Jack Norton *Drunk at Bar* Charles Irwin *Bartender* Frank Orth *Barker* Cecil Cunningham *Meek Man on Bus* Chester Clute *Bus Driver* James Flavin *District Attorney's Secretary* Mary Field *Head Waiter* Eddie Kane *Ticket Taker* Ray Teal *Pianist* Leon Belasco

Additional Oscar Nominations: *Sound Recording* (Gordon Sawyer); *Music — Song* ("So in Love" by David Rose and Leo Robin); *Music — Scoring of a Musical Picture* (Lou Forbes, Ray Heindorf)

1946

Special Effects Nominations

*Noel Coward's *"Blithe Spirit"* Thomas Howard
(Rank-Two Cities, UA)

A Stolen Life . William McGann
(Warner Bros.) *Audible:* Nathan Levinson

Scientific or Technical Awards

Class III . Herbert E. Britt
For the development and application of formulas and equip-
ment for producing cloud and smoke effects

Class III Marty Martin and Hal Adkins
of the RKO Radio Studio Miniature Department
For the design and construction of equipment providing
visual bullet effects

Comments

Adding ghosts and twinning the same performer on screen are exacting
but basic Special Effects. They are too commonly associated with children's
movies, and no matter how well done or elaborate they are, they just fail to
impress. Of course both nominated features employed other illusions beside
traveling mattes.

Blithe Spirit, the more enjoyable of this year's nominations, concerned
a newly married husband who was haunted by the ghost of his first wife.

A Stolen Life, with its love triangle of twin sisters and the same man, has
been parodied to death on television comedy programs.

The British feature was not nominated for its sound effects.

Credits

Noel Coward's *"Blithe Spirit"*
(United Artists; August 25, 1945)

Producer Noel Coward *Director* Daivd Lean *Screenplay* Noel Coward, David

Lean, Anthony Havelock-Allan, Ronald Neame *Based on the Play by* Noel Coward *Associate Producers* David Lean, Anthony Havelock-Allan, Ronald Neame *Cinematographers* Ronald Neame *Musical Score* Richard Addinsell *Musical Director* Muir (Dock) Mathieson *conducting* The London Symphony Orchestra *Film Editor* Jack Harris *Production Executive* Anthony Havelock-Allan *Production Managers* Norman Spencer, Sydney S. Streeter *Assistant Director* George Pollock *Script Supervisor* Hilda Collins *Art Supervisor to Noel Coward* G.E. Calthrop *Art Director* C.P. Norman *Costume Designer* Rahvis *Makeup* Tony Sforzini *Hairdresser* Viviene Walker *Camera Operator* William McLeod *Technicolor Director* Natalie Kalmus *Technicolor Consultant* Joan Bridge *Technicolor Technician* George Minassian *Production Mixer* John Coore *Dubbing Mixer* Desmond Dew *Special Effects* Thomas Howard

A J. Arthur Rank Organization Presentation. A Noel Coward-Cineguild Ltd. Production. A Two Cities Films Ltd. Picture. Copyright December 14, 1945 by General Film Distributors Ltd. Filmed at D & P Studios, Denham, England. Technicolor. Western Electric Mirrophonic Recording. 96 minutes.

The Players: *Charles Condomine* Rex Harrison *Ruth Condomine* Constance Cummings *Elvira Condomine* Kay Hammond *Mme. Arcati* Margaret Rutherford *Dr. George Bradman* Hugh Wakefield *Violet Bradman* Joyce Carey *Edith* Jacqueline Clarke *Commentator* Noel Coward

Note: Released in England on April 5, 1945 by General Film Distributors Ltd. with a B.B.F.C. A certificate. Insomuch as this was the first ghost film of note in Technicolor a word on the phantoms' makeup is in order. Strange! That is if you consider green faces and hair with red lips strange. The clothes were also green. Remember, this wasn't a rock film.

A Stolen Life

(Warner Bros.; July 6, 1946)

Executive Producer Jack L. Warner *Producer* Bette Davis *Director* Curtis Bernhardt *Screenplay* Catherine Turney *Adaptation* Margaret Buell Wilder *Based on the Story "Uloupeny Zivot"* ("The Stolen Life") *by* Karel J. Benes *Cinematographers* Sol Polito, Ernest Haller *Musical Score* Max Steiner *Musical Director* Leo F. Forbstein *Film Editor* Rudi Fehr *Art Director* Robert Haas *Set Decorator* Fred M. MacLean *Costume Designer* Orry-Kelly *Makeup* Perc Westmore *Orchestration* Hugo Friedhofer *Assistant Director* Jesse Hibbs *Script Supervisor* Meta Rebner *Dialogue Coach* Jack Gage *Sound Supervisor* Nathan Levinson *Production Mixer* Robert B. Lee *Special Effects Director* William McGann *Special Effects Cinematographers* E. Roy Davidson, Willard van Enger *Special Effects* Russell Collings

A B.D. Inc. Production. A Warner Bros.–First National Picture. Made at Warner Bros. Studios and on location in Monterey and Long Beach, California. Copyright June 29, 1946 by Warner Bros. Pictures Inc. RCA Photophone Recording. 107 minutes.

The Players: *Kate Bosworth and Patricia Bosworth* Bette Davis *Bill Emerson* Glenn Ford *Karnok* Dane Clark *Eben Folger* Walter Brennan *Deidre* Peggy Knudsen *Freddie Linley* Charles Ruggles *Jack Talbot* Bruce Bennett *Mrs. Johnson* Esther Dale *Martha* Clara Blandick *Lucy* Joan Winfield *Old Fisherman* Robert Dudley *Fisherman* Jack Mower, Harlan Briggs, Tom Fadden *Man in Launch* Dale Van Sickel *Attendant* Creighton Hale *Investigator* James Flavin *Lippencott* Monte Blue *Patricia's Dance Partner* Sherman Sanders *Waiters* Leo White, Paul Panzer *Art Patrons* Mary Forbes, Philo McCullough *Bridesmaid* Rosalie Rey *Large Woman* Ruth Cherrington

Note: Previously made in Europe. Due to illness, Sol Polito was replaced by Ernest Haller as director of photography.

1947

Special Effects Nominations

**Green Dolphin Street* A. Arnold Gillespie,
(MGM) Warren Newcombe
 Audible: Douglas Shearer,
 Michael Steinore
Unconquered Farciot Edouart, Devereaux
(De Mille, Paramount) Jennings, Gordon Jennings,
 Wallace Kelley, Paul Lerpae
 Audible: George Dutton

Scientific or Technical Awards

Class III Farciot Edouart, C.R. Daily,
 Hal Corl, H.G. Cartwright and the
 Paramount Studio Transparency and
 Engineering Department
For the first application of a special anti-solarizing glass to high intensity background and spot arc projectors
Class III . Fred Ponedel
 of Warner Bros. Studios
For pioneering the fabrication and practical application to motion picture color photography of large translucent photographic backgrounds

Comments

Frontier life highlighted this year's nominations. In nineteenth century New Zealand, two sisters vied for the same man who lived on *Green Dolphin Street*; and in sixteenth century New England, British homesteaders showed the natives they were *Unconquered*.

The MGM production employed more matte art and, being monochrome, was able to pull its illusions less noticeably. Technicolor added greatly to Paramount's super epic in general but did wash out the rear screens terribly. Both were long, often tedious, but elaborate features. A tidal wave in the MGM feature was by far more spectacular than anything in the De Mille adventure.

Credits

Green Dolphin Street

(Metro-Goldwyn-Mayer; November 21, 1947)

Producer Carey Wilson *Director* Victor Saville *Screenplay* Samson Raphaelson *Based on the Novel by* Elizabeth Goudge *Cinematographer* George Folsey *Musical Score* Bronislau Kaper *Film Editor* George White *Art Directors* Cedric Gibbons, Malcolm Brown *Set Decorator* Edwin B. Willis *Costume Designers* Walter Plunkett, J. Arlington Valles *Costume Supervisor* Irene *Makeup* Jack Dawn, Robert Dawn *Hairdressing* Sydney Guilaroff *Sound Supervisor* Douglas Shearer *Assistant Sound Supervisor* Wesley C. Miller *Production Mixer* Standish J. Lambert *Supervising Sound Editor* Michael Steinore *Song "On Green Dolphin Street"* Bronislau Kaper, Ned Washington *Assistant Director* Norman Elzer *Publicity Supervisors* Howard Dietz, Howard Strickling *Special Effects* A. Arnold Gillespie, Warren Newcombe *Miniatures* Donald Jahraus

A Victor Saville Production. Produced by Loew's Inc. Made at MGM Studios and on location in Oregon. Copyright October 22, 1947 by Loew's Inc. Western Electric Mirrophonic Recording. 141 minutes.

The Players: *Marianne Patourel* Lana Turner *Timothy Haslam* Van Heflin *Marguerite Patourel* Donna Reed *William Ozanne* Richard Hart *Dr. Edmund Ozanne* Frank Morgan *Octavious Patourel* Edmund Gwenn *Mother Superior* May Whitty *Capt. O'Hara* Reginald Owen *Sophie Patourel* Gladys Cooper *Mrs. Metivier* Moyna Macgill *Hing-Moa* Linda Christian *Jacky-Pato* Bernie Gozier *Kapua-Manga* Pat Aherne *Native* Al Kikume *Sister Angelique* Edith Leslie *Veronica at Age 4* Gigi Perreau *Sir Charles Maloney* Douglas Walton *Capt. Hartley* Leslie Dennison *Anderson* Lumsden Hare *Nat* William Fawcett *Priest* Pedro de Cordoba *Eurasian Girl* Lila Leeds *Emily* Rhea Mitchell *Corinne* Ramsey Ames *Brother* Franco Corsaro *Young Fisherman* Guy Kingsford *Government General* Wyndham Standing *Wife* Florence Wix *Niece* Patricia Emery *Chinese Man* Tetsu Kamei *Brown* Michael Kirby *Chinese Longshoreman* James B. Leong *Samuel Kelly* Murray Keats *Mrs. Kelly* Lucille Curtis *Maori Chieftain* George Bennett *Young Priest* Richard Abbott *Veronica at Age 7* Carol Nugent

Additional Oscar Nominations: *Cinematography — Black-and-White* (George Folsey); *Sound Recording* (MGM Sound Department); *Film Editing* (George White)

Unconquered
(Paramount; September 24, 1947)

Producer and Director Cecil B. De Mille *Associate Producer* Henry Wilcoxon *Screenplay* Charles Bennett, Fredric M. Frank, Jesse L. Lasky, Jr., Jeanie Macpherson *Based on the Novel* "The Judas Tree" *by* Neil H. Swanson *Cinematographer* Ray Rennahan *Musical Score* Victor Young *Film Editor* Anne Bauchens *Art Directors* Hans Dreier, Walter Tyler *Set Decorators* Sam Comer, Stanley Jay Sawley *Production Illustrator* Dan Sayre Groesbeck *Second Unit Directors* Arthur Rosson, Ralph Jester *Assistant Director* Edward Salven *Second Assistant Director* Francisco Day *Property Master* Joe Thompson *Unit Publicist* Phil Koury *Technicolor Director* Natalie Kalmus *Technicolor Consultant* Robert Brower *Makeup* Wally Westmore, Frank Westmore *Hairdressing* Nellie Manley *Choreography* Jack Crosby *Costume Designers* Gwen Wakeling, Natalie Visart, Joe De Yong *Costume Coordinator* Barbara Karinska *Technical Adviser* Capt. Fred F. Ellis B.M.M. Retd. *Research* Arthur Pierson, Henry S. Noerdlinger *Indian Technical Supervisors* Iron Eyes Cody, J.W. Silvermoon Cody *Unit Production Manager* Roy Burns *Production Assistant* Donald Hayne *Sound Supervisor* Loren L. Ryder *Production Mixer* Hugo Grenzbach *Dubbing Mixers* John Cope, George Dutton, Gene Garvin *Dialogue Coach* Robert Foulk *Producer-Director's Secretaries* Berenice Mosk, Florence Cole *Song* "Whippoor-wills-a-Singing" Ray Evans, Jay Livingston *Visual Effects Director* Gordon Jennings *Visual Effects Cinematographer* J. Devereaux Jennings *Matte Cinematography* Irmin Roberts *Matte Artist* Jan Domela *Optical Cinematography* Paul K. Lerpae *Process Cinematography* Farciot Edouart, W. Wallace Kelley *Mechanical Effects* Walter Hoffman

A Cecil B. De Mille Productions Inc. Picture. Made at Paramount Studios and on location in Oregon. Copyright October 3, 1947 by Paramount Pictures Inc. Technicolor. Western Electric Mirrophonic Recording. 147 minutes.

The Players: *Capt. Christopher Holden* Gary Cooper *Abigail Martha Hale* Paulette Goddard *Martin Garth* Howard Da Silva *Chief Guyasuta* Boris Karloff *Jeremy Love* Cecil Kellaway *John Fraser* Ward Bond *Hannah* Katherine De Mille *Capt. Steele* Henry Wilcoxon *Lord Chief Justice* C. Aubrey Smith *Capt. Simeon Ecuyer* Victor Varconi *Diana* Virginia Grey *Leach* Porter Hall *Dave Boone* Mike Mazurki *Col. George Washington* Richard Gaines *Mrs. Frazer* Virginia Campbell *Lt. Fergus McKenzie* Gavin Muir *Sir William Johnson* Alan Napier *Mrs. Pratt* Nan Sutherland *Sioto* Marc Lawrence *Evelyn* Jane Nigh *Frontiersmen* Jack Montgomery, Robert Kortman *White Slave* Richard Alexander *Farmer* Si Jenks *Dr. Diablo's Spieler* Sid Sailor *Soldiers* Hugh Prosser, Ray Teal, Edgar Dearing *Corporal* John Merton *Guard* Buddy Roosevelt *Prosecutor* John Miljan *Big Ottowa* Noble Johnson *Townsman* Byron

Fougler *Citizen* Denver Dixon (Victor Adamson) *Drummer Boy* Robert Baughman *Chief Pontiac* Robert Warwick *Brother Andrews* Griff Barnett *Lt. Hutchins* Lloyd Bridges *Lt. Baillie* Oliver Thorndike *Jim Lovet* Jack Pennick *Dan McCoy* Paul E. Burns *Mr. Carroll* Davidson Clark *Mrs. Brunt* Dorothy Adams *Jason* Clarence Muse *Venango Scout* Raymond Hatton *Widow Stevens* Julia Faye *Chief Killbuck* Chief Thundercloud *Mulligan* Charles B. Middleton *Bondswoman* Elizabeth "Tiny" Jones *Sergeant* Fred Kohler, Jr. *Red Crow* Iron Eyes Cody *Indian Warrior* Jay Silverheels *Maggie* Mary Field *Col. Henry Bouquet* John Mylong *Mamaultee* Rus Conklin *Charles Mason* George Kirby *Royal American Officer* Lex Barker *Jeremiah Dixon* Leonard Carey *Richard Henry Lee* Frank R. Wilcox *Capt. Brooks* Matthew Boulton *Wide-Shouldered Youth* Jeff York *Narrator* Cecil B. De Mille *with* Boyd Irwin, Hope Landin, Richard Reeves, James Horne, Ottola Nesmith, Greta Granstedt, Mike Kilian, Francis Ford, Francis J. McDonald, Olaf Hytten, Eric Alden, Frank Hagney, Sally Rawlinson, Chuck Hamilton, Ethel Wales, Christopher Clark, Bill Murphy, June Harris, William Haade, Jeff Corey, Erville Alderson, Lane Chandler, Anna Lehr, Isabel Chabing Cooper, Charmienne Harker, Belle Mitchell, Fernanda Eliscu, Claire DuBrey, Mimi Aguglia, Inez Palange, Rose Higgins, Constance Purdy, Al Ferguson, Gertrude Valerie, J.W. Silvermoon Cody

1948

Special Effects Nominations

Deep Waters Ralph Hammeras, Fred
(20th Century-Fox) Sersen, Edward Snyder
 Audible: Roger Heman

Portrait of Jennie (Selznick Releasing
Organization) Paul Eagler, J. McMillan
 Johnson, Russell Shearman,
 Clarence Slifer
 Audible: James G. Stewart,
 Charles Freeman

Scientific or Technical Awards

Class II Nick Kalten, Louis J. Witti
 and the 20th Century-Fox Studio
 Mechanical Effects Department
For a process of preserving and flame-proofing foliage
Class III Marty Martin, Jack Lannon,
 Russell Shearman and the RKO Radio
 Studio Special Effects Department
For the development of a new method of simulating falling
snow on motion picture sets

Comments

Portrait of Jennie was an incredible fantasy about a struggling painter who
kept encountering a girl who with each meeting grew older. The climax was
a stupendous hurricane during which he tried to save her from drowning.
Though some of this was noticeably miniaturizations, it was so spectacularly
staged, with marvelous cloud effects and sound (originally tinted and toned
and stereophonically re-channeled), and so well edited that it almost over-
powered the viewer. This was tremendously exciting footage. There were
many beautiful mist shrouded scenes, several with mystical clouds painted
in. Sequences were bridged with canvas textured overlays. It was an
astounding visual treat throughout. James G. Stewart, a former RKO
dubbing mixer, had become Selznick's technical director and as such super-
vised all sound recording and in this incidence the visual and mechanical
effects. Charles Freeman was dubbing editor.

The love of a little boy brought together a fisherman and his girl friend in *Deep Waters*. Featured were lots of model marine shots which were good enough stuff but no match for the Selznick production.

Credits

Deep Waters
(20th Century-Fox; July 7, 1948)

Producer Samuel G. Engel *Director* Henry King *Screenplay* Richard Murphy *Based on the Novel* Spoonhandle *by* Ruth Moore *Cinematographer* Joseph La Shelle *Musical Score* Cyril J. Mockridge *Musical Director* Lionel Newman *Film Editor* Barbara McLean *Art Directors* Lyle Reynolds Wheeler, George W. Davis *Set Decorator* Thomas Little *Costume Supervisor* Charles LeMaire *Makeup* Ben Nye *Orchestration* Maurice De Packh *Sound Supervisor* Thomas T. Moulton *Production Mixer* Bernard Freericks *Dubbing Mixer* Roger Heman *Special Effects Supervisor* Fred Sersen *Special Effects Cinematographers* Ralph Hammeras, Edward Snyder *Special Effects Assistant Cameraman* L.B. Abbott *Matte Artist* Ray Kellogg *Assistant Matte Artist* Emil Kosa, Jr.

Made at 20th Century-Fox Studios and on location in Maine. Copyright July 7, 1948 by 20th Century-Fox Film Corporation. Sepia. Western Electric Mirrophonic Recording. 85 minutes.

The Players: *Hod Stilwell* Dana Andrews *Ann Freeman* Jean Peters *Joe Sanger* Cesar Romero *Danny Mitchell* Dean Stockwell *Mary McKay* Anne Revere *Josh Hovey* Ed Begley, Sr. *Mrs. Freeman* Leona Powers *Molly Thatcher* Mae Marsh *Nick Driver* Will Geer *Druggist* Bruno Wick *Harris* Cliff Clark *Hopkins* Harry Tyler *Judge Tate* Raymond Greenleaf

Portrait of Jennie
(Selznick Releasing Organization; December 30, 1948)

Producer David O. Selznick *Associate Producer* David Hampstead *Director* William Dieterle *Screenplay* Paul Osborn, Peter Berneis, David O. Selznick *Prologue* Ben Hecht *Adaptation* Leonard Bercovici *Based on the Novel by* Robert Nathan *Cinematographers* Joseph August, Lee Garmes, Paul Eagler *Musical Score* Dimitri Tiomkin *Musical Themes* "Arabesques One and Two," "Clouds," "Prelude to the Afternoon of a Faun," "The Maid with the Flaxen Hair" Claude Debussy *Supervising Film Editor* William Morgan *Film Editor* Hal C. Kern, Sr. *Associate Film Editor* Gerald J. Wilson *Sound Editor* Charles L. Freeman *Sound Supervisor* James G. Stewart *Dubbing Mixer* Fred Hynes *Production Manager*

W. Argyle Nelson, Sr. *Production Associate* Don Downs *Production Designer* Joseph McMillan Johnson *Associate Production Designer* Joseph B. Platt *Set Decorator* Claude Carpenter *Assistant Director* Arthur Fellows *Makeup* Mel Berns *Hairdressing* Larry Germain *Costume Designer* Anna Hill Johnstone *Assistant Costume Designer* Lucinda Ballard *Production Assistant* Peter Scoppa *Publicity Supervisor* Paul MacNamara *Casting* Ruth Burch *Jennie's Portrait* Robert Brackman *Production Executive* Daniel O'Shea *Camera Operator* Arthur E. Arling *Story Editor* Margaret McDonnell *Unit Manager* Clem Beauchamp *Music Consultant* Bernard Herrmann *Scenario Assistant* Lydia Schiller *Production Mixer* Don McKay *Production Cooperation* Metropolitan Museum of Art *Special Effects Director* James G. Stewart *Special Effects Cinematographer* Paul Eagler *Special Effects Engineer* Russell Shearman *Matte Artist* Joseph McMillan Johnson *Process Cinematography* Clarence W.D. Slifer

A David O. Selznick Productions Inc. Presentation. A Vanguard Films Production. Made at The Selznick Studio and on location in New York City and Boston. Copyright March 29, 1949 by Vanguard Films Inc. Cycloramic Screen. Technicolor. Western Electric Mirrophonic Recording. Cylcophonic Sound. 86 minutes.

The Players: *Eben Adams* Joseph Cotten *Miss Spinney* Ethel Barrymore *Matthews* Cecil Kellaway *Jennie Appleton* Jennifer Jones *Mrs. Jekes* Florence Bates *Mrs. Bunce* Esther Somers *Gus O'Toole* David Wayne *Moore* Albert Sharpe *Policeman* John Farrell *Old Doorman* Felix Bressart *Clara Morgan* Maude Simmons *Mother Mary of Mercy* Lillian Gish *Capt. Caleb Cobb* Clem Bevans *Old Mariner* Robert Dudley *Eke* Henry Hull *Teenager* Ann Francis

Additional Oscar Nominations: *Cinematography — Black-and-White* (Joseph August)

Note: Director of photography Joe August died of a heart attack while on location in New York, and Lee Garmes and Paul Eagler completed the production without credit. The story's main action was in black-and-white with some sequences in sepia, the storm sequence in green, and the last scene and end titles in full color. During the storm sequence selected theaters employed a stereophonic surround sound system. These theaters also utilized the Magnascope projection lens and enlarged the same scenes over a very large screen. Though not actually copyrighted until 1949, a notice of registration was filed in 1948.

1949

Special Effects Nominations

Mighty Joe Young Willis H. O'Brien,
 (Cooper, RKO Radio) Harold Stine, Bert Willis†
Tulsa (Wanger, Eagle-Lion) John P. Fulton

Scientific or Technical Awards

Class III M.B. Paul
For the first successful large-area seamless translucent backgrounds

Class III Herbert Britt
For the development and application of formulas and equipment producing artificial snow and ice for dressing motion picture sets

Comments

Tulsa was the story of a tough woman wildcatter, and as spectacular as it was with its Technicolor oilfield fire and various miniatures, it just couldn't match *Mighty Joe Young*, the adventures of a teenage girl who raised a gigantic gorilla that becomes a popular night club attraction. *Mighty Joe Young*'s Special Effects were designed by *King Kong*'s technical genius Willis O'Brien, and they were topnotch. The extraordinary models, matte art, and opticals worked almost perfectly. The synced stop-motion animation brought Joe to vivid life. (Unfortunately, the trained eye could occasionally catch reflections of miniatures on the glass mattes.) There were even zoom shots involving mattes and process projection. The climactic fire sequence kept even the most coldhearted patron on the edge of their seat as Joe saved a baby from the blazing inferno. O'Brien, who labored long and hard in the effects field, never received the recognition he deserved within the industry. This was probably due to the fact that he never headed a studio effects department and his most notable work was done during a period when the Academy was not honoring Special Effects. Strangely, neither of this year's features received audio nominations, yet both employed unusual sound effects, especially during their more violent scenes.

†Current Academy publications credit Willis O'Brien only as recipient of the Oscar, but material published in 1950 also listed Harold Stine and Bert Willis as winners.

Credits

Mighty Joe Young
(RKO Radio; July 30, 1949)

Producers John Ford, Merian C. Cooper *Director* Ernest B. Schoedsack *Screenplay* Ruth Rose Schoedsack *Story* Merian C. Cooper *Cinematographer* J. Roy Hunt *Musical Score* Roy Webb, Max Steiner *Musical Director* Constantin Bakaleinikoff *Song "Beautiful Dreamer"* Stephen Foster *Film Editor* Ted Cheesman *Sound Editor* Walter G. Elliott *Art Director* James Basevi *Assistant Art Director* Howard Richmond *Set Decorator* George Altwills *Costume Supervisor* Adele Balkan *Unit Production Manager* Lloyd Richards *Assistant Director* Samuel Ruman *Script Supervisor* Ellen Corby *Lion Stunt Coordinator* Mel Koontz *Sound Supervisor* John O. Aalberg *Production Mixer* John L. Cass *Dubbing Mixers* Clem Portman, Earl Mounce *Visual Effects Designer and Director* Willis H. O'Brien *Stop Motion Animator* Ray Harryhausen *Second Stop Motion Animator* Peter Peterson *Stop Motion Technicians* Marcel Delgado, George Lofgren, Harry Cunningham *Matte Artists* Fitch Fulton, Louis Lichtenfield, Jack Shaw *Visual Effects Cinematographers* Harold Stine, Bert Willis *Optical Cinematography* Linwood G. Dunn *Mechanical Effects* Jack Lannon

A John Ford-Merian C. Cooper Presentation. An ARKO Production. Made at RKO Radio Studios. Copyright July 13, 1949 by ARKO Inc. Color Tint. RCA Photophone Recording. 94 minutes.

The Players: *Jill Young* Terry Moore *Gregg Johnson* Ben Johnson *Max O'Hara* Robert Armstrong *Mr. Joseph Young* Himself *Windy* Frank McHugh *First Drunk* Douglas V. Fowley *Crawford* Dennis Green *Second Drunk* Paul Guilfoyle *Third Drunk* Nestor Paivia *John Young* Regis Toomey *Jill as a Child* Lora Lee Michael *Sgt. Joe Schultz* James Flavin *Truck Driver* Jack Pennick *Gas Station Attendant* William Schallert *Man at Bar* Charles Lane *Woman at Bar* Irene Ryan *Night Club Patrons* Selmer Jackson, Addison Richards, Iris Adrian *Patron Attacked by Lion* Mel Koontz *Cowboys* Edwin Parker, Dale Van Sickel *Orphanage Matron* Ellen Corby *Sammy Stein* Himself *Killer Karl Davis* Himself *Rasputin the Mad Russian* Ivan Rasputin *Bomber Kukly* Henry Kuklovitch *Slammin' Sammy Menaker* Himself *Max the Ironman* Max Batchelor *Wee Willie Davis* William Davis *Mountain Dean* Frank S. Leavitt *The Swedish Angel* Phil Olafsson *Primo Carnera* Himself *Stuntmen* Dale Van Sickel, Edwin Parker, Mel Koontz

Note: Working titles were *Mr. Joseph Young of Africa* and *The Great Joe Young*. A purposed sequel, *Tarzan Meets Mighty Joe Young*, was shelved after the box

office failure of this outing. ARKO Inc. was a joint venture of Argosy Pictures Corporation and RKO Radio Pictures Inc. It was deactivated after this production. Though given a single-card screen credit, Mr. Joseph Young was, of course, a stop-motion model. Max Steiner did not work on the score, but many of his themes were incorporated into it.

The orphanage sequence was tinted red.

Tulsa

(Eagle-Lion Films Inc.; April 13, 1949)

Executive Producer Edward Lasker *Producer* Walter Wanger *Director* Stuart Heisler *Screenplay* Frank S. Nugent, Curtis Kenyon *Story* Richard Wormser *Cinematographer* Winton C. Hoch *Musical Score* Frank Skinner *Musical Conductor* Charles Previn *Musical Director* Irving Friedman *Film Editor* Terrill O. Morse *Production Mixer* Howard Fogetti *Art Director* Nathan Hertz Juran *Set Decorators* Armor Marlowe, Al Orenbach *Costume Designer* Herschel McCoy *Orchestration* David Tamkin *Technicolor Director* Natalie Kalmus *Technicolor Consultant* Richard Mueller *Makeup* Ern Westmore, Del Armstrong *Hairdressing* Joan St. Oegger, Helen Turpin *Assistant Director* Howard W. Koch, Sr. *Production Supervisor* James T. Vaughn *Title Song* Allie Wrubel, Mort Green; *Vocal* Chill Wills *Special Effects* John P. Fulton

A Walter Wanger Pictures Inc. Presentation. A Walter Wanger–Edward Lasker Production. Made at Eagle-Lion Studios and on location in Southern California. Copyright April 13, 1949 by Pathe Industries Inc. Technicolor. RCA Photophone Recording. 90 minutes.

The Players: *Cherokee Lansing* Susan Hayward *Brad Brady* Robert Preston *Jim Redbird* Pedro Armendariz, Sr. *Bruce Tanner* Lloyd Gough *Pinky Jimson* Chill Wills *Crude Johnny Brady* Ed Begley, Sr. *Homer Triplette* Jimmy Conlin *Steve Roland* Jack *Nelse Lansing* Harry Shannon *Tooley* Paul E. Burns *Charlie Lightfoot* Chief Yowlachie *Winters* Pierre Watkin *Taxi Driver* Tom Dugan *Kelly* Lane Chandler *Candy Williams* Lola Albright *Osage* Iron Eyes Cody *Joker* Dick Winslow *Oilmen* John Dehner, Selmer Jackson *Oil Worker* Fred Graham *Governor* Larry Keating *Judge McKay* Joseph Crehan *Man with Newspaper* Nolan Leary *Winslow* Thomas Browne Henry

Note: Copyright registration in notice in 1948.

1950

Special Effects Nominations

Destination Moon . Lee Zavitz
 (Pal, Eagle-Lion)
Samson and Delilah Gordon Jennings
 (De Mille, Paramount)

Comments

A group of entrepreneurs backed the first manned moon flight and landing in George Pal's prophetic *Destination Moon*. The effects were realistic enough, the only unusual aspect being the employment of stop-motion animation in the sequence involving repair of the spaceship during flight. Otherwise all work was standard matte paintings and miniatures. Wire rigging was utilized for weightlessness segments.

The Biblical epic *Samson and Delilah* used De Mille's Holy Land photography via both traveling matte and rear screen to expand the soundstage-bound principal photography. The spectacular climax with Samson toppling the great temple god was exceptionally well executed. It employed a very large miniature with optically inserted people. There were some noticable matte bleeds, but the sequence was quite impressive.

Both features were photographed in Technicolor and were handsomely mounted. Neither was cited for sound effects.

Credits

Destination Moon
(Eagle-Lion; August 1950)

Executive Producer Peter Rathvon *Producer* George Pal *Director* Irving Pichel *Screenplay* Alford "Rip" Van Ronkel, Robert A. Heinlein, James O'Hanlon *Based on the Novel* Rocket Ship Galileo *by* Robert A. Heinlein *Cinematographer* Lionel Lindon *Musical Score* Leigh Stevens *Film Editor* Duke Goldstone *Production Mixer* William Lynch *Woody Woodpecker Cartoon* Walter Lantz Productions, Inc. *Production Supervisor* Martin Eisenberg *Assistant Director* Harold

Godsoe *Production Designer* Ernest Fegte *Assistant Art Director* Jerome Pycha *Set Decorator* George Sawley *Spacecraft Designers* Chesley Bonestell, Robert A. Heinlein *Technicolor Consultant* Robert Brower *Makeup* Webster Philips *Orchestration* David Torbet *Technical Advisers* Herman Oberth, Robert A. Heinlein, Chesley Bonestell, Dr. Robert S. Richardson *Still Photographer* Madison Lacey *Script Supervisor* Cora Palmatier *Visual Effects Technical Supervisor* John S. Abbott *Visual Effects Technicians* Miles E. Pike, Dale Tholen *Stop Motion Animator* Fred Madison *Matte Artist* Chesley Bonestell *Mechanical Effects Supervisor* Lee Zavitz *Mechanical Effects Technician* Herman Townsley

A George Pal Productions Inc. Presentation. Made at General Service Studios and on location in Apple Valley, Mojave, California. Copyright August 1, 1950 by George Pal Productions Inc. Technicolor. Western Electric Movietone Recording. 91 minutes.

The Players: *Jim Barnes* John Archer *Dr. Charles Cargraves* Warner Anderson *Gen. Thayer* Tom Powers *Joe Sweeney* Dick Wesson *Emily Cargraves* Erin O'Brien-Moore *Brown* Ted Warde *Scientist* Mike Miller *Voice Characterization for Woody Woodpecker* Grace Stafford Lantz

Additional Oscar Nomination: *Art Direction-Set Decoration — Color* (Ernest Fegte, George Sawley)

Note: Pal later produced a semi-sequel, *Conquest of Space* (Paramount, 1955).

Samson and Delilah

(Paramount; October 21, 1949)

Producer and Director Cecil B. De Mille *Associate Producer* Henry Wilcoxon *Screenplay* Jesse L. Lasky, Jr., Fredric M. Frank *Adaptation* Harold Lamb *Based on the Novel* Judge and Fool *by* Vladimir Jabotinsky; and Judges 13–16 in The Old Testament *Cinematographer* George Barnes *Holy Land Cinematography* Dewey Wrigley *Musical Score* Victor Young *Film Editor* Anne Bauchens *Assistant Director* Edward Salven *Second Assistant Director* Francisco Day *Technicolor Director* Natalie Kalmus *Technicolor Consultant* Robert Brower *Unit Publicists* Richard Condon, Phil Koury *Second Unit Directors* Arthur Rosson, Ralph Jester *Art Directors* Hans Dreier, Walter Tyler *Set Decorators* Sam Comer, Ray Moyer *Property Master* Joe Thompson *Choreography* Theodore Kosloff *Dialogue Coaches* Frances Dawson, James Vincent *Costume Designers* Edith Head, Gus Peters, Gile Steele, Dorothy Jeakins, Gwen Wakeling, Elois Jenssen *Makeup* Wally Westmore, Harold Lierly, William Wood *Hairdressing* Nellie Manley *Research* Henry S. Noerdlinger, Gladys Percy *Unit Production Manager* Roy Burns *Production Assistants* Donald Hayne, Donald MacLean *Sound Supervisor*

Loren L. Ryder *Production Mixer* Harry Lindgren *Dubbing Mixers* John Cope, George Dutton, Gene Garvin *Production Secretary* Gladys Rosson *Producer-Director's Secretaries* Berenice Mosk, Florence Cole *Production Illustrator* Dan Sayre Groesbeck *Casting* Joe Egli *Stunt Coordinator* Ed Hinton *Lion Stunt Coordinator* Mel Koontz *"Song of Delilah"* Victor Young, Ray Evans, Jay Livingston *Camera Operators* Arthur A. Lane, Archie R. Dalzell *Assistant Cameramen* James Hawley, Edward Wahrman *Special Effects Director* Gordon Jennings *Special Effects Cinematographer* J. Devereaux Jennings *Matte Cinematography* Irmin Roberts *Matte Artist* Jan Domela *Optical Cinematography* Paul K. Lerpae *Process Cinematography* Farciot Edouart, W. Wallace Kelley *Motion Control Engineering* S.L. Stancliffe, Jr., Frank Butler

A Cecil B. De Mille Productions Inc. Picture. Made at Paramount Studios and on location in the Holy Land and Southern California. Copyright October 25, 1949 by Paramount Pictures Inc. Technicolor. Western Electric Movietone Recording. 131 minutes.

The Players: *Samson* Victor Mature *Delilah* Hedy Lamarr *Saran of Gaza* George Sanders *Semadar* Angela Lansbury *Ahtur* Henry Wilcoxon *Miriam* Olive Deering *Hazeleponit* Fay Holden *Hisham* Julia Faye *Saul* Russell (Russ) Tamblyn *Tubal* William Farnum *Teresh* Lane Chandler *Targil* Moroni Olsen *Storyteller* Francis J. McDonald *Garmiskar* William "Wee Willie" Davis *Lesh Lakish* John Miljan *Fat Philistine Merchant* Arthur Q. Bryan *Spectators* Laura Elliot, Jeff York, Bert Moorhouse, Margaret Field, John Kellogg, Dorothy Adams *Lord of Ashdod* Victor Varconi *Lord of Gath* John Parrish *Lord of Ekron* Frank Wilcox *Lord of Ashkelon* Russell Hicks *Priests* Boyd Davis, Fred Graham, Pierre Watkin *Lord Sharif* Fritz Leiber *Lead Philistine Soldier* Mike Mazurki *Merchant Prince* Davidson Clark *Wounded Messenger* George Reeves *Bar Simon* Pedro de Cordoba *Village Barber* Frank Reicher *Princes* Colin Tapley, Nils Asther, James Craven, Harry Cording *Danite Merchant* Charles Judels *Manoah* Charles Evans *Chief Scribe* Lloyd Whitlock *Court Astrologer* Crauford Kent *Gristmill Overseer* Ray Bennett *Saran's Charioteer* Henry Wills *Midget at Arena* Charles Dayton *Gammad* Harry Woods *Bergam* Stephen Roberts *Makon* Ed Hinton *Gristmill Captain* Tom Tyler *Sword Dancers* George Zoritch, Hamil Petroff *Master Architect* Frank Mayo *Slave* Carl Saxe *High Priest* Charles Meredith *Man with Burro* John "Skins" Miller *Saddlemaker* Lester Sharpe *Tax Collectors* Edgar Dearing, Hugh Prosser *Assistant Tax Collector* John Merton *Villager* Al Ferguson *Soldier* Fred Kohler, Jr. *Temple Dancer* Brahm van den Berg *Courier* Eric Alden *Vendor* Robert Kortman *Merchant* Philo McCullough *Captain Killed by Jawbone* Ted Mapes *Narrator* Cecil B. De Mille *with* Karen Morley, Gertrude Messenger, Betty Boyd, Betty Farrington, Claire DuBrey, Greta Grandstedt, Byron Fougler, Stanley Blystone, Crane Whitley, Kenneth Gibson, Frank Mayo, Robert St. Angelo, Wheaton Chambers, Paul Scardon, Gordon Richards, Edward Peil, Sr., James Horne, Ottola Nesmith, Ynez Seabury

Additional Oscar Nominations: *Cinematography — Color* (George Barnes); *Art Direction-Set Decoration — Color* (Hans Dreier, Walter Tyler, Sam Comer, Ray Moyer)*; *Costume Design — Color* (Edith Head, Dorothy Jeakins, Elois Jenssen, Gile Steele, Gwen Wakeling)*; *Music — Scoring of a Dramatic or Comedy Picture* (Victor Young)

Note: Previously made as *Samson und Delila: Der Roman einer Opernsangerin* (Adria, 1922). Remade in 1983 by Comworld/Catalina.

1951

Special Effects *(now classified as an "other" award, not necessarily given each year, hence no nominations):*

When Worlds Collide Gordon Jennings, Paul K.
(Pal, Paramount) Lerpae, J. Devereaux Jennings,
Irmin Roberts, Harry Barndollar, Jan
Domela, Chesley Bonestell, Ivyl Burks†

Scientific or Technical Awards

Class II Gordon Jennings, S.L. Stancliffe
and the Paramount Studio Special Photo-
graphic and Engineering Departments
For the design, construction and application of a servo-
operated recording and repeating device

Class III Fred Ponedel, Ralph Ayres
and George Brown of Warner Bros. Studio
For an air-driven water motor to provide flow, wake and white
water for marine sequences in motion pictures

Class III Jack Gaylord and the MGM
Studio Construction Department
For the development of balsa falling snow

Comments

For the next few years the Academy reclassified the Special Effects
Oscar, making it a noncompetitive category. This year, George Pal's *When
Worlds Collide* was deemed recipient. Most of the illusions were quite good,
especially the destruction segments; but the miniatures always appeared to
be just that. It should be noted that the bad matte painting that concludes
the picture was never intended to be used. It was quickly produced to
demonstrate to the Paramount executives how the story would wrap up, but
the studio hierarchy felt it was good enough to be utilized as was and the test
footage was left intact despite protests from Pal. Again this year the sound
effects were not included in the award even though of vast importance.

†Current Academy publications list only Gordon Jennings as Oscar winner but con-
temporary material included all of the above names.

Credits

When Worlds Collide

(Paramount; August 1951)

Producer George Pal *Director* Rudolph Mate *Screenplay* Sydney Boehm *Based on the Novel by* Edwin Balmer, Philip Wylie *Cinematographers* John F. Seitz, W. Howard Greene *Musical Score* Leith Stevens *Supervising Film Editor* Doane Harrison *Film Editor* Arthur Schmidt *Supervising Sound Editor* Tommy Middleton *Technical Adviser* Chesley Bonestell *Art Directors* Hal Pereira, Albert Nozaki *Set Decorators* Sam Comer, Ross Dowd *Technicolor Consultant* Robert Brower *Costume Supervisor* Edith Head *Makeup* Wally Westmore *Hairdressing* Nellie Manley *Producer's Secretary* Gae Griffith *Sound Supervisor* Loren L. Ryder *Production Mixer* Eugene Merritt *Dubbing Mixers* Walter Oberst, George Dutton, Gene Garvin *Special Effects Directors* Gordon Jennings, Harry Barndollar *Special Effects Cinematographer* J. Devereaux Jennings *Optical Cinematography* Paul K. Lerpae *Miniature Supervisor* Ivyl Burks *Process Cinematography* Farciot Edouart *Matte Supervisor* Irmin Roberts *Matte Artists* Jan Domela, Chesley Bonestell

A George Pal Production. Made at Paramount Studios. Copyright November 1, 1951 by Paramount Pictures Corporation. Technicolor. Western Electric Movietone Recording. 83 minutes.

The Players: *Dave Randall* Richard Derr *Joyce Hendron* Barbara Rush *Tony Drake* Peter Hanson *Sydney Stanton* John Hoyt *Dr. Cole Hendron* Larry Keating *Julie Cummings* Judith (Rachel) Ames *Dr. Dean George Frey* Stephen Chase *Harold Ferris* Frank Cady *Dr. Emery Bronson* Hayden Rorke *Dr. Ottinger* Sandro Giglio *Students* Mary Murphy, Kirk Alyn, Robert Chapman, Charmienne Harker, Walter Kelley, Chad Madison, Dolores Mann, Robert Sully, Richard Vath, Kip (Stuart) Whitman *Stewardess* Laura Elliot *Announcer* Paul Frees *Eddie Garson* Jim Congdon *Alice* Frances Sanford *Rudolph Marston* Freeman Lusk *Glen Spiro* Joseph Mell *Head Waiter* Marcel de la Brosse *Matron with Cigarette* Queenie Smith *Paul* Art Gilmore *Stanley* Keith Richards *Leda* Gay Nelson *Mike* Rudy Lee *Chief Inspector* John Ridgley *Donovan* James Seay *Dr. Zenta* Harry Stanton *Travelers* Sam Finn, Gertrude Astor, Estelle Etterre *Indian Chairman* Hassan Khayyam *Clerk* Bill Meader *Frenchman* Ramsay Hill *Newsvendor* Gene Collins

Additional Oscar Nomination: *Cinematography — Color* (John F. Seitz, W. Howard Greene)

Note: After Worlds Collide, the sequel novel, was proposed for filming but never made. The original novel had been purchased for Cecil B. De Mille.

1952

Special Effects

Plymouth Adventure A. Arnold Gillespie
(MGM)

Scientific or Technical Award

Class III Projection, Still Photographic
and Development Engineering
Departments of MGM Studios
For an improved method of projecting photographic backgrounds

Comments

MGM's *Plymouth Adventure* told of the seventeenth-century journey of the Pilgrims to Massachusetts. It included Ansco Color matte and process work along with a great deal of model marine footage, notably a massive storm-at-sea. The howling winds and other noises were not acknowledged with an audible effects award.

Credits

Plymouth Adventure
(Metro-Goldwyn-Mayer; November 28, 1952)

Producer Dore Schary *Director* Clarence Brown *Screenplay* Helen Deutch *Based on the Novel by* Ernest Gabler *Cinematographer* William Daniels *Musical Score* Miklos Rozsa *Film Editor* Robert J. Kern *Sound Supervisor* Douglas Shearer *Assistant Sound Supervisor* Wesley C. Miller *Art Directors* Cedric Gibbons, Urie McCleary *Set Decorators* Edwin B. Willis, Hugh Hunt *Costume Designer* Walter Plunkett *Makeup* William Tuttle *Hairdressing* Sydney Guilaroff, Mary Keats *Second Unit Director* James C. Havens *Assistant Director* Ridgeway Callow *Technicolor Consultant* Henri Jaffa *Color Consultant* Alvord Eisenman *Special Effects Supervisors* A. Arnold Gillespie, Warren Newcombe *Special Effects Cinematographer* Irving G. Ries *Miniature Supervisor* Donald Jahraus *Miniature Cinematographers* Maximillian Fabian, Harold Lipstein *Process Cinematography* Carroll L. Shepphird.

A Loew's Inc. Production. Made at MGM Studios. Copyright October 15, 1952 by Loew's Inc. Color by Ansco and Technicolor. Print by Technicolor. Western Electric Movietone Recording. 105 minutes.

The Players: *Capt. Christopher Jones* Spencer Tracy *Dorothy Bradford* Gene Tierney *John Alden* Van Johnson *William Bradford* Leo Genn *Coppin* Lloyd Bridges *Priscilla Mullins* Dawn Adams *William Brewster* Barry Jones *Miles Standish* Noel Drayton *Gilbert Winslow* John Dehner *William Putton* Tommy Ivo *Edward Winslow* Lowell Gilmore *Men* Rhys Williams, Damian O'Flynn, Keith McConnell, Owen McGiveney, Paul Cavanagh, Murray Matheson, David Sober, Roger Broaddus, Hugh Pryse, James Logan, Gene Coogan, Matt Moore, John Dierkes *Women* Iris Goulding, Elizabeth Flournoy, Kathleen Lockhart, Kay English

Note: Visual effects shot in Ansco color with principal photography in Technicolor. Remade as *Mayflower: The Pilgrims' Adventure* (1979).

1953

Special Effects

The War of the Worlds Gordon Jennings, W.
(Pal, Paramount) Wallace Kelley, Paul K. Lerpae,
Irmin Roberts, Jan Domela,
Chesley Bonestell, Ivyl Burks,
George Ulrick, Lee Vasque
Audible: Loren L. Ryder, George Dutton,
Louis Mesenkop, William Andrews†

Comments

George Pal Productions grabbed another Oscar this year. *The War of the Worlds* is probably their most popular feature and one of the classics in many areas. After its completion, Paramount realized they had a winner and went all-out with the advertising, including a very large television campaign. It was decided to crop the frame slightly in first run engagements to give a wide screen look of 1.47 × 1; and the already completed soundtrack was converted to "Multi-Track Stereo" and boosted with additional audio effects. This helped immensely at the box office. What was made as a moderately budgeted general release item became a Class A product. The trick work was very good throughout, with little use of rear screens. Traveling mattes were employed extensively. The miniatures were larger than usual and well crafted, with excellent motion control via a very complex wire system. Cartoon animation was utilized in several shots. The pyrotechnics were impressive and the sound effects enhanced the visuals very well. It should be noted that all current release prints are dupes by Opticals West and do not have the sharpness nor clarity of the original Technicolor version. These new Eastman Color prints, because they were reproduced from an old release print and not from the Technicolor master, have a very limited "grey range." Consequently the grey motion control guide wires supporting the Martian assault craft are now black and very noticeable in all scenes. This was not the case with the original IB prints and has led recent viewers to think less of the Special Effects. Regrettably, current prints are available only with a monophonic soundtrack, another subtraction of the original quality.

†While all of the above appeared in contemporary Academy material, their current official publications credit only Gordon Jennings as Oscar recipient.

Credits

The War of the Worlds
(Paramount; February 1953)

Executive Producer Don Hartman *Producer* George Pal *Associate Producer* Frank Freeman, Jr. *Director* Byron Haskin *Screenplay* Barre Lyndon *Based on the Novel by* H.G. Wells *Cinematographer* George Barnes *Musical Score* Leith Stevens *Film Editor* Everett Douglas *Supervising Sound Effects Editor* Tommy Middleton *Sound Effects Editors* Lovell Norman, Howard Beals *Art Directors* Hal Pereira, Albert Nozaki *Set Designer* Teal Senter *Set Decorators* Sam Comer, Emile Kuri *Assistant Director* Michael Moore *Costume Designer* Edith Head *Makeup* Wally Westmore *Martian Makeup* Charles Gemora *Hairdressing* Nellie Manley *Technicolor Consultant* Monroe W. Burbank *Technical Advisers* Chesley Bonestell, Dr. Robert C. Richardson *Producer's Secretary* Gae Griffith *Executive Production Manager* Frank Caffey *Unit Production Manager* C. Kenneth DeLand *Sound Supervisor* Loren L. Ryder *Production Mixer* Harry M. Lindgren *Dubbing Mixers* Gene Garvin, Don Johnson, Walter Oberst, George Dutton, Louis H. Mesenkop, William Andrews *Property Supervisor* Gordon Cole *Gaffer* Soldier Graham *Assistant Cameraman* Edward Wahrman *Visual Effects Supervisor* Gordon Jennings *Visual Effects Cinematographer* W. Wallace Kelley *Matte Cinematography* Irmin Roberts *Optical Cinematography* Paul K. Lerpae *Process Cinematography* Farciot Edouart *Matte Artists* Jan Domela, Chesley Bonestell *Optical Printers* Jack Caldwell, Aubrey Law *Miniature Supervisor* Ivyl Burks *Modeller* Albert Silva *Mechanical Effects Supervisor* Walter Hoffman *Mechanical Effects Foremen* George Ulrick, Lee Vasque *Mechanical Effects Technicians* Marcel Delgado, Milt Olsen, Charles Davis, Romaine Brickmeyer, Chester Pate, Bob Springfield, Eddie Sutherland

A George Pal Production. Made at Paramount Studios and on location in Phoenix, Arizona. Copyright October 1, 1953 by Paramount Pictures Corporation. Panoramic Screen. Technicolor. Western Electric Movietone Recording. Multi-Track Stereophonic Sound. 85 minutes.

The Players: *Prof. Clayton Forrester* Gene Barry *Sylvia van Buren* Ann Robinson *Gen. Mann* Les Tremayne *Dr. Pryor* Robert Cornthwaite *Dr. Bilderbeck* Sandro Giglio *Rev. Matthew Collins* Lewis Martin *Captain Aide to Gen. Mann* Housley Stevenson, Jr. *Radio Announcer; Reporter; and Prologue Narrator* Paul Frees *Wash Perry* Bill Phipps *Col. Ralph Hefner* Vernon Rich *Sheriff Bogany* Walter Sande *Salvatore* Jack Kruschen *Dr. Gratzman* Ivan Lebedeff *Dr. DuPrey* Ann Codee

Dr. James Hettinger Alex Frazer *Zippy* Alvy Moore *Alonzo Hogue* Paul Birch *Fiddler Hawkins* Frank Kreig *Ranger* Robert Rockwell *Martian* Charles Gemora *Commentator* Cedric Hardwicke *Policeman* Henry Brandon *Television Commentator* Gabriel Heater *Brunt Soldier* Mushy Callahan *Prof. McPherson* Edgar Barrier *Buck Monahan* Ralph Dumke *Bird-Brained Blonde* Carolyn Jones *Men* Pierre Cressoy, John Mansfield *Well-Dressed Man During Looting* Ned Glass *Military Police Driver* Anthony Warde *Newsvendor* Gertrude Hoffman *Secretary of Defense* Freeman Lusk *Fire Chief* Sydney Mason *Look-Out* Peter Adams *KGEB Reporter* Ted Hecht *Japanese Diplomat* Teru Shimada *Chief of Staff* Herbert Lytton *Marine Staff Sergeant* Dougals Henderson *Looters* David Sharpe, Dale Van Sickel, Fred Graham *First Reporter* Walter Richards *Rev. Bethany* Russell Conway *First Bum Listening to Radio* George Pal *Second Bum Listening to Radio* Frank Freeman, Jr. *Young Wife* Nancy Hale *Girl* Virginia Hall *Doctor* John Maxwell *Australian Policeman* Cliff Clark *Spanish Priest* Edward Colmans *Deacon* Jameson Shade *Minister* David McMahon *Staff Colonel* Don Kohler *Cub Reporter* Morton C. Thompson *Red Cross Official* Ralph Montgomery *Second Reporter* Jerry James *Huge Man* Bud Wolfe *Civil Defense Official* James Dundee *Military Policeman* Joel Marston *Little Girl* Patricia Iannone *P.E. Official* Bill Meader *Police Chief* Al Ferguson *Big Guy* Eric Alden *Boys* Rudy Lee, Waldon Williams *Elderly Man* Gus Taillon *Mother* Ruth Barnell *Elderly Woman* Dorothy Vernon *Brigadier General* Hugh Allan *Marine Major* Stanley W. Orr *Marine Sergeant* Martin Coulter *Marine Lieutenant* Freddie Zendar *Marine Commanding Officer* Jim Davies *Marine Captains* Dick Fortune, Charles J. Stewart *Cameraman* Edward Wahrman *Screaming Woman* Hazel Boyne *Old Lady* Cora Shannon *Young Man* Mike Mahoney

Additional Oscar Nominations: *Sound Recording* (Paramount Sound Department, Loren L. Ryder); *Film Editing* (Everett Douglas)

Note: Advertised as *H.G. Wells' The War of the Worlds*. Copyright registration put in notice in 1952. A Paramount Television remake went into production in the late '70s but was never completed. Remade as *War of the Worlds — Next Century* (Film Polski, 1981).

1954

Special Effects Nominations

Hell and High Water Ray Kellogg
(20th Century–Fox)

Them! . Ralph Ayres
(Warner Bros.)

*Jules Verne's *Twenty Thousand
Leagues Under the Sea* Ralph Hammeras,
(Walt Disney Studios) Ub Iwerks†

Scientific or Technical Awards

Class III David S. Horsley and the
Universal-International Studio
Special Photographic Department
For a portable remote control device for process projectors

Class III . Fred Knoth and Orien
Ernest of the Universal-International
Studio Technical Department
For the development of a hand portable, electric, dry oil-fog
machine

Comments

After three years of no Special Effects nominations the Academy
reclassified the award category and returned it to its pre–1951 status.

This year's winner was Disney's first major Hollywood live action
feature and one of their most successful ventures: *Twenty Thousand Leagues
Under the Sea*. The studio went all-out with the latest technical innovations —
CinemaScope, color, and stereophonic sound — and turned out a top-drawer
sci-fi fantasy adventure with incredible attention to detail and atmosphere.
The matte art and miniatures were perfect; the mechanical devices were ex-
traordinary. The only flaw was some noticably bad blue screen work in the
shipboard scenes. Strangely, Ub Iwerks, who supervised these shots, re-
ceived the Oscar. The other visual and mechanical artisans went uncredited.

†While all information now published by the Academy states that Ub Iwerks received
the Oscar, material published in 1955 listed Ralph Hammeras as the recipient.

It has been re-issued several times in a slightly re-edited version and unfortunately always with monophonic sound.

Hell and High Water had many things in common with the Disney production: 'scope, color, stereo sound and submarines. Its tale of cold war countries almost coming to hot war was well executed, with good matte and model work.

Them! was one of the best sci-fi horror entries made, yet its release showed no pride on the part of the studio. Its story of gigantic radioactive-evolved ants employed no photographic trickery, opting instead for the use of full-size mechanical props. These were excellent, and the whole was backed with an electronic-based sound effects track. Warner Bros. blew their opportunity to really showcase this picture. Had they been more realistic and gauged the box office potential better, they could have given its release the attention a quality production deserved.

There were no sound effects nominations this year.

Credits

Hell and High Water
(20th Century–Fox; February 1954)

Producer Raymond A. Klune *Director* Samuel Fuller *Screenplay* Jesse L. Lasky, Jr., Samuel Fuller *Story* David Hampstead *Cinematographer* Joseph Mac-Donald *Musical Score* Alfred Newman *Film Editor* James B. Clark *Art Directors* Lyle R. Wheeler, Leland Fuller *Set Decorators* Walter M. Scott, Stuart A. Reiss *Assistant Director* Ad Schaumer *Costume Designer* William Travilla *Costume Supervisor* Charles LeMaire *Makeup* Ben Nye *Color Consultant* Leonard Doss *Orchestration* Edward B. Powell *Special Lyrics* Harry Powell *Sound Supervisor* Carlton W. Faulkner *Production Mixer* Eugene Grossman *Dubbing Mixer* Roger Heman *Special Effects Supervisor* Ray Kellogg *Special Effects Cinematographers* L.B. Abbott, Walter Castle, James B. Gordon *Matte Artist* Emil Kosa, Jr.

Made at 20th Century–Fox Studios. Copyright July 7, 1954 by 20th Century–Fox Film Corporation. CinemaScope. Color by Technicolor. Prints by Technicolor and De Luxe. Western Electric Movietone Recording. Stereophonic Sound. 103 minutes.

The Players: *Cmdr. Adam Jones* Richard Widmark *Denise Gerard* Bella Darvi *Prof. Montel* Victor Francen *Ski Brodski* Cameron Mitchell *Crew Chief Holter* Gene Evans *Tugboat Walker* David Wayne *Neuman* Stephen Bekassy *Fujimori* Richard Loo *Happy Mosk* Peter Scott *Gunner McGrossin* Henry Kulky *Chin Lee*

Wong Artarne *Quartermaster* Harry Carter *Welles* Robert Adler *Carpino* Don Orlando *Soto* Rollin Moriyama *Torpedo* John Gifford *Ho-sin* William Yip *Crewman* Tommy Walker *Aylesworth* Leslie Bradley *Col. Schuman* John Wengraf *McAuliff* Harry Denny *Taxi Driver* Edo Mita *Lieutenant* Ramsey Williams *Reporter* Robert B. Williams *Photographer* Harlan Warde *Bit* Neyle Morroro

Them!

(Warner Bros.; June 19, 1954)

Producers David Weisbart, Ted Sherdeman *Director* Gordon Douglas *Screenplay* Ted Sherdeman *Adaptation* Russell Hughes *Story* George Worthing Yates *Cinematographer* Sidney Hickox *Musical Score* Bronislau Kaper *Musical Director* Ray Heindorf *Film Editor* Thomas Reilly *Art Director* Stanley Fleischer *Set Designer* Edward Held *Set Decorator* G.W. Bernstein *Makeup* Gordon Bau *Orchestration* Robert Franklin *Costume Designer* Moss Mabry *Costume Supervisor* Joseph H. Hiatt *Assistant Director* Russell Saunders *Sound Supervisor* William A. Mueller *Assistant Sound Supervisor* George R. Groves *Production Mixer* Francis J. Scheid *Casting* Hoyt Bowers *Special Effects* Ralph Ayres, Richard Smith

A Warner Bros.–First National Picture. Made at Warner Bros. Studio and on location in Los Angeles and the Southern California desert. Copyright June 27, 1955 by Warner Bros. Pictures Inc. Wide Screen. WarnerColor. RCA Photophone Recording. 94 minutes.

The Players: *Sgt. Ben Peterson* James Whitmore, *Sr. Dr. Harold Medford* Edmund Gwenn *Dr. Patricia Medford* Joan Weldon *Federal Agent Robert Graham* James Arness *Brig. Gen. O'Brien* Onslow Stevens *Maj. Kibbee* Sean McClory *Ofr. Ed Blackburn* Chris Drake *Little Girl* Sandy Deschner *Mrs. Tom Lodge* Mary Ann Hokanson *Trooper Captain* Don Shelton *Crotty* Fess Parker *Jensen* Olin Howland *Railroad Watchman* Dub Taylor *Army Sergeant* Leonard Nimoy *Paramedic* William Schallert *Pyschiatrist* Ann Doran *First Official* Willis Bouchey *First Reporter Outside Senate Meeting* Booth Colman *Second Reporter Outside Senate Meeting* Walter Coy *Ofr. Ryan* John Bernadino *Reporter at Press Conference* Richard Deacon *Army Officer* Nat Perrin *Dixon* Frederick J. Foote *Jerry Lodge* Robert Scott Correll *Mike Lodge* Richard Bellis *Peterson's Driver* Joel Smith *Voice of Pilot* John Close *Laboratory Man* Cliff Ferre *Gramps* Matthew McCue *Doctors* Marshall Bradford, Waldron Boyle *Troopers* Ken Smith, Kenner Kemp, Richard Boyer *Coroner Putnam* Joe Forte *Airman* Wally Duffy *Attendant* Fred Shellic *Five Star General* Norman Field *Admiral* Otis Garth *Dr. Grant* John Maxwell *WAVE* Janet Stewart *Second Official* Alexander Campbell *Policeman* Dick Wessell *Coroner* Russell Gage *Sutton* Robert Berger *Inmates* Harry Tyler, Oscar Blanke, Harry Wilson *Officers* Eddie Dew, James Card-

Sequential stills showing the mobility of the giant squid's tentacles in Jules
Verne's "Twenty Thousand Leagues Under the Sea." Copyright by Walt Disney
Productions.

well *Matron* Dorothy Green *M.P. Sergeant* Dean Cromer *Engineer* Lawrence Dobkin *Loader* Chad Mallory *Gunner* Gayle Kellogg *Senator* Victor Sutherland *Soldier* Charles Perry *Radio Operator* Warren Mare *Jeep Drivers* Hubert Kerns, Royden Clark

Note: Copyright in notice in 1954. Only the opening titles were in color.

Jules Verne's *Twenty Thousand Leagues Under the Sea*
(Buena Vista; December 23, 1954)

Producer Walt Disney *Director* Richard Fleischer *Screenplay* Earl Felton *Based on the Novel* Deux cent mille lieues sous les mers *by* Jules Verne *Cinematographer* Franz F. Planer *Underwater Cinematographer* Til Gabbani *Music* Paul J. Smith *Film Editor* Elmo Williams *Production Designer* Harper Goff *Art Director* John Meehan *Set Decorator* Emile Kuri *Costume Designer* Norman Martien *Orchestration* Joseph S. Dubin *Production Manager* Fred Leahy *Second Unit Directors* James C. Havens, Elmo Williams *Assistant Directors* Thomas J. Connors, Jr., Russ Haverick *Diving Master and Diving Equipment Designer* Fred Zendar *Production Illustrator* Bruce Bushman *Color Consultant* Morgan Padelford *Makeup and Hairdressing* Lou Hippe *Sound Supervisor* C.O. Slyfield *Production Mixer* Robert O. Cook *Song "A Whale of a Tale"* Al Hoffman, Norman Gimbel *Titles* Albert Whitlock *Assistant Film Editor* Elmo Vernon *Second Unit Cinematographer* Franz Leahy *Set Designers* J. Toos, Edward Held *Marine Coordinator* Howard Lightbourn *Underwater Engineer* Jordan Klein *Scenic Artist* Jack Bianchi *Music Editor* Evelyn Kennedy *Legal Affairs* Gunther Lessing *Underwater Camera Housings* Bob Otto *CinemaScope Lenses* Bausch & Lomb *Visual Effects Cinematographer* Ralph Hammeras *Process Cinematographer* Ub Iwerks *Optical Cinematography* Art Cruickshank, Eustace Lycett *Optical Coordinator* Robert Broughton *Animation Effects* Joshua Meador, John Hench *Matte Artist* Peter Ellenshaw *Mechanical Effects Supervisor* Robert A. Mattey *Miniature Consultants* Howard Lydecker, Theodore Lydecker *Miniature Technicians* Les Wharburton, William Ray Hamilton *Giant Squid Modeller* Chris Mueller *Giant Squid Technician* Marcel Delgado *Special Action Props* Don Post Studios

A Walt Disney Production. Copyright September 23, 1954 by Walt Disney Productions. Made at Walt Disney Studios, 20th Century–Fox Studios and Universal City Studios and on location at Corona, California, Montego Bay, Lyford Cay, New Province, Bahamas, Long Bay, Jamaica and off the coast of San Diego, California. CinemaScope. Technicolor. RCA Photophone Recording. Stereophonic Sound. 127 minutes.

The Players: *Ned Land* Kirk Douglas *Capt. Nemo* James Mason *Prof. Aronnax* Paul Lukas *Conseil* Peter Lorre *Nautilus Mate* Robert J. Wilke *John Howard*

Carleton Young *Capt. Farragut* Ted de Corsia *Coach Driver* Percy Helton *Lincoln Mate* Ted Cooper *Shipping Agent* Edward Marr *Casey Moore* Fred Graham *Billy* J.M. Kerrigan *Shipping Clerk* Harry Harvey *Reporter* Herb Vigran *Chief Cannoneer* Jack Pennick *Stunts* Ed Stepner, Fred Graham, Norm Bishop, Gil Parker, Charles Regan, Fred Zendar

Additional Oscar Nominations: *Art Direction-Set Decoration — Color* (John Meehan, Emile Kuri)*; *Film Editing* (Elmo Williams)

Note: A remake of the 1916 Universal feature. Several features based on the sequel novel *L'Isle Mystérieuse* have been made. Unofficial sequels to this feature were *Captain Nemo and the Underwater City* (Metro-Goldwyn-Mayer, 1970) and *Return of Captain Nemo* (a.k.a. *The Amazing Captain Nemo*; Warner Bros., 1978). After original release Disney removed some brief underwater shots. All re-issues have been with mono sound. A few underwater scenes were shot using spherical lenses and specially built models compressed to match the CinemaScope footage. Disney's proposed sequel, *The Adventures of Captain Nemo*, never got beyond preproduction.

1955

Special Effects Nominations

The Bridges at Toko-Ri John P. Fulton
(Paramount) *Audible:* Loren L. Ryder
The Dam Busters . George Blackwell
(Associated British, Warner Bros.)
The Rains of Ranchipur Ray Kellogg
(20th Century–Fox)

Scientific or Technical Awards

Class II Farciot Edouart, Hal Corl and
the Paramount Studio Transparency
Department
For the engineering and development of a double-frame
triple-head background projector
Class III Farciot Edouart, Hal Corl
and the Paramount Studio Transparency
Department
For an improved dual stereopticon background projector

Comments

Two classy aerial war films and one disaster epic were nominated this year. The latter of the three was the British-produced *The Dam Busters*. A monochrome, low budget (by Hollywood standards) effort, it employed noticeable models, matte paintings, and blue screen work. None of this was very impressive, though the overall production was top-rung English mounting.

The Bridges at Toko-Ri, on the other hand, used large models photographed outside by John P. Fulton in the hi-fi optics of VistaVision and color. The action was enhanced in those theaters equipped for proper playback by Perspecta directional sound. Few in the audience were even aware of the use of miniatures. The bomb run was actually photographed from a helicopter swooping over the models.

CinemaScope, color, and stereo sound added greatly to the spectacle of *The Rains of Ranchipur*, a remake of 20th Century–Fox's *The Rains Came* (1939). Attractive matte art, detailed models and good optical photography

made this a more impressive effort than *The Bridges at Toko-Ri*, but it still lost to the latter, which also was this year's only sound effects nominee.

Credits

The Bridges at Toko-Ri
(Paramount; January 1955)

Producers William Perlberg, George Seaton *Director* Mark Robson *Screenplay* Valentine Davies *Based on the Novel by* James A. Michener *Cinematographer* Loyal C. Griggs *Aerial Cinematographer* Charles G. Clarke *Second Unit Cinematographers* W. Wallace Kelley, Thomas Tutweiler *Musical Score* Lynn Murray *Film Editor* Alma Macrorie *Sound Editor* Howard Beals *Art Directors* Hal Pereira, Henry Bumstead *Set Decorators* Sam Comer, Grace Gregory *Costume Designer* Edith Head *Makeup* Wally Westmore *Hairdressing* Nellie Manley *Technical Adviser* Cmdr. Marshall V. Beebe U.S.N. *Assistant Director* Francisco Day *Sound Supervisor* Loren L. Ryder *Production Mixer* Hugo Grenzbach *Dubbing Mixer* Gene Garvin *Color Consultant* Richard Mueller *Assistant to the Producers* Arthur Jacobson *Production Cooperation* U.S. Navy, Department of Defense *Special Effects and Second Unit Director* John P. Fulton *Optical Cinematography* Paul K. Lerpae *Process Cinematography* Farciot Edouart, W. Wallace Kelley *Miniature Supervisor* Ivyl Burks

A Perlberg-Seaton Production. A Perlsea Picture. Made at Paramount Studios. Copyright January 12, 1955 by Paramount Pictures Corporation. VistaVision. Technicolor. Western Electric Movietone Recording. Perspecta Stereophonic Sound. 102 minutes.

The Players: *Lt. Harry Brubaker* William Holden *R. Adm. George Tarrant* Fredric March *Nancy Brubaker* Grace Kelly *Mike Forney* Mickey Rooney *Beer Barrel* Robert Strauss *Cmdr. Wayne Lee* Charles McGraw *Kimiko* Keiko Awaji *Nestor Gamidge* Earl Holliman *Lt. (s.g.) Olds* Richard Shannon *Capt. Evans* Willis B. Bouchey *Kathy Brubaker* Nadene Ashdown *Susie* Cheryl Lynn Calloway *Assistant C.I.C. Officer* James Jenkins *Pilot* Cmdr. Marshall V. Beebe *Military Police Major* Charles Tannen *Japanese Father* Teru Shimada *Air Intelligence Officer* Dennis Weaver *C.I.C. Officer* Gene Reynolds *Officer of the Day* James Hyland *Flight Surgeon* Robert A. Sherry *Chief Petty Officer 2nd Class* Gene Hardy *Quartermaster* Jack Roberts *Bellboys* Rollin Moriyama, Robert Kino *Capt. Parker* Paul Kruger *Japanese Mother* Ayama Ikeda *Japanese Children* Sharon Munemura, Claudia Satow *Enlisted Men* Corey Allen, Jim Cronan *Spotter* Paul Raymond *Bartender* James Connell *Military Police Sergeant* Burton Metcalfe *Setsuko* Chise Freeman *Talker* Bill Ash

Additional Oscar Nomination: *Film Editing* (Alma Macrorie)

Note: Dedicated to the U.S. Navy and especially the Naval Air and Surface Forces. Copyright in notice in 1954.

The Dam Busters

(Warner Bros. Pictures; July 16, 1955)

Director Michael Anderson, Sr. *Screenplay* R.C. Sherriff *Based on the Books* The Dam Busters *by* Paul Brickhill *and* Enemy Coast Ahead *by* Wing Cmdr. Guy P. Gibson *Ground and Aerial Cinematographer* Erwin Hillier *Musical Score* Leighton Lucas *March "The Dam Busters"* Eric Coates *Musical Director* Louis Levy *conducting the* Associated British Studio Orchestra *Film Editor* Richard Best *Director in Charge of Production* Robert Clark *Production Supervisor* W.A. Whittaker *Production Manager* Gordon Scott *Assistant Director* John Street *Script Supervisor* Thelma Orr *Technical Adviser* Group Capt. J.N.H. Whitworth *Camera Operator* Norman Warwick *Sound Supervisor* Harold V. King *Production Mixer* Leslie Hammond *Sound Effects Editor* Arthur Southgate *Casting* Robert Lennard, C.B. Walker *Makeup* Stuart Freeborn *Hairdresser* Hilda Winifred Fox *Courtesy Credit* British Air Ministry, Royal Air Force, A.V. Roe & Company Ltd. *Special Effects Supervisors* George Blackwell, Les Bowie *Special Effects Cinematographer* Gilbert Taylor

An Associate British Picture Corporation Production. Copyright 1955 by Associated British Picture Corporation, Ltd. Made at Associated British Studios, Elstree, England. Wide Screen 1.66 × 1. RCA Photophone Recording. 102 minutes.

The Players: *Wing Cmdr. Guy P. "Gibby" Gibson* Richard Todd *Dr. Barnes N. Wallis* Michael Redgrave *Mrs. Wallis* Ursula Jeans *Air Chief Marshal Sir Arthur Harris* Basil Sydney *Capt. Joseph "Mutt" Summers* Patrick Barr *Air Vice Marshal the Hon.* Ralph Cochrane, Ernest Clark *Group Capt. J.N.H. Whitworth* Derek Farr *Physician* Charles Carson *Sir David Pye* Stanley Van Beers *Dr. W.H. Glanville* Colin Tapley *National Physical Laboratory Official* Raymond Huntley *Flight Lt. J.V. "Hoppy" Hopgood* John Fraser *Flight Ofr. F.M. Spofford* Nigel Stock *Flight Lt. H.B. Martin* Bill Kerr *Flight Lt. D.J.H. Maltby* George Baker *Flight Sgt. J. Pulford* Robert Shaw *Flight Lt. R.E.G. Hutchinson* Anthony Doonan *Flying Cmdr. Crosby* Harold Goodwin *Complaining Egg Farmer* Laurence Naismith *B.B.C. Radio Announcer* Frank Phillips *Ministry of Aircraft Production Official* Hugh Manning *Flight Lt. R. David Trevor-Rober* Brewster Mason *Committee Members* Frederick Leister, Eric Messiter, Laidman Browne *Observers at Trials* Edwin Styles, Hugh Moxey *R.A.F. Officer at Trials* Anthony Shaw *Group Signals Officer* Harold Siddons *Flight Lt. A.T. Taerum*

Brian Nissen *Flight Ofr. G.A. Deering* Peter Assinder *Sq. Ldr. H.M. Young*
Richard Leech *Sq. Ldr. H.E. Maudslay* Richard Thorp *Flight Lt. W. Astell*
David Morell *Flight Lt. D.J. Shannon* Ronald Wilson *Flying Ofr. L.G. Knight*
Denys Graham *Flight Lt. R.C. Hay* Basil Appleby *Flight Lt. J.F. Leggo* Tim
Turner *Flight Sgt. G.E. Powell* Ewen Solon

Note: Released in England in April 1955 by Associated British-Pathe Ltd.
with a B.B.F.C. U certificate. All U.S. sources checked credited Robert
Clark and W.A. Whittaker as producers, but they are screen billed as listed
above.

The Rains of Ranchipur
(20th Century-Fox; December 1955)

Producer Frank Ross *Director* Jean Negulesco *Screenplay* Merle Miller *Based on
the Screenplay* The Rains Came *by* Philip Dunne, Julien Josephson *From the
Novel* The Rains Came *by* Louis Bromfield *Cinematographer* Milton Krasner
Musical Score Hugo Friedhofer *Musical Director* Lionel Newman *Film Editor*
Dorothy Spencer *Assistant Director* Eli Dunn *Art Directors* Lyle R. Wheeler,
Addison Hehr *Set Decorators* Walter M. Scott, Paul S. Fox *Costume Designers*
William Travilla, Helen Rose *Costume Supervisor* Charles LeMaire
Choreography Stephen Papich *Camera Operator* Paul Lockwood *Assistant
Cameraman* Al Lebovitz *Second Assistant Cameraman* Larry Prather *Grips* Rex
Turnmire, Jack Richardson *Gaffer* Kenneth Lang *Makeup* Ben Nye *Hair-
dressing* Helen Turpin *Orchestration* Maurice de Packh *Sound Supervisor* Carlton
W. Faulkner *Production Mixer* Alfred Bruzlin *Dubbing Mixer* Harry M.
Leonard *Color Consultant* Leonard Doss *Anamorphic Lenses* Bausch & Lomb
Special Effects Supervisor Ray Kellogg *Special Effects Cinematographers* L.B.
Abbott, Walter Castle, James B. Gordon *Matte Artist* Emil Kosa, Jr.

Made at 20th Century-Fox Studios and on location in India. Copyright
December 15, 1955 by 20th Century-Fox Corporation. CinemaScope.
Color by De Luxe. Western Electric Movietone Recording. Stereophonic
Sound. 104 minutes.

The Players: *Lord Alan Esketh* Michael Rennie *Lady Edwina Esketh* Lana
Turner *Dr. Safti* Richard Burton *Maharani* Eugenie Leontovich *Tom Ransome*
Fred MacMurray *Fern Simon* Joan Caulfield *Mr. Adoani* Carlo Rizzo *Mr.
Smiley* King Calder *Mrs. Smiley* Madge Kennedy *Mrs. Simon* Gladys Hurlbut
Oriental Dancer Beatrice Kraft *Mrs. Adoani* Argentina Brunetti *Ranchid* John
Banner *Louise* Ivis Goulding *Major Domo* Ram Singh *First Courier* Lou
Krugman *Lachmaania* Rama Bai *Wagonlit Porter* Naji Babbay *Head Hunter*
Jugat Bhatia *Nurse Gupta* Phyllis Johannes *Mr. Simon* George Brand *Nurse*

Patel Elizabeth Prudhomme *Guest* Trude Wyler *Satter* Ram Chandra *Sundar* Paul H. Frees *Officer at Party* Maj. Sam Harris *Second Courier* Aly Wassil

Note: Previously made as *The Rains Came* (20th Century-Fox). See 1939. Stock footage of the destruction scenes has been incorporated into several films.

1956

Special Effects Nominations

Forbidden Planet A. Arnold Gillespie,
(MGM) Irving Ries
Audible: Wesley C. Miller
**The Ten Commandments* John P. Fulton
(De Mille, Paramount)

Scientific or Technical Awards

Class III Roy C. Stewart & Sons of
Stewart-Trans Lux Corporation,
Dr. C.R. Daily, and the Transparency
Department of Paramount Pictures
Corporation
For the engineering and development of the Hi-Trans and
Para-Hi-Trans rear projection screens
Class III The Construction Department
of MGM Studio
For a new hand-portable fog machine

Comments

There is no denying *The Ten Commandments* was one of the most impressive epics ever made; but it could not by any means be compared to *Forbidden Planet* in the quality of its trick work. Handsome as it was, the De Mille remake had very noticeable blue screen mattes, and the rear screen shots were so washed out as to be laughable. The parting of the Red Sea was terrific and exciting, but like so much of the film, was heavily marred by image shrinking that created extremely glaring blue matte fringes. (A good deal of the impressiveness lay not in the visuals but in Elmer Bernstein's tremendous music, very possibly the best ever scored.) On the other hand, *Forbidden Planet*, Shakespeare's *"The Tempest"* ultra-modernized, offered flawless model, matte and optical illusions with interesting, though a bit childish, Disney animation. It also received a nomination for its Perspecta sound effects, more the efforts of musicians Bebe and Louis Barron than the sound department.

Credits

Forbidden Planet

(Metro-Goldwyn-Mayer; February 1956)

Producer Nicholas Nayfack *Director* Fred M. Wilcox *Screenplay* Cyril Hume *Adaptation* Irving Block, Allen Adler *Based on the Stage Play "The Tempest" by* William Shakespeare *Cinematographer* George Folsey *Musical Score* Bebe Barron, Louis Barron *Film Editor* Ferris Webster *Art Directors* Cedric Gibbons, Arthur Lonergan, Robert Kinoshita, Irving Block, A. Arnold Gillespie *Production Illustrator* Mentor Huebner *Set Decorators* Edwin B. Willis, Hugh Hunt *Assistant Director* George Rhein *Sound Supervisor* Wesley C. Miller *Dubbing Mixer* William Steinkamp *Color Consultant* Charles K. Hagedon *Makeup* William Tuttle *Hairdressing* Sydney Guilaroff, Mary Keats *Men's Costume Designer* Walter Plunkett *Anne Francis' Costume Designer* Helen Rose *Scenic Supervisor* George Gibson *Scenic Artists* Leo Atkinson, Tommy Duff, H. Gibson, Ed Helms, F. Wayne Hill, Bob Overbeck, Clark Provins, Arthur Rider, Bill Smart, Bob Woolfe *Anamorphic Lenses* Panavision, Inc. *Special Effects Supervisor* A. Arnold Gillespie *Matte Supervisor* Warren Newcombe *Matte Artists* Henri Hillinick, Howard Fisher *Special Effects Cinematographer* Irving G. Ries *Miniature Supervisor* Maximillan Fabian *Special Effects Technicians* A.D. Flowers, Glen Robinson, Dean Pearson, Logan Frazee, Joe Zomar, Jack McMasters, Robert A. MacDonald, Max Gebinger, Earl McCoy, Chuck Frazier, Dion Hansen, Eddie Fisher *Id Monster Designer* Ken Hultgren *Animation Supervisor* Joshua Meador *Animation* Walt Disney Productions *Animators* Joseph Alves, Dwight Carlisle, Ron Cobb

A Loew's Inc. Production. Made at MGM Studios and Walt Disney Studios. Copyright February 27, 1956 by Loew's Inc. CinemaScope. Eastman Color. Prints by Metrocolor. Western Electric Movietone Recording. Perspecta Stereophonic Sound. 98 minutes.

The Players: *Dr. Edward Moribus* Walter Pidgeon *Attaira (Alta) Moribus* Anne Francis *Cmdr. John J. Adams* Leslie Nielson *Lt. Doc Ostrow* Warren Stevens *Lt. Jerry Farman* Jack Kelly *Crew Chief Quinn* Richard Anderson *Cookie* Earl Holliman *Bosum* George Wallace *Grey* Robert Dix *Youngerford* Jimmy Thompson *Joe Strong* James Drury *Randall* Harry Harvey, Jr. *Lindstrom* Roger McGee *Moran* Peter Miller *Nichols* Morgan Jones *Silvers* Richard Grant *Robby the Robot* Frankie Carpenter, Frankie Darro *Crewmen* James Best, William Boyett *Voice Characterization of Robby the Robot* Marvin Miller *Narrator* Les Tremayne

Note: As well as mono and stereo sound versions MGM offered three

different wide screen editions: CinemaScope anamorphic, with a 2 × 1 compression and a 2.35 × 1 aspect ratio; Scanoscope anamorphic, with a 1.5 × 1 compression and a 2 × 1 aspect ratio; and Metroscope spherical, with a 1.75 × 1 aspect ratio. In 1982 Columbia released another modernized version entitled *Tempest*.

The Ten Commandments
(Paramount; October 5, 1956)

Producer and Director Cecil B. De Mille *Associate Producer* Henry Wilcoxon *Screenplay* Aeneas MacKenzie, Jesse L. Lasky, Jr., Jack Gariss, Fredric M. Frank *Based on the Books* Prince of Egypt *by* Dorothy Clarke Wilson, Pillar of Fire *by* Rev. J.H. Ingraham, *and* On Eagle's Wings *by* Rev. G.E. Southon *in accordance with the ancient writings of* Josephus, Eusebius *and* Philo Judaeus *and the texts of the* Midrash Rabbah, the Koran, the Malmud, the Mishnah, the Old Testament and the New Testament *Cinematographer* Loyal C. Griggs *Additional Cinematographers* J. Peverell Marley, John F. Warren, W. Wallace Kelley *Musical Score* Elmer Bernstein *Film Editor* Anne Bauchens *Supervising Sound Editor* Tommy Middleton *Color Consultant* Richard Mueller *Art Directors* Hal Pereira, Walter H. Tyler, Albert Nozaki *Production Illustrators* Arnold Friberg, John Jensen *Set Designer* Walter McKeegan *Construction Coordinator* Jerry Cook *Set Decorators* Sam M. Comer, Ray Moyer *Property Masters* Gordon Cole, Robert Goodstein *Costume Designers* Edith Head, Ralph Jester, John Jensen, Dorothy Jeakins, Arnold Friberg *Choreography* LeRoy Prinz, Ruth Godfrey *Dialogue Coaches* Frances Dawson, Donald MacLean *Makeup Supervisor* Wally Westmore *Makeup* Frank Westmore, Frank McCoy, Paul Malcolm, Robert Dawn *Hairdressing* Nellie Manley *Sound Supervisors* Loren L. Ryder, Louis H. Mesenkop *Production Mixer* Harry M. Lindgren *Boom Operator* Ottis Gunter *Dubbing Mixers* John Cope, Robert L. Hoyt, George Dutton, Gene Garvin *Sound Editor* Howard Beals *Music Editor* June Edgerton *Camera Operators* Albert Meyers, James V. King *Assistant Cameraman* Edward Wahrman *Chariot Master* Abbas El Boughdadly *Bird Handler* Bill Lasky *Production Managers* Frank Caffey, Kenneth DeLand, Donald Robb, Andrew J. Durkus, Roy Burns *Production Assistant* Donald Hayne *Assistant to the Director* Justin Buehrlen *Unit Paramedic* Dmax Jacobson *Producer-Director's Secretaries* Berenice Mosk, Florence Cole *Publicity Supervisors* Art Arthur, Ann del Valle *Orchestration* Lucien Cailliet, Nathan Van Cleave, Leo Shuken *Second Unit Directors* Arthur Rosson, Cecilia De Mille, Francisco Day, Henry Wilcoxon *Assistant Directors* Francisco Day, Michael Moore, Edward Salven, Daniel J. McCauley *Egyptian Assistant Director* Fouad Aref *Second Assistant Director* Sheldon Schrager *Research* Henry S. Noerdlinger, Gladys Percy *Research Assistance* Dr. William C. Hayes, Metropolitan Museum of Art, New York City; Dr. Labib Habachi, Department of Antiquites, Luxor Egypt; Dr.

Keith C. Steele, Dr. Ralph Marcus, Dr. George R. Hughes, Oriental Institute, University of Chicago; Rabbi Rudolph Lupo, Jewish Community Library, Los Angeles *Visual Effects* John P. Fulton *Additional Visual Effects* David Stanley Horsley *Optical Cinematography* Paul K. Lerpae *Optical Printers* Frank Stanley, Jack Caldwell, Aubrey Law *Process Cinematography* Farciot Edouart, W. Wallace Kelley *Matte Cinematography* Irmin Roberts *Matte Artist* Jan Domela *Miniature Supervisor* Ivyl Burks *Mechanical Effects* Richard Parker

A Cecil B. De Mille Production. Produced by Motion Picture Associates Inc. Made at Paramount Studios and on location in Cairo, Abu Ruwash, Beni Youssef, at Mt. Sinai and on the Sinai Peninsula, Egypt. Copyright November 8, 1956 by Paramount Pictures Corporation. VistaVision. Technicolor. Western Electric Movietone Recording. Perspecta Stereophonic Sound. 221 minutes plus intermission.

The Players: *Moses* Charlton Heston *Rameses II* Yul Brynner *Nefretiri* Anne Baxter *Dathan* Edward G. Robinson *Sephora* Yvonne De Carlo *Lilia* Debra Paget *Joshua* John Derek *Sethi* Cedric Hardwick *Bithiah* Nina Foch *Yochabel* Martha Scott *Memnet* Judith Anderson *Baka* Vincent Price *Aaron* John Carradine *Jethro* Eduard Franz *Miriam* Olive Deering *Mered* Donald Curtis *Jannes* Douglass Dumbrille *Abiram* Frank DeKova *Amminadab* H.B. Warner *Pentaur* Henry Wilcoxon *Hur Ben Caleb* Lawrence Dobkin *Elisheba* Julia Faye *Rameses II's Charioteer* Abbas El Boughdadly *Infant Moses* Fraser Heston *Gershom* Tommy Duran *Rameses II's Son* Eugene Mazzola *Korah* Ramsay Hill *Rameses I* Ian Keith *Jethro's Daughters* Lisa Mitchell, Joanna Merlin, Joyce Vanderveen, Noelle Williams, Pat Richard, Diane Hall *Blind One* John Miljan *Simon* Francis J. McDonald *Eleazor* Paul De Wolf *Korah's Wife* Joan Woodbury *Ethiopian King* Woodrow Strode *Princess Tharbis* Esther Brown *Commander of the Hosts* Henry Brandon *Amalekite Herder* Touch (Michael) Connors *Sardinian Captain* Clint Walker *Drum Beater* Herb Alpert *Pharoah's Chariot Host* Royal Egyptian Armed Forces Cavalry Corps *African Princess* Rushti Abaza *Old Hebrew in Moses' Home* Luis Alberni *Taskmasters* Michael Ansara, Eric Alden, Fred Coby *Slave Carrying Load* Stanley Price *Slaves* Frankie Darro, Rodd Redwing, Dorothy Adams, Kenneth MacDonald, Carl Switzer, Edward Earle *Pretty Slave Girl* Gail Kobe *Little Slave Girl* Kathy Garver *Flame Dancer* LaWanda Page *Herald* Walter Woolf King *Hebrew Spearman* Robert Vaughn *Little Slave Boy* Alan Roberts *Hebrew* Ward Ramsey *Foreman* Fred Kohler, Jr. *Fan Bearer* Addison Richards *Wazir* Frank Wilcox *High Official* Franklyn Farnum *Praying Old Man* Frank Lackteen *Cretan Ambassador* John Hart *Ezion Shiek* Henry Corden *Court Lady* Edna Mae Cooper *Assistant Architects* John Merton, Amena Mohamed *Libyan Captain* Tony Dante *Egyptian Corporal* Kem Dibbs *Lugal* Onslow Stevens *Hebrew by Golden Calf* Zeev Bufman *Flagman* Ed Hinton *Old Slave* Emmett Lynn *Narrator* Cecil B. De Mille *With* Maude Fealy, George Melford, Dorothy Neumann, Keith

Richards, Jeane Wood, Lillian Albertson, Joel Ashley, George Baxter, Robert Bice, Peter Coe, J. Stevan Darrell, Antony Eustrel, Matty Fain, Anthony George, Gavin Gordon, Kay Hammond, Peter Hansen, Barry Macollum, Adeline de Walt Reynolds, Irene Tedrow, E.J. Andre, Babette Bain, Baynes Barron, Kay Bell, Mary Benoit, Louis Zito, Robert Carson, Robert Clark, Rus Conklin, Mimi Gibson, Diane Gump, Nancy Hale, June Jocelyn, Richard Kean, Peter Mamakos, Irene Martin, Paula Morgan, John Parrish, Marcoreta Starr, Amanda Webb, Joe Flynn, Robert Morgan

Additional Oscar Nominations: *Picture* (De Mille, Paramount; Cecil B. De Mille); *Cinematography — Color* (Loyal Griggs); *Art Direction-Set Decoration — Color* (Hal Pereira, Walter H. Tyler, Albert Nozaki, Sam M. Comer, Ray Moyer); *Costume Design — Color* (Edith Head, Ralph Jester, John Jensen, Dorothy Jeakins, Arnold Friberg); *Sound Recording* (Paramount Studio Sound Department, Loren L. Ryder); *Film Editing* (Anne Bauchens)

Note: Previously made in 1922 by De Mille for Paramount.

1957

Special Effects Nominations

The Enemy Below *Audible:*
(20th Century-Fox) Walter Rossi
The Spirit of St. Louis Louis Lichtenfield
(Hayward-Wilder, Warner Bros.)

Comments

The complete stupidity of incorporating visual and audible effects under one category of Special Effects was never more evident than this year. Of the two nominations one was for sound effects only and the other was for trick photography only. Two completely different technical aspects in direct competition. Totally absurd! This is not to say supervising sound editor Walter Rossi was undeserving of an Oscar, but his efforts just could not be judged on the same plane as those of matte artist Louis Lichtenfield. More strangely still, *The Enemy Below* featured quite good miniature marine work and could have reasonably been nominated for visual effects. *The Spirit of St. Louis*, the story of Lucky Lindy's transatlantic solo flight, also had good audible effects. But the only true technical comparisons that could be made regarding audio-visual was that both films were in 'scope, color, and stereo sound.

Credits

The Spirit of St. Louis
(Warner Bros.; April 20, 1957)

Producer Leland Hayward *Associate Producer* Doane Harrison *Director* Billy Wilder *Screenplay* Billy Wilder, Wendell Mayes *Adaptation* Charles Lederer *Based on the Book by* Charles A. Lindbergh *Cinematographers* Robert Burks, J. Peverell Marley *Cinematographic Adviser* Ted McCord *Aerial Cinematographer* Thomas Tutweiler *Musical Score* Franz Waxman *Film Editor* Arthur P. Schmidt *Art Director* Art Loel *Set Decorator* William L. Kuehl *Monatage and Production Consultant* Charles Eames *Technical Advisers* Maj. Gen. Victor Bertran-dias U.S.A.F. Retd., Harlan A. Gurney *Sound Supervisor* George R. Groves

Production Mixer M.A. Merrick *Casting* Hoyt Bowers *Orchestration* Leonid Rabb *Production Manager* Norman Cook *French Production Manager* Jean-Marie Loutrel *Assistant Directors* Clifford C. Coleman, Don Page *Makeup* Gordon Bau *Aerial Supervisor* Paul Mantz *Pilot* Jim Thompson *Camera Operator* Leonard South *Assistant Cameraman* Bert Eason *French Camera Operator* Marc Fossard *WarnerColor Supervisor* Fred Gage *Special Effects Cinematographer* Hans F. Keonekamp *Matte Artist* Louis Lichtenfield

A Leland Hayward-Billy Wilder Production. A Leland Hayward Productions Picture. Made at Warner Bros. Studios and on location in Guyancourt, France, Santa Monica, California and Long Island, Manhattan, New York. Copyright April 20, 1957 by Leland Hayward Productions, Inc. CinemaScope. WarnerColor. RCA Photophone Recording. Perspecta Stereophonic Sound. 138 minutes.

The Players: *Charles A. Lindbergh* James Stewart *Bud Gurney* Murray Hamilton *Mirror Girl* Patricia Smith *B.F. Mahoney* Bartlett Robinson *Father Hussman* Marc Connelly *Donald Hall* Arthur Space *O.W. Schultz* Charles Watts *Knight* Robert Cornthwaite *Model Dancer* Sheila Bond *Boedecker* Harlan Warde *Goldsborough* Dabbs Greer *Blythe* Paul Birch *Harold Bixby* David Orrick *Maj. Lambert* Robert Burton *William Robertson* James L. Robertson, Jr. *E. Lansing Ray* Maurice Manson *Earl Thompson* James O'Rear *Lane* David McMahon *Dad* Griff Barnett *Jess* John Lee *Casey Jones* Herb Lytton *Associate Producer* Roy Gordon *Director* Nelson Leigh *Louie* Jack Daly *Inspecting Captain* Carleton Young *Gendarme* Eugene Borden *Burt* Erville Alderson *Surplus Dealer* Olin Howland *Fearless* Aaron Spelling *Secretary* Virginia Christine *Photographers* Sid Saylor, Lee Roberts *Barker* Ray Walker *San Diego Editor* Robert B. Williams *Levine* Richard Deacon *Fearless' Wife* Ann Morrison *Professor* Percival Vivian *Mechanic* George Selk (Budd Buster) *Oakie* Paul Brinegar *Indian* Chief Yowlachie *Cadets* William Neff, William White

Note: Photographed with either Panavision or WarnerScope lenses.

1958

Special Effects Nominations

tom thumb . Tom Howard
(Pal, MGM)
Torpedo Run . A. Arnold Gillespie
(MGM) *Audible:* Harold Humbrock

Scientific or Technical Award

Class III Fred Ponedel, George Brown and
Conrad Boye of the Warner Bros.
Special Effects Department
For the design and fabrication of a new rapid fire marble gun

Comments

Tom Howard introduced a new, elaborate, and impressive traveling matte system called Automotion in George Pal's enchanting children's fantasy, *tom thumb*. (The studio insisted that the title always appear only in lower case type, never with capitals.) It allowed the almost perfect blending of several characters or objects in ways not employed before. They could move about, around or through each other with startling realism.

By comparison, Arnold Gillespie's model marine shots in *Torpedo Run*, a dreary story of a submarine commander seeking revenge on the Japanese, were crude, though effective. Sound effects cutter Harold Humbrock was cited for his audio work.

Credits

tom thumb
(Metro-Goldwyn-Mayer; December 25, 1958)

Producer and Director George Pal *Associate Producer* Dora Wright *Screenplay* Ladislas Fodor *Based on the Story by* Jacob Grimm, Wilhelm Grimm *Cinematographer* Georges Perinal *Musical Score* Douglas Gamley, Kenneth Jones *Musical Director* Muir Mathieson *Film Editor* Frank Clarke *Choreography*

Alex Romero *Makeup* Charles Parker *Assistant Director* David Middlemas *Second Assistant Director* Peter Yates *Art Director* Elliot Scott *Costume Designer* Olga Lehmann *Production Manager* E.J. Holding *Camera Operator* Denys Coop *Assistant to the Producer* Gae Griffith *Script Supervisor* Angela Martelli *Sound Supervisor* Anthony W. Watkins *Production Mixer* John Bramall *Hairdressing* Hilda Fox *Songs "tom thumb's Tune," "Are You a Dream"* by Peggy Lee *"The Talented Shoes," "After All These Years"* by Fred Spielman, Janice Torre *"The Yawning Song"* by Fred Spielman, Kermit Goell *Special Effects* Thomas Howard *Stop-Motion Animation* Project Unlimited, Gene Warren, Sr., Wah Chang, Don Sahlin, Herb Johnson

A George Pal Production. A Galaxy Picture. Made at MGM British Studios. Copyright November 10, 1958 by Galaxy Pictures, Ltd. Metroscope. Automotion. Metrocolor. Westrex Recording System. 98 minutes.

The Players: *tom thumb* Russ Tamblyn *Woody the Piper* Alan Young *Ivan* Terry-Thomas *Tony* Peter Sellers *Anna Thumb* Jessie Matthews *Forest Queen* June Thorburn *Jonathan Thumb* Bernard Miles *Cobbler* Ian Wallace *Band Master* Peter Butterworth *Town Crier* Peter Bull *Puppetoon Voice Characterizations: Thumbelina* Barbara Ferris *Yawning Man* Stan Freberg *Con-Fu-Shon* Dal McKennon

Note: Released in England in December 1958 with a B.B.F.C. U certificate. Remade in 1972 as a Mannic-UP-Para-Francos co-production and released in the U.S. in 1976 by Paramount.

Torpedo Run

(Metro-Goldwyn-Mayer; September 1958)

Producer Edmund Grainger *Director* Joseph Pevney *Screenplay* Richard Sale, William Wister Haines *Based on Stories by* Richard Sale *Cinematographer* George J. Folsey *Film Editor* Gene Ruggiero *Sound Editor* Harold Humbrock *Art Directors* William A. Horning, Malcolm Brown *Set Decorators* Henry Grace, Otto Siegel *Color Consultant* Charles K. Hagedon *Assistant Director* Robert Saunders *Makeup* William Tuttle *Hairdressing* Sydney Guilaroff, Mary Keats *Technical Adviser* V. Adm. Charles A. Lockwood U.S.N. Retd. *Sound Supervisor* Wesley C. Miller *Assistant Sound Supervisor* Franklin E. Milton *Dubbing Mixer* William Steinkamp *Anamorphic Lenses* Panavision, Inc. *Special Effects Supervisor* A. Arnold Gillespie *Special Effects Technician* A.D. Flowers

A Loew's Inc. Production. Made at MGM Studios and on location in the Pacific Ocean off the coasts of San Diego and Long Beach, California. Copyright September 26, 1958 by Loew's Inc. CinemaScope. Metrocolor. Westrex Recording System. Perspecta Stereophonic Sound. 98 minutes.

The Players: *Lt. Cmdr. Barney Doyle* Glenn Ford *Lt. Archer Sloan* Ernest Borgnine *Jane Doyle* Diane Brewster *Lt. Jake "Fuzz" Foley* Dean Jones *Hash Benson* L.Q. Jones *Adm. Samuel Setton* Philip Ober *Cmdr. Don Adams* Richard Carlyle *Orville "Goldy" Goldstein* Fredy Wayne *Ens. Ron Milligan* Don Keefer *Lt. Redley* Robert Hardy *Lt. Burl Fisher* Paul Picerni

1959

Special Effects Nominations

Ben-Hur: A Tale of the Christ A. Arnold Gillespie,
(MGM) Robert MacDonald
 Audible: Milo Lory

Jules Verne's *Journey to the Center*
of the Earth L.B. Abbott,
(20th Century–Fox) James B. Gordon
 Audible: Carl Faulkner

Scientific or Technical Award

Class III Ub Iwerks of Walt Disney Prod.
For the design of an improved optical printer for special effects
and matte shots

Comments

Ben-Hur: A Tale of the Christ, about a Jewish prince enslaved by the Romans, was one of the most honored films ever. It received twelve Oscar nominations and countless other awards and citations worldwide. It was a quality effort throughout, including its trick work (aside from the model marine shots), sound effects for which dubbing editor Milo Lory was cited, and matte paintings.

Jules Verne's *Journey to the Center of the Earth*, a long, detailed period novel, became a highly enjoyable adventure-fantasy with topnotch matte art and extraordinary use of live iguanas bedecked with fins subsituting for dimetrodons. Except for shots of the altar stone ascending the volcano cone on the lava flow, the miniatures were excellent. Studio sound chief Carlton W. Faulkner was nominated for audible effects.

Credits

Ben-Hur: A Tale of the Christ
(Metro-Goldwyn-Mayer, November 1959)

Producers Sam Zimbalist, William Wyler *Director* William Wyler *Screenplay*

Karl Tunberg, Christopher Fry, Maxwell Anderson, S.N. Behrman, Gore Vidal *Based on the Novel by* Lew Wallace *Music* Miklos Rosza *Cinematographer* Robert L. Surtees *Second Unit Cinematographer* Harold E. Wellman *Third Unit Cinematographer* Pietro Portalupi *Art Directors* William A. Horning, Edward Carfagno *Set Decorator* Hugh Hunt *Set Color Consultant* Charles K. Hagedorn *Film Editors* Ralph E. Winters, John D. Dunning *Chariot Race Director* Andrew Marton *Second Unit Directors* Yakima Canutt, Mario Soldati *Third Unit Director* Richard Thorpe *Assistant Directors* Agustus Agosti, Alberto Cardone *Second Assistant Directors* Donald C. Klune, Sergio Leone, Ferdinando Baldi *Makeup* Charles Parker, Charles Schram, William Tuttle *Hairdressing* Gabriella Borzelli, Mary K. Keats *Production Executive* Joseph J. Cohn *Production Supervisor* Henry Henigson *Unit Production Manager* Edward Woehler *Sound Supervisor* Franklin E. Milton *Production Mixer* Alexander Sash Fisher *Dubbing Mixer* William Steinkamp *Costume Designer* Elizabeth Haffenden *Costume Color Consultant* Joan Bridge *Chariot Builders* Fratelli Danesi *Chariot Master* Alfredo Danesi *Horse Trainer* Glenn Randall *Music Editor* William Saracino *Sound Effects Editor* Milo Lory *Editorial Coordinator* Frederic Steinkamp *Assistant Production Supervisor* Maurizio Lodi-Fe *Unit Publicist* Morgan Hudgins *Assistant Art Director* Ken Adam *Camera Operator* John Schmitz *Assistant Cameramen* Edward Phillips, Edward Wahrman *Still Photographer* Eric Carpenter *MGM Camera 65 Equipment* Panavision Inc. *Special Effects Supervisor* A. Arnold Gillespie *Matte Supervisor* Lee LeBlanc *Matte Artist* Matthew Yuricich *Optical Cinematography* Robert R. Hoag *Special Effects Foreman* Robert A. MacDonald, Sr. *Special Effects Technicians* A.D. Flowers, Glen Robinson

A William Wyler Presentation. A Loew's Inc. Production. Made at Cinecitta Studios and MGM Studios and on location in Italy. Copyright November 11, 1959 by Loew's Inc. MGM Camera 65. Technicolor. Westrex Recording System. Stereophonic Sound. 212 minutes plus intermission.

The Players: *Judah Ben-Hur* Charlton Heston *Quintus Arrius* Jack Hawkins *Massala* Stephen Boyd *Esther* Haya Harareet *Sheik Ilderim* Hugh Griffith *Miriam* Martha Scott *Simonides* Sam Jaffe *Tirzan* Cathy O'Donnell *Bathasar* Finlay Currie *Pontius Pilate* Frank Thring *Drusus* Terence Longden *Sextus* Andre Morell *Flavia* Marina Berti *Tiberius* George Ralph *Malluch* Adi Berber *Amrah* Stella Vitelleschi *Mary the Mother* Jose Greci *Joseph the Carpenter* Lawrence Payne *Spintho* John Horsley *Metellus* Richard Coleman *Marius* Duncan Lamont *Tiberius' Aide* Ralph Truman *Gaspar* Richard Hale *Melchior* Reginald Lal Singh *Quaestor* David Davies *Jailer* Dervis Ward *Jesus Christ* Claude Heater *Gratus* Mino Doro *Chief of Rowers* Robert Brown *Rower No. 42* John Glenn *Rower No. 43* Maxwell Shaw *Rower No. 28* Emile Carrer *Leper* Tutte Lemkow *Hortator* Howard Lang *Rescue Ship Captain* Ferdy Mayne *Doctor* John Le Mesurier *Blind Man* Stevenson Long *Barca* Aldo Mozele *Race Starter* Thomas O'Leary *Centurion* Noel Sheldon *Officer* Hector Ross *Soldier* Bill

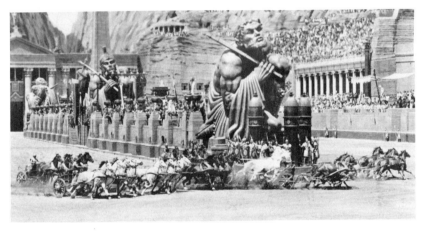

The chariot race in "Ben-Hur." The squeeze has been removed from these MGM Camera 65 frame blowups. The cliffs, parts of the arena, and the upper audience are painted. The original matte art was painted with a squeezed look and photographed with a spherical lens as the Ultra Panavision 70 lenses were not suitable for matte photography.

Kuehl *Nazareth Man* Aldo Silvani *Villager* Diego Pozzetto *Marcello* Dino Fazio *Raimondo* Michael Cosmo *Cavalry Officer* Aldo Pini *Decurian* Remington Olmstead *First Galley Officer* Victor De La Fosse *Second Galley Officer* Enzo Fiermonte *Mario* Hugh Billingsley *Roman at Bath* Tiberio Mitri *Pilate's Servant* Pietro Tordi *Corinthian Charioteer/Stuntman* Jerry Brown *Byzantine Charioteer/ Stuntman* Otello Capanna *Syrian Charioteer/Stuntman* Luigi Marra *Lubian Charioteer/Stuntman* Cliff Lyons *Athenian Charioteer/Stuntman* Edward J. Auregui *Egyptian Charioteer/Stuntman* Joe Yrigoyan *Armenian Charioteer/Stuntman* Alfred Danesi *Old Man* Raimondo Van Riel *Seaman/Stuntman* Mike Dugan *Sportsman/Stuntman* Joe Canutt *Men* Count Mario Rivoltella, Guiseppe Tosi *Aristocratic Roman Party Guests* Prince Emanuele Ruspoli, Prince Raimondo, Count Santiago Orreto, Prince Hohenlohe, Princess Wassilchikoff, Count Marigliano del Monte, Baroness Lillian de Balzo, Duchess Nona Medici *Stuntmen* Tap Canutt, Mickey Gilbert

Additional Oscar Nominations: *Picture* (MGM, Sam Zimbalist)*; *Actor* (Charlton Heston)*; *Supporting Actor* (Hugh Griffith)*; *Direction* (William Wyler)*; *Writing — Screenplay based on material from another medium* (Karl Tunberg); *Cinematography — Color* (Robert L. Surtees)*; *Art Direction-Set Decoration — Color* (William A. Horning, Edward Carfagno, Hugh Hunt)*; *Costume Design-Color* (Elizabeth Haffenden)*; *Sound* (Metro-Goldwyn-Mayer Studio Sound Department, Franklin E. Milton)*; *Film Editing* (Ralph E. Winters, John D. Dunning)*; *Music — Scoring of a Dramatic or Comedy Picture* (Miklos Rozsa)*

Note: Previously made in 1925 by Metro-Goldwyn. Sam Zimbalist died during shooting and William Wyler took over as producer without screen credit. (The credit line *A William Wyler Presentation* appeared on all advertising but was not on the actual screen credits.) MGM Camera 65 became known as Ultra Panavision 70. All currently available 70mm prints have been converted from the Ultra Panavision format (anamorphic) to the Super Panavision format (spherical) with a .57 reduction in the aspect ratio. Later re-edited to 165 minutes without an intermission but restored to original 212 minutes for television sales and theatrical re-issue.

Jules Verne's *Journey to the Center of the Earth*
(20th Century–Fox; December 1959)

Producer Charles Brackett *Director* Henry King *Screenplay* Walter Reisch, Charles Brackett *Based on the Novel* Voyage au centre de la terre *by* Jules Verne *Cinematographer* Leo Tover *Musical Score* Bernard Herrmann *Musical Director* Lionel Newman *Film Editors* Stuart Gilmore, Jack W. Holmes *Art Directors* Lyle R. Wheeler, Franz Bachelin, Herman A. Blumenthal *Set Decorators*

Walter M. Scott, Joseph Kish *Costume Designer* David Ffolkes *Associate Musical Director* Ken Darby *Assistant Director* Hal Herman *Assistant to the Producer* Bernard Schwartz *Technical Advisers* Lincoln Barnett, Peter Ronson *Makeup* Ben Nye *Hairdressing* Helen Turpin *Color Consultant* Leonard Doss *Camera Operator* Irving Rosenberg *CinemaScope Lenses* Bausch & Lomb *Sound Supervisor* Carlton W. Faulkner *Production Mixer* Bernard Freericks *Dubbing Mixer* Warren B. Delaplain *Supervising Sound Editor* Walter Rossi *Supervising Music Editor* George Adams *Songs* "Twice as Tall," "The Faithful Heart" by Sammy Cahn, James van Heusen "My Love Is Like a Red, Red Rose" by Robert Burns, James van Heusen "My Heart's in the Highlands," *traditional, sung by* Pat Boone *and the* Ken Darby Chorus *Production Cooperation* National Park Service, U.S. Department of Interior *Special Effects* L.B. Abbott, James B. Gordon *Matte Artist* Emil Kosa, Jr.

A Joseph M. Schenck Enterprises Production in Association with Cooga Mooga Productions. Made at 20th Century–Fox Studios and on location in Carlsbad Caverns, New Mexico and Edinburgh, Scotland. Copyright December 2, 1959 by Joseph M. Schenck Enterprises Inc. and 20th Century–Fox Film Corporation. CinemaScope. Color by De Luxe. Westrex Recording System. Stereophonic Sound. 132 minutes.

The Players: *Alec McEwen* Pat Boone *Prof. Oliver Lindenbrook* James Mason *Carla Goetaborg* Arlene Dahl *Jenny Lindenbrook* Diane Baker *Count Saknussemm* Thayer David *Hans Bjelker* Peter Ronson *Saknussem's Groom* Bob Adler *Groom* John Epper *Dean* Alan Napier *Chancellor* Frederick Halliday *Rector* Alan Caillou *Peter Goetaborg* Ivan Triesault *Laird of Glendarich* Peter Wright *Housekeeper* Molly Roden *Proprietress* Edith Evanson *Shopkeeper* Owen McGiveney *Scot Newsman* Kendrick Huxham *Newsvendor* Molly Giessing *Prof. Bayle* Alex Finlayson *Paisley* Ben Wright *Kristy* Mary Brady *Edinburgh Man* Thomas F. Martin *Edinburgh Woman* Myra Nelson *English Scientists* John Barclay, Peter Fontaine, John Ainsworth

Additional Oscar Nominations: *Art Direction-Set Decoration — Color* (Lyle R. Wheeler, Franz Bachelin, Herman A. Blumenthal, Walter M. Scott, Joseph Kish); *Sound* (20th Century-Fox Sound Department, Carl Faulkner)

Opposite, top: An MGM Camera 65 frame blowup, with the squeeze removed, from "Ben-Hur: A Tale of the Christ." Most viewers believed the miniature ships were full size. Bottom: "Ben-Hur" was photographed in such a way that the Savior's face would never be seen. It was then decided to include views of His face, and scenes such as this unaltered shot had the head matted in, giving a strange but not unpleasant halo effect. Reportedly the first prints released did not include the added head shots.

Note: James Mason replaced Clifton Webb in the role of Professor Lindenbrook.

Later the basis of an animated children's Saturday morning series on ABC-TV, produced by Filmation Associates and running during 1968. Remade in Spain in 1977 as *Jules Verne's Fabulous Journey to the Centre of the Earth* (viaje al centro de la tierra) by Alameda Films S.A. This was considerably re-edited and released in the U.S. as *Where Time Began* (International Picture Show, 1978).

1960

Special Effects Nominations

The Last Voyage . A.J. Lohman
 (Stone, MGM)
*The Time Machine Gene Warren,
 (Pal, MGM) Tim Barr

Scientific or Technical Award

Class III Anthony Paglia and the 20th
 Century–Fox Studio Mechanical
 Effects Department
 For the design and construction of a miniature flak gun and
 ammunition

Comments

The Last Voyage detailed the sinking of a luxury liner in heart-stopping realism. Filmed aboard an actual vessel, all trick work was full size and completely convincing. For one shot a split-screen matte was employed to show the ship tilting forward in the water. No miniatures or painted mattes were utilized.

On the other hand, this year's winner, The Time Machine, used models and matte art extensively and in some scenes none too convincingly. The destruction of London was notably bad. The seasonal changes were accomplished through stop motion and cartoon animation.

Neither of these action tales received Oscar acknowledgement for sound effects.

Credits

The Last Voyage
(Metro-Goldwyn-Mayer; February 19, 1960)

Producers Andrew L. Stone, Virginia L. Stone Writer and Director Andrew L. Stone Cinematographer Hal Mohr Musical Arranger and Conductor Rudy

Schrager *Film, Sound and Music Editor* Virginia L. Stone *Production Manager and Assistant Director* Harrold A. Weinberger *Production Mixer* Philip N. Mitchell *Sound* Ryder Sound Services Inc. *Technical Director* Cmdr. Francis Douglas Fain U.S.N. Ret. *Special Effects* August J. Lohman, Robert Bonning

An Andrew and Virginia Stone Production. Made on board the *Ile de France* off the coast of Osaka, Japan. Copyright January 18, 1960 by Loew's Inc. and Andrew L. Stone Inc. Wide Screen. Metrocolor. Westrex Recording System. 91 minutes.

The Players: *Cliff Henderson* Robert Stack *Laurie Henderson* Dorothy Malone *Capt. Robert Adams* George Sanders *2nd Eng. Walsh* Edmond O'Brien *Jill Henderson* Tammy Marihugh *Hank Lawson* Woody Strode *Chief Eng. Pringle* Jack Kruschen *3rd Ofr. England* Joel Marston *1st Ofr. Osborne* George Furness *Quartermaster* Marshall Kent *3rd Eng. Cole* Richard Norris *Radio Operator* Andrew Hughes *2nd Mate Mace* Robert Martin *Youth* Bill Wilson *Narrator* Andrew L. Stone

Note: Copyright in notice in 1959.

The Time Machine

(Metro-Goldwyn-Mayer; August 4, 1960)

Producer and Director George Pal *Screenplay* David Duncan *Based on the Novel by* H.G. Wells *Cinematographer* Paul C. Vogel *Musical Score* Russell Garcia *Film Editor* George Tomasini *Art Directors* George W. Davis, William Ferrari *Production Illustrator* Mentor Huebner *Set Decorators* Henry Grace, Keogh Gleason *Color Consultant* Charles K. Hagedon *Assistant Director* William Shanks *Assistant to the Producer* Gae Griffith *Makeup* William Tuttle, Charles Schram, Ron Berkley *Hairdressing* Sydney Guilaroff, Mary Keats *Sound Supervisor* Franklin E. Milton *Dubbing Mixer* William Steinkamp *Special Effects* Project Unlimited *Additional Special Effects* Howard A. Anderson Company *Special Effects Supervisors* Gene Warren, Sr., Wah Chang *Special Effects Technicians* Don Sahlin, Tim Barr *Stop Motion Animation* Dave Pal *Matte Artist* Bill Brace *Optical Effects* Howard A. Anderson, Jr.

A George Pal Production. A Galaxy Picture. Made at MGM Studios. Copyright March 6, 1960 by Loew's Inc. and Galaxy Films Inc. Wide Screen. Metrocolor. Westrex Recording System. 103 minutes.

The Players: *H. George Wells* Rod Taylor *David Filby and James Filby* Alan Young *Weena* Yvette Mimieux *Dr. Phillip Hillyer* Sebastian Cabot *Anthony Bridewell* Tom Helmore *Walter Kemp* Whit Bissell *Mrs. Watchett* Doris Lloyd *Talking Rings* Paul Frees *First Eloi* Rob Barron *Second Eloi* James Skelly

Note: Advertised as *H.G. Wells' The Time Machine*. Pal's proposed sequel was never filmed. Remade in 1978 by Schick Sunn Classic.

1961

Special Effects Nominations

The Absent Minded Professor Robert A. Mattey
(Disney, Buena Vista) Eustace Lycett
*The Guns of Navarone Bill Warrington
(Foreman, Columbia) Audible: Vivian C. Greenham

Comments

A college instructor developed an anti-gravity goo he called flubber — flying rubber — in Disney's comedy The Absent Minded Professor. Every type of mechanical and photographic effect was used, notably full-size wire flying, miniatures, and matte paintings. The basketball game sequence has become a comedy classic and an extraordinary display of Robert Mattey's engineering genius.

Though it copped the Oscar, The Guns of Navarone was inferior. Its miniatures were finely detailed, but the matte paintings stood out badly. The very dark, grainy CinemaScope photography only added more mismatching to the actual and drawn backgrounds. There was also a huge editorial mistake: After the mountain fortress started blowing up, we saw in long shot the two enormous cannons fall into the bay; then we went back to close shots, where we saw them still intact. Dubbing editor Chris Greenham was nominated for the explosive and other noises.

Credits

The Absent Minded Professor
(Buena Vista; March 16, 1961)

Producer Walt Disney *Associate Producer* Bill Walsh *Director* Robert Stevenson *Screenplay* Bill Walsh *Based on the Story "A Situation of Gravity" by* Samuel W. Taylor *Sequence Consultant* Donald Da Gradi *Cinematographer* Edward Colman *Musical Score* George Bruns *Film Editor* Irvine "Cotton" Warburton *Art Director* Carroll Clark *Set Decorators* Emile Kuri, Hal Gausman *Costume Supervisors* Chuck Keehne, Gertrude Casey *Orchestration* Franklin Marks *Second Unit*

Director Arthur J. Vitarelli *Assistant Director* Robert G. Shannon *Makeup* Pat McNalley *Hairdressing* Ruth Sandifer *Sound Supervisor* Robert O. Cook *Production Mixer* Dean Thomas *Special Sound Effects* William J. Wylie *Music Editor* Evelyn Kennedy *Songs "Medfield Flight Song" by* Richard M. Sherman, Robert B. Sherman *"Sweet Betsy of Pike" Special Lyrics by* Richard M. Sherman, Robert B. Sherman *Matte Artists* Peter Ellenshaw, Eustace Lycett *Animation Effects* Joshua Meador *Process Cinematography* Ub Iwerks *Optical Cinematography* Art Cruickshank *Optical Coordinator* Robert Broughton *Mechanical Effects Supervisor* Robert A. Mattey *Mechanical Effects Technicians* Danny Lee, Walter Stone

A Walt Disney Production. Made at Walt Disney Studios. Copyright December 20, 1960 by Walt Disney Productions. Wide Screen. RCA Photophone Recording. 97 minutes.

The Players: *Prof. Ned Brainard* Fred MacMurray *Betsy Carlisle* Nancy Olson *Alonzo Hawk* Keenan Wynn *Bill Hawk* Tommy Kirk *Fire Chief* Ed Wynn *Pres. Rufus Daggett* Leon Ames *Coach Elkins* Wally Brown *First Referee* Alan Carney *Shelby Ashton* Elliott Reid *Defense Secretary* Edward Andrews *Gen. Singer* David Lewis *Air Force Captain* Jack Mullaney *Mrs. Chatsworth* Belle Montrose *Ofr. Kelly* Forrest Lewis *Ofr. Hanson* James Westerfield *Youth* Ned Wynn *Rev. Bosworth* Gage Clarke *Gen. Hotchkiss* Alan Hewitt *Adm. Olmstead* Raymond Bailey *Gen. Poynter* Wendell Holmes *Lenny* Don Ross *Sig* Charlie Briggs *TV Newsman* Wally Boag *Basketball Player No. 18* Leon Tyler *Rival Basketball Coach* Gordon Jones *Radio Voices* Paul Frees

Additional Oscar Nominations: *Cinematography — Black-and-White* (Edward Colman); *Art Direction-Set Decoration — Black-and-White* (Carroll Clark, Emile Kuri, Hal Gausman)

Note: Sequel was *Son of Flubber* (Buena Vista, 1963). Director of Photography Edward Colman had been known in England as Edward Cohen.

The Guns of Navarone

(Columbia; June 22, 1961)

Producer Carl Foreman *Associate Producers* Cecil F. Ford, Leon Becker *Directors* J. Lee Thompson, Alexander Mackendrick *Screenplay* Carl Foreman *Based on the Novel by* Alistair MacLean *Cinematographer* Oswald Morris *Second Unit Cinematographer* John Wilcox *Musical Score* Dimitri Tiomkin *conducting* The Sinfonia of London *Film Editor* Alan Osbiston *Associate Film Editors* John Victor Smith, Raymond Poulton, Oswald Hafenrichter *First Assistant Film Editor* Joan Morduch *Assistant Director* Peter Yates *Second Assistant Director* Roy

Millichip *Costume Designer* Olga Lehmann *Wardrobe Supervisor* Monty Berman *Production Designer* Geoffrey Drake *Assistant Art Director* Frank Willson *Set Designers* Robert Cartwright, John Graysmark *Set Decorator* Maurice Fowler *Property Master* Bernard Murrell *Script Supervisor* Pamela Davies *Second Unit Script Supervisor* Lee Turner *Makeup* George Frost, Wally Schneidermann *Hairdressing* Joan Smallwood *Maps* Halas & Batchelor Cartoon Films Ltd. *Camera Operator* Denys Coop *Assistant Cameraman* Ronnie Maasz *Second Assistant Cameraman* Michael Rutter *Second Unit Camera Operator* Dudley Lovell *Second Unit Assistant Cameramen* Geoffrey Glover, Jimmy Turrell *Second Unit Second Assistant Cameraman* Douglas Milsons *Sound Supervisor* John Cox *Sound* Shepperton Studios *Production Mixer* George Stephenson *Recorder* Ernie Webb *Boom Operator* Jack W. Davis *Sound Editor* Vivian (Chris) Greenham *Production Manager* Harold Buck *Production Secretary* Golda Offenheim *Camera Grip* Albert Lott *Gaffer* Jack Sullivan *Chief Carpenter* G.J. Moody *Songs* Dimitri Tiomkin, Paul Francis Webster, Alfred Perry *Sung by* Elga Anderson, James Darren *Technical Advisers* Lt. Gen. Fritz Bayerlein, Brid. Gen. D.S.T. Twinbull, Lt. Col. P.F. Kertemilidis, Lt. Gen. P.J. Hands, Cmdr. John Theologitis, Maj. P.M. Lazaridis, Maj. W.D. Mangham *Production Cooperation* British Ministry of Defense; Hellenic Army, Navy and Air Force *Special Effects Supervisors* William Warrington, Wally Veevers *Special Effects Technicians* Pat Moore, John Stears

A Highroad Presentation. A Carl Foreman Production. An Open Road Film. Made at Shepperton Studios and Associated British Studios and on location in Rhodes. Copyright July 1, 1961 by Open Road Films Ltd. CinemaScope. Eastman Color. Processed by Technicolor. Print by Pathe. Westrex Recording System. 159 minutes.

The Players: *Capt. Keith Mallory* Gregory Peck *Cpl. Miller* David Niven *Col. Andrea Stavros* Anthony Quinn *Chief Petty Ofr. Brown* Stanley Baker *Maj. Roy "Lucky" Franklin* Anthony Quayle *Mara Pappadimos* Irene Papas *Anna* Gia Scala *Pvt. Spyros Pappadimos* James Darren *Cmdr. Jensen and Introductory Narrator* James Robertson Justice *Sq. Ldr. Barnsby* Richard Harris *Cohn* Bryan Forbes *Baker* Allan Cuthbertson *Weaver* Michael Trubshawe *Sgt. Grogan* Percy Herbert *Capt. Hoffman* Sessler George Mikell *Capt. Muessel* Walter Gotell *Nikolai* Tutte Lemkow *Commandant* Albert Lieven *Group Captain* Norman Wooland *Bride* Cleo Scouloudi *Patrol Boat Captain* Nicholas Papakonstantinou *German Gunnery Officer* Christopher Rhodes

Additional Oscar Nominations: *Picture* (Foreman, Columbia; Carl Foreman); *Direction* (J. Lee Thompson); *Writing — Screenplay based on material from another source* (Carl Foreman); *Sound* (Shepperton Studio Sound Department, John Cox); *Music — Scoring of a Dramatic or Comedy Picture* (Dimitri Tiomkin)

Note: Alexander Mackendrick was replaced as director due to illness. The final release prints may not contain any footage he shot. On British prints Carl Foreman is credited as executive producer and Cecil Ford is billed as producer. Eastman Color and Pathe credits are only on U.S. prints, with Technicolor receiving solo credit on British prints. Released in England in May 1961 with a B.B.F.C. A certificate. Sequel was *Force Ten from Navarone* (American International, 1978).

1962

Special Effects Nominations

*Daryl F. Zanuck's *The*
Longest Day Robert MacDonald
(Zanuck, 20th Century–Fox) *Audible:* Jacques Maumont
Mutiny on the Bounty A. Arnold Gillespie
(Arcola, MGM) *Audible:* Milo Lory

Comments

Two hard-ticket spectaculars received this year's nominations. *The Longest Day*, the incredibly accurate dramatization of the Allied D-Day offensive, had pyrotechnical effects galore. It also employed some excellent miniatures, especially gilders, matte art and occasionally noticeable traveling mattes. Mechanical wizard Bob MacDonald was one of a very large Special Effects crew but was solo cited. Re-recordist Jacques Maumont was awarded the sound effects Oscar. For some idiotic reason, the film clip shown at the Awards ceremony was just an aerial shot of a Luftwaffe fighter strafing the beached Allied Forces. This was exciting stuff but hardly the scene to present as an example of the overall effects work.

MGM's 70mm remake of *Mutiny on the Bounty* had nothing unusual except the excellent incorporation of process photography during the interior shots of the burning ship. This sequence looks unimpressive, however, when viewed today on 16mm nontheatrical or television prints which are grainy with predominating orange hues. A very pale representative of the bright and sharp theatrical original. The miniature marine storm was okay but not extraordinary. The South Seas adventure about Britain's first naval mutiny was also nominated for audible effects.

Credits

Darryl F. Zanuck's *The Longest Day*
(20th Century–Fox; October 4, 1962)

Producer Darryl F. Zanuck *Associate Producer* Elmo Williams *Directors* Ken Annakin *(British exteriors)*; Andrew Marton *(American exteriors)*; Bernhard

Wicki *(German sequences)* Gerd Oswald *(Ste. Mere Eglise sequences)* Darryl F. Zanuck *(American interiors and Irina Demich sequences)* Elmo Williams *(additional action sequences)* Screenplay Cornelius Ryan *Additional Script Material* Romain Gary, David Purcell, James Jones, Jack Seddon *Based on the Book by* Cornelius Ryan *Cinematographers* Henri Persin, Pierre Levent, Walter Wottitz, Jean Bourgoin *Aerial Cinematographer* Guy Tabory *Musical Score* Maurice Jarre *Title Song* Paul Anka *Vocal Arrangement* Mitch Miller *Vocal* Mitch Miller's Sing Along Gang *Film Editors* Marie-Louise Barberot, Samuel E. Beetley *Supervising Sound Editor* Douglas O. Williams *Sound Editor* Alain Antik *Battle Coordinator* Elmo Williams *Camera Operators* Jean Benezech, Andreas Winding, Gilles Bonneau, Yvan Ygouf, Jean-Marie Maillols, Daniel Diot, Albert Militen, Robert Foucard, Georges Pastier, Francois Franchi, Louis Stein, Rene Guissart, Vladimir Ivanov, Jean Lalier, Henri Tiquet *Assistant Cameraman* Jean Castagnier *Camera Helicopter Pilot* Gilbert Chomat *Art Directors* Ted Haworth, Auguste Capelier, Leon Barsacq, Vincent Korda *Assistant Art Director* Gilbert Margerie *Set Decorator* Gabriel Bechir *Makeup* Georges Bouban, Boris Karabanoff *Hairdressing* Marc Blanchard, Janine Jarreau, Renee Guidet *Production Mixers* Joseph de Bretagne, Antoine Petitjean, William Robert Sivel, Robert Philippe, Robert Teisseire *Dubbing Mixer* Jacques Maumont *Costume Designer* Monique Plotin *Wardrobe* Colette Baudot, John MacCory, Margaret Brachet, Leon Zay, Jacques Cottin, Jean Zay *Production Managers* Georges Charlot, Lee Katz, Julien Derode, Louis Wipf, Henri Jacquillard *Assistant Directors* Bernard Farrel, Henri Sokal, Sam Itzkovitch, Jean Herman, Tom Pevsner, Guy Parodi, Louis Pitzele, Gerard Renateau, Paul Seban *Script Supervisors* Lydie Doucet, Lucie Lichtig, Gladys Goldsmith, Helly Sterian, Christiane Gremillon, Fabienne Strouve, Marie-Jose Kling *Dialogue Coach* Mickey Knox *Casting* Margot Capelier *Property Masters* Andre Davalan, Samuel Gordon *Gaffer* Claude Couty *British Army Coordinator* Roger De Fontaele *Assistants to the Producer* Richard D. Zanuck, Frank McCarthy *Unit Publicist* Fred Hift *Production Illustrator* Mentor Huebner *Technical Advisers* Maurice Chauvet, Gilbert Delamore *Military Consultants* Gen. Gunther Blumentritt, Lt. Gen. James Gavin, Maj. John Howard, Capitaine de Fregate Philippe Kieffer, Gen. D'Armee Pierre Koenig, Capt. Helmuth Lang, Brig. the Earl of Lovat, Gen. Sir Frederick Morgan, Lt. Gen. Max Pemsel, Maj. Werner Pluskat, Col. Josef Priller, Frau Lucie Marie Rommel, V. Adm. Friedrich Rugs *Technical Consultants* Cmdt. Jean Barral, Lt. Col. Roger Bligh, Com. Willard L. Bushy, Cmdt. Hubert Deschard, Lt. Col. A.J. Hillebrand, Col. James R. Johnson, Capitaine Fernand Prevost, Lt. Cmdr. E.C. Peake, Col. Albert Saby, Col. Joseph B. Seay, Mme. Leonard Gille, Johnny Jendrich *Processing* Franay LTC St. Cloud *Prints* De Luxe *Visual Effects* L.B. Abbott, Jean Fouchet F.L., David Stanley Horsley, Wally Veevers *Mechanical Effects* Henri Assola, Karl Baumgartner, Pedro Coronadolar, Basilio Cortijo, Karl Helmer, August J. Lohman, Robert A. MacDonald Sr., Alex C. Weldon

A Darryl F. Zanuck Production. Made at Studios de Boulogne and on location in France and Corsica. Copyright October 4, 1962 by Darryl F. Zanuck Productions Inc. and 20th Century–Fox Film Corporation. CinemaScope. Westrex Recording System. Stereophonic Sound. 180 minutes plus intermission.

The Players: *Lt. Col. Benjamin Vandervoort* John Wayne *Brig. Gen. Norman Cota* Robert Mitchum *Col. Tom Newton* Eddie Albert *U.S. Rangers* Paul Anka, Tommy Sands, Fabian Forte *Mme. Barrault* Arletty *Group Capt. J.N. Stagg* Patrick Barr *Pvt. Dutch Schultz* Richard Beymer *Colleville Mayor* Bourvil *R.A.F. Flight Ofr. David Campbell* Richard Burton *Pvt. John Steele* Red Buttons *Pvt. Flanagan* Sean Connery *Capt. Frank* Raymond Danton *Janine Boitard* Irina Demich *Maj. Gen. Robert Haines* Mel Ferrer *Brig. Gen. Theodore Roosevelt* Henry Fonda *Capt. Harding* Steve Forrest *Brig. Gen. Parker* Leo Genn *British Padre* John Gregson *R.A.F. Pilot* Donald Houston *Sgt. John Fuller* Jeffrey Hunter *Maj. Gen. Gunther Blumentritt* Curt Jurgens *Lord Lovat* Peter Lawford *Cmdr. Philippe Kieffer* Christian Marquand *Pvt. Morris* Roddy McDowell *Pvt. Watney* Michael Medwin *Pvt. Martini* Sal Mineo *Capt. Colin Maud* Kenneth More *Gen. Raymond O. Barton* Edmond O'Brien *R.A.F. Flight Officer* Leslie Phillips *Correspondent Joe Williams* Ron Randall *Pvt. Clough* Norman Rossington *Brig. Gen. James M. Gavin* Robert Ryan *Destroyer Commander* Rod Steiger *Maj. John Howard* Richard Todd *Lt. Wilson* Tom Tryon *Lt. Col. Ocker* Peter Van Eyck *U.S. Ranger Sergeant* Robert Wagner *Lt. Sheen* Stuart Whitman *Maj. Gen. Walter Bedell Smith* Alexander Knox *Gen. Dwight D. Eisenhower* Henry Grace *Pvt. Harris* Mark Damon *Sgt. Wilder* Dewey Martin *Col. Caffey* John Crawford *Lt. Gen. Omar N. Bradley* Nicholas Stuart *British Briefing Officer* Jack Hedley *Adm. Sir Bertram Ramsey* John Robinson *Gen. Sir Bernard L. Montgomery* Trevor Reid *Father Roulland* Jean-Louis Barrault *Mother Superior* Madeleine Renaud *Sgt. Guy de Montlaur* Georges Riviere *R. Adm. Jaujard* Jean Servais *Mayor Alexandre Renaud* Georges Wilson *Louis* Fernand Ledoux *Field Marshal Erwin Rommel* Werner Hinz *Field Marshal Gerd von Rundstedt* Paul Hartmann *Sgt. Kaffeeklatsch* Gerd Frobe *Maj. Werner Pluskat* Hans Christian Blech *Maj. Gen. Max Pemsel* Wolfgang Priess *Col Josep "Pips" Priller* Heinz Reincke *Gen. Erich Marcke* Richard Muench *Gen. Hans von Salmuth* Ernest Schroeder *Capt. Ernst During* Karl Meisel *Lt. Col. Hellmuth Meyer* Heinz Spitzner *Col. Gen. Alfred Jodl* Wolfgang Luckschy *Maj. Gen. Dr. Hans Speidel* Wolfgang Buttner *First U.S. Commando Up Cliff* George Segal *U.S. Ranger Major* Fred Dur *R. Adm. Alan G. Kirk* John Meillon *U.S. Officers* Gary Collins, Sgt. Charles Pace *British Soldiers* Richard Wattis, Christopher Lee, Bill Nagy, Harold Goodwin, Michael Beint, Harry Flower, Neil McCallum *German Soldiers* Eugene Deckers, Peter Helm *Lt. Col. Meyer's Aide* Robert Freytag *Frau Lucie Marie Rommel* Ruth Hausmeister *Manfred Rommel* Michael Hinz *Col. Schiller* Paul Roth *Sgt. Bergsdorf* Harmret Rock *Luftwaffe General* Karl John *Luftwaffe Major* Dietmar Schonherr *Lt. Fitz Theen* Reiner Penkert *German Commander* Kurt Pecher *German Officer* Serge Tolstoy *Jean* Maurice Poli

Housekeeper Alice Tissot *Naval Captain* Jo D'Avra *Pvt. Coke* Frank Finlay *Lt. Walsh* Lyndon Brook *Ronald Callan* Bryan Coleman *A. C. M. Sir Trafford Leigh-Mallory* Simon Lack *A. C. M. Sir Arthur William Teddar* Louis Mounier *W. R. E. N.* Sian Phillips *British Army Doctor* Howard Marion Crawford *U. S. Ranger Commandos* Second U.S. Ranger Battalion *U. S. Assault Troops* Third U.S. Marine Battalion *French Women* Pauline Carton, Francoise Rosay

Additional Oscar Nominations: *Picture* (Zanuck, 20th Century–Fox; Darryl F. Zanuck); *Cinematography — Black-and-White* (Jean Bourgoin, Walter Wottitz)*; *Art Direction-Set Decoration — Black-and-White* (Ted Haworth, Leon Barsacq, Vincent Korda, Gabriel Bechir); *Film Editing* (Samuel E. Beetley)

Note: Test sequences were shot in Eastman Color, but discarded and the entire feature was produced in black-and-white. Even though all sequences were recorded in English, it was decided to release only an edition in which people of each nationality spoke their own language with English subtitles. Zanuck wanted the feature run without an intermission, and no announcement card was included on release prints. However, midway through, there was a dramatic buildup and fadeout so placed at reel's end that those theaters that wanted an intermission could break without damaging the narrative flow. Sequel was *Up from the Beach* (20th Century–Fox, 1965).

Mutiny on the Bounty

(Metro-Goldwyn-Mayer; November 8, 1962)

Producer Aaron Rosenberg *Directors* Lewis Milestone, Carol Reed *Screenplay* Charles Lederer, Eric Ambler, William L. Driscoll, Borden Chase, John Gay, Ben Hecht *Based on the Novels* Mutiny on the Bounty, Men Against the Sea *and* Pitcairn's Island *by* Charles Nordhoff, James Norman Hall *Cinematographer* Robert L. Surtees *Additional Cinematographer* Harold E. Wellman *Musical Score* Bronislau Kaper *Musical Director* Robert Armbruster *conducting the* MGM Studio Symphony Orchestra *Film Editor* John McSweeney *Associate Film Editor* Thomas J. McCarthy *Sound Editor* Milo Lory *Sound Supervisor* Franklin E. Milton *Dubbing Mixer* William Steinkamp *Music Editor* William Saracino *Art Directors* George W. Davis, Joseph McMillan Johnson *Set Decorators* Henry Grace, Hugh Hunt *Marine and Second Unit Director* James C. Havens *Unit Production Manager* Rudy Rosenberg *Assistant Director* Ridgeway Callow *Second Assistant Director* Major Roup *Production Assistant* Alan Callow *Color Consultant* Charles K. Hagedorn *Costume Designer* Moss Mabry *Makeup* William Tuttle *Hairdressing* Mary K. Keats *Choreography* Hamil Petroff *Technical Advisers* Capt. Donald MacIntyre R.N., Bengt Danielson, Aurora Natua, Leo Langomazino *Camera Operator* Conrad Hall *Assistant Cameramen* Bruce Surtees, Charles Termini *Stunt Coordinator* Larry

Duran *Still Photographer* Eric Carpenter *Unit Publicist* Morgan Hudgins *Location Liaison* Nick Rutgers *Ship Builders* Smith & Rhuland Shipyard *Ship's Captain* Ellsworth Coggins *Ship's Rigger* Olof Olsson *Blockmaker* Alfred Dauphinee *Sailmaker* Charlie Hebb *Song "Follow Me"* Bronislau Kaper, Paul Francis Webster *Titles and Opticals* MGM Laboratories *Special Effects* A. Arnold Gillespie *Matte Artist* Lee LeBlanc *Optical Cinematography* Robert R. Hoag

An Aaron Rosenberg Production. An Arcola Picture. Made at MGM Studios and on location in Tahiti, Pitcairn's Island, and Bora Bora. Copyright November 19, 1962 by Metro-Goldwyn-Mayer Inc. and Arcola Pictures Corporation. Ultra Panavision 70. Technicolor. Westrex Recording System. Stereophonic Sound. 179 minutes plus overture, intermission and exit music.

The Players: *First Ofr. Fletcher Christian* Marlon Brando *Capt. William Bligh* Trevor Howard *John Mills* Richard Harris *Alexander Smith* Hugh Griffith *William Brown* Richard Haydn *Maimiti* Tarita (Taritatumi Teriipaia) *Mathew Quintal* Percy Herbert *Edward Birkett* Gordon Jackson *William McCoy* Noel Purcell *John Williams* Duncan Lamont *Michael Byrne* Chips Rafferty *Samuel Mack* Ashley Cowan *John Fryer* Eddie Byrne *Edward Young* Tom Seely *Minarii* Frank Silvera *James Morrison* Keith McConnell *Tahitians* Rahera Tuia, Ruita Salmon, Nathalie Tehahe, Tematai Tevaearai, Odile Hinano Paofai, Teretiaiti Maifano, Virau Tepii, Maeva Maitihe, Louise Tefaafana, Tinorua Vaitahe, Adrien Mahitete, Tufariu Haamoeura, Leo Langamazino, Aurora Natua, Bengt Danielson *Chief Hitihiti* Matahiarii Tama *Tahitian Girls* Marabayshi, Tefaaoro, Faatiarau, Ahuroa, Teriitemihau, Manitearo, Agnes, Marie, Emily *Native Population* Citizens of Tahiti, Pitcairn's Island, Bora Bora *Sailor* Wayne DeWar *Court Martial Judge* Henry Daniell *Graves* Ben Wright *Staines* Torin Thatcher

Additional Oscar Nominations: *Picture* (Arcola, MGM, Aaron Rosenberg); *Cinematography — Color* (Robert L. Surtees); *Music — Song ("Love Song [Follow Me]" by* Bronislau Kaper, Paul Francis Webster); *Music — Music Score substantially original* (Bronislau Kaper); *Art Direction-Set Decoration — Color* (George W. Davis, J. McMillan Johnson, Henry Grace, Hugh Hunt)

Note: Lewis Milestone replaced Carol Reed as director. Previously filmed as *The Mutiny of the Bounty* (Crick & Jones, 1916), the present film is a remake of MGM's 1935 feature. A sequel went into production in the late 1970s but was never completed. Set decorator Henry Grace is the same man who portrayed Eisenhower in *The Longest Day*. Ultra Panavision 70 had previously been called MGM Camera 65, and pre-release publicity listed it as such in the credits. All current prints are in Metrocolor. The overture and exit music have been removed from current prints. Remade as *The Bounty* (Orion, 1984).

1963

Special Visual Effects Nominations

Alfred Hitchcock's *The Birds* Ub Iwerks
(Hitchcock, Universal)
*Joseph L. Mankiewicz' *Cleopatra* Emil Kosa, Jr.
(Wanger, 20th Century-Fox)

Scientific or Technical Award

Class III Douglas G. Shearer and A. Arnold
Gillespie of MGM Studios
For the engineering of an improved Background Process Projection System

Comments

Our natural fowl went on a rampage in Alfred Hitchcock's *The Birds*, a Technicolor nightmare of one Northern California community's helplessness when the title creatures start attacking people. Real birds plus exceptional mechanical props and cartoon animation were employed, along with topnotch matte art and some good sodium vapor and generally noticeable blue screen traveling mattes. Only Ub Iwerks, who was one of many effects men involved, was nominated. He worked on the sodium vapor shots.

The Academy felt that Emil Kosa's extraordinary matte paintings in Joseph L. Mankiewicz' *Cleopatra* were better overall.

Neither film was noted for sound effects, strange considering *The Birds'* use of electronic foley throughout. Starting this year—and about time!— Sound Effects would be honored under a separate category. This year was also noteworthy for the reclassification of Special Effects to Special Visual Effects.

Credits

Alfred Hitchcock's *The Birds*

(Universal; April 20, 1963)

Producer and Director Alfred J. Hitchcock *Screenplay* Evan Hunter, Alfred J.

Hitchcock *Based on the Novella by* Daphne du Maurier *Cinematographer* Robert Burks *Electronic Sounds* Oskar Sala, Remi Gassman *Electronic Sounds Consultant* Bernard Hermann *Film Editor* George Tomasini *Associate Film Editor* Bud Hoffman *Sound Editor* Edward M. Abroms *Second Unit Director* Jon Hall *Second Unit Cinematographer* Roswell A. Hoffman *Assistant to Alfred Hitchcock* Peggy Robertson *Assistant Director* James H. Brown *Second Assistant Director* Foster H. Phinney *Production Manager* Norman Deming *Script Supervisor* Lois Thurman *Art Director* Robert Boyle *Set Decorator* George Milo *Costume Supervisor* Rita Riggs *Tippi Hedron's Costume Designer* Edith Head *Makeup* Bud Westmore, Howard Smit, Robert Dawn, John Chambers *Hairdressing* Larry Germain, Virginia Darcy *Bird Trainer* Ray Berwick *Bird Wranglers* James Dannaldson, John "Bud" Carlos *Camera Operator* Leonard South *Assistant Cameraman* Gosta "Gus" Ryden *Title Design* James S. Pollack *Producer-Director's Secretary* Suzanne Gauthier *Production Illustrator* Harold Michaelson *American Humane Association Observer* Paul Ridge *Sound Supervisor* Waldon O. Watson *Production Mixer* William Russell *Dubbing Mixer* Robert L. Hoyt *Matte Artist* Albert J. Whitlock *Process Cinematography* Ub Iwerks, Walt Disney Studios *Optical Cinematography* Roswell A. Hoffman *Additional Visual Effects* Robert R. Hoag, MGM Studios; L.B. Abbott, 20th Century–Fox Studios; Linwood G. Dunn, Film Effects of Hollywood *Animation* David Fleischer *Mechanical Effects Supervisor* Lawrence W. Hampton *Mechanical Effects Technician* Marcel Delgado

An Alfred J. Hitchcock Production. Made at Universal City Studios and on location in Bodega Bay, San Francisco, Bodega, and Bodega Head, California. Copyright March 28, 1963 by Alfred J. Hitchcock Productions Inc.; Applied Author: Universal Pictures Company Inc. Wide Screen. Technicolor. Westrex Recording System. 120 minutes.

The Players: *Mitch Brenner* Rod Taylor *Lydia Brenner* Jessica Tandy *Annie Hayworth* Suzanne Pleshette *Melanie Daniels* Tippi Hedron *Cathy Brenner* Veronica Cartwright *Mrs. Bundy* Ethel Griffies *Sebastian Sholes* Charles McGraw *Mrs. MacGruber* Ruth McDevitt *Deputy Sheriff Al Malone* Malcolm Atterbury *Deke Carter* Lonny Chapman *Helen Carter* Elizabeth Wilson *Hysterical Mother* Doreen Lang *Drunk* Karl Swenson *Traveling Salesman* Joe Mantell *Fisherman* Doodles Weaver *Post Office Clerk* John McGovern *Man in Elevator* Richard Deacon *Cafe Patron* William (Bill) Quinn *Little Girl* Suzanne Cupito [Morgan Brittany] *Man Exiting Bird Shop* Alfred Hitchcock

Note: Ub Iwerks' official screen billing was Special Photographic Adviser. Previously made as a British television film. Evan Hunter is the famous novelist Ed McBain's real name.

Joseph L. Mankiewicz' *Cleopatra*

(20th Century-Fox; June 12, 1963)

Producer Walter Wanger *Director* Joseph L. Mankiewicz *Screenplay* Joseph L. Mankiewicz, Ranald MacDougall, Sidney Buchman, Nunnally Johnson *Based on the Book* The Life and Times of Cleopatra *by* C.M. Franzero *and on historical writings by* Plutarch, Suetonoius and Appian *Cinematographer* Leon Shamroy *Musical Score* Alex North *Film Editor* Dorothy Spencer *Production Designer* John De Cuir *Art Directors* Jack Martin Smith, Hilyard Brown, Herman Blumenthal, Elven Webb, Maurice Pelling, Boris Juraga, Enzo Bulgarelli *Set Decorators* Walter M. Scott, Paul S. Fox, Paul Ray Moyer *Men's Costume Designer* Vittorio Nino Novarese *Women's Costume Designer* Renie *Elizabeth Taylor's and Additional Costumes Designer* Irene Sharaff *Choreography* Hermes Pan *Assistant Director* Fred R. Simpson *Second Assistant Director* Richard Lang *Unit Production Managers* Forrest E. Johnston, C.O. Erickson *Italian Production Manager* Franco Magli *Casting* Owen McLean *Casting Consultant* Stuart Lyons *Makeup* Alberto De Rossi *Elizabeth Taylor's Hairdressing* Vivienne Zavitz *Second Unit Directors* Ray Kellogg, Andrew Marton *Second Unit Cinematographers* Claude Renoir, Pietro Portalupi *Second Unit Production Manager* Saul Wurtzel *Associate Musical Director* Lionel Newman *Color Consultant* Leonard Doss *Music Editor* George Adams *Production Executive* Doc Merman *Production Supervisor* Sid Rogell *Property Masters* Samuel Gordon, Joseph LaBella, Bill Middlesat *Production Illustrators* Ed Graves, Leon Harris *Set Designer* John Barry *Costume Makers* Western Costume Company *Costume Coordinator* Irina Wassilichikov *Costume Model Maker* Wah Chang *Wardrobe Supervisors* Courtney Haslem, Eddie Wynigear *Production Assistant* Rosemary Mathews *Dialogue Coach* Pamela Danova *Elizabeth Taylor's Secretary* Dick Hanley *Assistant to Elizabeth Taylor* John Lee *Construction Supervisors* Jack Tait, Herbert Cheek *Gaffer* Fred Hall *Key Grip* Leo McCreary *Still Photographer* Bert Stern *Script Supervisors* Elaine Schreyeck, Stanley K. Scheuer *Unit Publicists* Jack Brodsky, Guilio Ascarelli *Production Accountant* Larry Rice *Camera Operator* Irving Rosenberg *Assistant Cameraman* Lee "Red" Crawford *Wig Makers* Stanley Hall of London *Sound Supervisors* Fred Hynes, James Corcoran *Sound* Todd-AO, 20th Century-Fox Studios *Production Mixer* Bernard Freericks *Scoring Mixers* Murray Spivack, Douglas O. Williams *Dubbing Mixer* Murray Spivack *Todd-AO Development* American Optical Company, Magna Theatre Corporation *Visual Effects* L.B. Abbott *Matte Artist* Emil Kosa, Jr. *Mechanical Effects* August J. Lohman, Gerald Endler

An MCL Films-Walwa Films Production. Produced by 20th Century-Fox Productions Ltd. Made at Studio Cinecitta and Studio Sperimentale, Rome, and Pinewood Studios, London, and on location in England, Almeria, Spain, Alexandra, Edkou and the northern desert, Egypt and Torre, Astura, Anzio, Ischia and Lanuvro, Italy. Copyright June 19, 1963 by 20th Century-

Fox Productions Ltd. Todd-AO. Color by De Luxe. Westrex Recording System. Stereophonic Sound. 243 minutes plus overture and intermission.

The Players: *Cleopatra* Elizabeth Taylor *Marc Antony* Richard Burton *Julius Caesar* Rex Harrison *High Priestess* Pamela Brown *Flavius* George Cole *Sosigenes* Hume Cronyn *Apollodorus* Casare Danova *Brutus* Kenneth Haigh *Agrippa* Andrew Keir *Octavian* Roddy McDowall *Germanicus* Robert Stephens *Eiras* Francesca Annis *Pothinos* Gregoire Aslan *Ramos* Martin Benson *Theodotos* Herbert Berghof *Phoebus* John Cairney *Rufio* Martin Landau *Lotos* Jacqui Chan *Charmian* Isabelle Cooley *Achillas* John Doucette *Canidius* Andrew Faulds *Cimber* Michael Gwynn *Cicero* Michael Hordern *Cassius* John Hoyt *Euphranor* Marne Maitland *Casca* Carroll O'Connor *Ptolemy* Richard O'Sullivan *Calphurnia* Gwen Watford *Decimus* Douglas Wilmer *Queen of Tarsus* Marina Berti *High Priest* John Karlsen *Caesarion at Age 4 Years* Loris Loddi *Octavia* Jean Marsh *Marcellus* Gin Mart *Mithridates* Furio Meniconi *Caesarion at Age 12 Years* Kenneth Nash *Caesarion at Age 7 Years* Del Russell *Valus* John Valva *Roman Soldier* Gary Collins *Dancers* Leo Coleman, Claude Marchant

Additional Oscar Nominations: *Picture* (20th Century–Fox, Walter Wanger); *Actor* (Rex Harrison); *Cinematography — Color* (Leon Shamroy)*; *Art Direction-Set Decoration — Color* (John De Cuir, Jack Martin Smith, Hilyard Brown, Herman Blumenthal, Elven Webb, Maurice Pelling, Boris Juraga, Walter M. Scott, Paul S. Fox, Paul Ray Moyer); *Costume Design — Color* (Irene Sharoff, Vittorio Nino Novarese, Renie)*; *Sound* (20th Century–Fox Studio Sound Department, James P. Corcoran, Todd-AO Sound Department, Fred Hynes); *Film Editing* (Dorothy Spencer); *Music — Music Score substantially original* (Alex North)

Note: Production began in England with a different cast and crew but was halted. After an almost complete changeover in all departments it was resumed. The film had changed from a moderately budgeted feature to the most expensive roadshow made up to that time. Several features had been made concerning the same lead characters, but this could be considered a remake of only one, Cecil B. De Mille's 1934 Paramount production. Re-edited to 222 minutes, 215 minutes and 166 minutes plus overture and intermission. This last version was the most generally released edition. It was restored to its original length for network television presentation and videocassette release.

1964

Special Visual Effects Nominations

Mary Poppins Peter Ellenshaw, Hamilton
(Disney, Buena Vista) Luske, Eustace Lycett
7 Faces of Dr. Lao . Jim Danforth
(Pal, MGM)

Scientific or Technical Awards

Class I Petro Vlahos, Wadsworth E.
Pohl and Ub Iwerks
For the conception and perfection of techniques for Color
Traveling Matte Composite Cinematography
Class III Stewart Filmscreen Corporation
For a seamless translucent Blue Screen for Traveling Matte
Color Cinematography
Class III . Anthony Paglia and the
20th Century–Fox Studio
Mechanical Effects Department
For an improved method of producing Explosion Flash Effects
for motion pictures

Comments

Two endearing fantasies, both from masters of the imaginary, were
pitted against each other in this year's balloting.

Mary Poppins, the story of a magically inclined nanny who takes over two
unruly English children, was the crowning live action Disney achievement.
Excellent wire mechanics, beautiful matte paintings, and extraordinary in-
corporation with interacting cartoon animation made this musical comedy a
treat to behold. It was at the time the highest-grossing Disney feature and
has been re-issued several times, though always in a monophonic sound ver-
sion, depriving repeat and new viewers of the opportunity to hear the
original stereophonic edition. Unfortunately, the nontheatrical version of
this classic has been reframed and duped over, resulting in a great loss of pic-
torial quality as well as allowing the flying wires, due to the increase in con-
trast, to become distractingly visible. This was not the case in the original
35mm IB prints, though they had been viewable in the original preview

trailers which were, of course, dupes. This has led recent spectators to mistakenly believe the flying work to be far less in quality than it was.

George Pal's production *7 Faces of Dr. Lao* related the effects a strange Chinese circus had on a small Western town. Definitely a message comedy, (as was *Mary Poppins* for that matter), its main effects sequence, for which Jim Danforth was cited, was the enlargement of a small fish into the giant Loch Ness monster. Through stop-motion animation and traveling mattes, this scene has become a classic movie segment and garnered Danforth a legion of Special Effects fans and a cult status.

Credits

Mary Poppins
(Buena Vista; August 26, 1964)

Producer Walt Disney *Co-Producer* Bill Walsh *Director* Robert Stevenson *Screenplay* Bill Walsh, Don Da Gradi *Based on the "Mary Poppins" Books by* P.L. Travers *Cinematographer* Edward Colman *Music and Lyrics* Richard M. Sherman, Robert B. Sherman *Musical Orchestrator and Conductor* Irwin Kostal *Film Editor* Irvine "Cotton" Warburton *Consultant* P.L. Travers *Art Directors* Carroll Clark, William H. Tuntke *Production Design Consultant and Costume Designer* Tony Walton *Set Decorators* Emile Kuri, Hal Gausman *Sound Supervisor* Robert O. Cook *Production Mixer* Dean Thomas *Special Sound Effects* William J. Wylie *Choreography* Marc Breaux, Dee Dee Woods Breaux *Costume Coordinator* Bill Thomas *Wardrobe Supervisors* Chuck Keehne, Gertrude Casey *Music Editor* Evelyn Kennedy *Makeup* Pat McNalley *Hairdressing* LaRue Matheron *Assistant Directors* Joseph L. McEveety, Paul Feiner *Dance Accompanist* Nat Farber *Assistant to the Conductor* James MacDonald *Second Unit Director* Arthur J. Vitarelli *Matte Artists* Peter Ellenshaw, Eustace Lycett *Assistant Matte Artist* Constantine Ganakes *Process Cinematography* Ub Iwerks *Optical Cinematography* Art Cruickshank *Optical Coordinator* Robert Broughton *Animation Director* Hamilton S. Luske *Animation Art Director* McLaren Stewart *Animators* Milt Kahl, Ollie Johnson, John Lounsberg, Hal Ambro, Frank Thomas, Ward Kimball, Eric Larson, Cliff Nordberg, Jack Boyd, Joe Hale *Effects Animation* Lee Dyer *Animation Backgrounds* Al Dempster, Don Griffith, Art Riley, Bill Layne *Nursery Sequence Designers* Bill Justice, Xavier Atenco *Mechanical Effects Supervisor* Robert A. Mattey *Mechanical Effects Technicians* Walter Stone, Danny Lee, Marcel Delgado

A Walt Disney Production. Made at Walt Disney Studios. Copyright August 18, 1964 by Walt Disney Productions. Wide Screen. Technicolor. RCA Photophone Recording. Stereophonic Sound. 139 minutes.

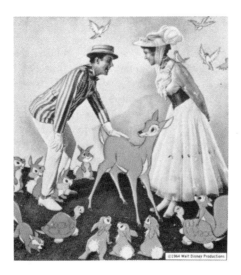

While this is a composite still for newspaper publicity purposes, it demonstrates the incorporation of live action with cel animation via "yellow screen" (sodium) traveling matte. This system, unlike the "blue screen" technique, required a modified three-color Technicolor camera and could not be used with anamorphic lenses.

The Players: *Mary Poppins* Julie Andrews *Bert* Dick Van Dyke *George Banks* David Tomlinson *Winifred Banks* Glynis Johns *Uncle Albert* Ed Wynn *Ellen* Hermione Baddeley *Jane Banks* Karen Dotrice *Michael Banks* Matthew Garber *Katie Nanna* Elsa Lanchester *Constable Jones* Arthur Treacher *Adm. Boom* Reginald Owen *Mrs. Brill* Reta Shaw *Junior Dawes* Arthur Malet *Bird Woman* Jane Darwell *Grubbs* Cyril Delevanti *Tomes* Lester Matthews *Mousley* Clive L. Halliday *Binnacle* Don Barclay *Miss Lark* Marjorie Bennett *Mrs. Cory* Alma Lawton *Miss Persimmon* Marjorie Eaton *Citizen* Maj. Sam Harris *Bank Depositor* Doris Lloyd *Man* Jimmy Logan *Senior Dawes* Navckid Keyd (Dick Van Dyke)

Additional Oscar Nominations: *Picture* (Disney, Buena Vista; Walt Disney, Bill Walsh); *Actress* (Julie Andrews)*; *Direction* (Robert Stevenson); *Writing — Screenplay based on material from another medium* (Bill Walsh, Don Da Gradi); *Cinematography — Color* (Edward Colman); *Art Direction-Set Decoration — Color* (Carroll Clark, William H. Tuntke, Emil Kuri, Hal Gausman); *Costume Design — Color* (Tony Walton); *Sound* (Walt Disney Studio Sound Department, Robert O. Cook); *Film Editing* (Cotton Warburton)*; *Music — Song* ("Chim Chim Cher-ee" by Richard M. Sherman, Robert B. Sherman)*; *Music — Music Score substantially original* (Richard M. Sherman, Robert B. Sherman)*; *Music — Scoring of Music, adaptation or treatment* (Irwin Kostal)

7 Faces of Dr. Lao

(Metro-Goldwyn-Mayer; April 1964)

Producer and Director George Pal *Screenplay* Charles Beaumont, Ben Hecht *Based on the Novel* The Circus of Dr. Lao *by* Charles G. Finney *Cinematographer* Robert Bronner *Musical Score* Leigh Harline *Film Editor* George Tomasini *Art Directors* George W. Davis, Gabriel Scognamillo *Set Decorators* Henry Grace, Hugh Hunt *Assistant Director* Al Shenberg *Assistant to the Producer* Gae Griffith *Makeup* William Tuttle, Charles Schram *Hairdressing* Sydney Guilaroff, Mary K. Keats *Magic Adviser* Duninger (George L. Boston) *Titles and Opticals* MGM Laboratories *Sound Supervisor* Franklin E. Milton *Dubbing Mixer* William Steinkamp *Visual Effects* Project Unlimited *Visual Effects Supervisors* Wah Chang, Gene Warren *Stop Motion Animators* Jim Danforth, Pete Kleinow *Optical Cinematography* Robert R. Hoag *Mechanical Effects* Paul B. Byrd, Ralph Rodine

A George Pal Production. A Galaxy-Scarus Picture. Made at MGM Studios. Copyright December 31, 1963 by Metro-Goldwyn-Mayer Inc., Galaxy Productions Inc. and Scarus Inc. Wide Screen. Metrocolor. Westrex Recording System. 100 minutes.

The Players: *Dr. Lao, Merlin the Magician, Pan, Medus, Apollonius of Tyana, Circus Spectator* Tony Randall *Angela Benedict* Barbara Eden *Clint Stark* Arthur O'Connell *Ed Cunningham* John Erickson *Tim Mitchell* Noah Beery, Jr. *Mrs. Howard T. Cassan* Lee Patrick *Kate Lindquist* Minerva Urecal *Luther Lindquist* John Qualen *Peter Ramsey* Frank Kreig *Mrs. Ramsey* Peggy Rea *George C. George* Eddie Little Sky *Carey* Royal Dano *Sarah Benedict* Argentina Brunetti *Lucas* John Doucette *Lean Cowboy* Dal McKennon *Mayor James Sargent* Frank Cady *Fat Cowboy* Chubby Johnson *Toothless Cowboy* Douglas Fowley *Mike Benedict* Kevin Tate *Abominable Snowman* Peter Pal

Additional Oscar Nomination: *Honorary Award — Statuette* (William Tuttle for his outstanding makeup achievement)

Note: Working title was *The Circus of Dr. Lao*. For publicity purposes Tony Randall was erroneously billed as the Giant Serpent (an animated model) and the Abominable Snowman (actually Peter Pal, George's son).

1965

Special Visual Effects Nominations

The Greatest Story Ever Told J. McMillan Johnson
(Stevens, UA)
*Ian Fleming's *Thunderball* John Stears
(Broccoli-Saltzman-McClory, UA)

Comments

How a movie with as poor effects as *Thunderball* could be nominated for an Oscar is anybody's guess. This spy thriller about an international terrorist organization threatening the world with nuclear bombs was great fun, but the visual effects were strictly substandard. The miniatures were plainly so, and the blue-screen traveling matte shots were grainy with distracting haloing. Supposedly one of the best sequences and the one viewed at the awards presentation ceremony showed a model aircraft crash-landing in the sea with the guide wires clearly visible! This threadbare work should have never seen the light of a projector beam.

The Greatest Story Ever Told, a hauntingly beautiful picturization of Christ's life, offered perfectly blended matte paintings and excellent optical photography. On the other hand, its rear screen process shots weren't too good and were especially noticeable in the 70mm Super Cinerama version.

Credits

The Greatest Story Ever Told
(United Artists; February 15, 1965)

Executive Producer Frank I. Davis *Producer* George Stevens, Sr. *Associate Producers* George Stevens, Jr., Antonio Vellani *Directors* George Stevens, Sr., David Lean, Jean Negulesco *Screenplay* James Lee Barrett, George Stevens, Sr. *Creative Associate* Carl Sandburg *Based on The Old Testament, The New Testament, various ancient writings, the Book by* Fulton Oursler *and the Radio Series and other writings by* Fulton Oursler *and* Henry Denker *Cinematographers* William C. Mellor, Loyal C. Griggs *Musical Score* Alfred Newman *Supervising Film*

Editor Harold F. Kress *Film Editors* W. Argyle Nelson, Jr., Frank O'Neill *Production Designer* David Hall *Art Directors* Richard Day, William J. Creber *Costume Designer* Vittorio Nino Novarese *Assistant Costume Designer* Marjorie O. Best *Special Color Consultant* Eliot Elisofon *Choral Supervisor* Ken Darby *Set Decorators* Paul Ray Moyer, Fred M. MacLean, Norman Rockett *Makeup* Del Armstrong *Makeup Assistant* Keester Sweeney *Hairdressing* Carmen Dirigo *Property Master* Sam Gordon *Construction Supervisor* Jack Tait *Cinerama Technical Adviser* Peter Gibbons *Sound Supervisors* Franklin E. Milton, William Steinkamp *Sound* Metro-Goldwyn-Mayer Studios *Production Mixer* Charles Wallace *Second Unit Directors* Richard Talmadge, William Hale *Assistant Directors* Ridgeway Callow, John Veitch *Second Assistant Director* Wendell Franklin *Research* Tony van Renterghem *Script Supervisor* John Dutton *Casting* Lynn Stalmaster *Production Managers* Nathan Barrager, Eric G. Stacey *Unit Managers* Thomas J. Andre, Raymond Gosnell, Lee William Lukather, Saul Wurtzel *Stunt Coordinator* Henry Wills *Orchestration* Leo Shuken, Jack Hayes *Special Music* Ovadia Tuvia *Special Music Adaptation* Frederick Steiner, Hugo Friedhofer *Aerial Sequences* Paul Mantz, Frank Tallman *Assistant Film Editor* Hal Ashby *Special Contact Lenses* Dr. Morton K. Greenspoon *Camera Operator* Irving Rosenberg *Assistant Cameraman* Charles Termini *Titles* Maury Nemoy *Special Effects* A. Arnold Gillespie *Matte Artists* Joseph McMillan Johnson, Matthew Yuricich *Process Cinematography* Clarence W.D. Slifer *Process Projectionist* Chares MacLeod *Optical Cinematography* Robert R. Hoag

A George Stevens Production. Made at Desilu Studios and MGM Studios and on location in Glen Canyon, Utah, and Waheep, Arizona. Copyright February 15, 1965 by George Stevens Productions Inc. and United Artists Corporation. Super Cinerama. Ultra Panavision 70. Technicolor. Westrex Recording System. Stereophonic Sound. 221 minutes including overture and intermission.

The Players: *Jesus Christ* Max Von Sydow *Mary the Mother* Dorothy McGuire *Joseph the Carpenter* Robert Loggia *John the Baptist* Charlton Heston *James the Younger* Michael Anderson, Jr. *Simon the Zealot* Robert Blake *Andrew* Burt Brinckerhoff *John* John Considine *Thaddaeus* Jamie Farr *Philip* David Hedison *Nathanael* Peter Mann *Judas Iscariot* David McCallum *Matthew* Roddy McDowell *Simon-Peter* Gary Raymond *Thomas* Tom Reese *James the Elder* David Sheiner *Martha of Bethany* Ina Balin *Mary of Bethany* Janet Margolin *Lazarus* Michael Tolan *Simon of Cyrene* Sidney Poitier *Mary Magdalene* Joanna Dunham *Veronica* Carroll Baker *Angel Guarding Tomb* Pat Boone *Bar Amand* Van Heflin *Uriah* Sal Mineo *Cured Woman* Shelley Winters *Old Aram* Ed Wynn *Centurion* John Wayne *Pontius Pilate* Telly Savalas *Claudia* Angela Lansbury *Pilate's Aide* Johnny Seven *Questor* Paul Stewart *Gen. Varus* Harold J. Stone *Caiaphas* Martin Landau *Shemiah* Nehemiah Persoff *Nicodemus* Joseph Schildkraut *Sorak* Victor Buono *Emissary* Robert Busch *Alexander* John Crawford *Scribe* Russell Johnson *Speaker of Capernaum* John

Lupton *Joseph of Arimathaea* Abraham Sofaer *Theophilus* Chet Stratton *Annas* Ron Whelan *Herod Antipas* Jose Ferrer *Herod the Great* Claude Rains *Aben* John Abbott *Lancer Captain* Rodolfo Acosta *Herod's Commander* Michael Ansara *Chuza* Philip Coolidge *Archelaus* Joe Perry *Herodias* Marian Seldes *Prince of Darkness* Donald Pleasence *Barabbas* Richard Conte *Tormentor* Frank De Kova *Dumah* Joseph Sirola *Melchior* Cyril Delevanti *Balthazar* Mark Leonard *Caspar* Frank Silvera *Jacob* Gil Perkins *Good Thief* Richard Bakalyan *Bad Thief* Marc Cavell *Weeping Woman* Renata Vanni *Simon-Peter's Second Accuser* John Pickard *Woman Behind Railings* Celia Lousky *Rabble Rouser* Mickey Simpson *Men* Frank Richards, Harry Wilson, Jim Boles *Woman* Dorothy Neumann *Lancer* Henry Wills *Salome's Dancers* Inbal Dance Theatre of Israel

Additional Oscar Nominations: *Cinematography — Color* (William C. Mellor, Loyal Griggs); *Art Direction-Set Decoration — Color* (Richard Day, William Creber, David Hall, Ray Moyer, Fred MacLean, Norman Rockett); *Costume Design — Color* (Vittorio Nino Novarese, Majorie Best); *Music — Music Score substantially original* (Alfred Newman)

Note: Originally announced for production in May 1955 by 20th Century-Fox to be filmed in CinemaScope 55, postponed until 1962 when that studio was to start filming in Todd-AO. After the failure of *Cleopatra* the project was sold to United Artists and shooting began in Cinerama then switched to Ultra Panavision 70. None of the three-panel footage appeared in the released version. David Lean and Jean Negulesco took over direction during George Stevens' illness. The first version prepared was 260 minutes, but the distributor demanded it be further edited. The premiere edition ran 238 minutes, but this was condensed to 197 minutes plus overture and intermission for all 70mm and 35mm general release prints. A 127 minute version, made by physically cutting the 197 minute 35mm prints, was briefly issued. It was then re-issued running 147 minutes; this is the version which is generally exhibited now. Restored to 197 minutes for television and videocassette. The life of Christ has been the subject of many features.

Ian Fleming's *Thunderball*

(United Artists; December 21, 1965)

Executive Producers Albert R. Broccoli, Harry Saltzman *Producer* Kevin McClory *Director* Terence Young *Screenplay* Richard Maibaum, John Hopkins *Based on the Screenplay by* Jack Whittingham *From the Story by* Jack Whittingham, Kevin McClory, Ian Fleming *Characters Created by* Ian Fleming *Cinematographer* Ted Moore *Musical Score* John Barry *Additional Music* Leslie Bricusse *Film Editor and Second Unit Director* Peter Hunt *Sound Editors* Norman Wanstall, Harry Miller *Production Designer* Ken Adam *Production Supervisor* David Middlemas *Title Song* John Barry, Don Black *Vocal* Tom

Jones *James Bond Theme* Monty Norman *Art Director* Peter Murton *Set Designer* Norman Reynolds *Assistant Director* Gus Agosti *Second Assistant Director* Richard Jenkins *Camera Operator* John Winbolt *Script Supervisor* Joan Davis *Makeup* Paul Rabiger, Basil Newall *Hairdressing* Eileen Warwick *Stunt Coordinator* Bob Simmons *Assembly Editor* Ben Rayner *Costume Designer* Anthony Mendelson *Costume Makers* Berman's Ltd. *Wardrobe* Eileen Sullivan, John Brady *Assistant Art Directors* Michael White, Peter Lamont *Set Decorator* Freda Pearson *Titles* Maurice Binder *Underwater Director* Ricou Browning *Production Manager* Edward Haldeman *Location Manager* Robert Watts *Bahamas Liaison* Patty Turtle *Underwater Cinematographer* Lamar Boren *Underwater Engineer* Jordan Klien *Sound* Pinewood Studios *Production Mixer* Bert Ross *Dubbing Mixer* Maurice Askew *Special Effects* John Stears

A Harry Saltzman–Albert R. Broccoli Presentation. An Eon Productions Ltd.–Danjaq S.A. Production. Made at Pinewood Studios and Ivan Tors Underwater Studios and on location in Florida, Chateau D'Arnet, France, and Nassau, Bahamas. Copyright December 10, 1965 by Danjaq of Johannesburg, S.A. Panavision. Technicolor. Westrex Recording System. Stereophonic Sound. 125 minutes.

The Players: *James Bond* Sean Connery *Domino* Claudine Auger *Emilio Largo* Adolfo Celi *Fiona Volpe* Luciana Paluzzi *Felix Leiter* Rik Van Nutter *M* Bernard Lee *Paula Caplan* Martine Beswick *Count Lippe* Guy Doleman *Patricia Fearing* Molly Peters *Maj. Boothroyd* Desmond Llewelyn *Miss Moneypenny* Lois Maxwell *Foreign Secretary* Roland Culver *Pinder* Earl Cameron *Maj. Francois Derval* Paul Stassino *Mme. Boitier* Rose Alba *Vargas* Philip Locke *Kutze* George Pravada *Janni* Michael Brennan *Group Captain* Leonard Sachs *Air Vice Marshal* Edward Underdown *Kenniston* Reginald Beckwith *Quist* Bill Cummings *Mlle. La Porte* Maryse Guy Mitsouko *Jacques Boitier* Bob Simmons *Stunts* Evelyn Boren, Frank Cousins, Harold Sanderson, Bob Simmons

Note: Released in G.B. in December 1965 with a B.B.F.C. A certificate and running 130 minutes. Remade as *Never Say Never Again* (Warner Bros., 1983). In the 1950s, Ian Fleming collaborated on an original screen version of his James Bond characters; however, the producer, Kevin McClory, was unable to raise financing. Fleming then novelized the script, which was sold in the package purchased by producers Harry Saltzman and Albert R. Broccoli with backing from United Artists. McClory still owned the screen rights, and after some legal hasseling, an arrangement was reached where McClory would produce the film as part of the Saltzman-Broccoli series and under their direct control. McClory retained remake rights. It was an unhappy arrangement for all concerned, and McClory worked on no other Bond projects for the two series producers. After more legal battles he finally remade it, much to the displeasure of his former partners. The other Bond films for United Artists were: *Dr. No* (1962), *From Russia with Love* (1963), *Goldfinger*

(1964), *You Only Live Twice* (1967), *On Her Majesty's Secret Service* (1969), *Diamonds Are Forever* (1971), *Live and Let Die* (1973), *The Man with the Golden Gun* (1974), *The Spy Who Loved Me* (1977), *Moonraker* (1979), which also received an Oscar nomination for trick work, *For Your Eyes Only* (1981), *Octopussy* (1983), and *A View to a Kill* (1985). *Casino Royale* (Columbia, 1964) was not part of their package, as the rights had already been sold and they were unable to secure them from the purchasers.

1966

Special Visual Effects Nominations

Fantastic Voyage Art Cruickshank
(20th Century–Fox)
Hawaii Linwood G. Dunn
(Mirisch, UA)

Comments

As with the previous year, we had two films with totally different quality effects. *Hawaii*, adapted from part of James Michener's historical novel about the white colonization of our fiftieth state, may have had a lot of good production values in other areas, but its visual effects were grainy and the storm sequence was polluted with very noticeable matte lines. The matte paintings were better, but all work was immediately recognizable as fake.

Fantastic Voyage, on the other end of the ruler, was top-of-the-heap stuff. Dealing with a medical team that had been microsized and injected into a patient to work their treatment from the inside out, this sci-fi classic featured every type of trick work. It too had grainy shots and noticeable matte bleeds, but as we were viewing a new world, those faults added to rather than subtracted from the imagery. Colorful models were used throughout, and almost every shot once the scientists entered the body involved some kind of optical or mechanical trickery.

Credits

Fantastic Voyage
(20th Century–Fox; August 24, 1966)

Producer Saul David *Director* Richard Fleischer *Screenplay* Harry Kleiner *Adaptation* David Duncan *Based on the Story by* Otto Klement and Jay Lewis Bixby *Cinematographer* Ernest Laszlo *Musical Score* Leonard Rosenman *Film Editor* William B. Murphy *Supervising Sound Editor* Walter A. Rossi *Creative Research and Production Design* Harper Goff *Production Illustrator* Frank Armitage *Art Directors* Jack Martin Smith, Dale Hennesy *Set Decorators* Walter M. Scott,

Examples of wire flying from "Fantastic Voyage."

Stuart A. Reiss *Unit Production Manager* Eric G. Stacey *Assistant Director* Ad Schaumer *Assistant Film Editor* Marion Rothman *Makeup* Ben Nye *Hairdressing* Margaret Donovan *Technical Adviser* Fred Zendar *Production Engineer* Oscar Wilson *Property Master* Jimmy Spies *Technical Consultant* Dr. Charles Bridgman *Construction Supervisor* Ivan Martin *Modeler* Jim Casey *Sound Supervisor* James B. Corcoran *Production Mixer* Bernard Freericks *Dubbing Mixer* David Dockendorf *Title Design* Richard Kuhn *Titles* National Screen Service *Costume Supervisors* Bruce Walkup, Truman Eli, Ollie Hughes *Casting* Marvin Schnall, Doris McHale, Michale McLean *Music Editor* George Adams *Visual*

Effects L.B. Abbott *Optical Cinematography* Art Cruickshank *Matte Artist* Emil Kosa, Jr. *Miniature Supervisor* Howard Lydecker *Miniaturists* Marcel Delgado, Roy Arbogast *Wire Floating/Flying Effects* Peter Foy

Made at 20th Century–Fox Studios and on location in Southern California. Copyright August 17, 1966 by 20th Century–Fox Film Corporation. CinemaScope. Color by De Luxe. Westrex Recording System. Stereophonic Sound. 100 minutes.

The Players: *Grant* Stephen Boyd *Cora Peterson* Raquel Welch *Gen. Carter* Edmond O'Brien *Dr. Michaels* Donald Pleasence *Col. Donald Reid* Arthur O'Connell *Capt. Bill Owens* William Redfield *Dr. Duval* Arthur Kennedy *Jan Banes* Jean Del Val *Communications Aide* Barry Coe *Secret Service Agent* Ken Scott *Nurse* Shelby Grant *Technician* James Brolin *Radio Operator* Brendan Fitzgerald

Additional Oscar Nominations: *Cinematography — Color* (Ernest Laszlo); *Art Direction-Set Decoration — Color* (Jack Martin Smith, Dale Hennesy, Walter M. Scott, Stuart A. Reiss)*; *Film Editing* (William B. Murphy); *Sound Effects* (Walter Rossi)

Note: Working titles were *Microscopia* and *Strange Journey*. After the film rights were sold, the short story was expanded into a novel. Filmation Associates produced an animated cartoon series for ABC-TV in 1968. The purposed sequel, *The Micronauts*, was never made.

James A. Michener's *Hawaii*
(United Artists; October 10, 1966)

Producer Walter Mirisch *Associate Producer* Lewis J. Rachmil *Directors* George Roy Hill, Arthur Hiller, Fred Zinneman *Screenplay* Dalton Trumbo, Daniel Taradash *Based on Portions of the Novel by* James A. Michener *Cinematographer* Russell Harlan *Musical Score* Elmer Bernstein *Film Editor* Stuart Gilmore *Sound Editor* Wayne B. Fury *Second Unit Cinematographer* Harold E. Wellman *Prologue Cinematographer* Charles F. Wheeler *Production Designer* Cary Odell *Song "My Wishing Doll"* Elmer Bernstein, Mack David *Costume Designer and Coordinator* Dorothy Jeakins *Prologue Director* James Blue *Art Director* James Sullivan *Set Decorators* Edward G. Boyle, Ray Boltz, Jr. *Production Supervisor* Allen K. Wood *Production Managers* Robert Anderson, Emmett Emerson *Second Unit Director* Richard Talmadge *Assistant Director* Ray Gosnell *Music Editor* Richard Carruth *Script Supervisor* Dixie McCoy *Research* Lelia Alexander *Sound Supervisor* Gordon E. Sawyer *Sound* Samuel Goldwyn Studios *Production Mixer* Robert Martin *Recorder* Bertil Hallberg *Scoring Mixer* John

Norman *Dubbing Mixer* Clem Portman *Technical Research* Louis Teague *Speech Consultant* Dr. Daniel Vandreagen *Property Master* Sam Gordon *Makeup Supervisor* Emile La Vigne *Makeup Artist* Daniel Striepeke *Makeup Technician* John Chambers *Hairdressing* Fae M. Smith *Wardrobe Supervisor* Eric Seelig *Choreography* Miriam Nelson *Casting* Marion Doughtery, Pat Rose *Orchestration* Leo Shuken, Jack Hayes *Violin Solo* Anatol Kaminsky *Cello Solo* Eleanor Slatkin *Flute Solo* Sylvia Suderman *Oboe Solo* Arnold Koblentz *Clarinet Solo* Mitchell Lurie *Camera Operator* Jack Whitman Jr. *Assistant Cameraman* Frank Stanley *Key Grip* Carl Gibson *Still Photographers* Dennis Stock, Al St. Hillaire *Marine Coordinator* Capt. Alan Villiers *Production Illustrator* Leon Harris *Assistant Costume Designer* Theodora Van Runkel *Visual Effects* Film Effects of Hollywood *Visual Effects Supervisor* Linwood G. Dunn *Visual Effects Cinematographer* James B. Gordon *Optical Cinematography* Cecil Love *Matte Artist* Albert Maxwell Simpson *Visual Effects Editor* Marshall M. Borden *Mechanical Effects* Paul Byrd

A Mirisch Corporation Presentation. A George Roy Hill–Walter Mirisch Production. Produced under arrangement with Pan Arts Co. Inc. Made at Samuel Goldwyn Studios and on location in Old Sturbridge, Massachusetts, Makua Beach, Oahu and Pearl City, Hawaii and off the coast of Bodo, Norway. Copyright October 24, 1966 by Mirisch Corporation of Delaware. Panavision 70. Color by De Luxe. Westrex Recording System. Stereophonic Sound. 189 minutes plus overture, intermission and exit music.

The Players: *Jerusha Bromley Hale* Julie Andrews *Abner Hale* Max Von Sydow *Capt. Rafer Hoxworth* Richard Harris *Charles Bromley* Carroll O'Connor *Abigail Bromley* Elizabeth Cole *Charity Bromley* Diane Sherry *Mercy Bromley* Heather Menzies *Rev. Thorn* Torin Thatcher *John Whipple* Gene Hackman *Immanuel Quigley* John Cullum *Abraham Hewlett* Lou Antonio *Alii Nui Malama* Jocelyne La Garde *Keoki* Manu Tupou *Kelolo* Ted Nobriga *Noelani* Elizabeth Logue *Iliki* Lokelani S. Chicarell *Gideon Hale* Malcolm Atterbury *Hepzibah Hale* Dorothy Jeakins *Capt. Janders* George Rose *Mason* Michael Constantine *Collins* John Harding *Cridland* Robert Crawford *Micah Hale at Age 4 Years* Robert Oakley *Micah at Age 7 Years* Henrik Von Sydow *Micah at Age 12 Years* Clas Von Sydow *Micah at Age 18 Years* Bertil Werjefelt *Man* Don Doolittle *Missionary's Seasick Wife* Bette Midler

Additional Oscar Nominations: *Supporting Actress* (Jocelyne La Garde); *Cinematography — Color* (Russell Harlan); *Costume Design — Color* (Dorothy Jeakins); *Sound* (Samuel Goldwyn Studio Sound Department, Gordon E. Sawyer); *Music — Song* ("My Wishing Doll" by Elmer Bernstein and Mack David); *Music — Original Music Score* (Elmer Bernstein)

Note: Director Fred Zinneman dropped out of the project after more than four years of preproduction. George Roy Hill took over but left during pro-

duction, with Arthur Hiller replacing him. Hill then returned and completed the show. Hiller's scenes were incorporated into the final release version. Zinneman may not have actually shot any footage. Later re-edited to 171 minutes, then 115 minutes. Mirisch's sequel, *The Hawaiians* (United Artists, 1970), was also based on portions of Michener's original novel.

1967

Special Visual Effects Nominations

Doctor Dolittle L.B. Abbott
(APJAC, 20th Century–Fox)

Tobruk Howard A. Anderson, Jr.,
(Gibraltar-Corman, Universal) Albert Whitlock

Comments

20th Century–Fox, recovering from the disaster of *Cleopatra* with the huge success of *The Sound of Music,* launched a series of elaborate, overly expensive and uniformly unsuccessful 70mm musical roadshows. This year's winner was one of those bombs. *Doctor Dolittle* was the studio's answer to *Mary Poppins* and was aimed at tune-loving adult patrons as well as children. This resulted in the overblown feature working on no level. Production-wise, this version of the children's stories of an English veterinarian who talked to animals was excellent, but at two and a half hours plus was such a bore that it failed to break even in any market. The songs were terrible to boot. All the matte and model work was good.

Tobruk was another story. Relatively inexpensive, it boasted excellent matte art, good mechanical action and was a box office winner if not a super hit. The action was so good that Universal lifted most of that footage and remade the story section four years later as *Raid on Rommel.*

Credits

Doctor Dolittle
(20th Century-Fox; December 19, 1967)

Producer Arthur P. Jacobs *Associate Producer* Mort Abrahams *Director* Richard Fleischer *Screenplay, Music and Lyrics* Leslie Bricusse *Based on the "Doctor Dolittle" Books by* Hugh Lofting *Cinematographer* Robert L. Surtees *Musical Directors* Lionel Newman, Alexander Courage *Film Editors* Samuel E. Beetley, Marjorie Fowler *Costume Designer* Ray Aghayan *Production Designer* Mario Chiari *Director and Choreographer of Musical Numbers* Herbert Ross *Art*

Directors Jack Martin Smith, Ed Graves *Set Decorators* Walter M. Scott, Stuart A. Reiss *Music Editor* Robert Mayer *Vocal Supervisor* Ian Fraser *Unit Production Managers* William Eckhardt, Jack Stubbs *Assistant Director* Jack Lang *Makeup* Ben Nye, Marvin Westmore, Tom Burman *Hairdressing* Margaret Donovan *Todd-AO Development* American Optical Company, Magna Theatre Corporation *Animal and Bird Owners-Trainers* Jungleland of Thousand Oaks, California *Animal and Bird Supervisor* Roy Kabat *Title Design* Don Record *Titles* Pacific Title & Art Studio *Unit Publicist* Harold Stern *Camera Operator* George Nogle *Assistant Cameraman* Emilio Calori *Gaffer* Earl Gilbert *Key Grip* Lou Pazelli *Script Supervisor* June Santantonio *Sound Supervisors* James P. Corcoran, Murray Spivack *Production Mixer* Bernard Freericks *Scoring Mixers* Douglas O. Williams, John Myers *Dubbing Mixer* Murray Spivack *Wardrobe Supervisor* Wesley Sherrard *Property Master* Allen Levine *Marine Coorinator and Ship's Master* Fred Zendar *Art Department Model Maker* Constantin Morros *Special Effects* L.B. Abbott *Optical Cinematography* Art Cruickshank *Matte Artist* Emil Kosa, Jr. *Miniature Supervisor* Howard Lydecker

An Arthur P. Jacobs Production. An APJAC Productions Inc. Picture. Made at 20th Century–Fox Studios and on location in Castle Combe, England and Santa Lucia, British West Indies. Copyright December 19, 1967 by 20th Century–Fox Film Corporation and APJAC Productions Inc. Music Copyright 1967 by 20th Century–Fox Music Corporation. Todd-AO. Color by De Luxe. Westrex Recording System. Stereophonic Sound. 152 minutes plus overture, intermission and exit music.

The Players: *Dr. John Dolittle* Rex Harrison *Emma Fairfax* Samantha Eggar *Matthew Mugg* Anthony Newley *Albert Blossom* Richard Attenborough *Gen. Bellowes* Peter Bull *Mrs. Blossom* Muriel Landers *Tommy Stubbins* William Dix *William Shakespeare X* Geoffrey Holder *Sarah Dolittle* Portia Nelson *Lady Petherington* Norma Varden

Additional Oscar Nominations: *Picture* (APJAC, 20th Century–Fox; Arthur P. Jacobs); *Cinematography* (Robert Surtees); *Art Direction-Set Decoration* (Mario Chiari, Jack Martin Smith, Ed Graves, Walter M. Scott, Stuart A. Reiss); *Sound* (20th Century–Fox Studio Sound Department); *Film Editing* (Samuel E. Beetley, Marjorie Fowler); *Music—Song* ("Talk to the Animals" by Leslie Bricusse)*; *Music—Original Music Score* (Leslie Bricusse); *Music—Scoring of Music, adaptation or treatment* (Lionel Newman, Alexander Courage)

Tobruk

(Universal; February 7, 1967)

Executive Producer Rock Hudson *Producer* Gene Corman *Director* Arthur Hiller

Screenplay Leo V. Gordon *Cinematographer* Russell Harlan *Musical Score* Bronislau Kaper *Musical Director* Joseph Gershenson *Film Editor* Robert C. Jones *Second Unit Director* Joseph Kane *Aerial Cinematographer* Nelson Tyler *Art Directors* Alexander Golitzen, Henry Bumstead *Set Decorators* John Mc-Carthy, Jr., Oliver Emert *Production Executive* Edward Muhl *Unit Production Manager* Robert E. Larson *Assistant Director* Terence Nelson *Second Assistant Director* John Anderson, Jr. *Titles* Pacific Title & Art Studio *Makeup* Bud Westmore *Hairdressing* Larry Germain *Technical Adviser* Col. L.J. Loughran R.A.I. Retd. *Dialogue Coaches* Norman Stuart, Martin Kosleck *Stunt Coordinator* John Daheim *Sound Supervisor* Waldon O. Watson *Production Mixer* Lyle B. Cain *Visual Effects* Howard A. Anderson Company *Additional Visual Effects* Film Effects of Hollywood *Visual Effects Supervisor* Howard A. Anderson, Jr. *Additional Visual Effects Supervisor* Linwood G. Dunn *Matte Artist* Albert Whitlock *Mechanical Effects* Fred Knoth, Herman Townsley

A Gene Corman-Rock Hudson Production. A Corman Company-Gibraltar Productions Picture. Made at Universal City Studios and on location near Yuma, Arizona. Copyright March 4, 1967 by Universal Pictures, Gibraltar Productions Inc. and Corman Company Inc. Techniscope. Technicolor. Westrex Recording System. 109 minutes.

The Players: *Maj. Donald Craig* Rock Hudson *Capt. Kurt Bergman* George Peppard *Col. John Harker* Nigel Green *Lt. Max Mohnfeld* Guy Stockwell *Sgt. Maj. Tyne* Jack Watson *Pvt. Dolan* Percy Herbert *Alfie* Norman Rossington *Henry Portman* Liam Redmond *Cheryl Portman* Heidy Hunt *Sgt. Krug* Leo V. Gordon *Cpl. Bruckner* Robert Wolders *Lt. Boyden* Anthony Ashdown *Nazi Colonel* Curt Lowens *Cpl. Stuhler* Henry Rico Cattani *Tuareg Chieftain* Peter Coe *Italian Officer* Laurence Montaigne *British Corporal* Robert Hoy *S.I.G. Bocker* Phil Adams *S.I.G. Schell* Ronnie Rondell *Kramarsky* Paul Stader *Armed Seaman* Gino Gottarelli *Nazi Officer* John Day [Daheim] *German Policeman* Barry Ford *French Lieutenant* Richard Angarola *Italian Soldier* Roger Etienne *French Soldier* Lucien Lanvin *First Italian* Dante DiPaulo *Second Italian* Jim Malinda *Italian Prisoners* Steve Conte, Phil Garris, David Gross, Blaisdell Makee, Mario Roccuzzo

Note: Copyright registration in notice in 1966. Remade as *Raid on Rommel* (Universal, 1971) utilizing most of the action and Special Effects footage from the original.

1968

Special Visual Effects Nominations

Ice Station Zebra . Hal Millar,
 (Filmways, MGM) J. McMillan Johnson
**2001: A Space Odyssey* Stanley Kubrick
 (Polaris, MGM)

Scientific or Technical Award

Class I Philip V. Palmquist of Minnesota
Mining and Manufacturing Company,
Dr. Herbert Meyer of the Motion
Picture and Television Research
Center, and Charles D. Staffell
of the Rank Organization
For the development of a successful embodiment of the reflex
background projection system for composite cinematography

Comments

To this day, *2001: A Space Odyssey* is a sore subject to many special effects craftsmen, especially those who worked on it. A favorite film with dopeheads, it has always been the center of controversy for its lack of plotting and the egomania of its infamous producer-director. It seems that the Academy's Board of Governors decided only three individuals could claim an Oscar for the Special Visual Effects of any given feature. Since there were several trick supervisors screen credited, it would be unfair to give or single out any for the statuette, so the only decent and fair thing to do would be give the nomination and Award to the producer-director of the whole project. They forgot, of course, that he deserved no real credit for the effects work. They just did the "right thing in the situation."

Regardless of who actually received the Oscar, *2001*'s visual effects were wonderful. They inspired awe and in the original Super Cinerama engagements drew applause and gasps. They were probably as close to perfect as ever will be achieved with today's technology. With finely detailed miniatures, excellent matte art, and blending, the film had it all, including the world's largest (but hardly the first!) front projection process shots. Unfortunately it also featured some of the silliest recolored landscape shots ever

seen; and the story was hilarious at best, unwatchable as a whole, and downright insulting to anyone with the least bit of intelligence.

The loser was also a Super Cinerama presentation, *Ice Station Zebra*, which, aside from its giant screen exhibition, would have been better as a telefeature. It was a cheap-looking, mostly studio-shot tale of American-Soviet confrontation over a downed satellite in the Arctic. It featured laughable miniatures, haloed mattes, and grainy (no mean feat when using Super Panavision 70), desaturated color. The stage sets of the snow-covered wastelands were atrocious. Though initially a bigger box office attraction than *2001*, it was a loser in more areas than the Academy effects sweepstakes.

Credits

Ice Station Zebra
(Metro-Goldwyn-Mayer; October 23, 1968)

Producer Martin Ranshoff *Associate Producer* James C. Pratt *Director* John Sturges *Screenplay* Douglas Heyes *Adaptation* Harry Julian Fink *Based on the Novel by* Alistair MacLean *Cinematographer* Daniel L. Fapp *Musical Score* Michel Legrand *Film Editor* Ferris Webster *Sound Editor* Milo Lory *Sound Supervisor* Franklin E. Milton *Art Directors* George W. Davis, Addison Hehr *Assistant Art Director* John Clark *Set Decorators* Henry Grace, Jack Mills *Unit Production Manager* Ralph W. Nelson *Assistant Director* Thomas J. Schmidt *Technical Adviser* Capt. John M. Connolly U.S.N. Retd. *Additional Arctic Cinematographers* John M. Stephens, Nelson Tyler *Assistant Arctic Cameraman* John Kiser *Makeup* William Tuttle *Dialogue Coach* Norman Stuart *Music Editor* Frank Urioste *Unit Publicists* John Tobias, Ted Bonnet *Production Cooperation* Gibraltar Productions Inc. *Stunt Coordinator* Ronnie Rondell, Jr. *Visual Effects* Joseph McMillan Johnson, Carroll L. Shepphird *Matte Artist* Matthew Yuricich *Process Cinematography* Clarence W.D. Slifer *Optical Cinematography* Robert R. Hoag *Mechanical Effects* Henry E. Millar, Sr., Ralph Swartz, Earl McCoy

A Martin Ransohoff Production. A Filmways Inc. Picture. Made at MGM Studios and on location in the Arctic. Copyright July 2, 1968 by Metro-Goldwyn-Mayer Inc. Super Cinerama. Super Panavision 70. Metrocolor. Westrex Recording System. Stereophonic Sound. 148 minutes plus overture and intermission. M.P.A.A. Rating: G.

The Players: *Cmdr. James Ferraday* Rock Hudson *Boris Vaslov* Ernest Borgnine *David Jones* Patrick McGoohan *Capt. Leslie Anders* Jim Brown *Lt. Russell*

Walker Tony Bill *Adm. Garvey* Lloyd Nolan *Col. Ostrovsky* Alf Kjellin *Lt. Cmdr. Bob Raeburn* Gerald S. O'Loughlin *Lt. Jonathan Hansen* Ted Hartley *Lt. George Mills* Murray Rose *Paul Zabrinczski* Ron Masak *Lt. Edgar Hackett* Sherwood Price *Lt. Mitgang* Lee Stanley *Dr. Jack Benning* Joseph Bernard *First Survivor* John Orchard *Second Survivor* William O'Connell *Third Survivor* Jim Goodwin *Lt. Courtney Cartwright* Michael T. Mikler *Russian Aide* Jonathan Lippe *Wassmeyer* Ted Kristian *Earl MacAuliffe* Jim Dixon *Bruce Kentner* Boyd Berlind *Cedrick Patterson* David Wendel *Lyle Nichols* Ronnie Rondell, Jr. *Gafferty* Craig Shreeve *Kohler* Michael Grossman *Parker* Wade Graham *Fannovich* Michael Rougas *Peter Costigan* Jed Allan *Webson* Lloyd Haynes *Edward Rawlins* Buddy Garion *Lt. Carl Mingus* T.J. Escott *Hill* Buddy Hart *Lorrison* Gary Downey *Kelvaney* Robert Carlson *Timothy Hirsch* Don Newsome *Philip Munsey* Bill Hillman *Gambetta* Dennis Alpert

Additional Oscar Nomination: *Cinematography* (Daniel L. Fapp)

Note: Special Effects stock shots were later utilized in *Fer de Lance* (a.k.a. *Death Dive*) (Leslie Stevens Productions, 1974) and *Firefox* (Warner Bros., 1982). Production began in Ultra Panavision 70, converted to Super Panavision 70, with some scenes likely shot in 35mm and blown up to 70mm.

2001: A Space Odyssey

(Metro-Goldwyn-Mayer; April 2, 1968)

Producer and Director Stanley Kubrick *Associate Producer and Production Supervisor* Victor Lyndon *Screenplay* Stanley Kubrick, Arthur C. Clarke *Based on the Story "The Sentinel" (a.k.a. "Sentinel of Eternity")* by Arthur C. Clarke *Cinematographer* Geoffrey Unsworth *Additional Cinematographers* John Alcott, Mike Wilson *Film Editor* Ray Lovejoy *Sound Editor* Winston Ryder *Production Designers* Tony Masters, Harry Lange, Ernest Archer *Art Director* John Hoesli *Set Designer* John Graysmark *Set Decorator* Robert Cartwright *Costume Designer* Hardy Amies *Production Manager* Robert Watts *Assistant Director* Derek Cracknell *Camera Operator* Kelvin Pike *Assistant Cameraman* Peter MacDonald *Still Photographer* Keith Hamshere *Makeup* Stuart Freeborn, Kay Freeborn, Graham Freeborn, Colin Arthur *Hairdressing* Carol Beckett *Assistant to the Producer and Unit Publicist* Roger Caras *Publicity Supervisor* Dan S. Terrell *Publicity Artist* Robert McCall *Assistant Film Editor* David De Wilde *Technical Adviser* Dr. Ormond G. Mitchell *Production Assistant* Ivor Powell *Sound Supervisor* Anthony W. Watkins *Sound* MGM British Studios *Production Mixer* H.L. Bird *Recorder* Robin Gregory *Chief Dubbing Mixer* J.B. Smith *Music Editor* Frank J. Urioste *Scientific Consultant and Construction Coordinator* Frederick I. Ordway III *Post Production Coordinator* Merle Chamberlin *Legal Affairs* Louis Blau *Production Cooperation* Aerojet-General Corporation, Aeronautical Chart and Information Center, Aerospace Medical Division of Wright-Patterson

Air Force Base, U.S.A.F. School of Aerospace Medicine, Department of the Air Force, Air Force Cambridge Research Laboratories, Analytical Laboratories Ltd., Army Map Service, U.S. Army Natick Laboratories, Barnes Engineering Company, Bell Telephone Laboratories Inc., Bendix Field Engineering Corporation, Boeing Company Aerospace Division, Chrysler Corporation, Computer Control Company, Department of Defense, Douglas Aircraft Company, Elliott Automation Ltd., Gen. Dr. Don Flickinger M.D. U.S.A.F. Retd., Institute for Advanced Study School of Mathematics, Flight Research Center of National Aeronautics and Space Administration, General Atomic Division of General Dynamics Corporation, General Dynamics-Convair, General Electric Company Missile and Space Division, Goddard Space Flight Center, Gruman Aircraft Engineering Corporation, Harbor General Hospital, Dr. A.T.K. Crockett, M.D., Chief of Urology, Hawker Siddeley Dynamics Ltd., Honeywell Inc., Illinois Institute of Technology Research Institute, International Business Machines, International Business Machines (U.K.) Ltd., Jet Propulsion Laboratory of California Institute of Technology, Langley Research Center, Lear Siegler Inc., Food Technology Research of Libby MacNeil and Libby, Lick Observatory, Ling-Temco-Vought Inc., Lowell Observatory, Lunar and Planetary Laboratory of University of Arizona, Manned Spacecraft Center of National Aeronautics and Space Administration, George C. Marshall Space Flight Center of National Aeronautics and Space Administration, Martin Company, Minnesota Mining and Manufacturing Company, Mt. Wilson and Palomar Observatories of California Institute of Technology, National Aeronautics and Space Administration Headquarters, National Aeronautics and Space Council, National Institute of Medical Research, U.S. Naval Observatory, Office of Naval Research Branch Office at U.S. Embassy in London, New York University College of Medicine, North American Aviation Inc. Space and Information Systems Division, Eliot Noyes and Associates, State of Oregon Department of Geology and Mineral Information, Paris Match, Philco Corporation, Royal Greenwich Observatory, Societé de Prospection Electrique Schlumberger, Smithsonian Astrophysical Observatory, Soviet Embassy in London, United Kingdom Atomic Energy Authority, University of London, University of Manchester Department of Astronomy, University of Minnesota School of Physics, Vickers Ltd. Medical Division, U.S. Weather Bureau, Whirlpool Corporation Systems Division *Musical Themes "Gayane Ballet Suite" by* Aram Khachaturian *Performed by the* Leningrad Philharmonic Orchestra *Conducted by* Gennadi Rozhdestvensky *Courtesy of* Deutsche Grammophon *"Atmospheres" by* Gyorgy Ligeti *Performed by the* Sudwestfunk Orchestra *Conducted by* Ernest Bour *"Lux Aeterna" by* Gyorgy Ligeti, *Performed by the* Stuttgart Schola Orchestra *Conducted by* Clytus Gottwald *"Requiem for Soprano, Mezzo-Soprano, Two Mixed Choirs and Orchestra" by* Gyorgy Ligeti *Performed by the* Bavarian Radio Orchestra *Conducted by* Francis Travis *"The Blue Danube" by* Johann Strauss *Performed by the* Berlin Philharmonic Orchestra *Conducted by*

Herbert von Karajan *Courtesy of* Deutsche Grammophon *"Thus Spoke Zarathustra" by* Richard Strauss *Performed by the* Berlin Philharmonic Orchestra *Conducted by* Karl Bohm *Color Timer* Harry V. Jones *Special Effects Designer and Director* Stanley Kubrick *Special Effects Supervisors* Wally Veevers, Douglas Trumbull, Con Pederson, Thomas Howard, Wally Gentleman *Special Effects Unit* Colin J. Cantwell, Bryan Loftus, Frederick Martin, Bruce Logan, David Osborne, John (Jack) Malick, Brian Johncock (Johnson), Roger Dicken, Zoran Perisic, John Dykstra, James R. Dickson *Additional Special Effects Supervisors* Les Bowie, Charles Staffell *Matte Artists* Roy Naisbitt, John Rose *Additional Matte Cinematography* Richard Yuricich

A Hawk Films Ltd. Picture. A Polaris Film. Made at MGM British Studios and Shepperton Studios. Copyright April 3, 1968 by Metro-Goldwyn-Mayer Inc. Super Cinerama. Super Panavision 70. Color by Technicolor and Metrocolor. Prints by Metrocolor. Westrex Recording System. Stereophonic Sound. 161 minutes plus intermission.

The Players: *Mission Cmdr. David Bowman* Keir Dullea *Astronaut Frank Poole* Gary Lockwood *Dr. Heywood Floyd* William Sylvester *Moonwatcher* Daniel Richter *Smyslov* Leonard Rossiter *Elena* Margaret Tyzack *Halvosen* Robert Beatty *Michaels* Sean Sullivan *H.A.L. 9000 Voice Characterization* Douglas Rain *Mission Controller* Frank Miller *Stewardesses* Edwina Carroll, Penny Brahms *Poole's Father* Alan Gifford *Photographer* Burnell Tucker *First Technician* John Swindell *Second Technician* John Clifford *Floyd's Daughter* Vivian Kubrick *Interviewer* Martin Amor *Astronaut* John Ashley *With* Bill Weston, Mike Lovell, Edward Bishop, Ann Gillis, Heather Downham, Glenn Beck, Jimmy Bell, David Charkham, Simon Davis, Jonathan Daw, Peter Delmar, Terry Duggan, David Fleetwood, Danny Grover, Brian Hawley, David Hines, Tony Jackson, John Jordan, Scott MacKee, Lawrence Marchant, Darryl Paes, Joe Refalo, Andy Wallace, Bob Wilyman, Richard Wood *Stand-ins* John Francis, Eddie Milburn, Gerry Judge, Brian Chutter, Tom Sheppard, Robin Dawson-Whisker

Additional Oscar Nominations: *Direction* (Stanley Kubrick); *Writing — Story and Screenplay written directly for the screen* (Stanley Kubrick, Arthur C. Clarke); *Art Direction-Set Decoration* (Tony Masters, Harry Lange, Ernie Archer)

Note: Working titles were *Journey Beyond the Stars* and *Space Odyssey*. Much of the visual effects were photographed in Todd-AO. After bad audience and critical response to the premiere, it was re-edited to 142 minutes plus intermission. Kubrick used recordings from Deutsche Grammophon without legal permission. After legal wrangling and fee paying, rights were officially granted. Douglas Rain replaced Martin Balsam as the computer's voice. The Academy's writing classification was incorrect; the screenplay was based on a published short story. Sequel was *2010* (MGM/UA, 1984).

1969

Special Visual Effects Nominations

Krakatoa East of Java Eugene Lourie,
(ABC Pictures, Cinerama) Alex Weldon
Marooned . Robie Robertson
(Frankovich-Sturges, Columbia)

Scientific or Technical Award

Class III Robert M. Flynn and Russell
Hessy of Universal City Studios Inc.
For a machine-gun modification for motion picture photography

Comments

Much was made of Krakatoa being west of Java by the critics of *Krakatoa East of Java*. Those same critics, apparently so well-versed geographically, seemed ignorant that the film's treasure seekers sailed toward Madura, where their adventures got really dangerous. Madura was east of Java. Of course the title was misleading, but it sounded great and invoked mystery and atmosphere of a faraway tale in a thrilling land. This Super Cinerama epic was one of the best adventures ever made. Expertly mounted, it had the best volcanic eruption and tidal wave scenes ever shot. The miniatures were excellent as were the pyrotechnics. Barely noticeable was the optical photography. It was a completely enjoyable film in its original uncut version, but unfortunately had a poor box office response.

For reasons unfathomable, *Marooned*, the story of three astronauts trapped in a disabled spacecraft, won the Oscar. This dull 70mm blowup failed to excite with its uninteresting story, bad mattes, and unimpressive miniatures. Some actual space footage was converted to *Super*Scope 235 and interloped into the action. In relation to the rest of the film, the trick shots, as bad as they were, were the best elements.

Credits

Krakatoa East of Java
(Cinerama; May 14, 1969)

Executive Producer Philip Yordan *Producer* William R. Forman *Co-Producer* Lester A. Sansom *Director* Bernard L. Kowalski *Screenplay* Clifford Newton Gould, Bernard Gordon *Cinematographer* Manuel Berenguer *Music* Frank DeVol *Film Editors* Maurice Rootes, Warren Low, Walter Hanneman *Production Designer* Eugene Lourie *Assistant Production Designer* Fernando Gonzales *Production Illustrator* Manolo Mampaso *Second Unit Directors* Eugene Lourie, Frank Kowalski *Second Unit Cinematographer* John Cabrera *Assistant Director* Jose Maria Ochoa *Costume Designer* Laure De Zarate *Camera Operator* Eduardo Noe *Assistant Cameramen* Luis Pena, Jose Martinez *Second Unit Assistant Cameraman* Jose Mateos *Production Supervisor* Gregorio Sacristan *Production Manager* Jose Manuel Herrero *Second Unit Production Manager* Irving Lerner *Art Directors* Julio Molina, Luis Espinosa *Set Decorator* Antonio Mateos *Property Master* Julian Mateos *Wardrobe* Charles Simminger *Songs* "Teacher, Teacher," "I'm An Old Fashioned Girl," "Java Girl" Mack David *Makeup* Julian Ruiz *Hairdresser* Antonia Lopez *Casting* Lillian Kelly *Gaffer* Vicente Acitores *Key Grip* Julian Fernandez *Still Photographer* Antonio Luengo *Sound Editors* Kenneth Heeley-Ray, Kurt Hernfeld *Production Mixer* Wallace H. Milner *Dubbing Mixer* Gordon K. McCallum *Title and Monatage Design* Don Record *Titles and Montage* Pacific Title & Art Studio *Underwater Cinematographer* Egil S. Woxholt *Script Supervisors* Eva Del Castillo, Lew Gerard *Dialogue Coach* John Kirby *Construction Manager* Francisco Prosper *Visual Effects Unit — Designer and Director* Eugene Lourie *Assistant Designer-Director* Fernando Gonzales *Cinematographer* Manuel Berenguer *Production Manager* Irving Lerner *Unit Manager* Giorgio Oddi *Editor* Derek Parsons *Miniatures* Henri Assola, Francisco Prosper *Illustrator* Manolo Mampaso *Art Director* Saverio De Eugenio *Camera Operator* Cezare Allione *Camera Helicopter Pilot* Claude *Hawaiian Location Tidal Wave Cinematographer* Jack Willoughby — *Mechanical Effects* Alex C. Weldon *Mechanical Effects Assistant* Basilio Cortijo

A Cinerama Inc. Presentation. A Security Pictures Inc. Production. From the American Broadcasting Companies. Copyright December 26, 1968 by American Broadcasting Companies Inc. Super Cinerama. Todd-AO and Super Panavision 70. Technicolor. Color by Fotofilm Madrid S.A. Print by Technicolor. Westrex Recording System. Stereophonic Sound. Made at Estudios Sevilla and Samuel Bronston Studios, Madrid, Spain and Studio Cinecitta, Rome, Italy and on location in Gijon, Denia, Mallorca, Puerto Soller, Marjorca, Spain and Java, Hawaii and on the Mediterranean

Publicity pasteups for "Marooned." Top: Realistic spacecraft, not much drama.
Bottom: Actual screen footage didn't look as good (marred by matte lines).

Sea. 127 minutes plus overture, intermission and exit music. M.P.A.A. Rating: G.

The Players: *Capt. Chris Hanson* Maximilian Schell *Laura Travis* Diane Baker *Harry Connerly* Brian Keith *Charley Adams* Barbara Werle *Douglas Rigby* John Leyton *Giovanni Borghese* Rossano Brazzi *Leoncavallo Borghese* Sal Mineo *Danzig* J.D. Cannon *Toshi* Jacqui Chan *First Ofr. Jacobs* Marc Lawrence *Bazooki Man* Geoffrey Holder *Sumi* Sumi Hari *Kiki* Victoria Young Keith *Midori* Midorri Arimoto *Peter Travis* Peter Kowalski *Henley* Niall MacGinnis *Helmsman Jan* Alan Hoskins *Guard* Robert Hall *Kuan* Joseph Hann *Men* Max Slaten, Peter Graves, John Clark, Mike Brendel *Old Seaman* Eugene Lourie

Note: Remake of *Fair Wind to Java* (Republic, 1953). Working title was *Krakatoa*. During its Cinerama engagements it was constantly being re-edited, with 143-, 135-, 131-minute versions and final 70mm 127-minute version. The general release 35mm version ran 101 minutes as do all 16mm non-theatrical prints. For its network television premiere it was retitled *Volcano*. For television syndication it was restored to 127 minutes and given back its original title. Lester A. Sansom was screened billed as associate producer but was credited as co-producer on the unit list and all "official credits" issued by Cinerama.

Marooned

(Columbia; December 11, 1969)

Producer M.J. Frankovich *Associate Producer* Frank Capra, Jr. *Director* John Sturges *Screenplay* Mayo Simon *Based on the Novel by* Martin Caidin *Cinematographer* Daniel L. Fapp *Film Editor* Walter Thompson *Sound Editor* Joseph Henrie *Production Designer* Lyle R. Wheeler *Set Decorator* Frank Tuttle *Property Master* Richard M. Rubin *Costume Supervisor* Seth Banks *Executive Production Manager* William J. O'Sullivan *Assistant Director* Daniel J. McCauley *Script Supervisor* John Franco *Dialogue Coach* Norman Stuart *Technical Advisers* Martin Caidin, George Smith, Maj. Gen. David M. Jones U.S.A.F. *Second Unit Director* Ralph Black *Second Unit Cinematographer* W. Wallace Kelley *Aerial Cinematographer* Nelson Tyler *Consulting Cinematographer* William Widmayer *Video Supervisor* Hal Landaker *Stunt Coordinator* Bill Couch *Production Mixer* Lester Fresholtz *Dubbing Mixer* Arthur Piantadosi *Sound* Columbia Studios *Production Cooperation* Philco-Ford Corporation, Houston Mission Control Center, U.S. Air Force Eastern Test Range and Launch Center *Titles* Maury Nemoy *Special Effects* Butler-Glouner Inc. *Special Effects Supervisors* Lawrence W. Butler, Donald C. Glouner, Danny Lee *Miniature Supervisor* Robie Robinson *Miniaturist* Terry Saunders

A Frankovich-Sturges Production. Made at Columbia Studios and Metro-Goldwyn-Mayer Studios and on location in Houston, Texas and Cape Kennedy, Florida. Copyright December 1, 1969 by Frankovich Productions Inc. Panavision 70. Eastman Color. Processed by Technicolor. Prints by Metrocolor. RCA Photophone Recording. Stereophonic Sound. 134 minutes. M.P.A.A. Rating: G.

The Players: *Chief of Manned Space Charles Keith* Gregory Peck *Spacecraft Cmdr. Jim Pruett* Richard Crenna *Senior Astronaut Ted Dougherty* David Janssen *Science Systems Astronaut Clayton Stone* James Franciscus *Appollo Guidance Pilot Buzz Lloyd* Gene Hackman *Celia Pruett* Lee Grant *Teresa Stone* Nancy Kovack *Betty Lloyd* Mariette Hartley *Public Affairs Officer* Scott Brady *Flight Director* Craig Huebing *Flight Surgeon* John Carter *Mission Director* George Gaines *Houston Cap Com* Tom Stewart *Space Systems Director* Frank Marth *Titan Systems Specialist* Duke Hobbie *Launch Director* Dennis Robertson *Cape Weather Officer* George Smith *Cannon* Vincent Van Lynn *Radin* Walter Brooke *Hardy* Mauritz Hugo *Russian Cosmonaut* Bill Couch *Priscilla Keith* Mary-Linda Rapelye

Additional Oscar Nominations: *Cinematography* (Daniel Fapp); *Sound* (Les Fresholtz, Arthur Piantadosi)

Note: Re-edited to approximately 100 minutes. Originally announced as a Super Cinerama presentation. Documentary footage was converted to *Super*Scope 235 and incorporated into the action.

1970

Special Visual Effects Nominations

Patton . Alex Weldon
 (20th Century–Fox)
*Tora! Tora! Tora! A.D. Flowers,
 (20th Century–Fox) L.B. Abbott

Comments

For the third year in a row, both nominated features were 70mm road-shows. And once again one of the nominees was strange.

Tora! Tora! Tora!, a docudrama of the Pearl Harbor assault by Japan, was a worthy nomination and winner. Its full-size effects were magnificent as was most of the model marine footage. Some of the miniature shots were dead giveaways, but there were so many that odds demanded a few slip-ups. The spectacle was so eye-grabbing and depicted such devastation that a few slips in quality were forgivable. Front projection was ably employed in many of the air scenes.

Patton, another docudrama, was the odd man out this year. There were some nicely staged pyrotechnics and weather effects but little from the trick photography department. Some split-screen work was employed to expand the number of tanks used in the desert battle action, and a matte shot showed distant ships at sea, but the visual effects crew was not cited for these undetectable shots. Instead, mechanical effects supervisor Alex Weldon was nominated for his efforts. Since these were basically simple, their nomination as Best Special Visual Effects was completely nonsensical.

Credits

Patton

(20th Century–Fox; February 4, 1970)

Producer Frank McCarthy *Associate Producer* Frank Caffey *Director* Franklin J. Schaffner *Screenplay* Francis Ford Coppola, James R. Webb, Edmund H. North *Based on the Books* Patton: Ordeal and Triumph *by* Ladislas Farago *and* A Soldier's Story *by* Omar N. Bradley *Cinematographer* Fred Koenekamp

Musical Score Jerry Goldsmith *Film Editor* Hugh S. Fowler *Supervising Sound Editor* Don Hall, Jr. *Sound Supervisor* James B. Corcoran *Production Mixer* Don Bassman *Scoring and Dubbing Mixers* Douglas O. Williams, Murray Spivack, Theodore Soderberg *Art Directors* Urie McCleary, Gil Parrando *Set Decorators* Antonio Mateos, Pierre-Louis Thevenet *Makeup Supervisor* Daniel Striepeke *Makeup* Del Acevedo and Jose Sanchez *Unit Production Managers* Francisco Day, Eduardo G. Maroto, Tadeo Villalba *Assistant Directors* Eli Dunn, Jose Lopez Rodero *Second Unit Cinematographers* Clifford Stine, Cecilio Paniaqua *Orchestration* Arthur Morton *Technical Advisers* Gen. Paul D. Harkins U.S.A. Retd., Col. Grover S. Johns Jr. U.S.A. Retd. *Senior Military Adviser* Gen. Omar N. Bradley U.S.A. *Spanish Military Adviser* Lt. Col. Luis Martin de Pozuelo *Second Unit Director* Michael Moore *Dimension 150 Consultants* Richard Vettier, Carl Williams *Gaffer* Gene Stout *Key Grip* Glenn Harris *Camera Operators* Bill Norton, Riccardo Navarreto *Assistant Cameraman* Charles G. Arnold, Emilio Calori *Second Assistant Cameraman* Mike Benson *Lighting Equipment* Mole-Richardson Company *Stunt Coordinator* Joe Canutt *Titles* Pacific Title & Art Studio *Production Executive* Richard D. Zanuck *Casting* Michael McLean *Visual Effects* L.B. Abbott, Clifford Stine *Optical Cinematography* Art Cruickshank *Mechanical Effects* Alex C. Weldon

A Frank McCarthy–Franklin J. Schaffner Production. Made at Sevilla Studios and on location in the U.S., Spain, England, Morocco, Crete and Greece. Copyright December 30, 1969 by 20th Century–Fox Film Corporation. Dimension 150. Color by Fotofilm Madrid S.A. and De Luxe. Print by De Luxe. Westrex Recording System. Stereophonic Sound. 171 minutes plus intermission. M.P.A.A. Rating: M.

The Players: *Gen. George S. Patton, Jr.* George C. Scott *Gen. Omar N. Bradley* Karl Malden *Capt. Chester B. Hansen* Stephen Young *Brig. Gen. Hobart Carver* Michael Strong *Bradley's Driver* Carey Loftin *Capt. Richard N. Jenson* Morgan Paull *Field Marshal Erwin Rommel* Karl Michael Vogler *Patton's Driver* Bill Hickman *1st Lt. Alexander Stiller* Patrick J. Zurica *Sgt. William George Meeks* James Edwards *Col. Gaston Bell* Lawrence Dobkin *Air Vice Marshal Sir Arthur Coningham* John Barrie *Col. Gen. Alfred Jodl* Richard Muench *Field Marshal Sir Bernard Law Montgomery* Michael Bates *Lt. Col. Charles R. Codman* Paul Stevens *Maj. Gen. Walter Bedell Smith* Edward Binns *Third Army Chaplain* Lionel Murton *Slapped Pfc* Tim Considine *Willy* Abraxas Aaran *Tank Captain* Clint Ritchie *Lt. Col. Henry Davenport* Frank Latimer *Capt. Oskar Steiger* Siegfried Rauch *Col. John Welkin* Peter Barkworth *Lt. Gen. Harry Buford* David Bauer *Moroccan Minister* Albert Dumortier *Fox Movietone News Narrator* Lowell Thomas *Air Chief Marshal Sir Arthur Tedder* Gerald Flood *Gen. Sir Harold Alexander* Jack Gwillim *Clergyman* David Healy *Correspondent* Sandy Kevin *British Briefing Officer* Alan MacNaughton *Maj. Gen. Francis de Guingand* Douglas Wilmer *Maj. Gen. Lucian K. Truscott* John Doucette

Additional Oscar Nominations: *Picture* (20th Century-Fox; Frank McCarthy)*; *Actor* (George C. Scott)*; *Direction* (Franklin J. Schaffner)*; *Story and Screenplay based on factual material or material not previously published or produced* (Francis Ford Coppola, Edmund H. North)*; *Cinematography* (Fred Koenekamp); *Art Direction-Set Decoration* (Urie McCleary, Gil Parrando, Antonio Mateos, Pierre-Louis Thevenet)*; *Sound* (Douglas Williams, Don Bassman)*; *Film Editing* (Hugh S. Fowler)*; *Music — Original Score* (Jerry Goldsmith)

Note: George C. Scott refused his Oscar for Best Actor.

The original title *Patton: Salute to a Rebel* was discarded just as the road-show version was beginning to open; consequently, most early ads bore that longer title. In Great Britain it was titled *Patton: Lust for Glory.* Jerry Goldsmith's music nomination was incorrect as the composer had employed the main theme several years earlier in an episode of the "Perry Mason" television series on CBS. Stock footage was later incorporated into *Fireball Forward* (20th Century–Fox, 1972) and *Ike: The War Years* (ABC Circle Films, 1979). A sequel, *The Last Days of Patton*, was aired by CBS-TV in 1986, with Scott repeating the lead.

Tora! Tora! Tora!

(20th Century–Fox; September 25, 1970)

Producer Elmo Williams *Japanese Sequences Associate Producers* Otto Lang, Masayuki Takagi, Keinsuke Kubo *Director* Richard Fleischer *Japanese Directors* Toshio Masuda, Kinji Fukasaku *Screenplay* Larry Forrester *Japanese Screenplay* Hideo Oguni, Ryuzo Kikushima *Based on the Books* Tora! Tora! Tora! *by* Dr. Gordon W. Prange *and* The Broken Seal: Operation Magic and the Secret Road to Pearl Harbor *by* Ladislas Farago *Cinematographer* Charles F. Wheeler *Japanese Cinematographers* Sinsaku Himeda, Masamichi Satoh, Osami Furuya *Second Unit Cinematographer* David Butler *Aerial Cinematography* Vision Photography Inc. *Musical Score* Jerry Goldsmith *Film Editors* James E. Newcom, Pembroke J. Herring *Japanese Film Editor* Inoue Chikaya *Supervising Sound Editor* Don Hall, Jr. *Sound Supervisor* James P. Corcoran *Production Mixer* Herman Lewis *Japanese Production Mixer* Shin Watarai *Scoring and Dubbing Mixers* Murray Spivack, Douglas O. Williams, Theodore Soderberg *Second Unit Director* Ray Kellogg *Art Directors* Jack Martin Smith, Richard Day *Japanese Art Directors* Yoshiro Muraki, Taizoh Kawashima *Set Decorators* Walter M. Scott, Norman Rockett, Carl Biddiscombe *Orchestration* Arthur Morton *Makeup Supervisor* Daniel J. Striepeke *Makeup* Layne "Shotgun" Britton *Wardrobe Supervisor* Courtney Haslam *Wardrobe* Ed Wynigear *Assistant Directors* David Hall, Elliot Schick *Japanese Assistant Director* Hiroshi Nagai *Unit Production Managers* William Eckhardt, Jack Stubbs, Stanley H.

Goldsmith *Japanese Unit Production Manager* Masao Namikawa *Script Supervisor* Duane Toler *Unit Publicists* Ted Taylor, Hal Sherman *Air Operations* Lt. Col. Arthur P. Wildern Jr. U.S.A.F. Retd., Capt. George Watkins U.S.N., Jack Canary *Production Executive* Richard D. Zanuck *Department of Defense Project Officer and Naval Coordinator* Cmdr. E.P. Stafford U.S.N. *Production Coordinators* Maurice Unger, Theodore Taylor *Technical Advisers* Kameo Sonokawa, Kuranosuke Isoda, Shizuo Takada, Tsuyoshi Saka, Konrad Schreier Jr., Minoru Genda, Robert Buckhart *Still Photographers* Sterling Smith, Malcolm Bullock, Doug Kirkland *Japanese Still Photographer* Tamotsu Yato *Camera Operator* Jack Whitman, Jr. *Assistant Cameraman* Tom Kerschner *Second Unit Camera Operators* Michael Butler, Tony Butler *Second Unit Assistant Cameraman* John Fleckstein *Gaffer* Bill Huffman III *Second Unit Gaffer* Don Knight *Second Unit Key Grip* Chuck Record *Chief Pilot* Dave Jones *Construction Supervisor* Ivan Martin *Army Affairs Coordinator* Col. B.H. Watson U.S.A. *Japanese Story Consultants* R. Adm. Yasuji Watanabe Retd., R. Adm. Shigeru Fukutomi *Japanese Aircraft Consultant* Kanoe Sonokawa *Titles* Pacific Title & Art Studio *Production Cooperation* U.S. Department of Defense, U.S. Navy, U.S. Army, U.S. Air Force, U.S. Embassy in Japan, Japanese Imperial Navy, Japanese Imperial Government *Visual Effects* L.B. Abbott *Optical Cinematography* Art Cruickshank *Miniature Supervisor* Gail Brown *Mechanical Effects* A.D. Flowers

An Elmo Williams–Richard Fleischer Production. Made at 20th Century–Fox Studios, Toei-Kyoto Studios and Shochiku Studios and on location in Hawaii and Washington, D.C. and Ashiya, Kagoshima Bay, Kyusho and Tokyo, Japan. Copyright September 30, 1970 by 20th Century–Fox Film Corporation. Panavision 70. Color by De Luxe. Westrex Recording System. Stereophonic Sound. 143 minutes plus intermission. M.P.A.A. Rating: G.

The Players: *Adm. Husband E. Kimmel* Martin Balsam *Lt. Gen. Walter C. Short* Jason Robards, Jr. *Adm. Yamamoto* Soh Yamamura *Sec. of War Henry L. Stimson* Joseph Cotten *Cmdr. Minoru Genda* Tatsuya Mihashi *Lt. Col. Bratton* E.G. Marshall *Lt. Cmdr. Mitsuo Fuchida* Takahiro Tamura *Adm. William "Bull" Halsey* James Whitmore, Sr. *V. Adm. Chuichi Nagumo* Eijro Tono *Lt. Cmdr. Kramer* Wesley Addy *Amb. Nomura* Shogo Shimada *Lt. Cmdr. Thomas* Frank Aletter *Prince Konoye* Koreya Senda *Sec. of the Navy Frank Knox* Leon Ames *Adm. Yoshida* Junya Usami *Capt. John Earle* Richard Anderson *Foreign Min. Matsuoka* Kazuo Kitamura *Gen. George C. Marshall* Keith Andes *Adm. Stark* Edward Andrews *Lt. Kaminsky* Neville Brand *Mrs. Kramer* Leora Dana *Gen. Tojo* Asao Uchida *Sec. of State Cordell Hull* George Macready *Maj. Truman Landon* Norman Alden *Capt. Theodore Wilkinson* Walter Brooke *Lt. George Welch* Rich Cooper *Doris Miller* Elven Havard *Ray Cave* June Dayton *Cornelia* Jeff Donnell *Col. Edward F. French* Richard Erdman *Lt. Cmdr. William Outerbridge* Jerry Fogel *Kameto Kuroshima* Shunichi Nakamura *Lt. Kenneth M.*

Taylor Carl Reindel *R. Adm. Bellinger* Edmon Ryan *Amb. Saburo Kuruso* Hisao Toake

Additional Oscar Nominations: *Cinematography* (Charles F. Wheeler, Osami Furuya, Sinsaku Himeda, Masamichi Satoh); *Art Direction-Set Decoration* (Jack Martin Smith, Yoshiro Muraki, Richard Day, Taizoh Kawashima, Walter M. Scott, Norman Rockett, Carl Biddiscombe); *Sound* (Murray Spivack, Herman Lewis); *Film Editing* (James E. Newcom, Pembroke J. Herring, Inoue Chikaya)

Note: The title translates as "Tiger! Tiger! Tiger!" This was the radio code used by the Japanese pilots to notify their base ships that the attack ("To! To! To!") was a successful surprise. Stock footage was later employed in *Midway* (Universal, 1976), *Pearl* (Warner Bros., 1978) and *From Here to Eternity* (Columbia, 1979). These scenes became so common and so extensively used that 20th Century-Fox executives changed their policies concerning the licensing of library footage to outside producers. This was one of the first major studio releases to employ Fujicolor release prints.

1971

Special Visual Effects Nominations

Bedknobs and Broomsticks Alan Maley, Eustace
(Disney, Buena Vista) Lycett, Danny Lee
When Dinosaurs Ruled the Earth Jim Danforth,
(Hammer, Warner Bros.) Roger Dicken

Comments

Disney Studios had not been able to recapture the *Mary Poppins* audience with their unsuccessful roadshow *The Happiest Millionaire* and so was determined to do so with another musical comedy fantasy, *Bedknobs and Broomsticks*. This children's adventure of a white witch who aided Britain in repelling a Nazi invasion had much in common with *Poppins*: a strong, magical female lead, an incompetent father, precious children, interaction between live actors and cartoon characters, period setting, etc. Most of the special effects were super. The matte art, optical photography and animation were first class. The mechanical rigging suffered from very visible guide wires in some shots. This was no *Poppins*, entertainment- or boxoffice-wise, but at least it wasn't another *Millionaire*.

When Dinosaurs Ruled the Earth was a better film for adults and offered excellent visual effects. Wonderful stop-motion animation blended perfectly with live action via sandwich and traveling matte. The matte paintings were expertly rendered for this primeval yarn. It was overall a better show than the Disney production, but the day had yet to come when Hammer, long associated with horror programmers, would be awarded an Oscar over a multimillion dollar Disney film regardless of the quality involved.

After this year, effects ceased to be an annual Oscar category.

Credits

Bedknobs and Broomsticks
(Buena Vista; November 1971)

Producer Bill Walsh *Director* Robert Stevenson *Screenplay* Bill Walsh, Donald

Da Gradi *Animation Story* Ralph Wright, Ted Berman *Based on the Book by* Mary Norton *Cinematographer* Frank Phillips *Music and Lyrics* Richard M. Sherman, Robert B. Sherman *Music Supervisor, Orchestrator and Conductor* Irwin Kostal *Film Editor* Irvine "Cotton" Warburton *Special Sound Effects* William Wylie *Second Unit Director* Arthur J. Vitarelli *Art Directors* John B. Mansbridge, Peter Ellenshaw *Set Decorators* Emile Kuri, Hal Gausman *Titles* David Jonas *Costume Designer* Bill Thomas *Makeup* Robert J. Schiffer *Hairdressing* La Rue Matheron *Unit Manager* John Bloss *Assistant Director* Christopher Hibler *Music Editor* Evelyn Kennedy *Choreography* Donald McKayle *Wardrobe* Chuck Keehne, Emile Sundby *Sound Supervisor* Robert O. Cook *Production Mixer* Dean Thomas *Technical Consultants* Manfred Lating, Milt Larsen, James McInnes, Bob Baker, Spungbuggy Works *Assistant to the Conductor* James Macdonald *Dance Accompanist* Albert Mello *Assistant to the Designer* Shelby Anderson *Assistant Choreographer* Carolyn Dyer *Script Supervisor* Lois Thurman *Visual Effects Designer and Supervisor* Peter Ellenshaw *Matte Artists* Peter Ellenshaw, Alan Maley, P.S. Ellenshaw *Optical Cinematography* Eustace Lycett *Optical Coordinator* Robert Broughton *Animation-Live Action Designer* McLaren Stewart *Animation Director* Ward Kimball *Animators* Milt Kahl, John Lounsbery, Eric Larsen, Fred Hellmich, Art Stevens, Julius Svendsen, Hal King, Jack Buckley, Jack Boyd *Animation Layout* Don Griffith, Joe Hale *Animation Backgrounds* Al Dempster, Bill Layne, Dick Kelsey, Ralph Hulett *Mechanical Effects* Danny Lee

A Walt Disney Productions Presentation. Made at Walt Disney Studios. Copyright 1971 by Walt Disney Production. Wide Screen. Techicolor. RCA Photophone Recording. 117 minutes. M.P.A.A. Rating: G.

The Players: *Eglantine Price* Angela Lansbury *Emelius Browne* David Tomlinson *Jelk* Roddy McDowall *Book Dealer* Sam Jaffe *Col. Heller* John Ericson *Swinburne* Bruce Forsyth *Carrie* Cindy O'Callaghan *Paul* Roy Snart *Charlie* Ian Weighill *Mrs. Hobday* Tessie O'Shea *Capt. Greer* Arthur E. Gould-Porter *Portobello Road Workman* Ben Wrigley *Gen. Teagler* Reginald Owen *Elderly Farmer* Cyril Delevanti *Gerry Sergeants* Rick Traeger, Manfred Lating *Vendor* John Orchard *Cartoon Voice Characterizations: Codfish* Robert Holt *Secretary Bird and Lion* Lennie Weinrib *Bear* Dal McKennon

Additional Oscar Nominations: *Art Direction–Set Decoration* (John B. Mansbridge, Peter Ellenshaw, Emile Kuri, Hal Gausman); *Costume Design* (Bill Thomas); *Music — Song* ("The Age of Not Believing" *by* Richard M. Sherman, Robert B. Sherman); *Music — Scoring: Adaptation and Original Song Score* (Richard M. Sherman, Robert B. Sherman, Irwin Kostal)

When Dinosaurs Ruled the Earth

(Warner Bros.; February 1971)

Executive Producer Michael Carreras *Producer* Aida Young *Direction and Screenplay* Val Guest *Story* J.B. Ballard *Cinematographer* Dick Bush *Second Unit Cinematographer* Johnny Cabrera *Second Unit Script Supervisor* Susana Merry *Musical Score* Mario Nascimbene *Musical Director* Philip Martell *Film Editor* Peter Curran *Sound Editor* Frank Golding *Art Director* John Blezard *Costume Designer* Carl Toms *Makeup* Richard Mills *Hairdressing* Joyce James *Production Manager* Christopher Sutton *Assistant Director* John Stoneman *Sound Supervisor* Anthony W. Watkins *Production Mixer* Kevin Sutton *Dubbing Mixer* Ted Karnon *Construction Manager* Arthur Banks *Wardrobe* Brian Owen-Smith *Visual Effects and Second Unit Director* Jim Danforth *Visual Effects Assistant* David Allen *Miniaturists* Allan Bryce, Roger Dicken *Optical Cinematography* Brian Johncock (Johnson)

A Hammer Film Production. Made at Shepperton Studios and on location in the Canary Islands. Copyright 1971 by Hammer Film Productions Ltd. Wide Screen. Technicolor. RCA Photophone Recording. 96 minutes. M.P.A.A. Rating: GP.

The Players: *Sanna* Victoria Vetri *Tara* Robin Hawdon *Kingsor* Patrick Allen *Khaku* Drewe Henley *Kane* Sean Caffrey *Ulido* Magda Konopka *Ayak* Imogen Hassall *Ammon* Patrick Holt *Rock Girl* Jan Rossini *Hunters* Billy Cornelius, Ray Ford *Yani* Carol-Anne Hawkins *Omah* Maria O'Brien *Sand Mother* Connie Tilton *Rock Mother* Maggie Lynton *Fisherman* Jimmy Lodge

Note: Second in the Hammer prehistoric trilogy, being preceded by *One Million Years B.C.* (20th Century–Fox, 1966) and followed by *Creatures the World Forgot* (Columbia, 1971). A purposed fourth entry was never made. Released in Great Britain in 1970 with a B.B.F.C. X certificate and running 100 minutes. Some nude shots were excised from the U.S. version.

1972

Special Achievement Award (new classification)
Visual Effects L.B. Abbott and A.D. Flowers
For *The Poseidon Adventure* (Irwin Allen, 20th Century–Fox)

Comments

The Board of Governors decided to declassify Special Visual Effects as a regular award and present it only as a Special Achievement Oscar for several years. Their first selection under this new system was *The Poseidon Adventure*, an incredible yarn about survivors of a capsized luxury ocean liner. The photographic effects were limited to a closing matte shot, the tidal wave and a few model marine shots. The mechanical effects included pyrotechnics and various forms of physical devastation. All of this was well-executed stuff but not worthy of a Special Achievement Award by anybody's standards, except, of course, the board's.

Credits

The Poseidon Adventure
(20th Century–Fox; December 1972)

Producer Irwin Allen *Associate Producer* Sidney Marshall *Directors* Ronald Neame, Irwin Allen *Screenplay* Stirling Silliphant, Wendell Mayes *Based on the Novel by* Paul Gallico *Cinematographer* Harold E. Stine *Musical Score* John Williams *Film Editor* Harold F. Kress *Supervising Sound Editor* Don Hall, Jr. *Orchestration* Alexander Courage *Song* "The Morning After" Al Kaska, Joel Hirschhorn *Vocal* Carol Lynley *Production Designer* William J. Creber *Set Decorator* Raphael Bretton *Stunt Coordinator* Paul Stader *Costume Designer* Paul Zastupnevich *Makeup* Ed Butterworth, Del Acevado, Allan Snyder *Hairdressing* Carol Pershing, Sheral Ross, Ann Wadlington *Unit Production Manager* Hal Herman *Assistant Director* Norman Cook *Second Assistant Directors* Les Warner, Don White *Camera Operators* Tommy Morris, Irving Rosenberg *Assistant Cameraman* Tom Kershner *Second Assistant Cameraman* Jose Valdez *Gaffer* Clyde Taylor *Key Grip* Lou Pazelli *Assistant Film Editor* William

DeNicholas *Script Supervisor* Teresa Brachetto *Property Master* Robert McLaughton *Assistant Art Director* Ward Preston *Production Illustrators* Tom Cranham, Dan Goozee *Casting* Jack Baur *Sound Supervisor* John Bonner *Production Mixer* Herman Lewis *Scoring Mixer* Vinton Vernon *Dubbing Mixer* Theodore Soderberg *Assistant to the Producer* Al Gail *Production Coordinator* Art Volpert *Unit Publicist* John Campbell *Visual Effects* L.B. Abbott *Mechanical Effects* A.D. Flowers

An Irwin Allen Production. A Kent Productions Inc. Picture. A Ronald Neame Film. Made at 20th Century–Fox Studios and aboard the Queen Mary, Long Beach, California. Copyright 1972 by 20th Century–Fox Film Corporation. Panavision. Color by De Luxe. Westrex Recording System. Stereophonic Sound. 117 minutes. M.P.A.A. Rating: PG.

The Players: *Rev. Frank Scott* Gene Hackman *Mike Rogo* Ernest Borgnine *James Martin* Red Buttons *Nonnie Parry* Carol Lynley *Acres* Roddy McDowell *Linda Rogo* Stella Stevens *Belle Rosen* Shelley Winters *Manny Rosen* Jack Albertson *Susan Shelby* Pamela Sue Martin *Ship's Captain* Leslie Nielson *Ship's Chaplain* Arthur O'Connell *Robin Shelby* Eric Shea *Linarcos* Fred Sadoff *Nurse* Sheila Mathews Allen *Doctor* Jan Arvan *Ship's Purser* Byron Webster *Master of Ceremonies* Bob Hastings *Ship's Engineer* John Crawford *Tinkham* Erik Nelson *Passenger* David Sharpe

Additional Oscar Nominations: *Cinematography* (Harold E. Stine); *Art Direction–Set Decoration* (William Creber, Raphael Bretton); *Costume Design* (Paul Zastupnevich); *Sound* (Theodore Soderberg, Herman Lewis); *Film Editing* (Harold F. Kress); *Music — Song* ("The Morning After" by Al Kasha and Joel Hirschhorn)*; *Music — Original Dramatic Score* (John Williams)

Note: Allen's direction of the action sequences was not screen billed. Sequel was *Beyond the Poseidon Adventure* (Warner Bros., 1979).

1973

Scientific or Technical Award

Class II Harold A. Scheib, Clifford H.
Ellis, and Roger W. Banks of
Research Products, Inc.

For the concept and engineering of the Model 2101 optical
printer for motion picture optical effects

1974

Special Achievement Award

Visual Effects Frank Brendel, Glen Robinson
and Albert Whitlock
For *Earthquake* (A Universal–Mark Robson–Filmmakers
Group Production; Universal)

Scientific or Technical Award

Class III Louis Ami of the Universal
City Studio
For the design and construction of a reciprocating camera
platform used when photographing special visual effects for
motion pictures

Comments

Los Angeles almost met its doom in *Earthquake*, a thriller A-1 that also
served as Universal's premiere Sensurround release. What a show it was.
Great effects abounded, including flawlessly rendered matte paintings,
miniatures, pyrotechnics, floods, and full-scale devastation. All were exe-
cuted with total realism and well deserved the Special Achievement award.
When viewed in its original Sensurround edition — the author screened a
preview version containing scenes later excised before theatrical
distribution — it was overwhelming and drew applause from the audience on
each action sequence. Even on television, where it has been expanded with
additionally shot story elements (but not containing the footage that was
edited from the preview version), and minus the Sensurround (the first net-
work showing was simulcast in a few areas), it still is a treat for the viewer.

Credits

Earthquake
(Universal; November 1974)

Executive Producer Jennings Lang *Producer and Director* Mark Robson *Story and*

Screenplay George Fox, Mario Puzo *Cinematographer* Philip Lathrop *Production Designer* Alexander Golitzen *Musical Score* John Williams *Film Editor* Dorothy Spencer *Supervising Sound Editor* Jerry Christian *Art Director* E. Preston Ames *Set Decorator* Frank McKelvy *Costume Designer* Burton Miller *Post Production Supervisor* Phil Scott *Assistant Art Directors* Fred Tuch, Leslie Thomas *Unit Production Manager* Wallace Worsley *Assistant Director* Fred R. Simpson *Second Assistant Director* Murray Schwartz *Unit Publicist* Booker McClay *Wardrobe Supervisor* Sheila Mason *Property Master* Eddie Keys *Stunt Coordinator* John Deheim *Assistant Film Editor* Ed Broussard *Production Coordinator* Esther Powell *Makeup* Nick Marcellino *Cosmetics* Cinematique *Sound Supervisor* Richard Stumpf *Sensurround Development and Sound Consultant* Waldon O. Watson *Production Mixer* Melvin M. Metcalfe, Sr. *Dubbing Mixers* Ronald Pierce, Robert Leonard *Titles and Opticals* Universal Title *Sensurround Development* MCA Inc., RCA *Scoring Concertmaster* Israel Baker *French Horn Solo* Vince De Rosa *Piano Solo* Ralph Greirson, Claire Fisher *Drums Solo* Shelley Manne *Percussion Solo* Jerry Williams *Assistant Cameraman* Robert F. Liu *Camera Helicopter Pilot* James W. Gavin *Special Effects Cinematographer* Clifford Stine *Matte Artist* Albert Whitlock *Matte Cinematography* Roswell A. Hoffman *Miniature Supervisor* Glen E. Robinson *Mechanical Effects* Frank Brendel, Jack McMasters, Lou Ami

A Jennings Lang Presentation. A Mark Robson Production. The Filmmakers Group Inc. Picture. A Red Lion Productions Inc. Film. Made at Universal City Studios and on location in Los Angeles. Copyright 1974 by Universal Pictures, a Division of MCA Inc. Panavision 70. Technicolor. Sensurround. Westrex and RCA Photophone Recording. Stereophonic Sound. 122 minutes. M.P.A.A. Rating: PG.

The Players: *Stewart Graff* Charlton Heston *Remy Royce Graff* Ava Gardner *Sgt. Lew Slade* George Kennedy *Sam Royce* Lorne Greene *Denise Marshall* Genevieve Bujold *Miles Quade* Richard Roundtree *Jody* Marjoe Gortner *Dr. Willis Stockle* Barry Sullivan *Dr. Vance* Lloyd Nolan *Rosa Amici* Victoria Principal *Drunk in Pool Hall* Walter Matthau *Barbara* Monica Lewis *Sal Amici* Gabriel Dell *Ofr. Emilio Chavez* Pedro Armendariz, Jr. *Bill Cameron* Lloyd Gough *Mayor Lewis* John Randolph *Walter Russell* Kip Niven *Assistant Dam Caretaker* Scott Hylands *Corry Marshall* Tiger Williams *Dr. Harvey Johnson* Donald Moffat *Buck* Jesse Vint *Ralph* Alan Vint *Hank* Lionel Johnston *Carl Leeds* John Elerick *Chief Inspector* John S. Ragin *Colonel* George Murdock *Sid* Donald Mantooth *Sandy* Michael Richardson *First Pool Player* Alex A. Brown *Dr. Frank Ames* Bob Cunningham *Bald Headed Pool Player* H.B. Haggerty *Brawny Foreman* John Dennis *Dam Caretaker* Gene Dynarski *Farmer Griggs* Bob Gravage *Technician* Dave Morick *Laura* Inez Pedroza *Las Vegas Booking Agent* Tim Herbert *Police Captain* Lonnie Chapman *Seismologist* Ernest Harada *Second Pool Player* Charles Picerni *Third Pool Player* Dean Smith *Laborer* Don Wilbanks *First Worker* Hal Bokar *Loudspeaker Voice* Stuart Nisbet *Private* Ric

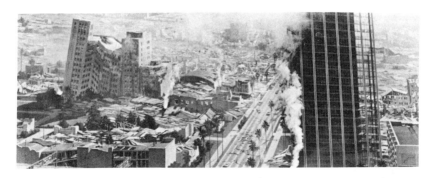

Carrott *Studio Guard* Sandy Ward *Second Worker* Clint Young *Housewife* Frances Osborne *Checkout Clerk* Kitty Vallacher *Ambulance Driver* William Whitaker *First Policeman at Car Wreck* Dave Cass *Second Policeman at Car Wreck* George Sawaya *Nurse* Shannon Christie *First Man* Bruce M. Fisher *Second Man* Jerry Hardin *Third Man* Karl Lukas *First Woman* Diane Herbert *Second Woman* Vivian Brown *Boy with Radio* Josh Albee *First Policeman* Bernie Stettner *Second Policeman* Bert Kramer *Third Radio Voice* Keith A. Walker *Fourth Radio Voice* Ron Fortner *Second Man* Forrest Wood *Stranger* Bill Burton *Boy on Honda* Reb Brown *Bartender* Fred Scheiwiller *Helicopter Pilot* James W. Gavin *Secretary* Patty Elder *Cook* Ken Endoso *Diver* Richard Warlock *Graduate Student* Jim Nickerson *Sports Car Driver* Robert Ferro *Third Policeman* Grant Owens *Ofr. Scott* Ian Bruce *Office Worker* Gene Collier *Stunts* Rick Arnold, Lorraine Baptist, Craig Baxley, Marilyn Beer, Mary R. Ross, Buff Brady, Robert Bralver, Fred Brookfield, Tony Brubaker, Jerry Brutsche, Polly Burson, Hank Calia, Joe Canutt, Mickey Caruso, Bill Catching, Royden Clark, Erik Cord, Paula Crist, Richard Crockett, Evelyne Cuffee, Howard Curtis, John Daheim, Jadie David, Carol DeMent, Dottie Catching, Paula Dell, Dick Dial, Nick Dimitri, Bennie Dobbins, Gary Downey, Larry Duran, Bud Ekins, Patty Elder, Ken Endoso, Andy Epper, Gary Epper, Jeannie Epper, Stephanie Epper, Pam Estrem, Robert Ferro, Lila Finn, Donna Lee Garrett, Ralph Garrett, Mickey Gilbert, Orwin Harvey, Robert D. Herron, Eddie Hice, Fred Hice, Larry Holt, Thomas J. Huff, Victor Hunsberger, Jr., Loren Janes, Edward Jauregui, Kevin Johnston, Julie Ann Johnson, Louise Johnson, Peaches Jones, Kim Kahana, Henry Kingi, William T. Lane, Gene LeBell, Julius Le Flore, Terry Leonard, Allison Logsden, Maurice Marks, Paula Martin, Denver Mattson, Troy Melton, Robert Minor, Jon Arnold Miller, Marilyn Moe, Harry Monty, Stevie Myers, Paul Nuckles, Harvey Parry, Reg Parton, Regina Parton, Barbara Perlman, Melvin Robert Porter, Byron Quisenberry, Glenn H. Randall, Jr., Ernest Robinson, Ronald Clark Ross, Audrey H. Saunders, Russ Saunders, Felix Silla, Eddie Smith, Evelyn Smith, Tom Steele, Cyndi Swan, Bob Terhune, Jack Verbois, Rock Walker, Bud Walls, Marvin Walters, Richard Washington, Jesse Wayne, Jack J. Wilson, Brayton W. Yerkes.

Additional Oscar Nominations: *Cinematography* (Philip Lathrop); *Art Direction–Set Decoration* (Alexander Gollitzen, E. Preston Ames, Frank McKelvey); *Sound* (Ronald Pierce, Melvin Metcalfe, Sr.)*; *Film Editing* (Dorothy Spencer); *Scientific or Technical Award, Class II* (Waldon O. Watson, Richard J. Stumpf, Robert J. Leonard and the Universal City Studio Sound Department for the development and engineering of the Sensurround System for motion picture presentation)

Opposite, top: A somewhat cropped frame blowup from "Earthquake." The scene of devastated Los Angeles is completely painted, with fire and smoke matted in. Bottom: One of the many full-scale special effects rigged for "Earthquake." This one involved a destroyed canal bridge, downed power lines, and onrushing water.

Note: When shown on network television additional footage had been shot and added with some of the principal cast plus new performers (including Debralee Scott). This new footage was shot spherical and in no way matched the scanned anamorphic original. This version did not carry any additional production credits but did note that it was re-edited and expanded for television and that Mark Robson was producer and director of the theatrical version only. It was simulcast in stereo in some areas. Walter Matthau was credited under his real name, Walter Matuschanskayasky.

1975

Special Achievement Award

Visual Effects Albert Whitlock and
Glen Robinson
For *The Hindenburg* (Robert Wise–Filmmakers Group, Universal)

Scientific or Technical Awards

Class III Lawrence W. Butler and
Roger Banks
For the concept of applying low inertia and stepping electric motors to film transport systems and optical printers for motion picture production
Class III . Joseph Westheimer
For the development of a device to obtain shadowed titles on motion picture films

Comments

The producers of *Earthquake* scored again with *The Hindenburg*, the fictionalized account of that great airship's last transAtlantic voyage. The trick work was astounding throughout, with extraordinary matte and glass shots and wonderfully detailed miniatures. The final sequence involved well-staged pyrotechnics intercut with actual newsreel footage that had been *Super*Scoped to match the new Panavision scenes. All the Zeppelin footage, except the last segment, was created by the special effects crew.

Credits

The Hindenburg
(Universal; December 1975)

Producer and Director Robert Wise *Screenplay* Nelson Gidding *Adaptation* Richard Levinson, William Link *Based on the Book by* Michael M. Mooney *Cinematographer* Robert L. Surtees *Musical Score* David Shire *Film Editor* Donn

Cambern *Supervising Sound Editor* Peter Berkos *Production Designer* Edward Carfagno *Costume Designer* Dorothy Jeakins *Sound Supervisor* Richard Stumpf *Production Mixer* Leonard Peterson *Dubbing Mixers* Don K. Sharpless, John A. Bolger, Jr., John Mack *Set Decorator* Frank McKelvey *Production Illustrator* Thomas Wright *Technical Adviser* George Lewis *Unit Production Manager* Ernest B. Wehmeyer *Assistant Director* Howard Kazanjian *Second Assistant Director* Wayne Farlow *Stunt Coordinator* John Daheim *Makeup* Nick Marcellino, Del Acevedo, Frank McCoy, Rick Sharp *Hairdressing* Lorraine Roberson *Men's Wardrobe* Tony Scarano *Assistant Film Editor* Todd Ramsay *Still Photographer* Larry Barbier *Titles and Opticals* Universal Title *Song "There's a Lot to Be Said for the Fuehrer"* David Shire, Edward Kleban *Assistant Cameraman* Robert F. Liu *Special Effects Cinematographer* Clifford Stine *Matte Artist* Albert Whitlock *Matte Cinematography* William Taylor *Mechanical Effects* Glen E. Robinson, Andrew Evans, Frank Brendel, Robert Beck

A Robert Wise Production. From The Filmmakers Group Inc. Made at Universal City Studios and on location in Munich, West Germany, Washington, D.C., New York City, Milwaukee, Wisconsin and El Toro Marine Base, Santa Ana, California. Copyright 1975 by Universal Pictures. Panavision 70. Technicolor. Westrex Recording System. Stereophonic Sound. 125 minutes. M.P.A.A. Rating: PG.

The Players: *Luftwaffe Col. Franz Ritter* George C. Scott *The Countess* Anne Bancroft *Boerth* William Atherton *Martin Otto Vogel* Roy Thinnes *Edward Douglas* Gig Young *Emilio Pajetta* Burgess Meredith *Capt. Pruss* Charles Durning *Lehmann* Richard A. Dysart *Joe Spah* Robert Clary *Maj. Napier* Rene Auberjonois *Reed Channing* Peter Donat *Albert Breslau* Alan Oppenheimer *Mildred Breslau* Katherine Helmond *Bess Channing* Joanna Moore *Capt. Fellows* Stephen Elliott *Eleanore Kessler* Joyce Davis *Valerie Breslau* Jean Rasey *Knorr* Ted Gehring *Freda Halle* Lisa Pera *Schulz* Joe di Reda *Ludecke* Peter Canon *Kirsch* Charles Macaulay *Dimmler* Rex Holman *Speck* Jan Merlin *Stewardess Imhoff* Betsy Jones-Moreland *Eliot Howell III* Colby Chester *Frankel* Teno Pollick *Felder* Curt Lowens *Lt. Truscott* Kip Niven *Rigger Neuhaus* Michael Richardson *Dr. Eckener* Herbert Nelson *Gestapo Major* Scott Walker *Hattie* Ruth Kobart *Morrison* Greg Mullavey *Lt. Lombardi* Val Bisoglio *Luftwaffe General* Simon Scott *Luftwaffe Colonel* William Sylvester *Goebbels* David Mauro *Det. Moore* Joseph Turkel *Det. Grunberger* Sandy Ward *Paul Breslau* John Scott (Johnny) Lee *Peter Breslau* Stephen Manley *Flakus* Jimmy Davila *Stamm* Pat Zurica *Bosun Hoban* Todd Martin *Lessing* James F. Murtaugh *Oster* John Brandon *Ambassador Luther* Rolfe Sedan *Miss Grant* Susan French *Mr. Shimura* Rollin Moriyama *Trudi* Deanna Martin *Tourist* Wade Crosby *Graves* Charles Wagenheim *Captain* Arch Johnson *Baker* Norman Alden *Gestapo Maj. Hochwald* Logan Field *First Secretary* William Wintersole *Undersecretary* John Lasell *Clerk* Victor Perrin *Immigration Officer* Jan Peters *Company Official* Richard Le Pore *Businessman* Arthur Hanson *Sauter* John Pickard *First*

Crewman David Morick *Second Crewman* William Scherer *Frau Knorr* Bea Silvern *Young Man* Danil Torpe *S.S. Man* Bill Sorrells *Kirby* James Lashly *Spah's Daughter* Bonnie Stover *Spah's Son* Eric O'Hauge *Girl at Table* Heide Crane *Kathie Rauch* Ruth Schudson *F.B.I. Man* John F. Swanson *F.B.I. Agent* Durward McDonald, Jr. *Stunts* John Daheim, Denny Arnold, Dottie Catching, William Catching, Randy Crawford, Dick Crockett, Howard Curtis, Dick Dial, Garry Epper, Jerry Gatlin, Orwin Harvey, Robert D. Herron, Bill Hickman, Victor Hunsberger, Jr., John Michael Johnson, Kevin Johnston, Rosemary Johnston, Jim Kingsley, Gerald Martin, Denver Mattson, Jim Nickerson, Regina Parton, Byron Quisenberry, Russell M. Saunders, Felix Silla, Evelyn Smith, Jack Verbois, Richard Warlock, Chuck Waters, George Wilbur

Additional Oscar Nominations: *Cinematography* (Robert Surtees); *Art Direction–Set Decoration* (Edward Carfagno, Frank McKelvey) *Sound* (Leonard Peterson, John A. Bolger, Jr., John Mack, Don K. Sharpless); *Special Achievement Award—Sound Effects* (Peter Berkos)*

Note: Original black-and-white 1.33 × 1 footage of the actual Hindenburg explosion and crash was converted to *Super*Scope 235 and tinted and toned in color to match the new Panavision and color scenes. It was decided, however, to go black-and-white for this sequence in the release prints. When the airship exploded all color was literally blown out and the following scenes, both original and recreated, were black-and-white until after the destruction sequence, when the film returned to color.

1976

Special Achievement Awards

Visual Effects Carlo Rambaldi, Glen
Robinson and Frank
van der Veer
For *King Kong* (De Laurentiis, Paramount)
Visual Effects . L.B. Abbott,
Glen Robinson and
Matthew Yuricich
For *Logan's Run* (Saul David, MGM)

Comments

A sad, disgusting year indeed for the Academy was this when two poor films received Special Achievement awards for substandard Visual Effects. The Special Effects Committee was not pleased with any of this year's releases and advised the Board of Governors that no Oscar would be given in the trick field. But the governors, under pressure from various outside sources, overrode the committee (which prompted some resignations) and handed out statuettes to the above. The Visual Effects Oscar could at this time be given for any or all of the following: full-size mechanical effects, optical effects, matte art and/or miniatures.

Logan's Run, about a future society in which all over thirty are killed, had okay matte art, but the miniatures were poor and the mechanical effects unimpressive.

King Kong, a comedy remake of the 1933 masterpiece, was poor in almost all of its trick work including bad models, bleed-through traveling mattes, unrealistic matte paintings, and a giant mechanical robot that did not work. The giant mechanical paw and the mechanically controlled ape mask, however, were excellent.

Neither film was deserving of any special recognition. This year, at least, brought the Academy much deserved criticism for a shameful move by the governors who apparently were reacting improperly to certain industry movers.

Credits

King Kong

(Paramount; December 1976)

Executive Producer Federico De Laurentiis, Christian Ferry *Producer* Dino De Laurentiis *Director* John Guillermin *Screenplay* Lorenzo Semple, Jr. *Based on the 1933 RKO Radio Screen Play by* James Ashmore Creelman, Ruth Rose Schoedsack *From a Story by* Merian C. Cooper, Edgar Wallace *and Concepts by* Merian C. Cooper, Harry O. Hoyt, Willis H. O'Brien *Cinematographer* Richard H. Kline *Musical Score* John Barry *Film Editor* Ralph E. Winters *Sound Editor* James J. Klinger *Production Executive* Jack Grossberg *Production Designers* Mario Chiaro, Dale Hennesy *Second Unit Director* William Kronick *Production Manager* Terry Carr *Unit Manager* Steve Bernhardt *Hawaii Unit Manager* Brian Frankish *New York Unit Manager* George Goodman *Assistant Directors* David McGiffert, Kurt Neumann, Jr. *Second Assistant Director* Pat Kehoe *Second Unit Assistant Director* Nate Haggard *Production Coordinator* Lori Imbler *Production Secretary* Charlotte Dreiman *Art Directors* Archie J. Bacon, David A. Constable, Robert Gundlach *Production Illustrators* Mentor Huebner, David Negron *Set Designers* Diane Wager, Carlton Reynolds, William Cruz *Set Decorator* John Franco, Jr. *Property Master* Jack Marino *Men's Costume Designer* Moss Mabry *Women's and Native Costume Designer* Anthea Sylbert *Script Supervisor* Doris Grau *Camera Operator* Al Bettcher *Assistant Cameraman* Robert Edesa *Key Grip* Robert Sordal *Crane Grip* Pat Walker *Grip* Al Santos *Gaffer* Ed Carlin *Still Photographers* Elliot Marks, Sid Baldwin *Special Action Props* Don Post Studios *Sound* Metro-Goldwyn-Mayer Studios *Production Mixer* Jack Solomon *Boom Operator* Joe Kenworthy *Scoring Mixer* Daniel Wallin *Scoring Re-Mixer* Aaron Rochin *Dubbing Mixers* Harry Warren Tetrick, William McCaughey *Makeup* Del Acevedo, John Truwe *Hairdressing* Jo McCarthy *Wardrobe* Arnold M. Lipin, G. Fern Weber *Painters* Robert Clark, Curtis "Red" Hollingsworth *Construction Coordinator* Gary Martin *Greensman* Ken Richey *Transportation Coordinator* Joe Sawyers *Stunt Coordinator* Bill Couch *Post Production Supervisor* Phil Tucker *Assistant to the Producer* Frederic M. Sidewater *Casting* Joyce Selznick & Associates, Toni Barton *Atmosphere Casting* Sally Perle & Associates *Assistant Film Editors* Robert Pergament, Margo Anderson *Music Editor* Kenneth J. Hall *Publicity Coordinator* Gordon Armstrong *Unit Publicist* Bruce Bahrenburg *Production Auditor* Robert F. Kocourek *Production Accountant* Meryle Selinger *Payroll* Thelma Norris *Production Assistants* Scott Thayler, Jeffrey Chernov, Michael Winter, Ron Volz *Choreography* Claude Thompson *Titles* Pacific Title & Art Studio *Producer's Secretary* Tara Cole *Director's Secretary* Beth Voiker *Helicopter Pilots* Ron Thrash, Tom Hauptman *Paramount Representative* Cathi Polich *Visual Effects* Frank

van der Veer *Visual Effects Assistant* Barry Nolan *Additional Visual Effects* Harold E. Wellman *Matte Artist* Louis Lichtenfield *Miniature Coordinator* Aldo Puccini *Visual Effects Editors* Margo Anderson, William Cruse *Optical Effects* Van der Veer Photo Effects *Mechanical Effects* Glen E. Robinson, Joe Day *Mechanical Kong Design and Engineering* Carlo Rambaldi, Isidoro Raponi *Mechanical Kong Construction* Carlo Rambaldi, Isidoro Raponi, Glen E. Robinson *Special Kong Contributions* Rick Baker, Rob Bottin *Mechanical Kong Coordinator* Eddie Surkin *Kong Hair Design* Michael Dino *Kong Modeler* Don Chandler

A Dino De Laurentiis Production. A John Guillermin Film. Made at Metro-Goldwyn-Mayer Studios and on location in Kauai, Hawaii and New York City. Copyright 1976 by Dino De Laurentiis Corporation. Panavision. Metrocolor. Westrex Recording System. Stereophonic Sound. 134 minutes. M.P.A.A. Rating: PG.

The Players: *Jeff Prescott* Jeff Bridges *Fred S. Wilson* Charles Grodin *Dwan* Jessica Lange *Capt. Ross* John Randolph *Ray Bagley* Rene Auberjonois *Boan* Julius Harris *Joe Perko* Jack O'Halloran *Sunfish* Dennis Femple *Carnahan* Ed Lauter *Garcia* Jorge Moreno *Timmons* Mario Gallo *Cook* John Lone *General* Garry Walberg *City Official* John Agar *Ape-Masked Native* Keny Long *Petrox Chairman* Sid Conrad *Helicopter Pilot* George Whitman *Colonel* Wayne Heffley *King Kong* Rick Baker *Radar Operator* Ray Buktenica *Girl* Lydia Cornell *Stunts* Bill Couch, Bill Shepherd, Sunny Woods, Beth Nufer, Julius LeFlore

Additional Oscar Nominations: *Cinematography* (Richard H. Kline); *Sound* (Harry Warren Tetrick, William McCaughey, Aaron Rochin, Jack Solomon)

Note: Remake of the fantasy classic. Released in 70mm and Sensurround outside the U.S. Originally Universal was going to do a version entitled *The Legend of King Kong* in Sensurround. De Laurentiis also had announced a remake, then titled *King Kong, A Legend Reborn*. In a much over-publicized legal battle, Universal agreed not to produce their edition in return for a percentage of the De Laurentiis production, certain overseas distribution rights through their Cinema International Corporation (owned in part with Paramount), and utilization of Sensurround in the overseas market. De Laurentiis's sequel was *King Kong Lives!* (1986). For the network television presentation, over an hour of outtakes and unused footage was reinserted. The original RKO feature had been followed by the sequel *The Son of Kong* (RKO Radio, 1933). They had purposed a third feature but this was never made. Toho Company, Ltd., was authorized by RKO General to produce *King Kong vs. Godzilla* (Universal-International, 1963) and *King Kong Escapes* (Universal, 1968). The first was co-produced with John Beck and the second co-produced by Rankin-Bass, who also produced an animated children's cartoon series for

ABC-TV in 1966–69. The second feature was actually an offshoot of the car-
toon series and utilized live action versions of characters from the television
program. In 1969 an unauthorized remake entitled *The Mighty Gorga* (Distrib-
utors Producing Organization) was released. Other unauthorized remakes in-
clude *The New King Kong* (a.k.a. *Super Kong 1, Ape, Gorilla, The Attack of the Giant
Horny Gorilla*) (Worldwide Entertainment, 1976) in Spacevision 3-D, *Queen
Kong* (British, 1976) and *Baby Kong* (Italian, 1976). 1976 was indeed the Year
of Kong. Other films, all unauthorized, have employed the Kong character
or variations thereof, including *Konga* (American International, 1961) and *King
of Kong Island* (Spanish, 1978). At least two producers have announced addi-
tional remakes of the original. These have not been authorized by RKO
General.

Logan's Run

(Metro-Goldwyn-Mayer through United Artists; June 1976)

Producer Saul David *Associate Producer* Hugh Benson *Director* Michael Ander-
son, Sr. *Screenplay* David Zelag Goodman *Based on the Novel by* William F.
Nolan, George Clayton Johnson *Cinematographer* Ernest Laszlo *Musical Score*
Jerry Goldsmith *Film Editor* Robert Wyman *Sound Editor* John P. Riordan
Production Designer Dale Hennesy *Set Decorator* Robert De Vestel *Costume
Designer* Bill Thomas *Assistant Director* David Silver *Second Assistant Directors*
Alan Brimfield, Win Phelps, Jerald Sobul *Stunt Coordinators* Glen Wilder, Bill
Couch *Dolby Stereo Consultant* Stephen Katz *Todd-AO Consultant* Richard
Vettier *Music Editor* William Saracino *Titles and Opticals* MGM Laboratories
Camera Operator Richard Johnson *Script Supervisor* Ray Quiroz *Property Master*
Jack Marino *Assistant Property Master* Charles Sertin *Production Mixer* Jerry Jost
Recorder William Manooch *Boom Operator* Joseph Kite *Dubbing Mixers* Harry
W. Tetrick, William McCaughey, Aaron Rochin *Hairdressing* Judy Alex-
ander Corey *Makeup* William Tuttle, Richard Cobos, Robert Dawn *Assistant
to the Producer* Lara Lindsay *Casting* Jack Baur *Unit Production Manager* Byron
Roberts *Choreography* Stephan Wenta *Construction Supervisor* Larry Yzuel
Wardrobe Dick Butz, Edna Taylor, Ronald Dawson, Joanne Hutchinson
Laser Consultant Christopher Outwater *Holograms* Multiplex Company *Video
Equipment* Bruce Hill Productions *Video Operator* Lindsey Hill *Unit Publicist*
Don Morgan *Gaffer* Don Stott *Key Grip* Martin Kaschuk *Cats* Cat Care
Shelter *Cat Wrangler* Hettie Kram *Assistant Film Editor* Freeman Davies
Courtesy Credit The Texas Film Commission *Visual Effects* L.B. Abbott *Visual
Effects Assistant* Larry Robinson *Visual Effects Coordinator* Brent Sellstrom
Optical Cinematography Jim Liles *Snorkel Camera Equipment* Kenworthy Camera
Systems *Matte Artist* Matthew Yuricich *Visual Effects Camera Operator* Albert
Meyers *Visual Effects Key Grip* Dick Deats *Additional Visual Effects* Frank van
der Veer *Mechanical Effects* Glen E. Robinson, Fred Kramer

A Saul David Production. Made at MGM Studios and on location in Dallas, Texas. Copyright 1976 by Metro-Goldwyn-Mayer Inc. Todd-AO. Metrocolor. Dolby Stereo. 118 minutes. M.P.A.A. Rating: PG.

The Players: *Logan* Michael York *Francis* Richard Jordan *Jessica* Jenny Agutter *Box* Roscoe Lee Browne *Holly* Farrah Fawcett-Majors *Doc* Michael Anderson, Jr. *Old Man* Peter Ustinov *First Sanctuary Man* Bob Neil *Second Sanctuary Man* Randolph Roberts *Female Runner* Lara Lindsay *Billy* Gary Morgan *Mary Lou* Michelle Stacy *First Male Runner/Stuntman* Denny Arnold *Second Male Runner/Stuntman* Glen Wilder *Sanctuary Woman* Camilla Carr *Ambush Man* Greg Michaels *Daniel* Roger Borden *Attractive Woman on Last Day* Ann Ford *New You Shop Customer* Laura Hippe *Girl* Ashley Cox *Stuntman* Bill Couch *Stuntwoman* Regina Parton

Additional Oscar Nominations: *Cinematography* (Ernest Laszlo); *Art Direction–Set Decoration* (Dale Hennesy, Robert De Vestel)

Note: Photographed in Todd-AO 35 and blown up to 70mm. MGM continued the story in an unsuccessful series for CBS-TV which ran from September 16, 1977 to January 16, 1978. The project was first announced as a George Pal production, but that producer left the studio before it became a reality.

1977

Visual Effects (reclassification) Nominations

Close Encounters of the Third Kind Roy Arbogast,
 (Columbia) Douglas Trumbull, Matthew
 Yuricich, Gregory Jein,
 Richard Yuricich
*Star Wars John Stears,
 (20th Century–Fox) John Dykstra, Richard
 Edlund, Grant McCune,
 Robert Blalack

Scientific or Technical Awards

Class II John C. Dykstra
For the development of a facility uniquely oriented toward visual effects photography

Class II Alvah J. Miller and
 Jerry Jeffress
For the engineering of the Electronic Motion Control System used in concert for multiple exposure visual effects motion picture photography

Comments

Once again the Visual Effects category was reclassified as a competitive award.

Star Wars took place "a long time ago in a galaxy far, far away" and recounted the efforts of a rebel army to overthrow a dictatorial warlord and his fascist stooges. It offered the most spectacular trick work created up to that time. All aspects were near flawless, with the only lapses being some matte hazing due to negative shrinkage.

Close Encounters of the Third Kind, a silly but impressive tale of mankind's first full encounter with alien superbeings of peaceful intent, had equally well done effects, more or less. With the use of glaring lights, any bad traveling mattes could be easily covered, so it's not quite fair to state that they were totally equal. They were also less complex than the *Star Wars* shots.

Both films employed extremely detailed miniatures and fine matte paintings. They completely regenerated the sci-fi movie genre. As a side

effect, they also helped immeasurably toward establishing the Dolby noise reduction encoded stereo variable area soundtrack as a new, inexpensive means of producing ultra high fidelity surround sound and created renewed interest in 70mm wide screen release printing. This last element has unfortunately resulted in numerous bad blowups while not inspiring the use of 70mm production filming.

Credits

Close Encounters of the Third Kind
(Columbia; November 1977)

Producers Julia Phillips, Michael Phillips *Director* Steven Spielberg *Screenplay* Steven Spielberg, Paul Schrader, Walter Hill, David Giler, Jerry Belson, Hal Barwood, Matthew Robbins *Story* Steven Spielberg *Cinematographer* Vilmos Zsigmond *Additional Cinematographers* John A. Alonzo, Laszlo Kovacs, Frank W. Stanley *India Sequences Cinematographer* Douglas Slocombe *Additional Sequences Cinematographer* William A. Fraker *Second Unit Cinematographer* Steve Poster *Musical Score* John Williams *Film Editor* Michael Kahn *Supervising Sound Effects Editor* Frank Warner *Supervising Dialogue Replacement Editor* Jack Schrader *Production Designer* Joe Alves *Associate Producer and Unit Production Manager* Clark L. Paylow *Technical Adviser* Dr. J. Allen Hynek *Art Director* Dan Lomino *Set Decorator* Phil Abramson *Assistant Director* Chuck Myers *Second Assistant Director* Jim Bloom *Assistant Film Editors* Geoff Rowlands, Charles Bornstein *Music Editor* Kenneth Wannberg *Sound Effects Editors* Richard Oswald, David Horten, Sam Gemette, Gary S. Gerlich, Chet Slomka, Neil Barrow *Technical Dialogue Effects* Colin Cantwell *Dialogue Replacement Editor* Dick Friedman *Assistant Dialogue Replacement Editors* Robert A. Reich, Bill Jackson *Production Illustrator* George Jensen *Dolby Stereo Supervisor* Steve Katz *Sound Supervisor* Fred Hynes *Sound* Todd-AO *Production Mixer* Gene Cantamessa *Scoring Mixer* John Neal *Dubbing Mixers* Buzz Knudson, Don MacDougall, Robert Glass *Music Recording* The Burbank Studios *Mother Ship Tuba Solo* Tommy Johnson *Light Board Oboe Solo* John Ellis *Music Supervisor* Richard Berres *Music Coordinator* Brendan Cahill *Camera Operator* Nick McLean *India Sequences Camera Operator* Chic Waterson *India Sequences Assistant Cameraman* Robin Vidgeon *Location Manager* Joe O'Har *Gaffer* Earl Gilbert *Key Grip* Dick Deats *Assistant to the Producers* Kendall Cooper *Second Assistant to the Producers* Judy Bornstein *Assistant to the Director* Ric Fields *Production Secretary* Gail Siemers *Production Staff* Sally Dennison, Janet Healey, Pat Burns *American Film Institute Intern* Seth Winston *Makeup Supervisor* Bob Westmoreland *Makeup* David Ayres *Hairdressing* Edie Panda *Property Master* Sam Gordon *Wardrobe Supervisor* James Linn *Stunt Coordinator* Buddy Joe

Hooker *Script Supervisor* Charlsie Bryant *Casting* Shari Rhodes, Juliette Taylor *Additional Casting* Sally Dennison *Publicity Coordinators* Pickwick Public Relations *Unit Publicists* Marvin Levy, Murray Weissman, Al Ebner *Still Photographers* Peter Sorel, Jim Coe, Pete Turner *Title Design* Dan Perri *Animal Sequences Supervisor* Dr. H.C. Edwards *Songs* "Chances Are" Publisher: International Kerwin Corp., From the Columbia Records Album "Johnny Mathis' All-Time Greatest Hits"; "When You Wish Upon a Star" Copyright 1940 by Bountie Co.; "The Square Song" Publisher: Jorico Music Inc., Courtesy of: Pickwick International Inc.; "Love Song of the Waterfall" Publishers: Unichappell Music Inc., Elvis Presley Music, From the United Artists Records Album "Love Song of the Waterfall." *"The Ten Commandments" Excerpt Courtesy of and Copyright 1955 by* Paramount Pictures Corp. *Courtesy Credits* The Governor of Alabama; the Governor of Wyoming; the Government of India; Kiddaly Musical Training Institute Inc. *Assistant to Francois Truffaut* Francoise Forget *Location Auditor* Steve Warner *Construction Manager* Bill Parks *Color Consultant* Robert McMillan *Video Technician* "Fast" Eddie Mahler *Alien Makeups* The Burman Studio, Ellis Burman, Tom Burman *Extraterrestrial Choreography* Susan Heldford *Visual Effects* Future General Corporation *Visual Effects Unit — Concepts* Steven Spielberg *Supervisor* Douglas Trumbull *Cinematographer* Richard Yuricich *Matte Artist* Matthew Yuricich *Coordinator and Editor* Larry Robinson *UFO Cinematography* Dave Stewart *Project Manager* Robert Shepherd *Chief Miniaturist* Gregory Jein *Matte Cinematography* Don Jarel *Project Coordinator* Mona Thal Benefiel *Camera Operators* Eugene Eyerly, Eldon Rickman, Dave Berry, Maxwell Morgan, Ron Peterson *Assistant Cameramen* David Hardberger, Alan Harding, Bill Millar, Bruce Nicholson, Richard Ripple, Scott Squares *Still Photographer* Marcia Reid *Cinetechnician* Robert Hollister *Miniature Shop Coordinator* J. Richard Dow *Miniaturists* Paul Huston, David M. Jones, Jor van Kline, Michael McMillen, Kenneth Swenson, Robert Worthington, Peter Anderson, Larry Albright *Camera and Mechanical Design* Don Trumbull, B.G. Engineering, John Russell, Fries Engineering *Mechanical Effects* George Polkinghorne *Electronics Design* Jerry L. Jeffries, Alvah J. Miller, Peter Regla, Dan Slater *Motion Control Techician* Gregory L. McMurray *Assistant Matte Artist* Rocco Gioffre *Gaffer* David Gold *Key Grip* Ray Rich *Illustrators* Dan Goozee, Ralph McQuarrie *Laboratory Expeditor* Charles Hinkle *Animation Supervisor* Robert Swarthe *Animator* Harry Moreau *Assistant Animators* Carol Boardman, Eleanor Dahlan, Cy Didjurgis, Tom Koester, Connie Morgan *Optical Cinematography* Robert Hall *Mother Ship Cinematography* Dennis Muren *Production Secretary* Joyce Goldberg *Production Accountant* Peggy Rosson *Project Assistants* Glenn Erickson, Hoyt Yeatman *Assistant Editor* Joseph Ippolito *Transportation Coordinator* Bill Bethea *Laboratory Technicians* Don Dow, Tom Hollister *Negative Cutter* Barbara Morrison *Special Consultants* Peter Anderson, Larry Albright, Richard Bennett, Ken Ebert, Kevin Kelly, Jim Lutes, George Randall, Jeff Shapiro, Rourke Engineering — *Mechanical Effects Supervisor* Roy Arbogast *Mechanical Effects*

Technician Michael Wood *Extraterrestrial Realization* Carlo Rambaldi, Isidoro Raponi

A Columbia Presentation in Association with EMI Films Inc. and Time Inc. A Julia Phillips-Michael Phillips Production. A Steven Spielberg Film. Made at The Burbank Studios and on location in Benares, India, Gillette, Wyoming, Mojave, California and Mobile and Bay Minette, Alabama. Copyright 1977 by Columbia Pictures Industries Inc. Music Copyright 1977 by Gold Horizon Music Corporation. Panavision 70. Metrocolor. Dolby Stereo. 135 minutes. M.P.A.A. Rating: PG.

The Players: *Roy Neary* Richard Dreyfuss *Claude Lacombe* Francois Truffaut *Ronnie Neary* Teri Garr *Jillian Guiler* Melinda Dillon *David Laughlin* Bob Balaban *Robert* Lance Hendrikson *Wild Bill* Warren Kemmerling *Farmer* Roberts Blossom *Jean Claude* Phillip Dodds *Barry Guiler* Cary Guffey *Brad Neary* Shawn Bishop *Sylvia Neary* Adrienne Campbell *Toby Neary* Justin Dreyfuss *Team Leader* Merrill Connally *Maj. Benchley* George Di Cenzo *Project Leader* J. Patrick McNamara *Power Plant Technician* Ted Henning *Executive Engineer* Norman Dreyfuss *Larry Butler* Josef Sommer *Scientist* Dr. J. Allen Hynek *Chief Art Traffic Controller* Bill Thurman *Military Policeman* Carl Weathers *Highway Patrolman* Roger Ernest *Ike* Gene Dynarski *Hawker* Gene Rader *A.R.P. Project Member* F.J. O'Neil *Implantees* Amy Douglas, Alexander Lockwood *Mrs. Harris* Mary Gadfrey *Ohio Tolls* Norman Bartold *Rev. Michael J. Dyer* Rev. Michael J. Dyer *Flight 19 Returnees* Randy Herrmann, Hal Barwood, Matthew Robbins *Air Traffic Controllers* David Anderson, Richard L. Hawkins, Craig Shreeve *Air East Pilot* Roy E. Richards *Federales* Eumenico Blanco, Daniel Nunez, Chuy Franco, Luis Contreras *Power Truck Dispatcher* Richard Stuart *Power Load Dispatcher* Bob Westmoreland *Support Leader* Matt Emery *Radio Telescope Team* James Keane, Dennis McMullen, Cy Young, Tom Howard *Special Forces* Galen Thompson, John Dennis Johnston *Dirty Tricks* John Ewing, Keith Atkinson, Robert Broyles, Kirk Raymond *Returnees* Bob Westmoreland, Dr. J. Allen Hynek *Stuntman* Buddy Joe Hooker *Stuntwoman* Jeannie Epper *World War II Pilot* Bruce Davidson *Man* Jim Mills *Scientist* Dr. Jacques Vallee *Howard J. Stein* Himself

Additional Oscar Nominations: *Supporting Actress* (Melinda Dillon); *Direction* (Steven Spielberg); *Cinematography* (Vilmos Zsigmond); *Art Direction-Set Decoration* (Joe Alves, Dan Lomino, Phil Abramson); *Sound* (Robert Knudson, Robert J. Glass, Don MacDougall, Gene S. Cantamessa); *Film Editing* (Michael Kahn); *Music — Original Score* (John Williams); *Special Achievement Award-Sound Effects Editing* (Frank Warner)*

Note: John Milins may have contributed to the screenplay. Working titles were *Experiences* and *Watch the Skies*. A very loose remake of Spielberg's

amateur film *Firelight* (1964). Most sequences were shot in Panavision with
visual effects filmed in Super Panavision 70 and Todd-AO. 70mm
engagements were advertised in Super Panavision 70 but this was incorrect
as all the 70mm footage had been reduced to 35mm, intercut with the 35mm
shots and then blown up to 70mm. The song lyrics to *"When You Wish Upon
a Star"* were not used. When Columbia requested a sequel, Spielberg con-
vinced them to let him shoot those sequences not shot but originally intended
for the first edition. The new footage was produced at The Burbank Studios
and on location at Dumont Dunes in Death Valley, California for approx-
imately $1,000,000 and totaled 6 minutes. Additionally, 6 minutes of unused
footage already shot was restored and 16 minutes of the first version was ex-
cised. This reworked version was issued and advertised as *Close Encounters of
the Third Kind Special Edition* in August 1980. The running time was 132
minutes. When presented on network television a third version was made up
of both earlier editions, but minus some footage, with a 143-minute running
time. The second edition credits were: Cinematographer, Alan Daviau; Pro-
duction Designer, Ron Cobb; Unit Production Manager, Ronald L.
Schwary; Visual Effects Supervisors, Robert Swarthe, Robert Short;
Masks, Robert Short; Motion Control Cinematography, Dream Quest Inc.;
Copyright 1980 by Columbia Pictures Industries Inc. None of these
crewmen were given a screen credit. Prints were available in 70mm blowup
and 35mm anamorphic. In 1982 Spielberg's pseudo-sequel *E.T. The Extra-
Terrestrial* was released by Universal after being rejected by Columbia. See
1982.

Star Wars
(20th Century–Fox; May 25, 1977)

Executive Producer, Writer and Director George Lucas *Additional Dialogue* Gloria
Katz Huyck, Willard Huyck *Producer* Gary Kurtz *Cinematographer* Gilbert
Taylor *Musical Score* John Williams *conducting the* London Symphony Or-
chestra *Film Editors* Paul Hirsch, Marcia Lucas, Richard Chew *Supervising
Sound Editor* Sam Shaw *Production Designers* Elliot Scott, John Barry *Production
Illustrators* Ralph McQuarrie, Michael Minor, Alex Tavoularis *Art Directors*
Norman Reynolds, Leslie Dilley, Harry Lange *Second Unit Art Directors* Leon
Erickson, Al Locatelli *Set Decorator* Roger Christian *Costume Designer* John
Mollo *Second Unit Directors* Robert Watts, Gary Kurtz *Makeup Supervisor*
Stuart Freeborn *Makeup* Kay Freeborn, Graham Freeborn, Christopher
Tucker *Hairdressing* Pat McDermott *Second Unit Makeup* Rick Baker, Douglas
Beswick, Lane Liska, Jon Berg, Philip Tippett, Rob Bottin *Casting* Irene
Lamb, Diane Crittenden, Vic Ramos *Stunt Coordinator* Peter Diamond *Script
Supervisor* Ann Skinner *Second Unit Cinematographers* Carroll Ballard, Rick
Clemente, Robert Dalva, Tak Fujimoto *Samuel Goldwyn Sound Supervisor* Don

Rogers *Todd-AO Sound Supervisor* Fred Hynes *Sound* De Lane Lea London, Producers Sound Service, Glen Glenn Sound, Todd-AO, Samuel Goldwyn Studios *Dolby Stereo Consultant* Stephen Katz *Production Mixer* Derek Ball *Scoring Mixer* Eric Tomlinson *Scoring Re-Mixer* John Neal *Dubbing Mixers* Don MacDougall, Bob Minkler, Ray West, Mike Minkler, Lester Fresholtz, Richard Portman, Robert Litt *Music Recording* Anvil Films Ltd. *Music Re-Recording* The Burbank Studios *Post Production Facilities* American Zoethrope Studios *Sound Editors* Robert R. Ruthledge, Gordon Davidson, Gene Corso *Assistant Sound Editors* Roxanne Jones, Karen Sharp *Sound Effects and Special Dialogue Creation* Ben Burtt *Production Supervisor* Robert Watts *Production Manager* Bruce Sharman *Additional Production Personnel* Jacob Bloom, Peter Beale, Richard Fichter, Jeff Segal, Jack Foster, Gary Jouvenat, Andy Rigrod, Jack Garsha *Construction Manager* Bill Welch *Legal Affairs* Tom Pollock *Second Unit Production Managers* David Lester, Peter V. Herald, Pepi Lenzi *Production Cooperation* Tunisian Government, U.S. Department of Interior, National Parks Service, Guatemalan Institute of History and Anthropology *Title Design* Dan Perri *Supervising Music Editor* Kenneth Wannberg *Orchestration* Herbert W. Spencer *Assistant Film Editors* Todd Boekelheide, Jay Miracle, Colin Kitchens, Connie Koehler *Camera Operators* Ronnie Taylor, Geoff Glover *Assistant Director* Tony Waye *Second Assistant Directors* Gerry Gavigan, Terry Madden *Location Manager* Arnold Ross *Assistant to the Producer* Bunny Alsup *Assistant to the Director* Lucy Autrey Wilson *Production Assistants* Pat Carr, Miki Herman *Gaffer* Ron Tabera *Property Master* Frank Bruton *Property Man* Phil "Maxie" Macdonald *Construction Storeman* David Middleton *Wardrobe Supervisor* Ron Beck *Costume Makers* Bermans & Nathans Ltd. *Production Controller* Brian Gibbs *Location Auditor* Ralph M. Leo *Assistant Auditors* Steve Cullip, Penny McCarthy, Kim Falkinburg *Advertising and Publicity Coordinator* Charles Lippincott *Unit Publicist* Brian Doyle *Still Photographer* John Jay *Electrical Contractors* Lee Electric (Lighting) Ltd. *C-3PO Design* Ralph McQuarrie, Norman Reynolds, Liz Moore *Publications Supervisor* Carol Wikarska *Additional Alien Design* Ralph McQuarrie, Ron Cobb *Visual Effects* Industrial Light & Magic Inc., a Division of Lucasfilm Ltd. *Visual Effects Unit — General Manager* Jim Nelson *Supervisor* John Dykstra *Cinematographer* Richard Edlund *Second Cinematographer* Dennis Muren *Assistant Cameramen* Douglas Smith, Kenneth Ralston, David Robman *Second Unit Cinematographer* Bruce Logan *Optical Cinematography* Robert Blalack, Praxis Film Works Inc. *Optical Coordinator* Paul Roth *Optical Printers* David Berry, David McCue, Richard Pecorella, Eldon Rickman, James Van Trees, Jr., Bill Rineholt *Optical Assistants* Caleb Aschkynazo, John C. Moulds, Bruce Nicholson, Gary Smith, Bert Terreri, Donna Tracy, Jim Wells, Vicky Witt, Mark Vargo *Production Supervisor* George E. Mather *Matte Artist* P.S. (Harrison) Ellenshaw *Planet and Satellite Artist* Ralph McQuarrie *Traveling Matte Consultant* Stanley Sayer *Production Designer and Illustrator* Joseph Johnston *Additional Spacecraft Designer* Colin Cantwell *Chief Miniaturist* Grant McCune *Miniaturists* David Beasley, Jon Erland, Lorne Peterson, Steve Gawley, Paul

Huston, David Jones *Animation and Rotoscope Designer* Adam Beckett *Animators* Michael Ross, Peter Kuran, Jonathan Seay, Chris Casady, Lyn Gerry, Diana Wilson, Nina Saxon *Stop Motion Animators* Jon Berg, Philip Tippett *Stop Motion Technician* Laine Liska *Pyrotechnical Effects* Joseph Viskocil, Greg Auer *Computer Animation and Graphic Displays* Dan O'Bannion, Larry Cuba, John Wash, Jay Teitzell, Dominic Iaia, Image West *Film Control Coordinator* Mary M. Lind *Film Librarians* Cindy Isman, Connie McCrum, Pamela Malouf *Electronic Design* Alvah J. Miller, Miller Electronics, Jerry Jeffress *Electronic Effects* Ron Hayes *Special Components* James Shourt *Special Components Assistants* Masaaki Norihoro, Eleanor Porter *Camera and Mechanical Equipment* Jerry Greenwood, Douglas Barnett, Stuart Ziff, David Scott *Production Managers* Bob Shepherd, Lon Tinney *Production Staff* Patricia Rose Duignan, Mark Kline, Rhonda Peck, Ron Nathan *Assistant Editor* Bruce Michael Green *Additional Optical Supervisors* Dan Genis, Ray Mercer, Sr., Frank van der Veer, Dick Bond *Additional Optical Effects* Modern Film Effects, Ray Mercer & Company, Van der Veer Photo Effects, Master Film Effects, De Patie-Freleng Enterprises Inc. — *Mechanical Effects Supervisor* John Stears

A Lucasfilm Ltd. Production. A Star Wars Corporation Picture. Made at EMI Elstree Studios, Shepperton Studio Centre and American Zoethrope Studios and on location in Nelfa, Jerba and Matama, Tunisia, Tikal National Park, Guatemala and Death Valley National Monument, California. Copyright 1977 by 20th Century–Fox Film Corporation. Music Copyright 1977 by Fox Fanfare Music Inc. Panavision 70. Color by Technicolor. Prints by De Luxe. Dolby Stereo. 121 minutes. M.P.A.A. Rating: PG.

The Players: *Luke Skywalker* Mark Hamill *Han Solo* Harrison Ford *Princess Leia Organa* Carrie Fisher *Grand Moff Tarkin* Peter Cushing *Ben (Obi-Wan) Kenobi* Alec Guinness *C-3PO* Anthony Daniels *R2-D2* Kenny Baker *Chewbacca* Peter Mayhew *Lord Darth Vader* David Prowse *Vader's Voice Characterization* James Earl Jones *Uncle Owen Lars* Phil Brown *Aunt Beru Lars* Shelagh Fraser *Chief Jawa* Jack Purvis *Jawas* Mahjoub, Mike Edmonds *Gen. Dodonna* Alex McCrindle *Gen. Willard* Eddie Byrne *Red Leader* Drewe Henley *Wedge* Dennis Lawson *Biggs* Garrick Hagon *John D* Jack Klaff *Porkins* William Hootkins *Gold Leader* Angus McInnis *Gold Two* Jeremy Sinden *Gold Five* Graham Ashley *Gen. Taggi* Don Henderson *Gen. Motti* Richard Le Parmentier *First Imperial Commander* Leslie Schofield *Extra* Kathleen Norris "Koo" Stark

Additional Oscar Nominations: *Picture* (20th Century–Fox; Gary Kurtz); *Supporting Actor* (Alec Guinness); *Direction* (George Lucas); *Writing — Screenplay written directly for the screen* (George Lucas); *Art Direction–Set Decoration* (John Barry, Norman Reynolds, Leslie Dilley, Roger Christian)*; *Costume Design* (John Mollo)*; *Sound* (Don MacDougall, Ray West, Bob Minkler,

Derek Ball)*; *Film Editing* (Paul Hirsch, Marcia Lucas, Richard Chew)*; *Music — Original Score* (John Williams)*; *Special Achievement Award — Sound Effects Creation* (Benjamin Burtt, Jr.)*

Note: The original title, *Star Wars Episode IV: A New Hope*, which was utilized on re-issue prints, was simplified to *Star Wars* by 20th Century-Fox when they first released. Unsure that there would be others in the series, they did not want to confuse patrons. Interestingly, the two sequels, *Star Wars Episode V: The Empire Strikes Back* (20th Century-Fox, 1980) and *Star Wars Episode VI: Return of the Jedi* (20th Century-Fox, 1983) have always been referred to by their installment titles, while the first segment has never been acknowledged as *A New Hope* anywhere except in the main titles of the print. It will apparently always be simply *Star Wars*, even though that is the overall moniker for the purposed nine-episode series and not actually the title of any of the films. Most dialogue scenes were shot in Panavision; some dialogue segments shot in Todd-AO 35; and all optical effects sequences shot in VistaVision and converted to *Super*Scope 235 for blowup to 70mm. Some shots were employed in the sixth episode.

1978

Special Achievement Award

Special Visual Effects Les Bowie, Colin Chilvers,
Denys Coop, Roy Field,
Zoran Perisic and Derek Meddings
For *Superman* (Salkind, Warner Bros.)

Medal of Commendation

Linwood G. Dunn, in appreciation for outstanding service and
dedication in upholding the high standards of the Academy of
Motion Picture Arts and Sciences

Comments

The Man of Steel finally arrived on the wide screen, not in the
announced 3-D (this had been hype only), but in 70mm grainily blownup
from 35mm 'scope. A comedy-adventure based on the classic comic book
characters, it featured excellent effects in many scenes, while others, notably
the dam and earthquake shots, were poor. Despite overblown expenses the
film made a huge profit and has so far been followed by three sequels. The
Zoptic front projection system was most impressively employed throughout,
and despite the mentioned shoddy work, the film was award-worthy.

Credits

Superman
(Warner Bros.; December 1978)

Executive Producers Ilya Salkind, Alexander Salkind *Producers* Pierre Spengler,
Richard Lester *Associate Producer* Charles F. Greenlaw *Director* Richard
Donner *Screenplay* Mario Puzo, David Newman, Leslie Newman, Robert
Benton *Additional Script Material* Norman Enfield *Story* Mario Puzo *Based on
the D.C. Comics Inc. Characters Created by* Jerry Siegel, Joe Shuster
Cinematographer Geoffrey Unsworth *Supervising Film Editor* Stuart Baird
Musical Score John Williams *conducting the* London Symphony Orchestra
Creative Consultant Tom Mankiewicz *Title Design* Denis Rich *Makeup Supervisor*

Stuart Freeborn *Makeup Artists* Philip Rhodes, Basil Newall, Kay Freeborn, Graham Freeborn, Nick Maley, Sylvia Croft, Connie Reeve *U.S. Makeup Artist* Louis Lane *Canadian Makeup Artist* Jamie Brown *Casting* Lynn Stalmaster *Casting Associate* Lou Di Giamo *English Casting* Mary Selway *Chief Script Supervisor* Elaine Schreyeck *Script Supervisors* Kay Rawlings, Doris Martin *U.S. Script Supervisor* Betsy Norton *Production Executive* Geoffrey Helman *Second Unit Directors* David Tomblin, John Glen, John Barry, David Lane, Peter Duffel, Robert Lynn *Film Editor* Michael Ellis *Supervising Sound Effects and Dialogue Replacement Editor* Chris Greenham *Samuel Goldwyn Studios Sound Supervisor* Don Rogers *Dolby Stereo Consultant* Max Bell *Production Mixers* Roy Charman, Norman Bolland, Brian Marshall *U.S. Production Mixers* Charles Schmitz, Dick Ragusa *Canadian Production Mixer* Chris Large *Sound Engineers* Michael Tucker, George Rice, Keith Pamplin, Des Edwards *Scoring Mixer* Eric Tomlinson *Dubbing Mixer* Gordon K. McCallum *Assistant Dubbing Mixers* Graham Hartstone, Nicholas Le Messurier, Otto Snel *Music Recording* Anvil Films Ltd. *Sound* Samuel Goldwyn Studios, Pinewood Studios *Production Supervisor* Robert Simmonds *North American Production Supervisor* Timothy Burrill *New Mexico Production Supervisor* Tim Hampton *Production Manager* Dusty Symonds *New York Production Manager* Peter Runfolo *Alberta Production Manager* Les Kimber *New Mexico Production Manager* Austen Jewell *New York Unit Coordinator* Bob Colesberry *Location Manager* Chris Coles *New York Location Manager* David Lane *Executive Assistant to the Producers* Maria Monreal *Executive Assistant to the Director* Jeanne Ferber *Assistant Directors* David Tomblin, Dominic Fulford, Vincent Winter, Michael Dryhurst, Allan James, Gareth Tandy *U.S. Assistant Directors* Jerry Grandey, Michael Rauch, Bud Grace *Second Assistant Directors* Steve Lanning, Roy Button, Michael Green, Kiernon Phipps, Charles Marriott, Vic Smith, Keith Lund, Michael Hook, Patrick Cadell, Peter Jacobs, Simon Milton, Michael Murray *U.S. Second Assistant Directors* Peter Bergquist, Candace Suerstedt *Canadian Second Assistant Director* Rick Drew *Apprentice Assistant Directors* Yves Gaumont, Paul Storey, Waldo Roeg, Bill Rudgard *Production Coordinator* Michael Duthie *Script Clerk* Katya Kolpaktchy *Additional Script Supervisors* Josie Fulford, Rita Davison, Angela Martelli *Production Assistants* Pat Carr, Jeannie Stone, Ann Green, Jean Hall, Liz Green, Joy Bayley, Diane Appleby, Sally Ball, Norma Hazelden, Norma Garment *U.S. Production Assistants* Adeline Leonard, Dick Liebegott *Canadian Production Assistant* Patti Allen *Special Unit Secretaries* Jeannie McClean, Jane Cox, Jane Dixie, Sue Edwards *Executive Producers' Secretary* Sue Hausner *Producers' Secretary* Trudy Balen *Additional Cinematographer* Alex Thomson *New Mexico Additional Cinematographer* Robert E. Collins *Alberta Additional Cinematographer* Reginald Morris *New York Additional Cinematographer* Sol Negrin *Aerial Cinematography* Peter Allwork *Camera Operators* Peter MacDonald, John Harris, Jimmy Devis, John Morgan, Michael Fox, Gordon Hayman, Geoff Glover, Ken Coles, Ronnie Fox Rogers, Ginger Gemmell, Roy Ford, Jack Lowen, George Pink *U.S. Camera Operators* Lou Barlia, Jim Contner, Michael

Chevalier, Jack Courtland, Howard A. Anderson III *Canadian Camera Operator* Rod Parkhurst *Assistant Cameramen* John Campbell, Jonathan Taylor, Trevor Coop, Peter Versey, Ronnie Anscombe, David Lenham, John Deaton, Alan Gatward *U.S. Assistant Cameraman* Domenic Mastrippolito *Canadian Assistant Cameraman* Tom Ryan *Second Assistant Cameramen* Steve Barron, Nick Schlesinger *Wesscam Cinematography* Ronald Goodman *New Mexico Helicopter Pilot* Marc Wolfe *New York Helicopter Pilot* Al Cerullo *Music Editor* Bob Hathaway *Assistant Music Editor* Ken Ross *First Assistant Film Editor* Bob Mullen *Assistant Film Editors* David Beesley, Tim Jordan, Mike Round, Neil Farrell, Christopher Morris, Colin Wilson, George Akers, Michael Duthie *Sound Effects Editors* Peter Pennell, Stan Fiferman, John Foster *Dialogue Replacement Editors* Michael Hopkins, Pat Foster *Assistant Sound Effects and Dialogue Replacement Editors* Geoff Brown, Leonard Green, Patrick Brennan, Jupiter Sen, Tony Orton, David Fisher *Production Designer* John Barry *England and New York Supervising Art Director* Maurice Fowler *Canada and New Mexico Supervising Art Director* Bill Brodie *Art Directors* Harry Lange, Norman Dorme, Norman Reynolds, Ernest Archer, Tony Reading, Les Dilley, Stuart Craig *U.S. Art Directors* Gene Rudolf, Philip Bennet, Stan Jolley *Set Designers* Tony Rimmington, Reg Bream, Ted Ambrose, Dennis Bosher, Alan Cassie *Set Decorator* Peter Howitt *U.S. Set Decorator* Fred Weiler *Production Illustrators* Ivor Beddoes, Roy Carnon, Reg Hill *Modelers* Janet Stevens, Peter Voysey *Scenic Artists* Ernest Smith, Bill Beavis *Decor and Lettering Artist* Norman Hart *Construction Managers* Larry Cleary, Jack Carter *U.S. Construction Managers* Harry Kersey, Herman Lowers *Assistant Construction Manager* Roy Evans *Property Masters* George Ball, Danny Skundric *Property Man* Eddie Francis *Property Buyers* John Lanzer, Peter Palmer *Production Accountant* Douglas Noakes *Assistant Accountant* Graham Henderson *Unit Publicist* Gordon Arnell *Assistant Publicists* June Broom, Pat O'Reilly *Still Photographers* Robert Penn, Douglas Luke *Crane Grip* Roy Van Buskirk *Costume Designer* Yvonne Blake *Additional Costume Designers* Betty Adamson, Ruth Morley *Wardrobe Supervisor* Betty Adamson *Wardrobe* Helen Gill, Eddie Silva, Austin Cooper, Janet Tebrooke, Colin Wilson, Barbara Gillett, Elvira Angelinetta *Hairdressing* Pat McDermott, Joan White, Stella Rivers, Cathy Kevany *U.S. Hairdressing* Darby Halpin *Canadian Hairdressing* Iloe Elliott *Lee Electric Gaffer* Maurice Gillett *Pinewood Studios Gaffer* John Tythe *Lee Electricians* Ray Evans, Ray Meehan *Pinewood Studios Electricians* John May, Harry Woodley, Bert Bosher, Fred Webster, Jack Thetford *Stunt Coordinators* Alf Joint, Vic Armstrong *New York Stunt Coordinator* Alex Stevens *Main Titles* Steve Frankfurt Communications, R/Greenberg Associates Inc. *End Titles* Camera Effects Ltd. *End Title Cinematography* Roy Pace, Sheldon Elbourne *Drivers* Bunny Barkus, Ron Jackson, Ken Cooper, John Scott *Video Operators* Chris Warren, Brian King *Louma Camera Crane Technical Advisers* Jean-Maria Lavalou, Alain Masseron *Poem "Can You Read My Mind"* John Williams, Leslie Bricusse *Performed by* Margot Kidder *Orchestration* Herbert W. Spencer, Arthur Morton *Sales Consultant* Armand Rubin *Aerial Camera Equipment*

Wesscam Camera Systems *Production Equipment* Samuelson Film Service Ltd. *Electrical Contractors* Lee Electric (Lighting) Ltd. *Costume Makers* Berman's & Nathan's Ltd. *Christopher Reeve's Clothes* Barney's Inc. *Jewelry* Cartier *Television and Audio Equipment* J.V.C. *Cheerios* General Mills Inc. *Watches* Timex *Production Cooperation* New York City Mayor's Office for Motion Pictures and Television, New Mexico State Film Commission, Alberta Government Film Industry Development Board, Canadian Pacific Railways, National Satellite Visual Survey Space Council for Space Photography *Visual Effects Designer* Dennis Rich *Optical Effects Supervisor* Roy Field *Matte and Composites Supervisor* Les Bowie *Traveling Matte Consultant* Stanley Sayer *Miniature Effects Director* Derek Meddings *Process Cinematography* Denys Coop *Zoptic Effects* Zoran Perisic *Process Unit Director* Andre de Toth *Visual Effects Editor* Peter Watson *Visual Effects Coordinators* Ernest Walter, Michael Campbell *Flying Unit Coordinator* Dominic Fulford *Miniature Cinematography* Paul Wilson, Jack Atcheler *Additional Miniature Cinematography* Harry Oakes, Robert Kindred, Leslie Dear *U.S. Additional Miniature Cinematography* Darryl A. Anderson *New York Process Plate Cinematography* Bob Bailin *New York Process Stills* Cervin Robinson *Matte Camera Operators* Peter Harman, Peter Hammond *Assistant Visual Effects Editor* Russell Woolnough *Additional Miniature Effects Directors* Brian Smithies, George Gibbs *Miniature Construction Manager* Michael Redding *Miniaturists* Terry Reed, Cyril Forster, Andrew Kelly, Jeff Luff, Tony Dunsterville, Tadeusz Krzanowski *Flying Systems and Process Projection* Wally Veevers, Jan Jacobson *Process Systems* Charles Staffell *Traveling Matte Supervisor* Dennis Bartlett *Optical Liaison* Martin Shortall, Harrow College of Technology and Art *Zoptic Operators* David Speed, Mike Drew, James Aspinall *Matte Artists* Doug Ferris, Ray Caple *Assistant Matte Artist* Liz Lettman *Wire Flying Effects* Derek Botell, Bob Harman *Special Optical Effects* Camera Effects Ltd. *Special Optical Cinematography* Roy Pace, Sheldon Elbourne *Special Optical Sequences* Howard A. Anderson Company, Continental Camera Systems Inc. *Optical Effects* Oxford Scientific Films Ltd., Peter Parks, Sean Morris, National Screen Service Ltd., Gillie Potter Productions Ltd., Delecluse Realisations, Cinema Research Corporation, Peter Donen, Joe Wallikas, Rocky Mahoney, Charles Colwell, Van der Veer Photo Effects, Frank van der Veer, Greg van der Veer, Rank Post Productions Ltd., Cinefex (London) Ltd., Vee Films Ltd., General Screen Enterprises Ltd. *Star Ship Designer* Ed Gimmell *Mechanical Effects Director* Colin Chilvers *New York and Canadian Mechanical Effects Supervisor* John Richardson *New Mexico Mechanical Effects Supervisor* Robert A. MacDonald *Mechanical Effects Technicians* Roy Spencer, Terry Schubert, Bob Nugent, Joe Fitt, Ron Burton, Brian Warner, Rodney Fuller, Michael Dunleavy, Jimmy Harris, Peter Biggs, Frank Richardson, Peter Pickering

An Alexander Salkind Presentation. An Alexander Salkind–Ilya Salkind Production. An International Film Production Inc. Picture. Produced by Dovemead Ltd. A Richard Donner Film. Made at Pinewood Studios,

Shepperton Studio Centre and Samuel Goldwyn Studios and on location in Calgary, Alberta and British Columbia, Canada and Gallup, New Mexico and New York City. Worldwide Distribution and Copyright 1978 by Film Export A.G. Music Copyright 1978 by Warner Tamerlane Publishing Corporation. Panavision 70. Color by Technicolor and TVC. Prints by Technicolor. Dolby Stereo. 143 minutes. M.P.A.A. Rating: PG.

The Players: *Clark Kent/Superman* Christopher Reeve *Jor-El* Marlon Brando *Lex Luther* Gene Hackman *Lois Lane* Margot Kidder *Otis* Ned Beatty *Perry White* Jackie Cooper *Jonathan Kent* Glenn Ford *First Krypton Council Elder* Trevor Howard *Non* Jack O'Halloran *Eve Teschmacher* Valerie Perrine *Vond-Ah* Maria Schell *Gen. Zod* Terence Stamp *Martha Kent* Phyllis Thaxter *Lara* Susannah York *Young Clark* Jeff East *Jimmy Olsen* Marc McClure *Ursa* Sarah Douglas *Second Krypton Council Elder* Harry Andrews *Third Krypton Council Elder* Vass Anderson *Fourth Krypton Council Elder* John Hollis *Fifth Krypton Council Elder* James Garbutt *Sixth Krypton Council Elder* Michael Gover *Seventh Krypton Council Elder* David Neal *Eighth Krypton Council Elder* William Russell *Ninth Krypton Council Elder* Penelope Lee *Tenth Krypton Council Elder* John Stuart *Eleventh Krypton Council Elder* Alan Cullen *Baby Kal-El* Lee Quigley *Baby Clark* Aaron Smolinski *Lana Lang* Diane Sherry *Football Coach* Jeff Atcheson *First Football Player* Brad Flock *Other Football Players* Ed Finneran, Tim Hussey *Football Team Manager* David Petrou *Young Lois* Kathy Painter *Mrs. Lane* Noel Niell *Mr. Lane* Kirk Alwyn *First Dailey Planet Editor* Billy J. Mitchell *Second Dailey Planet Editor* Robert Henderson *First Dailey Planet Reporter* Larry Lamb *Second Dailey Planet Reporter* James Brockington *Third Dailey Planet Reporter* John Cassady *Fourth Dailey Planet Reporter* John F. Parker *Fifth Dailey Planet Reporter* Antony Scott *Sixth Dailey Planet Reporter* Ray Evans *Seventh Dailey Planet Reporter* Su Shifrin *Eighth Dailey Planet Reporter* Miguel Brown *First Copy Boy* Vincent Marzello *Second Copy Boy* Benjamin Feitelson *First Dailey Planet Secretary* Lise Hilboldt *Second Dailey Planet Secretary* Leueen Willoughby *Perry White's Secretary* Jill Ingham *Window Cleaner* Pieter Stuyck *Rex Reed* Himself *Mugger* Weston Gavin *First Policeman* Stephen Kahan *Second Policeman* Ray Hassett *Third Policeman* Randy Jurgenson *Newsvendor* Matt Russo *News Customer* Robert Dahdad *Helicopter Pilot* Colin Skeaping *Pimp* Bo Rucker *Television Cameraman* Paul Avery *Burglar* David Baxt *Ofr. Mooney* George Harris II *First Hood* Michael Harrigan *Second Hood* John Cording *Third Hood* Raymond Thompson *Fourth Hood* Oz Clarke *Desk Sergeant* Rex Everhardt *Little Girl* Jayne Tottman *Air Force One Pilot* Frank Lazarus *Air Force One Co-Pilot* Brian Protheroe *First Air Force One Crewman* Lawrence Trimble *Second Air Force One Crewman* Robert Whelan *Third Air Force One Crewman* David Calder *First Newscaster* Norwich Duff *Second Newscaster* Keith Alexander *Third Newscaster* Michael Ensign *Concorde Pilots* Michael Behr, John Rees *Missile Convoy Major* Larry Hagman *Sgt. Hayley* Paul Tuerpe *Missile Convoy Lieutenant* Graham McPherson *Missile Convoy Petty Officer* David Yorston *Mission Control Admiral* Robert O'Neill *Mission Control General* Robert

MacLeod *First Mission Controller* John Ratzenberger *First State Senator* Phil Brown *Second State Senator* Bill Bailey *Joint Chief of General Pentagon Staff* Bruce Boa *Secret Service Agent* Burnell Tucker *Indian Chief* Chief Tug Smith *Superchief Driver* Norman Warwick *Assistant Superchief Driver* Chuck Julian *Power Company Driver* Colin Etherington *Power Company Technician* Mark Wynter *Prison Warden* Roy Stevens *Stunts* Stunts Inc., Alf Joint, Vic Armstrong, Alex Stevens, Terry Hill, John Bodimeade, Paul Weston, George Cooper, Wendy Leech, Bill Weston, Stuart Fell, Ellen Bry, Martin Grace, Dick Butler, Richard Hackman

Additional Oscar Nominations: *Film Editing* (Stuart Baird); *Music in Connection with Motion Pictures — Original Score* (John Williams); *Sound* (Gordon K. McCallum, Graham Hartstone, Nicholas LeMessurier, Roy Charman)

Note: Jackie Cooper replaced the ailing Keenan Wynn as Perry White. Dedicated to stuntmen Terry Hill and John Bodimeade who were killed doing action sequences and cinematographer Geoffrey Unsworth who died soon after completion of production. Advertised as *Superman the Movie*. Released in Europe in 1978. Running time varies as follows: 143 minutes in 70mm; 127 minutes in 35mm; 119 minutes on videocassette; 76 minutes in super 8; 192 minutes on ABC-TV network; and 143 minutes on cable TV. There have been three sequels thus far, *Superman II* (Warner Bros., 1981), *Superman III* (Warner Bros., 1983) and *Superman IV* (Cannon, 1986). A semi-sequel feature, *Supergirl*, was produced for Tri-Star Pictures and released in 1984. Other theatrical outings for the characters were: seventeen Technicolor cartoons released by Paramount between 1941 and 1943; two Columbia serials, *Superman* (1948) and *Atom Man Vs. Superman* (1950), both released overseas in feature editions; *Superman and the Mole Men* (Lippert, 1951). In 1954, 20th Century-Fox released five features, each of which consisted of three episodes from the television series, they being *Superman's Peril* (made up of "The Golden Future," "The Semi-Private Eye" and "The Defeat of Superman"), *Superman Flies Again* (made up of "Jet Ace," "The Dog Who Knew Superman" and "The Clown Who Cried"), *Superman in Exile* (made up of "Superman in Exile," "The Face and the Voice" and "The Whistling Bird"), *Superman and Scotland Yard* (made up of "A Ghost for Scotland Yard," "Lady in Black" and "Panic in the Sky") and *Superman and the Jungle Devil* (made up of "Machine That Could Plot Crimes," "Jungle Devil" and "Shot in the Dark"). In 1973, Warner Bros. Film Gallery released *Superman*, made up of four color TV episodes, "The Mysterious Cube," "Superman's Wife," "Tin Hero" and "The Town That Wasn't." The government released a two-reel Savings Bond short, "Stamp Day for Superman," in 1952. There were 104 live-action TV episodes plus two pilots, "Superpup" and "The Adventures of Superboy." Additionally there has been a continuing series of TV cartoons produced by Filmation and Hanna-Barbera. The Broadway musical, *It's a Bird, It's a Plane, It's Superman*, was videotaped and shown on network TV.

1979

Special Visual Effects (reclassification) nominations

**Alien* Carlo Rambaldi, Brian Johnson,
 (20th Century–Fox) Nick Allder, Denys Ayling
The Black Hole Peter Ellenshaw, Art
 (Disney, Buena Vista) Cruickshank, Eustace Lycett,
 Danny Lee, Harrison Ellenshaw,
 Joe Hale
Moonraker Derek Meddings, Paul
 (Broccoli, UA) Wilson, John Evans
1941 William A. Fraker, A.D.
 (Columbia-Universal) Flowers, Gregory Jein
Star Trek Douglas Trumbull, John
 (Paramount) Dykstra, Richard Yuricich,
 Robert Swarthe, Dave
 Stewart, Grant McCune

Scientific or Technical Awards

Technical Achievement Award Zoran Perisic of
 Courier Films Ltd.
For the Zoptic Special Optical Effects Device for motion picture photography
Technical Achievement Award A.D. Flowers and
 Logan R. Frazee
For the development of a device to control flight patterns of miniature airplanes during motion picture photography

Comments

 Alien was this year's surprise winner; *Star Trek* had been the favored nomination, but honestly was undeserving, as I'll point out.

 The British-made *Alien* had excellent optical and mechanical work throughout, but was able to get away with much due to its low-key photography. This thriller about a killer creature rampaging aboard a spacecraft was the least expensive feature nominated, and one only wonders what this had to do with the voting. For a change, did it win because more was done with less? Most probably!

Disney's *The Black Hole*, telling of a space crew's encounter with such, was a box office loser. It opened late and was forced into the worst possible theaters, where it had no reasonable chance of breaking even. It was the studio's most costly effort but was issued several months too late in the year and had nowhere to go. Its technical effects were quite impressive, certainly equal to other nominees this year, but its dialogue was the most laughable heard in a non-comedy in years.

James Bond had to stop a madman (what's new?) from depopulating the Earth in the first of that series' Anglo-Franco co-productions, *Moonraker*. It was much better than its advertising suggested it would be, and it offered top-level visual effects produced mostly in England with some created in France.

1941, a supercomedy (based very loosely on fact) about a Japanese submarine attacking Southern California at the outbreak of World War II, was Steven Spielberg's only major box office bomb. Strangely, it was his best film to that date and one which will eventually be recognized as the comedy classic it is. Though being undervoted in the Special Visual Effects category, it was honored with a Technical Achievement award for its extraordinary model aircraft sequences. These employed an improved Lydecker system (named after brothers Howard and Theodore Lydecker of Republic Pictures fame) for some truly exciting scenes. Its many model shots were fantastic.

Star Trek, an incredibly poor film entertainment-wise, retold in the worst way two stories from its mother television series. The film deserved no nomination. Like *Alien*, it utilized very dark images that strained the eyes trying to see what was on the wide screen. Unlike that import, what there was to see was not worth the effort. The finely detailed miniatures were completely invalidated by the poor photography. It may really be dark in deep space, but fantasy films are not reality and should not be treated as such. It cost at least ten times what it should have and none of the money showed in any way.

All of this year's nominees were released in grainy 70mm blowup versions.

Credits

Alien
(20th Century-Fox; May 25, 1979)

Executive Producer Ronald Shusett *Producers* Gordon Carroll, David Giler, Walter Hill *Associate Producer* Ivor Powell *Director* Ridley Scott *Screenplay* Dan O'Bannion, David Giler, Walter Hill, Ronald Shusett *Based on the Screenplay* Starbeast *by* Dan O'Bannion, Ronald Shusett *Cinematographer* Derek

Vanlint *Musical Score* Jerry Goldsmith *Musical Director* Lionel Newman *Supervising Film Editor* Terry Rawlings *Film Editor* Peter Weatherly *Production Designers* Michael Seymour, Hans R. Giger *Art Directors* Lesley Dilley, Roger Christian *Design Consultant* Dan O'Bannion *U.S. Casting* Mary Goldberg *U.K. Casting* Mary Selway *Production Manager* Garth Thomas *Construction Manager* Bill Welch *Title Design* Frankfurt Communications, R/Greenberg Associates, Tony Silver Films *Sound Effects Editor* James Shields *Dialogue Replacement Editor* Bryan Tilling *Dolby Stereo Consultant* Max Bell *Music Editor* Bob Hathaway *First Assistant Film Editor* Les Healy *Assistant Film Editors* Peter Culverwill, Bridget Reiss, Peter Baldock, Maureen Lyndon *Assistant Director* Paul Ibbetson *Second Assistant Directors* Raymond Becket, Steve Harding *Apprentice Assistant Director* Bob Jordan *Production Assistant* Valerie Craig *Script Supervisor* Kay Fenton *Production Accountant* Bill Finch *Assistants to the Producers* Alice Harmon, Lori Covel *Assistant to the Director* Sandy Molloy *Production Executive* Mark Haggard *Costume Designer* John Mollo *Wardrobe Supervisor* Tiny Nicholls *Makeup Supervisor* Tommy Manderson *Makeup* Pat Hay *Hairdressing* Sarah Monzani *Set Decorator* Ian Whittaker *Assistant Art Directors* Jonathan Amberston, Benjamin Fernandez, Anton Furst *Property Master* Dave Jordan *Property Buyer* Jill Quertier *Chief Carpenter* George Gunning *Chief Plasterer* Bert Rodwell *Chief Painter* John Davey *Camera Operators* Ridley Scott, Derek Vanlint *Assistant Cameramen* Adrian Biddle, Colin Davidson *Key Grip* Jimmy Walters *Gaffer* Ray Evans *Electrical Contractors* Lee Electric (Lighting) Ltd. *Electronics and Video Coordinator* Dick Hewitt *Video Equipment* Sony U.K. Ltd. *Production Equipment* Samuelson Film Service Ltd. *Production Mixer* Derrick Leather *Dubbing Mixer* Bill Rowe *Assistant Dubbing Mixer* Ray Merrin *Sound* De Lane Lea London *Music Recording* Anvil Films Ltd. *Post Production Facilities* EMI Elstree Studios *Advertising and Publicity Consultants* Stanley Bielecki, Charles Lippincott *Unit Publicist* Brian Doyle *Still Photographer* Robert Penn *Special Title Graphics* Bernard Lodge *Stunt Coordinator* Roy Scammel *Cat Trainers* Animals Unlimited *Classical Music: "Symphony No. 2 (Romantic)" by* Howard Hanson *"Eine kleine Nachtmusik" by* Wolfgang Amadeus Mozart *Conceptual Artists* Ron Cobb, Jean "Moebius" Giraud, Christopher Foss *Visual Effects Director* Brian Johnson *Visual Effects Supervisor* Nick Allder *Visual Effects Cinematographer* Denys Ayling *Matte Artist* Ray Caple *Visual Effects Camera Operator* David Litchfield *Visual Effects Assistant Cameraman* Terry Pearce *Visual Effects Key Grip* Peter Woods *Supervising Miniaturists* Martin Bower, Bill Pearson *Miniaturist* Philip D. Rae *Special Opticals* Filmfex Animation Services Ltd. *Mechanical Effects Supervisor* Allan Bryce *Mechanical Effects Technicians* David Watkins, Phil Knowles, Roger Nicholls, Dennis Lowe, Neil Swann, Guy Hudson *Alien Design* Hans R. Giger *Alien Head Effects* Carlo Rambaldi, Isidoro Raponi *Head Effects Assistant* Ralph Cobis *Small Alien Forms Co-Designer, Builder and Operator* Roger Dicken *Additional Alien Mechanics* Carlo de Marchis, Dr. David Watling *Alien Effects Coordinator* Clinton Cavers *Supervising Modeler* Peter Boysey *Modelers* Eddie Butler, Shirley Denny, Patti Rodgers

A Brandywine Productions Ltd.–Ronnie Shusett Production. A Ridley Scott Film. Produced by 20th Century–Fox Productions Ltd. Made at Shepperton Studio Centre and Bray Studios. Copyright 1979 by 20th Century–Fox Film Corporation. Music Copyright 1979 by Fox Fanfare Music Inc. Panavision 70. Eastman Color. Processed by Rank. Prints by De Luxe. Dolby Stereo. 125 minutes. M.P.A.A. Rating: R.

The Players: *Capt. Dallas* Tom Skerrit *3rd Ofr. Ripley* Sigourney Weaver *Coms. Ofr. Lambert* Veronica Cartwright *Main. Ofr. Brett* Harry Dean Stanton *2nd Ofr. Kane* John Hurt *Sc. Ofr. Ash* Ian Holm *Main. Ofr. Parker* Yaphet Kotto *Alien* Bolaji Badejo *Stuntman* Eddie Powell *Voice of MU/TH/UR 6000* Helen Horton *Ship's Mascot* Jones the Cat

Additional Oscar Nomination: *Art Direction–Set Decoration* (Michael Seymour, Les Dilley, Roger Christian, Ian Whittaker)

Note: Working title was *Starbeast*. This was an unofficial remake of *It! The Terror from Beyond Space* (United Artists, 1958). An unauthorized sequel, *Alien II*, was made in Italy in 1980 but received little or no U.S. distribution. The B.B.F.C. certificate was X. An official sequel, also titled *Alien II*, has been announced for production.

The Black Hole

(Buena Vista; December 1979)

Producer Ron Miller *Director* Gary Nelson *Screenplay* Jeb Rosebrook, Gerry Day, William Wood, Sumner Arthur Long, Ed Coffey *Story* Jed Rosebrook, Bob Barbash, Richard Landau *Cinematographer* Frank Philips *Musical Score* John Barry *Film Editor* Gregg McLaughlin *Production Designer* Peter Ellenshaw *Orchestration* Al Woodbury *Art Directors* John B. Mansbridge, Al Roelofs, Robert T. McCall *Production Illustrators* Fred Lucky, Gene Johnson, Robert Ayres, Leon R. Harris *Sentry Robot Coordinator* Tommy McLoughlin *Production Manager* John Bloss *Unit Manager* Christopher Seiter *Costume Designer* Bill Thomas *Set Decorators* Frank R. McKelvey, Roger M. Shook *Supervising Music Editor* Evelyn Kennedy *Music Editor* Helen Sneddon *Assistant Director* Tom McCrory *Second Assistant Directors* Christopher D. Miller, Joseph P. Moore *Assistant Film Editor* Nicholas Vincent Korda *Costume Supervisor* Chuck Keehne *Makeup Supervisor* Robert J. Schiffer *Makeup* Nadia *Hairdressing* Gloria Montemayor *Wardrobe* Jack Sandeen, Mary Dye *Camera Operator* Lloyd N. Ahern *Assistant Cameraman* Robert LaBonge *Second Assistant Cameraman* Cecil R. Wilson *Special Sound Effects* Ben F. Hendricks, William J. Wylie, James MacDonald *Additional Special Sound Effects* Stephen Katz *Sound Effects Editors* George Fredrick, Wayne A. Allwine, Joseph Parker,

Louis Terrusa, John J. Jolliffe *Dialogue Replacement Editors* Bernard P. Cabral, Norman Carlisle, Al Maguire *Script Supervisor* Sandy Nelson *Property Master* Wilbur L. Russell *Production Associate* Christopher Hibler *Unit Publicist* Mike Bonifer *Story Editor* Frank Paris *Key Grip* Donald Capel *Best Boy Grip* Howard L. Hagadorn *Gaffer* Carl Boles *Best Boy* Bernard F. Bayless *Technical Adviser* L. Gordon Cooper *Business Manager* Robert Gibeaut *Video Sychronization* Video Pack *Sound Supervisor* Herb Taylor *Production Mixer* Henry A. Maffett *Scoring Mixer* Daniel Wallin *Dubbing Mixers* John Van Frey, Frank C. Regula, Nick Alphin, Bob Hathaway *Miniature Designer and Miniature Effects Supervisor* Peter Ellenshaw *Miniature Cinematographer* Art Cruickshank *Optical Cinematography* Eustace Lycett *Matte Supervisor and Matte Artist* Harrison Ellenshaw *Animation Director* Joe Hale *Animators* Dorse A. Lanpher, Ted C. Kierscey, Jack Boyd, Jane Boyd *Optical Coordinator* Robert Broughton *Assistant Matte Artists* David Mattingly, Constantine Ganakes *Visual Effects Camera* A(utomatic) C(amera) E(ffects) S(ystems) *A.C.E.S. Operators* Bill Kilduff, Robert R. Wilson *Matte Cinematography* Ed Sekac, Arthur Miller *Optical Printers* Ray O. Hoar, Fred E. Branson, Phillip L. Meador *Chief Miniaturist and Miniature Mechanical Effects Supervisor* Terence Saunders *Visual Effects Production Assistant* Stephen M. McEveety *Visual Effects Key Grip* Doc Reed *Visual Effects Gaffer* Roger E. Redel *Pitching Lens Relay Systems* Continental Camera *Miniaturists* Mike Edmundson, Mike Paris *Visual Effects Mechanical Engineer* Don Iwerks *A.C.E.S. Design* Bob Otto, Bill Watkins, David English *A.C.E.S. Programming and Special Mechanical Design* David Snyder *A.C.E.S. Programmer* Steve Crane *A.C.E.S. Builders* Richardson Camera Company *A.C.E.S. Control Systems Design* Vic Owens *A.C.E.S. Servo-System and Servo-Control Builders* Northern Precision Labs *A.C.E.S. Anamorphic Lenses* Bausch & Lomb *Mechanical Effects Supervisor* Danny Lee *Assistant Mechanical Effects Supervisor* Hal Bigger *Robot Designer* George F. McGinnis *Robot Operator* Brian Stevenson *Robot Modeler* Joe Cava *Mechanical Effects Technician* Eric Allard

A Walt Disney Productions Presentation. Made at Walt Disney Studios. Copyright 1979 by Walt Disney Productions. Technovision 70. Technicolor. RCA Photophone Recording. Dolby Stereo. 97 minutes. M.P.A.A. Rating: PG.

The Players: *Dr. Hans Reinhardt* Maximilian Schell *Dr. Alex Durant* Anthony Perkins *Capt. Dan Holland* Robert Forster *Lt. Charles Pizer* Joseph Bottoms *Dr. Kate McCrae* Yvette Mimieux *Harry Booth* Ernest Borgnine *Captain S.T.A.R.* Tommy McLoughlin *Sentry Robots* Mike Hawes, Don Lewis, Steve Bankes *Voice Characterization of Vincent* Roddy McDowell *Voice Characterization of Old Bob* Slim Pickens *Stunts* Bill Couch, Alan Oliney, Conrad Palmisano, Bobby Sargent, Billy Jackson, Terry Nichols, Katee McClure, Bob Herron, Stevie Myers, Howard Curtis, Don Pulford, Regina Parton, Len Glascow, Melvin Jones, Ronald Oliney

Additional Oscar Nomination: *Cinematography* (Frank Philips)

Note: Working titles were *The Space Probe, Space Station One,* and *Probe One.* Process plates were photographed in VistaVision and the visual effects were filmed in CinemaScope.

Moonraker
(United Artists; June 1979)

Executive Producer Michael G. Wilson *Producer* Albert R. Broccoli *Associate Producer* William P. Cartlidge *Director* Lewis Gilbert *Screenplay* Christopher Wood *Adaptation* Tom Mankiewicz *Based on the Novel by* Ian Fleming *Cinematographer* Jean Tournier *Second Unit Cinematographer* Jacques Renoir *Musical Score* John Barry *Film Editor* John Glen *Production Controller* Reginald A. Barkshire *French Production Manager* Jean-Pierre Spiri Mercanton *British Production Manager* Terence Churcher *Brazil Location Manager* Frank Ernst *Italy Location Manager* Phillippe Modave *Florida Location Manager* John Comfort *French Unit Manager* Robert Saussier *British Unit Manager* Chris Kenny *Second Unit Directors* Ernest Day, John Glen *Assistant Directors* Michael Chegco, Christopher Carreras *Second Unit Assistant Directors* Peter Bennett, Meyer Berreby *Camera Operators* Alec Mills, Michael Deloire, Guy Delattre, James Devis *Production Designer* Ken Adams *Art Director* Charles Bishop *French Art Director* Max Douy *Outer Space Art Director* Harry Lange *Set Decorators* Peter Howitt, Pierre Charron, Andre Labussiere *James Bond Theme* Monty Norman *The Magnificent Seven Theme* Elmer Bernstein *Title Song* John Barry, Hal David *Vocal* Shirley Bassey *Costume Designer* Jacques Fonteray *Makeup* Monique Archambault, Paul Engelin *Sound Editors* Alan Sones, Colin Miller, Dino Di Campo *Special Sound Effects* Jean-Pierre Lelong *Dolby Stereo Consultant* John Iles *N.A.S.A. Space Consultant* Eric Burgess *Stunt Coordinator* Bob Simmons *French Stunt Coordinator* Claude Carliez *Aerial Cinematography* Rande De Luca *Pilot* B.J. Worth *Boats* Glastron Boat Company *Video Equipment* Sony *Production Mixer* Daniel Brisseau *Dubbing Mixers* Gordon K. McCallum, Graham V. Hartstone, Nicholas Le Messurier *Sound* SIMO Boulogne, Pinewood Studios *Music Recording* Studio Davoict *Unit Publicists* Steven Swan, Gilles Durieux *Script Supervisors* Josie Fulford, Elaine Schreyeck, Gladys Goldsmith *Key Grip* Rene Strasser *Property Buyer* John Lanzer *Casting* Margot Capelier, Weston Drury, Jr. *Wardrobe* Jean Zay *Hairdressing* Pierre Vatti *Titles* Maurice Binder *Production Cooperation* U.S. Air Force, U.S Marine Corps, Brazil Department of National Parks, Rockwell International Space Division, National Aeronautics and Space Administration, Christian Dior, British Airways *Visual Effects Director* Derek Meddings *Visual Effects Engineer* Peter Biggs *Visual Effects Cinematographer* Paul Wilson *Visual Effects Camera Operator* John Morgan *French Optical Effects* Michael Francois

Films *Optical Cinematography* Robin Browne *French Visual Effects Supervisor* Jean Berard *French Process Cinematography* Louis Lapeyre *Process Consultant* Bill Hansard *Visual Effects Art Director* Peter Lamont *Visual Effects Assistant Director* Gareth Tandy *Mechanical Effects* John Evans, John Richardson, Rene Albouze, Serge Ponvianne

An Albert R. Broccoli Presentation. An Eon Productions Ltd.–Les Productions Artistes Associes Production. A Danjaq Picture. Made at Pinewood Studios, Boulogne Studios and Cinema Eclair Studios and on location in London, England, Vaux le Vicomte and Paris, France, Venice, Italy, Rio de Janeiro and Igriaca Falls, Brazil, Tikal, Guatemala, Pope Valley, California and Florida. Copyright 1979 by Danjaq S.A. Panavision 70. Color by LTC St. Cloud and Technicolor. Prints by Technicolor. Dolby Stereo. 126 minutes. M.P.A.A. Rating: PG.

The Players: *James Bond* Roger Moore *Holly Goodhead* Lois Childs *Hugo Drax* Michael Lonsdale *Jaws* Richard Kiel *Corinne Dufour* Corinne Clery *Manuela* Emily Bolton *Chang* Toshiro Suga *Blonde Beauty* Irka Bochenko *Frederick Gray* Geoffrey Keen *Miss Moneypenny* Lois Maxwell *Drax' Boy* Nicholas Arbez *M* Bernard Lee *Maj. Boothroyd* Desmond Llewelyn *Museum Guide* Ann Lonnberg *Private Jet Pilot* Jeanne-Pierre Costaldi *Dolly* Blanche Ravalec *Col. Scott* Michael Marshall *Private Jet Hostess* Leila Shenna *Gen. Gogol* Walter Gotell *Mission Control Director* Douglas Lambert *Cavendish* Arthur Howard *Consumptive Italian* Alfie Bass *U.S Shuttle Captain* Brian Keith *Boeing 747 Captain* George Birt *R.A.F. Officer* Kim Fortune *Russian Girl* Lizzie Warville *Funambulists* Johnny Traber's Troupe *Ambulance Attendant* Guy di Rigo *Drax' Technicians* Chris Dillinger, George Beller *Gondolier* Claude Carliez *Boeing 747 Officer* Denis Seurat *Drax' Girls* Chichinou Kaeppler, Christine Hui, Francoise Gayat, Nicaise Jean-Louis, Catherine Serre, Beatrice Libert *Stunts* Bob Simmons, Claude Carliez, Martin Grace, Richard Graydon, Dorothy Ford, Michael Berreur, Daniel Breton, Guy di Rigo, Paul Weston, Jack Lombard, Don Caltvedt, Ron Luginbill, Howard Curtis

Note: Released in England with a B.B.F.C. A certificate. For details regarding the James Bond films see the note to *Thunderball* (1965).

1941
(Universal; December 19, 1979)

Executive Producer John Milius *Producer* Buzz Feitshans *Associate Producers* Michael Kahn, Janet Healy *Director* Steven Spielberg *Screenplay* Robert Zemeckis, Bob Gale *Story* Robert Zemeckis, Bob Gale, John Milius *Cinematographer* William A. Fraker *Production Designer* Dean Edward Mitzner

Film Editor Michael Kahn *Musical Score* John Williams *Production Executive* John Wilson *Unit Production Managers* Chuck Myers, Herb Willis *Location Manager* Janet Healy *Assistant Directors* Jerry Ziesmer, Steve Perry *Second Assistant Director* Chris Soldo *Costume Designer* Deborah Nadoolman *Art Director* William F. O'Brien *Assistant Film Editor* Daniel Todd Cahn *Casting* Sally Dennison *Production Illustrator* George Jensen *Set Decorator* John Austin *Set Designers* Henry Alberti, Dan Gluck, Greg Pickrell, Carlton Reynolds, Virginia L. Randolph, William Skinner *Production Mixer* Gene S. Cantamessa *Music Editor* Kenneth Wannberg *Scoring Mixer* John Neal *Color Consultant* Robert M. McMillan *Orchestra Manager* Marion Klein *Orchestration* Herbert W. Spencer *Supervising Sound Editor* Fred J. Brown *Sound Editors* Michele Sharp Brown, Alex Bamattre, Edward L. Sandlin, Bud Asman, Freddie Stafford, Caryl Wickman *Assistant Sound Editors* Juno J. Ellis, Lori Hollingshead, Shelley Brown *Makeup Supervisor* Bob Westmoreland *Hairdressing* Susan Germaine *Script Supervisor* Marie Kenney *Stunt Coordinator* Terry Leonard *Construction Coordinator* Mickey Woods *Construction Foremen* Bill Wolford, Joe Karras *Additional Cinematographer* Frank Stanley *Camera Operator* Dick Colean *Assistant Cameramen* Ron Vargas, Steve Bridge *Todd-AO Sound Supervisor* Fred Hynes *Dubbing Mixers* Robert "Buzz" Knudson, Robert J. Glass, Don MacDougall, Chris Jenkins *Sound* Todd-AO *Associate to the Producer* Mary Ellen Trainor *Production Associate* R. Anthony Brown *Production Coordinator* Lata Ryan *Production Staff* Carol Byron, Maria Melcher McConnell, Davi Loren *Director's Secretary* Gail Lyn Stemers *Assistant to the Executive Producer* Kathleen Kennedy *Additional Second Assistant Directors* Bruce Solow, Paul Moen *Casting Assistant* Stanzi Foster *Choreography* Paul De Rolf *Assistant Choreographer* Judy Van Wormer *Additional Production Illustrator* Joe Griffith *Apprentice Film Editors* Darrin Martin, Randy Morgan *Property Master* Sammy Gordon *Assistant Property Master* Ted Mossman *Property Men* Lou Flemming, Oscar Esquivel *Wardrobe* Mina Mittelman, Ed Wynigear *Wardrobe Assistants* Theresa T. Volpe, Jerry Sklar *Costumers* Dan North, Adrienne Childers *Production Accountant* Margaret Mitchell *Production Assistants* Timothy Bright, Paul Martin Casella, Richleigh Kerr *Gaffer* Doug Pentek *Best Boy* Jerry Boatright *Electricians* Edward J. Reilly, John Wright, Don Yamasaki, Bill Krattiger, John Cucura, Tom Riffo *Key Grip* Gary Dodd *Best Boy Grips* John Donnelly, Jack Kennedy *Dolly Grip* Jan Koshay *Grips* Don Glenn, Ty Suehiro, Fredrick Albrecht, Randy Vargas, Bill Sutton *Boom Operator* Raul Bruce *Cable Man* David Wolpa *Additional Set Decorator* Jim Hasinger *Weapons Consultant* Syd Stembridge *Lean Men* Tom Furginson, Ray Critzas *Swing Man* Sandy Armstrong *Louma Camera Crane* Filmtrucks Inc. *Louma Camera Crane Technical Adviser* Jean-Marie Lavalou *Louma Camera Crane Operator* Andy Romanoff *Second Unit Cinematographers* Donald M. Morgan, Charles W. Short *Second Unit Assistant Cameramen* Aaron Pazanti, Ed Natividad *Second Unit Gaffer* Bill Peets *Second Unit Key Grip* Bill Beam *Assistant Hairdresser* Ellen Powell *Makeup* Jack Obringer, Dorothy Pearle *Unit Publicist* Saul Kahan *Publicity Coordinators* Pickwick Public Relations *Still Photographers* Peter Sorel,

Phil Stern *Paint Foreman* Arnold Ciaralo *Sign Writer* Dave Margolin *Chief Painters* Doug Wilson, Edward Zingelewicz *Painters* Wayne Smith, Ed Cornell, Clyde Booten, Teri Mensch, D.J. Zingelewicz, Glen E. Bardlerar, Bernard Charron, Michele Miller, Hillery Clinton *Transportation Coordinator* Paul Casella *Transportation Captain* Chuck Hauer *Transportation Co-Captain* William Scott Pierson *Tank Operator* Pat Carmen *Pilot* Tom Camp *Research* Lillian Michaelson *Craft Services* Matt Ford *Mammal and Ventrioloquial Creations* Eric Von Buello *Ventriloquial Consultant* Jerry Layne *Atmosphere Casting* Robert Buckingham *in Association with* Hollywood Casting *Studio Teacher* Adria Licklider *Title Design* Denis Hofman *Titles* Freeze Frame *Film Excerpt From* Dumbo *Copyright 1941 by* Walt Disney Productions *Songs "Down by the Ohio," "Daddy" Performed by* The Andrews Sisters *Courtesy of* MCA Records Inc. *"I'll Be Home for Christmas" Performed by* Bing Crosby *"Baby of Mine," "If I Could See an Elephant Fly" by* Frank Churchill, Ned Washington *Visual Effects Supervisor* Larry Robinson *Visual Effects Cinematographer* William A. Fraker *Optical Consultant* L.B. Abbott *Traveling Matte Consultant* Frank van der Veer *Matte Artist* Matthew Yuricich *Miniature Supervisor* Gregory Jein *Miniature Lighting Designer* Robin Leyden *Process Technician* John Russell *Matte Consultant* Jim Liles *Optical Effects* Van der Veer Photo Effects *Assistant Miniature Supervisor* Ken Swenson *Miniature Coordinator* Glenn Erickson *Miniature Production Assistant* Mitch Suskin *Miniaturists* Tom Cengar, Michael Del Genio, Anthony Doublin, Ken Ebert, Frances W. Evans, David Heilman, Tim Huchthausen, Sharon Lee, Illyanna Lowry, Michael McMillen, Milius Romyn, Nicholas Seldon, Susan Turner, Gary Weeks, Robert Worthington, Ken Ralston, Will Guest, Jack Isaacs, Tom Sheldon, Steve Telsky *Miniature Riggers* Bill Aldridge, Michael Barrett, Don Hathaway, Robert Johnston, David Peterson, Doyle Smiley, Richard Stutsman, Matt Sweeney, Brad Turpin *Special Miniature Consultants* Larry Albright, Robert Short *Mechanical Effects Supervisor* A.D. Flowers *Mechanical Effects Technicians* Logan Z. Frazee, Logan R. Frazee, Terry Frazee, Steve Galich, Steve Lombardi, Marlin "Buck" Jones, Gary Monak, Bill Myat, Don Myers, Joe Zomar, Eugene Crum, Kenneth Estes, Arthur Arp, Wilbur Arp, Thomas Arp

A Universal Pictures–Columbia Pictures Presentation. An A-Team Production. A Steven Spielberg Film. Made at The Burbank Studios and Metro-Goldwyn-Mayer Studios. Copyright 1979 by Universal City Studios Inc. and Columbia Pictures Industries Inc. Panavision 70. Color by Technicolor and Metrocolor. Prints by Metrocolor. Westrex Recording System. Stereophonic Sound. 118 minutes. M.P.A.A. Rating: PG.

The Players: *Sgt. Frank Tree* Dan Aykroyd *Ward Douglas* Ned Beatty *Capt. "Wild Bill" Kelso* John Belushi *Joan Douglas* Lorraine Gary *Claude* Murray Hamilton *Capt. von Kleinschmidt* Christopher Lee *Capt. Loomis Birkhead* Tim Matheson *Capt. Mitamura* Toshiro Mifune *Col. "Mad Man" Maddox* Warren Oates *Maj. Gen. Joseph W. Stilwell* Robert Stack *Cpl. "Stretch" Sitarski* Treat

Williams *Donna Stratton* Nancy Allen *Gas Mama* Lucille Bensen *Macey Douglas* Jordan Brian *Patron at Gas Mama's* Elisha Cook, Jr. *Herbie* Eddie Deezen *Wally* Bobby DiCicco *Betty Douglas* Diane Kay *Dennis* Perry Lang *Lydia Hedberg* Patti LuPone *Miss Fitzroy* Penny Marshall *Sgt. DuBois* J. Patrick McNamara *Pvt. Ogden Johnson Jones* Frank McRae *Gus Douglas* Steven Mond *Hollis P. "Holly" Wood* Slim Pickens *Maxine* Wendie Jo Sperber *Angelo Scioli* Lionel Stander *Pop Malcomb* Dub Taylor *Meyer Mishkin* Ignatius Wolfington *Stevie Douglas* Christian Zika *Sol Stuart* Joseph P. Flaherty *Joe* David Lander *Willy* Michael McKean *Polar Bear Club Swimmer* Susan Backlinie *Cpl. Foley* John Candy *Telephone Man* E. Hampton Beagle *U.S.O. Girls* Deborah Benson, Audrey Landers, Kerry Sherman, Maureen Teefy, Carol Ann Williams, Jenny Williams *Telephone Operator* Don Calfa *Reporters* Dave Cameron, John R. McKee, Dan McNally, Rita Taggart *Vito* Vito Carenzo *Stilwell's Aides* Mark Carlton, Paul Cloud, Jack Thibeau, Galen Thompson *Zoot Suitors* Gary Cervantes, Luis Contreras *Anderson Sisters* Carol Culver, Marjorie Gaines, Trish Garland *Lucinda* Lucinda Dooling *Lt. Bressler* Gray Frederickson *U.S.O. Goon* Brian Frishman *Interceptor Commander* Samuel Fuller *Twins* Dian Gallup, Denise Gallup *Interceptor Assistants* Barbara Gannen, Diane Hill *Map Man* Jerry Hardin *U.S.O. Nerds* Brad Gorman, Frank Verroca, John Voldstad *Maddox's Courier* Bob Houston *Pvt. Mizerany* John Landis *Cpl. Winowski* Ronnie McMillan *Ofr. Miller* Richard (Dick) Miller *Ashimoto* Akio Mitamura *Mrs. Scioli* Antoinette Molinari *Pvt. Hinshaw* Walter Olkewicz *Pvt. Reese* Mickey Rourke *Daffy* Whitney Rydbeck *Kid Sailor* Donovan Scott *Ito* Hiroshi Shimizu *Martinez* Geno Silva *Babyface* Andy Tennant *Elmer the Dummy* Elmer the Dummy *Stunt Serviceman* Terry Leonard *Stuntwomen* Jeannie Epper, Regina Parton, Erlynne Epper

Additional Oscar Nomination: *Sound* (Robert Knudson, Robert J. Glass, Don MacDougall, Gene Cantamessa)

Note: Based on an actual incident that occurred in 1942, when Japanese aircraft and a submarine attacked an oil refinery and depot. All the film characters were fictional except Maj. Gen. Stilwell, who was in charge of defending the California coast. When presented on network television, 3 minutes were deleted and 26 minutes of outtakes added. Among those appearing in the restored footage were Sidney Lassick as the clothing salesman, Douglas Foley as the department store Santa Claus, and Mark Marias as a little boy.

Star Trek

(Paramount; December 1979)

Producer Gene Roddenberry *Associate Producer* Jon Povill *Director* Robert Wise

Screenplay Harold Livingston, Gene Roddenberry, Alan Dean Foster *Adaptation* Alan Dean Foster *Based on the Television Episodes "The Doomsday Machine"* by Norman Spinrad *and "The Changeling" by* John Meredith Lucas *"Star Trek" Television Series Creator* Gene Roddenberry *Cinematographer* Richard H. Kline *Second Unit Cinematographer* Bruce Logan *Musical Score* Jerry Goldsmith *Film Editor* Todd Ramsay *Supervising Sound Effects Editor* Richard L. Anderson *Production Designer* Harold Michelson *Production Executives* Lindsley Parsons, Jr., Jeff Katzenberg *Special Science Consultant* Isaac Asimov *Special Science Adviser* Jesco von Puttkamer *Costume Designer* Robert Fletcher *Set Decorator* Linda DeScenna *Makeup* Fred Phillips, Janna Phillips, Ve Neil, Charles Schram, Mike LaValley, Steve Neill *Hairdressing* Barbara Kaye Minster *Music Editor* Kenneth Hall *Unit Production Manager* Phil Rawlins *Assistant Director* Daniel J. McCauley *Second Assistant Director* Douglas Wise *Apprentice Assistant Director* Kevin Cremin *Second Unit Assistant Director* David Lester *Second Unit Second Assistant Director* Jim Benjamin *Art Directors* Joe Jennings, Leon Harris, John Vallone *Property Master* Richard M. Rubin *Script Supervisor* Bonnie Prendergast *Second Unit Script Supervisor* Rosemary Dorsey *Assistant Film Editors* Rick Mitchell, Randy D. Thornton, Darren Holmes, John Dunn *Alien Languages* Marc O. Krand *Sound Effects Editors* Stephen Hunter Flick, Cecelia Hall, Alan Murray, Colin Waddy, George Watters II *Special Sound Effects* Dirk Dalton, Joel Goldsmith, Alan S. Howarth, Francisco Lupica, Frank Serafine *Dialogue Replacement Editor* Sean Hanley *Construction Coordinator* Gene Kelley *Graphic Designer* Lee Cole *Production Illustrators* Maurice Zuberano, Michael Minor, Rick Sternbach *Unit Publicists* John Rothwell, Suzanne Gordon *Still Photographer* Mel Traxel *Production Accountant* Charles A. Ogle *Production Coordinator and Secretary* Anita Terrian *Camera Operator* Al Bettcher *Assistant Cameraman* Michael Genne *Second Assistant Cameraman* Robert A. Wise *Second Unit Camera Operator* Gary Kibbe *Second Unit Assistant Cameraman* Terry Bowen *Costume Coordinators* Charles Tomlinson, Norman Stalling *Costume Model Maker* Kelly Kimball *Wardrobe* Agnes Henry, Jack Baer, Daniel Cartwright, Ron Hodge, Michael Lynn, David L. Watson, Harry Curtis, Elizabeth Manny, Pat Bradshaw, William Mas *Special Assistant to the Producer* Susan Sackett *Transportation Coordinator* Michael Avisov *Titles* Richard Foy/Communication Arts Inc. *Gaffer* Larry Howard *Best Boy* Larry Freeman *Electricians* Jim Purcell, Ed Reilly, Keith L. Roverud, Al "Tiny" Zimmerman, Norman M. Stuart *Key Grips* Robert Sorbel, John L. Black *Best Boy Grip* John C. Hann *Dolly Grip* Buzz Warren *Second Unit Gaffer* Bob Smith *Second Unit Key Grip* Jerry Deats *Sound Supervisor* Don Rogers *Sound* Samuel Goldwyn Studios *Production Mixer* Tom Overton *Boom Operator* Dennis Jones *Second Boom Operator* Winfred Tennison *Scoring Mixer* John Neal *Assistant Scoring Mixers* Terry Brown, Randy Saunders, Barry Walters *Special Scoring Mixer* Greg Hanley *Supervising Dubbing Mixer* Bill Varney *Dubbing Mixers* Steve Maslow, Gregg Landaker *Music Recording* 20th Century–Fox Studios *Additional Sound Effects* Glen Glenn Sound *Orchestration* Arthur Morton *"Star Trek" Television Series Theme Music* Alexander Courage, Gene

Roddenberry *Special Production Assistance* National Aeronautics and Space Administration *Medical Computer Displays* Digital Equipment Corporation *Kinetic Lighting Effects* Sam Nicholson, Brian Longbotham *Technical Assistance* Polaroid Corporation *Certain Computer Equipment* Sutherland Computer Corporation *Casting* Marvin Paige *Special Graphics* Stomar Enterprises Inc., Spectrum Productions *Assistant Art Director* John Cartwright *Assistant Property Masters* Charles Shepard, Richard Leon *Music Supervisor* Hunter Murtaugh *Special Music Assistance* Lionel Newman *Set Designers* Lewis Splittgerber, Richard MacKenzie, Dan Maltese, Jack Taylor, Marit Monsos, Al Kemper *Lead Man* Michael Huntoon *Craft Services* Jimmy Chirco *Construction Foremen* Robert Chitwood, Jim Kelley *Paint Foreman* Sam Giardina *Casting Assistant* Skitch Hendricks *Atmosphere Casting* Central Casting *Assistant to the Director* Esther Hall *Assistant to Harold Livingston* Michele Ameen Billy *Assistant to the Associate Producer* Roanna Attias *Research* Joan Pearce, Kellam de Forrest Research *American Film Institute Intern* Rick Fichter *Director Intern* Uri Pollack *Music Contractor* Carl Fortina *Security* Richard Thompson, Elaina Vescio *Production Assistant* Lex Rawlins *Technical Consultants* Jet Propulsion Laboratory, California Institute of Technology, Massachusetts Institute of Technology, John Casani, Richard Greene, Bill Koselka, Russell Schweickart *Master Scenic Artist* Benny Resella *Scenic Art* J.C. Backing Company *Second Unit Wardrobe* Bill Smith *Location Coordinator* John James *Panaflex Cameras and Lenses* Panavision Inc. *Visual Effects Producer* Richard Yuricich *Visual Effects Director* Douglas Trumbull *Visual Effects* Future General Corporation, Apogee Inc. *Certain Visual Effects* Robert Abel & Associates Inc. *Future General Visual Effects Unit — Cinematographers* Richard Yuricich, Dave Stewart *Matte Artist* Matthew Yuricich *Additional Matte Artist* Rocco Gioffre *Miniature Supervisor* Greg Jein *Camera Operators* Don Baker, Phil Barberio, Don Cox, Douglas Eby, John Ellis, David Hardberger, Alan Harding, Don Jarel, Lin Law, Clay Marsh, David McCune, Max Morgan, Scott Squires, Hoyt Yeatman *Additional Cinematographers* Jim Dickson, Bruce Logan, Charles F. Wheeler *Editors* Jack Hinkle, Vicki Witt *Special Electronic and Mechanical Design* Evans Wetmore, Richard Hollander *Illustrators* David Negron, Andy Probert, Tom Cranham, Robert McCall, Don Moore *Special Mechanical Design* George Polkinghorne *Visual Consultants* Virgil Mirano, Guy Marsden *Gaffer* David Gold *Key Grip* Pat van Auken *Miniaturists* Bruce Bishop, Al Broussard, Mike Fink, Kris Gregg, Mike McMillen, Robert Short, Robert Spurlock, Rick Thompson, Don Wheeler *Cinematography* Thane Berti, Glenn Campbell, Christopher George, Scott Farrar, Robert Friedstand, Robert Hollister, Russ McElhatton, Mike Peed, Lex Rawlins, Jonathan Seay, Steve Slocum, Bob Thomas *Animation and Graphics* Deena Burkett, Alison Yerxa, Lisze Bechtold, Merllyn Ching, Elrene Cowan, Cy Didjurgis, Leslie Ekker, Linda Harris, Nicola Kaftan, John Kimball, Thomas Koester, Deidre Le Blanc, Linda Moreau, Connie Morgan, Paul Olsen, Greg Wilzbach, Richard E. Hollander *Special Electronics* Kris Dean, Stephen Fog, John Gilman, Jim Goodnight, Fred Iguchi, Robin Leyden, Greg Mc-

Murray, Mike Myers, Josh Morton *Special Editors* Michael Backauskas, Kathy Campbell, Nora Jeanne Smith *Projectionist* John Piner *Project Managers* John James, Bill Millar *Assistant to Douglas Trumbull* Mona Thal Benefiel *Assistant to Richard Yuricich* Joyce Goldberg *Special Assistants* Leora Glass, Brett Webster *Optical Consultants* Alan Gundelfinger, Milt Laiken *Special Mechanical Designs* George Randle Company, Precision Machine, Dieter Seifert, Rourke Engineering *Transportation Coordinator* Robert Mayne. *Apogee Visual Effects Unit — Supervisor* John Dykstra *Project Manager* Robert Shepherd *Miniature Supervisor* Grant McCune *Optical Cinematography* Roger Dorney *Camera Operators* Chuck Barbee, Bruno George, Michael Lawler, Jerry Pooler, Doug Smith, John Sullivan *Special Animation* Harry Moreau *Special Electronic Design* Alvah J. Miller, Mat Beck, Paul Johnston, Steve Sass *Illustrators* Mark Kline, Syd Meade, Jack Johnson, John Shourt *Special Mechanical Design* Dick Alexander, Bill Shourt, Don Trumbull *Cinematography* Cosmos Bolger, Dennis Dorney, Robert Elswit, Phil Gonzales, Greg Kimble, Ron Nathan, Michael Sweeney, Diane E. Wooten *Miniaturists* David Beasley, Jon Erland, Joe Garlington, Pete Gerard, Rick Gilligan, Richie Helmer, Michael Joyce, Deborah Kendall, Don Kurtz, Pat McClung, Gary Rhodaback, John Ramsay, Dennis Schultz, David Scott, Dick Singleton, Richard Smiley, David Sosalla, Susan Turner, Don Webber, Gary Weeks *Key Grips* Mark Cane, Mark Kline *Gaffer* Chuck Embrey *Wardrobe* Mary Etta Lang *Animation and Graphics* Angela Diamos, John Millerburg *Editors* Denny Kelley, David Bartholomew, Steve Klein, Steve Mark *Visual Consultants* Mike Middleton, Erik Nash, Phil Joanou *Assistant to John Dykstra* Mimi McKinney *Assistant to Robert Shepherd* Ann M. Johnston *Special Assistants* Deborah Baxter, Janet Dykstra, Philip Golden, Proctor Jones, Tut Shurtleff *Special Optical and Mechanical Consultants* B/G Engineering, Abbot Grafton, Gerald Nash *Geometric Designs* Ron Resch, Boston University. *Robert Abel & Associates Visual Effects Unit — Designer* Richard Taylor *Project Manager* Con Pederson. *Process Cinematography* Bill Hansard *Special Animation* Robert Swarthe *Miniature Computer Motion Control System* Bob Gehring *Certain Miniatures* Magicam Inc. *Magicam Supervisors* James Dow, Russ Simpson *Magicam Technicians* Larry Albright, Peter Anderson, David Ascher, Brad Bluth, Bob Buckner, Chris Crump, Lee Ettleman, Nick Esposet, Rick Gutierrez, Dann Linck, Carey Melcher, Chris Miller, Paul Olsen, Tom Pahk, Richard Raymis, Chris Ross, Mark Stetson, Zuzana Swansea, Rick Thompson, Chris Tietz, George Trimmer, Paul Turner, Steve Wilson *Additional Miniatures* Brick Price Miniatures *Mechanical Effects Supervisor* Alex C. Weldon *Location Mechanical Effects Supervisor* Joe Viskovil *Mechanical Effects Technicians* Darrell Pritchett, Ray Mattey, Marty Bresin

A Gene Roddenberry Production. A Robert Wise Film. A Century Associates Picture. Made at Paramount Studios and on location in Yellowstone National Park, Montana. Copyright 1979 by Century

Associates. Panavision 70. Metrocolor. Dolby Stereo. 132 minutes including overture. M.P.A.A. Rating: G.

The Players: *Capt. James T. Kirk* William Shatner *Spock* Leonard Nimoy *Dr. Leonard "Bones" McCoy* DeForest Kelley *Cmdr. Montgomery "Scotty" Scott* James Doohan *Lt. Cmdr. Sulu* George Takei *Dr. Christine Chapel* Majel Barrett Roddenberry *Lt. Pavel Chekov* Walter Koenig *Lt. Cmdr. Uhura* Nichelle Nichols *Ilia* Persis Khambatta *Cmdr. Willard Decker* Stephen Collins *Transporter Chief Janice Rand* Grace Lee Whitney *Klingon Captain* Mark Leonard *Chief Di Falco* Marcy Lafferty *Alien Ensign* Billy Van Zandt *Starship Bridge Technicians* Ralph Brannen, Ralph Byers, Iva Lane, Franklyn Seales, Momo Yashima *Cmdr. Branch* David Gautreaux *Epsilon Lieutenant* Michele Ameen Billy *Epsilon Technician* Roger Aaron Brown *Transporter Assistant* John D. Cowans *Lt. Cmdr. Sonak* Jon Rashad Kamal *Yeomen* Leslie C. Howard, Lisa Chess *Lt. Cleary* Michael Rougas *Engine Room Technicians* Junero Jennings, Sayra Hummel *Cargo Deck Ensign* Howard Itzkowitz *Computer Voice Characterization* Doug Hale *Woman in Transporter* Susan J. Sullivan *Vulcan Masters* Paul Weber, Norman Stuart *Vulcan Mistress* Edna Glover *Worene* Paula Crist *Chief Ross* Terence O'Connor *Airlock Technician* Gary Faga *Security Officers* Rod Perry, John Dreaden, Joshua Gallegos *Klingon Crewmen* Jimmie Booth, Joel Kramer, Bill McTosh, Dave Moordigian, Tom Morga, Tony Rocco, Joel Schultz, Craig Thomas *Recreation Deck Personnel* Leah Livingston, Millicent Wise, Christopher Doohan, Montgomery Doohan, Denise Tathwell, Bjo Trimble, Susan Sackett, Kathleen Sky-Golden, Leigh Strother-Vien, Dennis Fischer, Verne Dietsche, Will Guest, Eileen Salamas, David Gerrold *Purple Lizard on Recreation Deck* Cedric Taporco *Vulcans on Recreation Deck* Scott Dale, JoAnn Cristy *Alien* Lex Rawlins *Stuntmen* Robert Bralver, William Couch, Keith L. Jensen, John Hugh McKnight *Stand-in* Brench Gooch

Additional Oscar Nominations: *Art Direction–Set Decoration* (Harold Michelson, Joe Jennings, Leon Harris, John Vallone, Linda DeScenna) *Music — Original Score* (Jerry Goldsmith)

Note: Advertised as *Star Trek The Motion Picture*, the silly title which does appear on nontheatrical prints. The overture was removed from nontheatrical editions. The sequels were *Star Trek II The Wrath of Kahn* (Paramount, 1982) and *Star Trek III The Search for Spock* (Paramount, 1984). The trick shots were made in Super Panavision 70, Todd-AO and VistaVision. The VistaVision scenes were converted to *Super*Scope 235, and the 70mm footage was reduced to 35mm for intercutting with the Panavision principal photography. This was then blown up to 70mm. The original NBC-TV series ran from September 8, 1966 to September 2, 1969. The two episodes on which the feature was based aired October 20, 1967 ("The Doomsday Machine") and September 29, 1967 ("The Changeling") in their first telecasts. A number of writers contributed to the screenplay without receiving or refusing credit. Rodden-

berry's credit for co-composing the television series theme music may be more ego than reality. He did not receive such credit on the series' billing nor on the other features. The feature was first announced as a telemovie and went through many false starts, story variations and budget changes before finally being produced as a multimillion dollar theatrical mess. When shown on network television, 12 minutes of out-takes were restored in an effort to clarify some of the story elements and characterizations. This footage has also been added to the video disc and video tape home sales versions. At the time of this writing *Star Trek IV* is in production.

1980

Special Achievement Award

Special Visual Effects Richard Edlund, Dennis
Muren, Brian Johnson and
Bruce Nicholson
For *The Empire Strikes Back* (Lucasfilm, 20th Century–Fox)

Scientific or Technical Awards

Award of Merit Linwood G. Dunn, Cecil D.
Love, Edward Furer and Acme Tool
and Manufacturing Company
For the concept, engineering and development of the Acme-
Dunn Optical Printer for motion picture special effects
Scientific and Engineering Award Ross Taylor
For the concept and development of a system of air guns for
propelling objects used in special effects motion picture pro-
duction
Technical Achievement Award Charles Vaughn and
Eugene Nottingham of Cinetron
Computer Systems Inc.
For the development of a versatile general purpose computer
system for animation and optical effects motion picture pho-
tography
Technical Achievement Award Peter A. Regla and
Dan Slater of Elicon
For the development of a follow focus system for motion
picture optical effects printers and animation stands

Comments

Rarely have sequels equaled their forefathers, yet with *The Empire Strikes Back (Star Wars Episode V)*, it seems that the followup surpassed the original. Not only did it cost three times as much, but it may have had three times the action. The effects were magnificent, outshining the first release in execution and spectacle. Even though it followed the first story, there was little resemblance in the staging of the battle scenes. Where *Star Wars* was generally outer space action, *The Empire Strikes Back* involved mostly land battles.

The motion control photography and stop-motion animation were marveleous. The detail devoted to all aspects of the production was nothing short of staggering.

Credits

The Empire Strikes Back
(20th Century–Fox; May 21, 1980)

Executive Producer George Lucas *Producer* Gary Kurtz *Associate Producers* Robert Watts, James Bloom *Director* Irvin Kershner *Screenplay* George Lucas, Leigh Brackett, Lawrence Kasden *Story* George Lucas *Cinematographer* Peter Suschitzky *Studio Second Unit Cinematographer* Chris Menges *Location Second Unit Cinematographer* Geoff Glover *Musical Score* John Williams *conducting the* London Symphony Orchestra *Film Editors* Paul Hirsch, George Lucas *Sound Designer and Supervising Sound Effects Editor* Ben Burtt *Sound Effects Editors* Richard Burrow, Teresa Eckton, Bonnie Koehler *Assistant Sound Effects Editors* John Benson, Joanna Cappuccilli, Ken Fischer, Craig Jaeger, Nancy Jencks, Laurel Ladevich *Foley Editors* Robert Rutledge, Scott Hecker *Assistant Foley Editors* Edward M. Steidele, John Roesch *Production Designer* Norman Reynolds *Design Consultant and Conceptual Artist* Ralph McQuarrie *Art Directors* Leslie Dilley, Harry Lange, Alan Tomkins *Set Decorator* Michael Ford *Construction Manager* Bill Welch *Assistant Art Directors* Michael Lamont, Fred Hole *Production Illustrator* Ivor Beddoes *Set Designers* Ted Ambrose, Michael Boone, Reg Bream, Steve Cooper, Richard Dawking *Modelers* Fred Evans, Roy Rogers, Allan Moss, Janet Stevens *Chief Property Buyer* Edward Rodrigo *Construction Storeman* Dave Middleton *Camera Operators* Kelvin Pike, David Garfath *Assistant Cameramen* Maurice Arnold, Chris Tanner *Second Assistant Cameramen* Peter Robinson, Madelyn Most *Location Second Unit Camera Operator* Bob Smith *Location Second Unit Assistant Cameramen* John Campbell, Mike Brewster *Location Second Unit Second Assistant Cameramen* John Keen, Greg Dupre *Dolly Grips* Dennis Lewis, Brian Osborn *Location Second Unit Dolly Grip* Frank Batt *Gaffer* Laurie Shane *Rigging Gaffer* John Clark *Electrical Contractors* Lee Electric (Lighting) Ltd. *Special Creature and Makeup Design* Stuart Freeborn *Chief Makeup Artist* Graham Freeborn *Makeup Artists* Kay Freeborn, Nick Maley *Hairdressing* Barbara Ritchie *Costume Designer* John Mollo *Wardrobe Supervisor* Tiny Nicholls *Wardrobe Mistress* Eileen Sullivan *Property Master* Frank Bruton *Property Supervisor* Charles Torbett *Supervising Set Dresser* Joe Dipple *Chief Carpenter* George Gunning *Chief Plasterer* Bert Rodwell *Chief Rigger* Red Lawrence *Music Supervisor* Lionel Newman *Supervising Music Editor* Kenneth Wannberg *Orchestration* Herbert W. Spencer *Music Librarian* Henry Greenwood *Orchestra Manager* John Duffy *Assistant Film Editors*

Duwayne Dunham, Phil Sanderson, Barbara Ellis, Steve Starkey, Paul Tomlinson *Dialogue Replacement Editors* Curt Schulkey, Leslie Shatz, Joanne D'Antonio *General Manager* Charles Weber *Production Manager* Bruce Sharman *Assistant Production Manager* Patricia Carr *Location Second Unit Production Manager* Sven Johansen *Production Coordinator* Miki Herman *Studio Second Unit Directors* Harley Cokliss, Gary Kurtz, John Barry *Location Second Unit Director* Peter MacDonald *Assistant Director* David Tomblin *Second Assistant Directors* Steve Lanning, Roy Button *Studio Second Unit Assistant Director* Dominic Fulford *Studio Second Unit Second Assistant Director* Andrew Montgomery *Location Second Unit Assistant Directors* Bill Westley, Ola Solum *Location Manager* Philip Kohler *Script Supervisors* Kay Rawlings, Pamela Mann *Casting* Irene Lamb, Terry Liebling, Bob Edmiston *Assistant to the Executive Producer* Jane Bay *Assistant to the Producer* Bunny Alsup *Assistant to the Director* Debbie Shaw *Production Assistants* Barbara Harley, Nick Laws, Charles Wessler *Stunt Coordinator* Peter Diamond *Fencing Master* Bob Anderson *Sound Supervisor* Don Rogers *Production Mixer* Peter Sutton *Boom Operator* Don Wortham *Sound Engineer* Ron Butcher *Scoring Mixer* Eric Tomlinson *Music Recording* Anvil Studios *Scoring Re-Mixer* John Neal *Music Re-Recording* 20th Century–Fox Studios *Sound Effects Recording* Randy Thom *Sound Effects Technicians* Gary Summers, Howie Hammerman, Kevin O'Connell *Dubbing Mixers* Bill Varney, Steve Maslow, Gregg Landaker *Sound* Samuel Goldwyn Studios *Legal Affairs* Tom Pollock *Production Accountant* Ron Phipps *Assistant Production Accountant* Michael Larkins *Set Cost Controller* Ken Gordon *Location Accountant* Ron Cook *Still Photographer* George Whitear *Unit Publicist* Alan Arnold *Assistant Publicist* Kristen Wing *Advertising and Publicity Coordinator* Sidney Ganis *Fan Public Relations* Craig Miller *Marketing* Susan Trembly *Animal Suppliers* Animal Actors *Animal Supervisor* Mike Culling *Music Publishers* Fox Fanfare Music Inc., Bantha Music *Color Timer* Ed Lemke *Negative Cutters* Robert Hart, Darrell Hixson *Dolby Stereo Consultant* Don Digirolamo *Aerial Camera Equipment* Wesscam Camera Systems (Europe) *Aerial Cinematographer* Ron Goodman *Assistant Aerial Camerawoman* Margaret Herron *Helicopter Supplier* Dollar Air Services Ltd. *Helicopter Pilot* Mark Wolfe *Helicopter Engineer* Michel Vautier *Astrovision Camera Equipment* Continental Camera Systems Inc. *Snow Vehicles* Aktiv Fischer *R2 Bodies Fabrication* White Horse Toy Company *Special Assistance* Giltspur Engineering, Compair *Costume Makers* Bermans & Nathans Ltd. *Millennium Falcon Construction* Pembroke Dock of Wales *Snowspeeders* Ogle Design Ltd. *The London Symphony Orchestra — First Violins* Michael Davis, Irvine Arditti, Lennox Mackenzie, Nigel Broadbent, Stanley Castle, Robert Clark, Sidney Colter, Dennis Gaines, Colin Renwick, Robert Retallick, Cyril Reuben, Norman Clarke, Brian Gaulton, David Llewellyn, Brian Smith, Paul Willey *Violas* Alexander Taylor, Brian Clarke, Peter Norriss, Patrick Hooley, Michael Mitchell, William Sumpton, David Hume, Patrick Vermont, Richard Holttum, William Krasnik, Eric Cuthbertson, Roger Welch *Double Basses* Bruce Mollison, Paul Marrion, Arthur Griffiths, John Cooper, Gerald Newson, Pashanko Dimitroff,

John Hill, Simon Hetherington, Robin McGee *Clarinets* Jack Brymer, Roy Jowitt, Ronald Moore, John Stenhouse, Ted Planas *Second Violins* Warwick Hill, Neil Watson, Sam Artis, William Brown, Thomas Cook, Geoffrey Creese, Terry Morton, Jack Steadman, Donald Stewart, Thomas Swift, David Williams, David Goodall, Alan Merrick, Edward Barry, David Ellis, Nicholas Maxted-Jones, John Ford *Cellos* Douglas Cummings, Rod McGrath, Ray Adams, Maurice Meulien, Clive Gillinson, Kenneth Law, David Powrie, Francis Saunders, Paul Kegg, Jack Long, Martin Robinson, Nigel Pinkett *Flutes* Peter Lloyd, Richard Taylor, Lowry Sanders, Francis Nolan *Oboes* Anthony Camden, Roger Lord, John Lawley, Geoffrey Browne, Michael Jeans *Bassons* Martin Gatt, Robert Bourton, Peter Francis, Nicholas Hunke, John Orford *Horns* David Cripps, Anthony Chidell, James Brown, John Rooke, James Quaife, Graham Warren, Jeffrey Bryant, Terry Johns, Denzil Floyd *Trumpets* Maurice Murphy, William Lang, Malcolm Hall, Norman Archibald, James Watson, Ralph Izen, Ian MacIntosh, Stanley Woods, Gerry Ruddock *Piano, Celeste, Electric Piano* Robert Noble, Michael Reeves, Leslie Pearson *Percussion* Michael Frye, Ray Northcott, Russell Jordan, Jack Lees, David Johnson, Keith Millar, Stephen Henderson *Trombones* Dennis Wick, Eric Crees, Roger Groves, Frank Mathison, Arthur Wilson, Roger Brenner *Tuba* John Fletcher, James Anderson, Patrick Harrild *Harps* Renata Scheffel-Stein, Clifford Lantaff, Nuala Herbert, Thelma Owen *Timpani* Kurtahans Goedicke *Sythesizer* Francis Monkman, Ann Odell, Brian Gascoigne. *Visual Effects* Industrial Light & Magic Inc., *a Division of* Lucasfilm Ltd. *Visual Effects Unit — Supervisors* Brian Johnson, Richard Edlund *Matte Cinematography Consultant* Stanley Sayer *Cinematographer* Dennis Muren *Second Cinematographers* Ken Ralston, Jim Veilleux *Camera Operators* Don Dow, Bill Neil *Assistant Cameramen* Selwyn Eddy, Jody Westheimer, Rick Fichter, Clint Palmer, Michael McAlister, Paul Huston, Richard Fish, Chris Anderson *Optical Cinematography* Bruce Nicholson *Optical Printers* David Berry, Kenneth Smith, Donald Clark *Optical Line-up* Warren Franklin, Mark Vargo, Peter Amundson, Loring Doyle, Thomas Rosseter, Tam Pillsbury, James Lim *Optical Coordinator* Laurie Vermont *Laboratory Technicians* Tim Geideman, Duncan Myers, Ed Jones *Art Director* Joe Johnston *Assistant Art Director* Nilo Rodis-Jamero *Stop Motion Animators* Jon Berg, Phil Tippett *Stop Motion Technicians* Tom St. Amand, Doug Beswick *Supervising Matte Artist* Harrison Ellenshaw *Matte Artists* Ralph McQuarrie, Michael Pangrazio *Matte Cinematography* Neil Krepela *Assistant Matte Cameramen* Craig Barron, Robert Elswit *Additional Matte Cinematography* Michael Lawler *Miniature Shop Foreman* Steve Gawley *Chief Miniaturist* Lorne Peterson *Miniaturists* Paul Huston, Tom Rudduck, Michael Fulmer, Samuel Zolltheis, Charles Bailey, Ease Owyeung, Scott Marshall, Marc Thorpe, Wesley Seeds, Dave Carson, Rob Gemmel, Pat McClung *Animation and Rotoscope Supervisor* Peter Kuran *Animators* Samuel Comstock, Garry Waller, John Van Vliet, Rick Taylor, Kim Knowlton, Chris Casady, Nina Saxon, Diana Wilson *Supervising Editor* Conrad Buff *Editor* Michael Kelly *Assistant*

Editors Arthur Repola, Howard Stein *Apprentice Editor* Jon Thaler *Editorial Coordinator* Roberta Friedman *General Manager* Tom Smith *Production Administrator* Dick Gallegly *Production Secretary* Patricia Blau *Production Associate* Thomas Brown *Production Accountant* Ray Scalice *Assistant Accountants* Glenn Phillips, Pam Traas, Laura Crockett *Production Assistant* Jenny Oznowicz *Transportation* Robert Martin *Still Photographer* Terry Chostner *Still Laboratory Assistant* Roberto McGrath *Electronic Systems Designer* Jerry Jeffress *Systems Programmer* Kris Brown *Electronic Engineers* Lhary Meyer, Mike MacKenzie, Gary Leo *Special Project Coordinator* Stuart Ziff *Equipment Engineering Supervisor* Gene Whiteman *Design Engineer* Mike Bolles *Machinists* Udo Pampel, Greg Beaumonte *Draftsman* Ed Tennler *Special Projects* Gary Platek *Key Grip* T.E. Moehnke *Grips* William Beck, Bobby Finley, Leo Loverro, Edward Hirsh, Dick Dova, Ed Breed *Pyrotechnical Effects* Joseph Viskocil, Dave Pier, Thaine Morris *Optical Printer Component Manufacturers* George Randle Company *Camera and Movement Design* Jim Beaumonte *Special Optics Designer* David Grafton *Special Optics Fabrication* J.L. Wood Optical Systems *Optical Printer Component Engineering* Fries Engineering *High Speed Camera Movements* Mitchell Camera Corporation *Ultra High Speed Camera* Bruce Hill Productions *Additional Optical Effects* Van der Veer Photo Effects, Modern Film Effects, Ray Mercer & Company, Westheimer Company, Lookout Mountain Films *Additional Optical Supervisors* Frank van der Veer, Barry Nolan, Ray Mercer, Sr., Joseph Westheimer *VistaVision Lenses* Nikon. *Mechanical Effects Staff—Supervisor* Nick Allder *Location Unit Supervisor* Allan Bryce *Technicians* Neil Swann, David Watkins, Phil Knowles, Barry Whitrod, Martin Gant, Brian Eke, Guy Hudson, Dennis Lowe *Engineers* Roger Nicholls, Steve Lloyd *Electrical Engineer* John Hatt *Electronics Consultant* Rob Dickson *Model Construction* John Pakenham *Assistant Technicians* Alan Poole, Digby Milner, Robert McLaren *Secretary* Gill Case *Yoda Fabrication* Wendy Midener

A Lucasfilm Ltd. Production. A Chapter II Productions Picture. An Irwin Kershner Film. Made at EMI Elstree Studios and on location on the Hard-Angerjokulen Glacier, Finse, Norway. Copyright 1980 by Lucasfilm Ltd. Music Copyright 1980 by Fox Fanfare Music Inc. and Bantha Music. Panavision 70. Color by Rank. Prints by De Luxe. Dolby Stereo. 124 minutes. M.P.A.A. Rating: PG.

The Players: *Luke Skywalker* Mark Hamill *Han Solo* Harrison Ford *Princess Leia Organa* Carrie Fisher *Lando Calrissian* Billy Dee Williams *C-3PO* Anthony Daniels *Lord Darth Vader* David Prowse *Vader's Voice Characterization* James Earl Jones *Chewbacca* Peter Mayhew *R2-D2* Kenny Baker *Yoda* Frank Oz *Ben (Obi-Wan) Kenobi* Alec Guinness *Boba Fett* Jeremy Bulloch *Calrissian's Aide* John Hollis *Chief Ugnaught* Jack Purvis *Snow Creature* Des Webb *Performing Assistant for Yoda* Kathryn Mullen *Voice Characterization for Emperor* Clive Revill *Adm. Piett* Kenneth Colley *Gen. Veers* Julian Glover *Adm. Ozzel* Michael Sheard *Capt. Needa* Michael Culver *Imperial Officers* John Dicks, Milton

Johns, Mark Jones, Oliver Maguire, Robin Scobey *Gen. Rieekan* Bruce Boa *Zev* Christopher Malcolm *Wedge* Dennis Lawson *Hobbie* Richard Oldfield *Dak* John Morton *Janson* Ian Liston *Maj. Derlin* John Ratzenberger *Deck Lieutenant* Jack McKenzie *Head Controller* Jerry Harte *Rebel Officers* Norman Chancer, Norwich Duff, Ray Hassett, Briggitte Kahn, Burnell Tucker *Stunt-men* Bob Anderson, Colin Skeaping, Peter Diamond

Additional Oscar Nominations: *Art Direction–Set Decoration* (Norman Reynolds, Leslie Dilley, Harry Lange, Alan Tomkins, Michael Ford); *Music — Original Score* (John Williams); *Sound* (Bill Varney, Steve Maslow, Gregg Landaker, Peter Sutton)*

Note: Sequel to *Star Wars (Episode IV: A New Hope*, 20th Century–Fox, 1977). Sequel was *Star Wars Episode VI: Return of the Jedi* (20th Century–Fox, 1983). Dialogue sequences were shot in Panavision and Todd-AO 35; visual effects were shot in VistaVision and Technirama (with the anamorphic mirrors removed) and converted to *Super*Scope 235; cloud plates were shot in Astrovision.

1981

Special Visual Effects Nominations

Dragonslayer Dennis Muren, Phil Tippett,
 (Paramount, Disney) Ken Ralston, Brian Johnson
Raiders of the Lost Ark Richard Edlund,
 (Lucasfilm, Paramount) Kit West, Bruce
 Nicholson, Joe Johnston

Scientific or Technical

Scientific and Engineering Award Richard Edlund and
 Industrial Light & Magic Inc.
For the concept and engineering of a beam-splitter optical
composite motion picture printer
Scientific and Engineering Award Richard Edlund
 and Industrial Light & Magic Inc.
For the engineering of the Empire Motion Picture Camera
System
Technical Achievement Award Dennis Muren and
 Stuart Ziff of Industrial
 Light & Magic Inc.
For the development of a Motion Picture Figure Mover for
stop-motion animation photography

Comments

George Lucas' Industrial Light & Magic effects house couldn't have lost
this year. They had both nominated features as well as the three effects-
related Scientific or Technical awards. *Dragonslayer* should have been so
much more than it was. Like the other Disney-Paramount co-venture,
Popeye, it was excessively expensive and a box office bomb. While the Go-
Motion models and the mechanical effects were very good, the matte art,
traveling mattes, and flying scenes were fair at best and often quite poor. The
dragon was very believable in its movements, but the poor blending with live
action immediately ruined the scenes. The overlayed cartoon animation
worked well, but as usual, the silly use of *Super*Scoped VistaVision rendered
a grainy look to all effects shots. While this technique does occasionally pro-

duce good results, it still is nonsensical when the VistaVision footage must be converted to fit anamorphic format and is then blown up to 70mm.

Raiders of the Lost Ark was something like a digested serial and was intended to give that impression. The mechanical effects were topnotch as were most of the visual effects. The cartoon animation worked well and the models were well detailed. The matte paintings left much to be desired, however. Industrial Light & Magic seem to have trouble with their matte art anytime it doesn't involve outer space shots.

Credits

Dragonslayer
(Paramount; June 24, 1981)

Executive Producer Howard W. Koch *Producer* Hal Barwood *Associate Producer* Eric Rattray *Director* Matthew Robbins *Second Unit Director* Peter MacDonald *Screenplay* Hal Barwood, Matthew Robbins *Cinematographer* Derek Vanlint *Musical Score* Alex North *conducting the* National Symphony Orchestra *Period Music* Christopher Page *Film Editor* Tony Lawson *Production Designer* Elliot Scott *Art Director* Alan Cassie *Costume Designer* Anthony Mendelson *Sound Design* Dale Strumpell *Casting* Deborah McWilliams, Deborah Brown *Assistant Director* Barry Langley *Second Assistant Director* Roy Stevens *Third Assistant Director* Jerry Daly *Second Unit Assistant Director* John Downes *Second Unit Second Assistant Directors* Charles Marriott, Andrew Wood *Script Supervisor* Pamela Davies *Second Unit Script Supervisors* Doris Martin, Georgina Hamilton *Unit Production Manager* Donald Toms *Production Secretary* Norma Garment *Location Manager* Rita Davison *Production Accountant* John Sargent *Production Staff* Monica Rogers, Jennie Johnson, Susan Kane, Paul Tucker, Deborah Vertue, Susan Axworthy, Sally Forino, Davina Watson, Susie Harrod *Camera Operator* Eddie Collins *Second Camera Operator* John Golding *Assistant Cameramen* Brian Harris, John Keen, Tony Brown, Nick Schlesinger, Robert Carlyle *Second Unit Camera Operator* John Campbell *Second Unit Assistant Cameraman* Beaumont Alexander *Second Unit Second Assistant Cameraman* Mark Cridlin *Grips* George Beavis, Albert Cowlard *Second Unit Grip* Frank Batt *Gaffer* Bert Bosher *Best Boy* Ron Hutton *Standby Technicians* Trevor Nicol, Terry Newvell, Fred Meakin, Michael Spivey, Tony Jordan, Philip Connolly *Graphics and Titles* David Bunnett *Set Decorator* Ian Whittaker *Property Master* Barry Wilkinson *Property Buyer* Bryn Siddal *Assistant Art Director* Ernest Archer *Chief Set Designer* Ted Ambrose *Set Designers* Peter Childs, Frank Walsh *Scenic Artist* Ernie Smith *Chief Sculptor* Derek Howarth *Sculptors* Arthur Healey, Brian Muir *Standby Property Men* Wally Hill, Tommy Davies, Robert Sherwood *Set Dressers* Bernard Hearn, Nick Rivers *Property Storeman*

Sid Alden *Property Maker* J.W. Kijko *Wardrobe* John Hilling, Dorothy Edwards *Wardrobe Assistants* Ken Crouch, Renee Heimer, Ken Lawton, Rene Leonard *Makeup* Graham Freeborn, Jane Royle *Hairdressing* Barbara Ritchie, Bobbie Smith *Construction Manager* Michael Redding *Assistant Construction Manager* Tony Morris *Chief Plasterer* Andrew Knapman *Chief Carpenter* Bill Evans *Chief Painter* Jock Campbell *Second Unit Standby Carpenter* Graham Britton *Stunt Coordinator* Terry Walsh *Magic Adviser* Harold Taylor *Latin Adviser* Eric Watts *Choreography* Peggy Dixon *Unit Publicist* Doreen Landry *Still Photographers* Laurie Ridley, Joe Pearce *Sound* Zoetrope Studios *Production Mixer* Anthony Dawe *Sound Engineer* David Bachelor *Boom Operator* Nicholas Dunn *Sound Effects Recording* Andrew Aaron, Douglas Hemphill *Scoring Mixer* Eric Tomlinson *Music Recording* Anvil/EMI Studios *Supervising Dubbing Mixer* Mark Berger *Dubbing Mixers* Walter Murch, Dale Strumpell *Assistant Sound Designer* Louis Benioff *Dialogue Replacement Editor* Leslie Shatz *Sound Effects Editors* Terry Eckton, Jay Boekelheide, Tim Holland *Assistant Sound Effects Editors* Dennie Thorpe, Barbara Ellis, Karen Wilson, Cliff Latimer, Carol Jean Appel *Apprentice Sound Effects Editors* George Budd, Daniel Kenney *First Assistant Film Editor* David Spiers *Assistant Film Editors* Duwayne Dunham, Paul Hodgson *Music Copyist* Ernest Locket *Music Editor* June Edgerton *Music Contractor* Sidney Sax *Production Cooperation* Department of the Environment, Welsh Office, National Trust, North Wales, Ancient Monuments Branch *Visual Effects* Industrial Light & Magic Inc., *a Division of* Lucasfilm Ltd. *Visual Effects Unit — Dragon Design* David Bunnett *Miniature and Optical Effects Supervisor* Dennis Muren *Dragon Supervisors* Phil Tippett, Ken Ralston *Traveling Matte Consultant* Dennis Bartlett *Closeup Dragon* Christopher Walas *Dragon Movers* Tom St. Amand, Stuart Ziff, Gary Leo *Dragon Consultant* Jon Berg *Dragon Set Designs* Dave Carson *Optical Cinematography* Bruce Nicholson *Cinematographers* Rick Fichter, Michael McAlister *Additional Cinematography* Jim Veilleux *Optical Coordinator* Warren Franklin *Optical Printers* Kenneth Smith, John Ellis, David Berry *Optical Line-up* Tom Rosseter, Mark Vargo *Optical Technician* Duncan Myers *Supervising Matte Artist* Alan Maley *Matte Artists* Christopher Evans, Michael Pangrazio *Matte Cinematography* Neil Krepela *Assistant Matte Cameraman* Craig Barron *Assistant Cameramen* Selwyn Eddy III, Jody Westheimer *Animation Supervisor* Samuel Comstock *Animators* Deitrich Friesen, Garry Waller, Loring Doyle, John Van Vliet, Kim Knowlton, Judy Elkins, Sylvia Keulen, Scott Caple *Additional Animation* Visual Concept Engineering *Additional Animation Supervisor* Peter Kuran *Additional Animators* Susan Turner, Kathrine Kean, Pam Vick, Chris Casady, Len Morganti *Animation Cameraman* Robert Jacobs *Optical Cameraman* James Hagedorn *Optical Laboratory* Alpha Cine Laboratories *Additional Optical Effects* RGB Film Processing, Lookout Mountain Films, Modern Film Effects *Ultra High Speed Camera* Bruce Hill Productions *Production Supervisor* Thomas Smith *Production Coordinator* Laurie Vermont *Administrative Coordinator* Chrissie England *Miniature Shop Supervisor* Lorne Peterson *Miniaturists* Ease Owyeung, Paul Huston, Charles Bailey, Michael Glenn Fulmer, Scott Marshall, Bruce

Richardson *Key Grip* T.E. Moehnke *Grips* Patrick Fitzsimmons, Dick Dova, Bobby Finley III, Edward Hirsh, William Beck *Production Accountant* Laura Kaysen *Dragon Assistants* Eric Jensen, Marc Thorpe, Wesley Seeds, Peter Stolz, Bess Wiley *Pyrotechnical Effects* Thaine Morris *Still Photographer* Terry Chostner *Assistant Still Photographers* Roberto McGrath, Kerry Nordquist *Editors* Arthur Repola, Howard Stein *Assistant Editor* Peter Amundsen *Equipment Engineering Supervisor* Gene Whiteman *Machinists* Udo Pampel, Conrad Bonderson *Electronic Systems Designer* Jerry Jeffress *Computer Engineer* Kris Brown *Electronic Engineer* Mike MacKenzie *Electronic Technicians* Marty Brenneis, Melissa Cargill, Cristi McCarthy *Aerial Cinematography* Continental Camera Systems *Camera Aircraft Pilot* Clay Lacey. *Mechanical Effects Staff—Supervisor* Brian Johnson *Chief Technicians* David Watkins, Philip Knowles, Neil Swann, John Gant, Peter W. Hutchinson, Andrew Kelly *Technicians* Barry Whitrod, Martin Gant, John Hatt, Norman Kerss, Ronald Hone, Nicholas J. Middleton, John Pakenham *Assistant Technicians* Clive Beard, Ian Corbould, Chris J. Gant, Guy Hudson, Digby Milner, Dennis Morgan, Daniel Murphy, Sean Nagle, Alan Poole, Peter Skehan, Philip Smith, Anthony Speake, Mark Pickford *Dragon Action Props* Danny Lee, Walt Disney Studios *Halo Crane* Nick Allder, Dennis Lowe, Ray Evans

A Paramount Pictures–Walt Disney Productions Presentation. A Barwood-Robbins Production. Made at Pinewood Studios and on location on the Isle of Skye, Scotland and Snowdonia National Park, North Wales. Copyright 1981 by Paramount Pictures Corporation and Walt Disney Productions. Panavision 70. Color by Rank. Prints by Metrocolor. Dolby Stereo. 108 minutes. M.P.A.A. Rating: PG.

The Players: *Galen* Peter MacNicol *Valerian* Caitlin Clarke *Ulrich* Ralph Richardson *Tyrian* John Hallam *Casidorus Rex* Peter Eyre *Greil* Albert Salmi *Hodge* Sidney Bromley *Princess Elspeth* Chloe Salaman *Simon* Emrys James *Horsrik* Roger Kemp *Brother Jacopus* Ian McDiarmid *Henchmen* Ken Shorter, Jason White *Victim* Yolanda Palfrey *Urlanders* Douglas Cooper, Alf Mangon, David Mount, James Payne, Chris Twinn *Stuntmen* Terry Walsh, Tony Smart

Additional Oscar Nomination — *Original Score* (Alex North)

Note: Trick photography in VistaVision and converted to *Super*Scope 235 to match the Panavision principal photography. A purposed sequel has been dropped.

Raiders of the Lost Ark

(Paramount; June 12, 1981)

Executive Producers George Lucas, Howard Kazanjian *Producer* Frank Marshall *Associate Producer* Robert Watts *Director* Steven Spielberg *Second Unit Directors* Michael Moore, Frank Marshall, George Lucas *Screenplay* Lawrence Kasden *Story* George Lucas, Philip Kaufman *Cinematographer* Douglas Slocombe *Additional Cinematographer* Paul Beeson *Musical Score* John Williams *conducting the* London Symphony Orchestra *Film Editor* Michael Kahn *Production Designer* Norman Reynolds *Casting* Michael Fenton, Jane Feinberg, Mary Selway *Stunt Coordinator* Glenn Randall *Costume Designer* Deborah Nadoolman *Sound Design* Benjamin Burtt *Sound Supervisor* Don Rogers *Production Mixer* Roy Charman *Scoring Mixer* Eric Tomlinson *Scoring Re-Mixer* John Neal *Sound Effects Recording* Gary Summers *Sound Effects Technician* Howie Hammerman *Dubbing Mixers* Bill Varney, Steve Maslow, Gregg Landaker *Dialogue Replacement Recording* Mayflower Film Recording Ltd. *Music Recording* Abbey Road Studios *Music Re-Recording* 20th Century–Fox Studios *Sound* Samuel Goldwyn Studios, The Burbank Studios *Assistant Director* David Tomblin *Second Assistant Directors* Roy Button, Patrick Cadell *Tunisia Assistant Director* Naceur Ktari *France Assistant Director* Vincent Joliet *Hawaii and Peru Assistant Director* Louis G. Friedman *Second Unit Assistant Director* Carlos Gill *Second Unit Second Assistant Director* Michael Hook *General Manager* Charles Weber *Production Supervisor* Douglas Twiddy *Tunisia Production Supervisor* Mohamed Ali Cherif *Tunisia Production Manager* Hassine Soufi *France Production Manager* Dorothy Marchini *Assistant Production Manager* Patricia Carr *Location Manager* Bryan Coates *Tunisia Location Managers* Habib Chaari, Abdelkrim Baccar *Hawaii and Peru Location Manager* Maile Semitokol *Script Supervisor* Pamela Mann *Second Unit Script Supervisor* Maggie James *Associate to the Director* Kathleen Kennedy *Camera Operator* Chic Waterson *Assistant Cameraman* Robin Vidgeon *Second Assistant Cameraman* Danny Shelmerdine *Second Unit Camera Operators* Wally Byatt, Gerry Dunkley, David Worley *Second Unit Assistant Cameraman* Chris Tanner *Second Unit Second Assistant Cameraman* Eamon O'Keefe *Dolly Grip* Colin Manning *Second Unit Dolly Grip* Jim Kane *Gaffer* Martin Evans *Hawaii and Peru Gaffer* Alan Brady *Chief Rigger* Red Lawrence *Art Director* Leslie Dilley *Set Decorator* Michael Ford *Construction Manager* Bill Welch *Property Master* Frank Bruton *Tunisia Property Master* Peter Hancock *Assistant Construction Manager* George Gunning *Assistant Art Directors* Fred Hole, Michael Lamont, John Fenner, Ken Court *Tunisia Assistant Art Director* Hassen Soufi *Production Illustrator* Ed Verreaux *Production Artists* Michael Lloyd, Ron Cobb *Sketch Artists* Roy Carnon, David Negron *Decor and Lettering Artist* Bob Walker *Set Designer* George Djurkovic *Scenic Artist* Andrew Garnet-Lawson *Modeler* Keith Short *Chief Property Buyer* David Lusby *Art Department Assistant* Sharon Cartwright *Supervising Plasterer* Kenneth

Clarke *Chief Plasterer* Bert Rodwell *Chief Painter* Eric Shirtcliffe *Construction Storeman* Charles Torbett *Armorer* Simon Atherton *Louma Camera Crane Technical Advisers* Jean Maria Lavalou, Alain Masseron *Vehicles* Classic Cars of Conventry *Titles* MGM *Wardrobe* Rita Wakely *Wardrobe Assistants* Sue Wain, Ian Hickinbotham *Chief Makeup Artist* Tom Smith *Makeup Artist* Dickie Mills *Second Unit Makeup* Magdalene Gaffney *Chief Hairdresser* Patricia McDermott *Hairdresser* Mike Lockey *Stunt Arranger* Peter Diamond *Animal Suppliers* Animal Actors *Wranglers* Michael Culling, Steve Edge, Jed Edge *Supervising Sound Effects Editor* Richard L. Anderson *Sound Effects Editors* Steven Hunter Flick, Mark Mangini *Apprentice Sound Effects Editor* Peter Grives *Supervising Dialogue Replacement Editor* Curt Schulkey *Dialogue Replacement Editor* Andy Patterson *Assistant Dialogue Replacement Editor* Eric Whitfield *Foley Editor* John Dunn *Music Supervisor* Lionel Newman *Supervising Music Editor* Kenneth Wannberg *Orchestration* Herbert W. Spencer *Assistant Film Editors* Phil Sanderson, Bruce Green, Colin Wilson *Visual Effects Sequences Assistant Film Editor* Duwayne Dunham *Apprentice Film Editor* Julie Kahn Zunder *Boom Operator* John Salter *Sound Engineer* George Rice *Research* Deborah Fine *Assistant to George Lucas* Jane Bay *Assistant to Howard Kazanjian* Laura Kenmore *Assistants to the Producer* Patty Rumph, Barbara Harley *Assistant to the Director* Marty Casella *Production Assistants* Gill Case, Daniel Parker *France Production Assistant* Junior Charles *Unit Doctor* Felicity Hodder *Second Unit Doctor* Hassam Moossun *Production Accountant* Arthur Carroll *Assistant Production Accountant* Michael Larkins *Location Accountant* Stefano Priori *Tunisia Accountant* Ridna Turki *France Accountant* Stella Quef *Hawaii and Peru Accountant* Bonne Radford *Still Photographers* Albert Clarke, Nancy Moran *Unit Publicist* Derek Robbins *Assistant Publicist* Kristen Wing *Tunisia Production Coordinator* Tarak Ben Ammar *Hawaii and Peru Production Coordinator* Dan Nichols *Legal Affairs* Tom Pollock *Tunisia Production Services* Carthage Films *Hawaii and Peru Transportation Captain* Harry Ueshiro *Negative Cutter* Brian Ralph *Color Timer* Robert McMillan *Production Cooperation* U.S. Fish and Wildlife Service *Visual Effects* Industrial Light & Magic Inc., *a Division of* Lucasfilm Ltd. *Visual Effects Unit—Supervisor* Richard Edlund *Optical Cinematography* Bruce Nicholson *Production Supervisor* Tom Smith *Art Director* Joe Johnston *Supervising Matte Artist* Alan Maley *Editor* Conrad Buff *Production Coordinators* Patricia Blau, Laurie Vermont *Production Associate* Miki Herman *Supervising Animators* Samuel Comstock, Dietrich Friesen *Additional Animation Supervisor* Peter Kuran *Additional Animation* Visual Concept Engineering *Cinematographer* Jim Veilleux *Camera Operators* Bill Neil, Don Dow *Assistant Cameraman* Clint Palmer *Optical Printers* David Berry, Kenneth Smith, John Ellis *Optical Lineup* Mark Vargo, Warren Franklin, Tom Rosester *Assistant Art Director* Nilo Rodis-Jamero *Illustrator* Ralph McQuarrie *Matte Artist* Michael Pangrazio *Matte Cinematography* Neil Krepela *Assistant Matte Cameraman* Craig Barron *Miniature Shop Foreman* Lorne Peterson *Miniaturists* Steve Gawley, Mike Fulmer, Wesley Seeds, Paul Huston, Charlie Bailey, Sam Zolltheis, Marc Thorpe, Bruce Richardson, Ease Owyeung *Animators*

John Van Vliet, Kim Knowlton, Garry Waller, Loring Doyle, Scott Caple, Judy Elkins, Sylvia Keulen, Scott Marshall *Assistant Editors* Peter Amundson, Howard Stein *Cloud Effects* Gary Platek *Special Makeup Effects* Christopher Walas *Laboratory Technicians* Tim Geideman, Duncan Myers, Ed Jones *Still Photographer* Terry Chostner *Administrative Assistant* Chrissie England *Production Accountants* David Kakita, Shirley Lee, Laura Kaysen *Still Lab Technicians* Roberto McGrath, Kerry Nordquist *Electronic Systems Designer* Jerry Jeffress *Computer Engineering* Kris Brown *Design Engineer* Mike Bolles *Electronic Engineers* Mike MacKenzie, Marty Brenneis, Gary Leo *Electronic Technicians* Cristi McCarthy, Bessie Wiley, Melissa Cargill *Equipment Engineering Supervisor* Gene Whiteman *Machinist* Udo Pampel *Special Projects* Wade Childress *Key Grip* Theodore E. Moehnke *Grips* William Beck, Dick Dova, Bobby Finley III, Edward Hirsh, Patrick Fitzsimmons, John McCleod, Peter Stolz *Pyrotechnical Effects* Thaine Morris *Ultra High Speed Camera* Bruce Hill Productions *Additional Optical Effects* MGM, Modern Film Effects. *Mechanical Effects Staff—Supervisor* Kit West *Chief Technician* Peter Dawson *Technicians* Terry Schubert, Rodney Fuller, Trevor Neighbour *Engineer* Terry Glass *Equipment Supervisor* William Warrington *Electrician* Chris Condon *Carpenter* Roy Combes *Welder* Yves De Bono *Assistant Technicians* Ken Gittens, Ray Hanson

A Lucasfilm Ltd. Production. A Lost Ark Productions Picture. A Steven Spielberg Film. Made at EMI Elstree Studios and Industrial Light & Magic and on location in England, France, Tunisia, Hawaii and Peru. Copyright 1981 by Lucasfilm Ltd. Panavision 70. Color by Rank and Metrocolor. Prints by Metrocolor. Dolby Stereo. 115 minutes. M.P.A.A. Rating: PG.

The Players: *Dr. Indiana Jones* Harrison Ford *Marion Ravenwood* Karen Allen *Dr. Rene Belloq* Paul Freeman *Toht* Ronald Lacey *Sallah* John Rhys-Davies *Brody* Denholm Elliott *Dietrich* Wolf Kahler *Gobler* Anthony Higgins *Satipo* Alfred Molina *Barranca and Monkey Man* Vic Tablian *Col. Musgrove* Don Fellows *Maj. Eaton* William Hootkins *Bureaucrat* Bill Reimbold *Jock* Fred Sorenson *Australian Climber* Patrick Durkin *Second Nazi* Matthew Scurfield *Ratty Nepalese* Malcolm Weaver *Mean Mongolian* Sonny Caldinez *Mohan* Anthony Chinn *Giant Sherpa and First Mechanic* Pat Roach *Otto* Christopher Frederick *Imam* Tutte Lemkow *Omar* Ishaq Bux *Abu* Kiran Shah *Fayah* Souad Messaoudi *Arab Swordsman* Terry Richards *German Agent* Steve Hanson *Flying Wing Pilot* Frank Marshall *Young Soldiers* Martin Kredt, Victor Mallet *Katanga* George Harris *Messenger Pirate* Eddie Tagoe *Sergeant* John Rees *Tall Captain* Tony Vogel *Peruvian Porter* Ted Grossman *Nazi Thrown from Truck* Martin Grace *Sergeant in Truck* Sergio Mione *Stuntmen* Terry Leonard, Vic Armstrong, Rocky Taylor, Chuck Waters, Martin Grace, Sergio Mione, Bill Weston, Reg Harding, Billy Horrigan, Peter Brace, Gerry Crampton, Romo Garrara, Paul Weston *Stuntwoman* Wendy Leech *Harrison Ford's Stand-in* Jack Dearlove *Karen Allen's Stand-in* Mercedes Burleigh *Stand-in* Joe Gibson

Additional Oscar Nominations: *Picture* (Lucasfilm, Paramount; Frank Marshall); *Direction* (Steven Spielberg); *Cinematography* (Douglas Slocombe); *Film Editing* (Michael Kahn)*; *Art Direction–Set Decoration* (Norman Reynolds, Leslie Dilley, Michael Ford)*; *Music – Original Score* (John Williams); *Sound* (Bill Varney, Steve Maslow, Gregg Landaker, Roy Charman)*; *Special Achievement Award – Sound Effects Editing* (Richard L. Anderson)*

Note: Visual effects shot in VistaVision and converted to *Super*Scope 235. Sequel was *Indiana Jones and the Temple of Doom* (Paramount; 1984) with a third entry announced for production.

1982

Visual Effects Nominations

Blade Runner Douglas Trumbull,
 (Michael Deeley–Ridley Scott Richard Yuricich,
 Production, The Ladd Company/ David Dryer
 Sir Run Run Shaw)

**E. T. The Extra-Terrestrial* Carlo Rambaldi,
 (Universal Pictures Production, Dennis Muren,
 Universal; Steven Spielberg, Kenneth F. Smith
 Kathleen Kennedy)

Poltergeist . Richard Edlund,
 (MGM/Steven Spielberg Michael Wood,
 Production; MGM/UA) Bruce Nicholson

Scientific or Technical

Technical Achievement Award Bran Ferren of
 Associates & Ferren
For the design and development of a computerized lighting-effect system for motion picture photography

Comments

The quality of this year's nominations was extraordinary, and once again, all were released in bad 70mm blowups.

E. T. The Extra-Terrestrial was Steven Spielberg's much-touted sequel to *Close Encounters of the Third Kind*. It was not what was expected, but instead a rather simple story of a stranded alien who is befriended by three children. All emotional stops were pulled out and the film pulled, tugged and twisted the heartstrings without mercy. And it all worked, much to the confusion and afterwards, much to the dislike of many in the audience. People came expecting a spectacular space picture and got a tearjerker. Like most highly charged romances, this one did not hold up too well when viewed a second time. But two viewings weren't enough for many, and *E. T.* has become the highest-grossing film in history, though hardly the most popular. (*Gone with the Wind* will probably always remain the most popular film no matter what comes after it.) While the effects were not flawless—tree leaves were transparent in some matte shots, for example—they were so nearly perfect

they almost defied criticism. The flying bicycle sequence, employing the Go-Motion technique, drew ahhs from every audience, and except for the beginning and ending shots involved miniatures and other fakery, the Go-Motion was so well executed that no one knew the human characters were puppets animated via computer control.

Blade Runner, a mismanaged project from the first, was a huge financial bomb. Its story of an ex-cop hunting super robots in Los Angeles of the not-too-distant future was just too stylized to be of much interest. A sci-fi film noir offered little appeal to the general patron, and the overly produced artiness turned most viewers off. The effects were most impressive, but since the story tended to bore so badly, much of the trick photography became too noticeable as there was little else to pay attention to. The matte art was often too apparent under heavy scrutiny, and the extremely detailed miniatures, when not surrounded with movement of some kind, appeared no more than what they were. Had the story been better, the effects would have been hailed by one and all instead of falling into the same critical pit as the rest of the production.

Poltergeist, a big-budget, glossy horror film, was a winner in all respects. Audiences liked it, were thrilled by it, and it became another feather in Steven Spielberg's already plume-covered hat. It didn't do much for director Tobe Hooper, who found himself almost completely overshadowed by his producer, so much so the Directors Guild of America investigated the production set-up. While matte lines did show in some shots, the mechanical and photographic effects were top level. Literally every trick technique was employed, from wire rigging to cel animation and it proved to be eye-pleasing as well as occasionally unnerving.

Credits

Blade Runner

(The Ladd Company in Association with Sir Run Run Shaw through Warner Bros.; June 25, 1982)

Executive Producers Brian Kelly, Hampton Fancher *Producer* Michael Deeley *Associate Producer* Ivor Powell *Director* Ridley Scott *Screenplay* Hampton Fancher, David People *Based on the Novel* Do Androids Dream of Electric Sheep *by* Philip K. Dick *Cinematographer* Jordan Cronenweth *Musical Score* Vangelis Papathanasaiou *Supervising Film Editor* Terry Rawlings *Film Editor* Marsha Nakashima *Production Designer* Lawrence G. Paull *Executive in Charge of Production* C.O. Erickson *Production Executive* Katherine Haber *Unit Production Manager* John W. Rogers *Assistant Directors* Newton Arnold, Peter Cornberg *Second Assistant Directors* Don Hauer, Morris Chapnick, Richard Schroer

Costume Designers Charles Knode, Michael Kaplan *Art Director* David Snyder *Visual Futurist* Syd Mead *Additional Cinematographers* Steven Poster, Brian Tufano *Casting* Mike Fenton, Jane Feinberg *Production Controller* Steve Warner *Production Auditor* Dick Dubuque *Assistant Auditor* Kelly Marshall *Payroll* Paulette Fine *Script Supervisor* Anna Maria Quintana *Production Coordinator* Vickie Alper *Location Manager* Michael Neale *Camera Operators* Robert Thomas, Albert Bettcher, Dick Colean *Assistant Cameramen* Mike Genne, Steve Smith *Second Assistant Cameraman* George D. Greer *Sound* Pinewood Studios, Twickenham Studios *Production Mixer* Bud Alper *Boom Operator* Eugene Byron Ashbrook *Cable Man* Beau Baker *Chief Dubbing Mixers* Gordon K. McCallum (*Pinewood Studios*), Gerry Humphries (*Twickenham Studios*) *Dubbing Mixers* Nicholas Le Messurier, Graham V. Hartstone *Sound Effects Editor* Peter Pennell *Assistant Sound Effects Editor* Joe Gallagher *Dialogue Replacement Editor* Michael Hopkins *Assistant Dialogue Replacement Editor* Peter Baldock *Set Decorators* Linda DeSenna, Tom Roysden, Leslie Frankenheimer *Lead Man* Michael Taylor *Production Illustrators* Sherman Labby, Mentor Huebner, Tom Southwell *Assistant Art Director* Stephen Dane *Set Designers* Tom Duffield, Bill Skinner, Greg Pickrell, Charles Breen, Louis Mann, David Klasson *Property Master* Terry Lewis *Assistant Property Masters* David Quick, Arthur Shippe, Jr., John A. Scott III *Makeup* Marvin G. Westmore *Hairdressing* Shirley L. Padgett *Wardrobe* James Lapidous, Bobby E. Horn, Winnie Brown, Linda A. Matthews *Gaffer* Dick Hart *Best Boy* Joseph W. Cardoz, Jr. *Key Grip* Carey Griffith *Best Boy Grip* Robert E. Winger *Dolly Grips* Donald A. Schmitz, Douglas G. Willas (*Crab Dolly*) *Construction Coordinator* James F. Orendorf *Assistant Construction Coordinator* Alfred J. Litteken *Construction Clerk* James Hale *Painting Coordinator* James T. Woods *Stand-by Painter* Buzz Lombardo *Stunt Coordinator* Gary Combs *Action Prop Supervisor* Mike Fink *Action Prop Consultant* Linda Fleisher *Additional Casting* Marci Liroff *Transportation Captain* Howard Davidson *Transportation Co-Captain* James Sharp *Unit Publicist* Saul Kahan *Still Photographers* Kim Gottlieb, Stephen Vaughan *Assistants to the Producer* Victoria Ewart, Bryan Haynes *Assistant Location Manager* Greg Hamlin *Craft Services* Michael Knutsen *Apprentice Assistant Director* Victoria Rhodes *Assistant Film Editor* William Zabala *British First Assistant Film Editor* Les Healey *Electron Microscope Photographs* David Scharf *Esper Sequence* Filmex & Lodge/Cheesman *Title Design* Anthony Goldschmidt *Titles* Intralink Film Graphic Design *Neon Street Signs* American Neon *Car Customization Supervisor* Gene Winfield *Car Customizer* Len Hokel *Additional Car Customization* Dean Jefferies *"Harps of the Ancient Temples" Writer-Performer* Gail Laughton *Courtesy of* Laurel Records *Additional Dressing Props* Modern Props, John Zabrucky *Special Toy Props* Lennie Marvin Collection *Visual Effects* Entertainment Effects Group *Visual Effects Unit — Supervisors* Douglas Trumbull, Richard Yuricich, David Dryer *Cinematographer* Dave Stewart *Additional Cinematography* James R. Dickson *Optical Cinematography* Robert Hall *Camera Operators* Don Baker, Rupert Benson, Glen Campbell, Charles Cowles, David Hardberger, Ronald Longo, Timothy McHugh,

Jon Seay *Matte Artist* Matthew Yuricich *Additional Matte Artist* Rocco Gioffre *Assistant Matte Artist* Michelle Moen *Matte Cinematography* Robert Bailey, Tama Takahashi, Don Jarel *Special Camera Technician* Alan Harding *Optical Line-up* Philip Barberio, Richard Ripple *Animation and Graphics* John Wash *Illustrator* Tom Cranham *Special Projects Consultant and Miniature Coordinator* Wayne Smith *Miniature Technician* Robert Spurlock *Assistant Editor* Michael Backauskas *Chief Miniaturist* Mark Stetson *Miniaturists* Jerry Allen, Sean Casey, Paul Curley, Leslie Ekker, Thomas Field, Vance Frederick, William George, Kristopher Gregg, Robert Johnston, Michael McMillian, Thomas Phak, Christopher Ross, Robert Wilcox, George Trimmer, Rick Guttier-rez, John Vidor *Key Grip* Pat van Auken *Gaffer* Gary Randall *Film Coordinator* Jack Hinkle *Cinetechnician* George Polkinghorne *Still Laboratory Technician* Virgil Mirano *Electronic and Mechanical Design* Evans Wetmore *Electronic Engineering* Greg McMurray *Computer Engineering* Richard Hollander *Special Engineering Consultants* Bud Elam, David Grafton *Office Manager* Joyce Goldberg *Auditor* Diana Gold *Assistant to David Dryer* Leora Glass *Visual Displays* Dream Quest, Inc. *Mechanical Effects Supervisor* Terry Frazee *Mechanical Effects Technicians* Steve Galich, Logan Frazee, William G. Curtis

A Jerry Perenchio–Bud Yorkin Presentation. A Tandem Productions Presentation. A Michael Deeley–Ridley Scott Production. A Blade Runner Productions Picture. Made at The Burbank Studios and on location in Los Angeles and Vernon, California. Copyright 1982 by The Blade Runner Partnership. Panavision 70. Technicolor. Dolby Stereo. 114 minutes. M.P.A.A. Rating: R.

The Players: *Rick Deckard* Harrison Ford *Roy Batty* Rutger Hauer *Rachael* Sean Young *Gaff* Edward James Olmos *Bryant* M. Emmet Walsh *Pris* Daryl Hannah *J.F. Sebastian* William Sanderson *Leon* Brion James *Tyrell* Joe Turkel *Zhora* Joanna Cassidy *Chew* James Hong *Holden* Morgan Paull *Bear* Kevin Thompson *Kaiser* John Edward Allen *Taffey Lewis* Hy Pyke *Cambodian Lady* Kimiro Hiroshige *Saleswoman* Carolyn DeMirjian *Sushi Master* Robert Okazaki *First Bartender* Charles Knapp *Second Bartender* Leo Gorcey, Jr. *Third Bartender* Thomas Hutchinson *Show Girl* Kelly Hine *First Barfly* Sharon Hesky *Second Barfly* Rose Mascari *First Geisha* Susan Rhee *Second Geisha* Hiroko Kimuri *First Chinese Man* Kai Wong *Second Chinese Man* Kit Wong *First Policeman* Hiro Okazaki *Second Policeman* Steve Pope *Third Policeman* Robert Reiter *Stunts* Ray Bickel, Janet Brady, Diane Carter, Ann Chatterton, Gilbert Combs, Anthony Cox, Rita Egleston, Gerry Epper, Jeannie Epper, James Halty, Jeffrey Imada, Gary McLarty, Karen McLarty, Beth Nufer, Roy Ogata Bobby Porter, Lee Pulford, Ruth Redfern, George Sawaya, Charles Tamburro, Jack Tyree, Mike Washlake, Michael Zurich

Additional Oscar Nomination: *Art Direction–Set Decoration* (Lawrence G. Paull, David Snyder, Linda DeScenna)

Note: Working titles were *The Android, Dangerous Days,* and *Gotham City.* Pre-production began under Filmways Pictures, but when the budget grew beyond their intentions they dropped the project in favor of Brian De Palma's *Blow Out.* Tandem Productions and the Ladd Company with outside backing from the Shaw Brothers of Hong Kong stepped in and took over the project. All visual effects sequences, including those incorporating live action, were photographed in Super Panavision 70. This footage was then reduced to 35mm for incorporation with the Panavision principal photography. Release prints in 70mm were produced via blowup of the 35mm CRI, even though some of the production personnel claimed the film was actually shot in 70mm. Dedicated to novelist Philip K. Dick, who died before production began. For whatever reasons, the producers had to pay William S. Burroughs and Alan E. Nourse for the use of the title *Blade Runner.*

E. T. The Extra-Terrestrial
(Universal; June 1982)

Producers Steven Spielberg, Kathleen Kennedy *Associate Producer* Melissa Mathison *Director* Steven Spielberg *Screenplay* Melissa Mathison *Cinematographer* Allen Daviau *Musical Score* John Williams *Film Editor* Carol Littleton *Supervising Sound Effects and Dialogue Replacement Editor* Charles L. Campbell *Production Designer* James D. Bissell *Production Supervisor* Frank Marshall *Production Manager* Wallace Worsley *Assistant Director* Katy Emde *Second Assistant Director* Daniel Attias *Casting* Mike Fenton, Jane Feinberg, Marci Liroff *Set Decorator* Jackie Carr *Second Unit Director* Glenn Randall *Apprentice Assistant Director* John Flynn *Production Coordinator* Sue Dwiggins *Script Supervisor* Esther Vivante *Location Services* Dick Vane *Assistant to Steven Spielberg* Janice Pober *Assistant to Kathleen Kennedy* Denise Durham *Assistant to the Production Supervisor* Patty Rumph *Production Associates* Michael Burmeister, Lance Young *Production Accountant* Bonne Radford *Assistant Accountant* Jane Goe *Cine Guarantors II Representative* Patricia Roedig *Production Completion Bonding* Cine Guarantors II *Camera Operators* John Fleckenstein, John Connor *Assistant Cameraman* Steven Shaw *Second Assistant Cameraman* Richard Fee *Sound Supervisor* Fred Hynes *Sound* Todd-AO *Production Mixer* Gene Cantamessa *Boom Operator* Raul Bruce *Sound Technician* Charles Payne *Scoring Mixer* Lyle Burbridge *Assistant Scoring Mixers* Paul Quan, Dick Horning, Carl Regan, Dave McDonald *Music Recording* Metro-Goldwyn-Mayer Studios *Dubbing Mixers* Robert "Buzz" Knudson, Robert Glass, Don Digirolamo *Gaffer* James Plannette *Best Boy* Joseph Capshaw *Key Grip* Gene Kearney *Best Boy Grip* Bob Munoz *Dolly Grip* Donald Hartley *Construction Coordinator* Ernest Depew *Set Designer* William Teegarden *Production Illustrator* Ed Verreaux *Property Making Foremen* Eero Hautanen, Jack Jennings, John Villarino *Labor*

Foreman Clark Shindel *Paint Foreman* James Moss *Greensman* Leslie Butcher *Lead Woman* Sandra Renfroe *Property Master* Russell Goble *Assistant Property Masters* Ken Walker, Michael Dunn *Wardrobe* Deborah Scott *Wardrobe Assistant* Daniel Moore *Makeup* Robert Sidell *Hairdressing* Lola "Skip" McNalley *Transportation Coordinator* Eugene Schwartz *Transportation Captain* John Feinblatt *Mobile Unit* Producers Location Vehicle *Still Photographer* Bruce McBroom *Security* Location Security Service *Craft Service* Ramon Pahoyo *Paramedic* Phyllis Levin *Studio Teacher* Adria Licklider *Unit Publicist* Lyla Foggia *Animal Suppliers* Dennis Grisco's Animal Talent *Harvey's Owner-Trainer* Richard L. Calkins *Atmosphere Casting* Judi's Casting Service *Assistant Film Editor* Kathleen Korth *Second Assistant Film Editor* Bruce Cannon *Sound Effects Editors* David A. Pettijohn, Louis L. Edemann, Richard C. Franklin, Jr., Samuel C. Crutcher *Dialogue Replacement Recording* Norman B. Schwartz, lipSSync Inc. *Dialogue Replacement Editors* Hank Salerno, Nicholas Korda *Assistant Sound Effects and Dialogue Replacement Editor* Chuck Neely *Foley Editors* John Roesch, Joan Rowe *E.T.'s Voice Design* Ben Burtt *Music Editor* Kenneth Hall *Orchestration* Herbert W. Spencer *Additional Music "Willie"* Jenifer Smith *Performed by* Jenifer Smith, Peter Meisner, Joe Scrima, Bob Parr *"Papa Oom Mow Mow" Performed by* The Persuasions *Published by* Beechwood Music *Courtesy of* Elecktra Records *"Accidents Will Happen"* Elvis Costello *Courtesy of* Plangent Visions Music Inc. *"People Who Died" Composer and Performer* Jim Carroll *Courtesy of* Earl McGrath Music *Excerpts from "Peter Pan" Courtesy of* Hospital for Sick Children, London *"Sesame Street" Segments Courtesy of* Children's Television Workshop *Respirator Helmets* Racal Airstream Inc. *Production Cooperation* American Hi-Lift, Beckman Instruments Inc., Dynatech Laboratories Inc., Everything Bicycles, Fieldtec Inc., Gould Inc., Hershey Chocolate Company, ILC Dover, Ivac Corporation, The North Face, Perkin-Elmer Inc., Fiker International, Quantel Business Computers, Stanford Linear Accelerator Center, Texas Instruments Inc. *Negative Cutters* Donah Bassett, Dennis Brookins *Color Timer* Robert Raring *Titles* Pacific Title & Art Studio *Communicator Design* Henry Feinberg *Communications Systems Designer* Eric Zechandelaar *Medical Consultants* David Carlberg, Robert W. Scholler *Panaflex Cameras and Lenses* Panavision Inc. *Visual Effects* Industrial Light & Magic Inc., *a Division of* Lucasfilm Ltd. *Visual Effects Unit—Supervisor* Dennis Muren *Cinematographer* Mike McAlister *Camera Operators* Robert Elswit, Don Dow *Assistant Cameramen* Pat Sweeney, Karl Herrmann, Selwyn Eddy III *Optical Cinematography* Kenneth F. Smith *Optical Coordinator* Mitchell Suskin *Optical Printer* David Berry *Optical Lineup* Ralph Gordon *Optical Technicians* Duncan Myers, Tim Geideman, Bob Chrisoulis *Go-Motion Technician* Tom St. Amand *Miniature Shop Supervisor* Lorne Peterson *Chief Miniaturists* Charlie Bailey, Mike Fulmer *Miniaturists* Scott Marshall, Ease Owyeung, Mike Cochrane, Suzanne Pastor, Michael Steffe, Jessie Boberg, Randy Ottenberg *Space Ship Design* Ralph McQuarrie *Supervising Matte Artist* Michael Pangrazio *Matte Artists* Chris Evans, Frank Ordaz *Matte Cinematography* Neil Krepela *Assistant Matte Cameraman* Craig Barron

Supervising Editor Conrad Buff *Editor* Howard Stein *General Manager* Tom Smith *Production Coordinators* Warren Franklin, Laurie Vermont *Supervising Animator* Samuel Comstock *Animators* Peggy Tonkonogy, Garry Waller, Terry Windell, Jack Mongovan *Still Photographer* Terry Chostner *Still Laboratory Technicians* Roberto McGrath, Kerry Nordquist *Key Grip* T.E. Moehnke *Grips* Dave Childers, Harold Cole, Dick Dova, Bobby Finley III, Patrick Fitzsimmons, Edward Hirsh, John McCleod, Thaine Morris, Peter Stolz *Production Accountant* Laura Kaysen *Equipment Maintenance* Wade Childress, Michael Smith *Electronic Systems Designer* Jerry Jeffress *Miniature Electronics* Gary Leo, Marty Brenneis *Optical Printer Engineering* Gene Whiteman, John Ellis *Additional Visual Effects* Dream Quest Inc. *Mechanical Effects Coordinator* Dale Martin *Mechanical Effects Assistants* Gary Crawford, Andrew Miller, Robert Worthington *E.T. Mechanical Creators* Carlo Rambaldi, Isidoro Raponi *E.T. Technical Supervisor* Steve Townsend *Additional E.T. Effects* Robert Short *Special E.T. Artistic Consultant* Craig Reardon *E.T. Eye Designer* Beverly Hoffman *E.T. Eye Makers* Ocular Prosthetics *E.T. Movement Coordinator* Caprice Rothe *E.T. Operators* Robert Avila, Eugene Crum, Frank Schepler, Bob Townsend, Steve Willis, Richard Zarro, Ronald Zarro

A Steven Spielberg Film. Made at Laird International Studios and Industrial Light & Magic and on location in Crescent City, Culver City, Northridge, and Tunguna, California. Copyright 1982 by Universal City Studios Inc. 70mm. Spherical Panavision. Color by De Luxe. Prints by Technicolor. Dolby Stereo. 115 minutes. M.P.A.A. Rating: PG.

The Players: *Mary* Dee Wallace *Keys* Peter Coyote *Elliott* Henry Thomas *Gertie* Drew Barrymore *Greg* K.C. Martel *Steve* Sean Frye *Tyler* Tom Howell *Pretty Girl* Erika Eleniak *School Boy* David O'Dell *Science Teacher* Richard Swinger *Policeman* Frank Toth *Ultra Sound Technician* Robert Barton *Van Man* Michael Darrell *Doctor* James Kahn *Dog* Harvey *E.T.* Michael (Pat) Bilon, Tamara De Treaux, Matthew De Meritt, Tina Palmer, Nancy MacLean, Pam Ybarra, Caprice Rothe *E.T. Voice Characterization* Pat Walsh, Howie Hammerman, Debra Winger *Medical Unit* Dr. David Berkson, Dr. David Carlberg, Dr. Milt Kogan, Dr. Alexander Lampone, Dr. Rhoda Makoff, Dr. Robert Murphy, Dr. Richard Pesavento, Dr. Tom Sherry, Will Fowler, Jr., Barbara Hartnett, Di Ann Lampone, Mary Stein, Mitchell Suskin, Susan Cameron *Stuntmen* Glenn Randall, Richard Butler, Bennie Dobbins, Ted Grossman, Keith Harvey, Fred Lerner, Bobby Porter, Felix Silla, Chuck Waters, Allan Wyatt

Additional Oscar Nominations: *Picture* (Universal, Steven Spielberg, Kathleen Kennedy); *Direction* (Steven Spielberg); *Original Screenplay* (Melissa Mathison)*; *Cinematography* (Allen Daviau); *Film Editing* (Carol Littleton); *Music—Original Score* (John Williams)*; *Sound* (Robert Knudson, Robert

Glass, Don Digirolamo, Gene Cantamessa)*; *Sound Effects Editing* (Charles L. Campbell, Ben Burtt)*

Note: A sequel of sorts to *Close Encounters of the Third Kind* and intended as a Columbia Pictures project but rejected by that studio. Working titles were *Close Encounters II, Growing Up, After School, A Boy's Life, Night Skies* (while a Columbia project, written by John Sayles—some of whose material appears in the final script—and to be directed, first by him, then by Ron Cobb, then by Spielberg, with special makeup effects by Rick Baker and Doug Beswick), and *E.T. and Me.* The title *E.T. The Extra-Terrestrial in His Adventure on Earth* appeared on all the original advertising and on the paperback novelization. It was shortened prior to opening. Shot flat and blown up to 70mm. Sequence with Harrison Ford as the school principal was edited out before release.

Poltergeist

(MGM/UA: May 1982)

Producers Steven Spielberg, Frank Marshall *Associate Producer* Kathleen Kennedy *Director* Tobe Hooper *Screenplay* Steven Spielberg, Michael Grais, Mark Victor *Story* Steven Spielberg *Cinematographer* Matthew F. Leonetti *Music* Jerry Goldsmith *Film Editor* Michael Kahn *Supervising Sound Effects and Dialogue Replacement Editors* Steven Hunter Flick, Richard L. Anderson *Sound* Goldwyn Sound Facilities *Production Mixer* Arthur Rochester *Scoring Mixer* Lyle Burbridge *Music Recording* Metro-Goldwyn-Mayer Studios *Dubbing Mixers* Kevin O'Connell, Bill Varney, Steve Maslow *Production Designer* James H. Spencer *Production Manager* Dennis E. Jones *Assistant Director* Pat Kehoe *Second Assistant Director* Bob Roe *Special Makeup Effects* Craig Reardon, Mike McCracken, James Burns *Set Decorator* Cheryl Kearney *Set Designers* Bob Matthews, Martha Johnson *Costume Supervisor* Anne Gray Lambert *Property Master* Craig Raiche *Special Property Maker* Annette Little *Sound Effects Editors* Mark Mangini, John Chih Acho Dunn *Special Sound Effects* Alan Howarth *Dialogue Replacement Editors* Bonnie Koehler, Warren Hamilton, Jr. *Foley Editors* John Roesch, Joan Rowe *Casting* Michael Fenton, Jane Feinberg, Marci Liroff *Transportation Coordinator* Gary Hellerstein *Production Secretary* Barbara Webb *Lead Man* Craig Lynch *Camera Operator* Dennis Matsuda *Script Supervisor* Marion Tumen *Boom Operator* Richard Thornton *Assistant to Steven Spielberg* Janice Pober *Assistant to the Director* Daphne Stacy *Assistant to Kathleen Kennedy* Denise Durham *Production Associate* Christopher Reynolds *Furniture* Grand Tree Furniture Rental and Sales *Associate Film Editor* Ric Fields *Assistant Film Editors* Mel Friedman, Howard Coleman *Gaffer* Pat Blymer *Best Boy* Hugo Cortina *Key Grip* John Linder *Dolly Grip* Martin Averill *Makeup* Dorothy Pearle *Hairdressing* Tony Walker *Negative Cutter* Brian Ralph *Color Timer* Robert McMillan *Stunt Coordinator* Glenn H. Randall, Jr. *Location Manager*

Paul Pav *Assistant Cameraman* John Leonetti *Second Assistant Cameraman* Tom Klines *Music Editor* Kenneth Hall *Orchestration* Arthur Morton *Titles* MGM *Ultracam 35 Cameras and Equipment* Leonetti Cine Rentals *Anamorphics* Joe Dunton Cameras Ltd. *Still Photographer* Bruce McBroom *Construction Coordinator* Michael A. Muscarella *Production Illustrators* Ed Verreaux, Dick Lasley *Wardrobe* Buffy Snyder, Charles DeMeth *Craft Services* Gerald Moore *Rip's Owner-Trainer* Richard L. Calkins *Unit Publicist* Donald Levy *Music Supervisor* Harry V. Lojewsky *Visual Effects* Industrial Light & Magic Inc. *a Division of* LucasFilm Ltd. *Visual Effects Unit — Supervisor* Richard Edlund *Coordinator* Mitchell Suskin *Optical Cinematography* Bruce Nicholson *Supervising Editor* Conrad Buff *Miniature Shop Supervisor* Lorne Peterson *Chief Miniaturist* Paul Huston *Art Director* Nilo Rodis-Jamero *Supervising Matte Artist* Michael Pangrazio *Cinematographers* Rick Fichter, Bill Neil *Production Supervisor* Tom Smith *Production Coordinator* Laurie Vermont *Matte Artists* Chris Evans, Frank Ordaz *Matte Cinematography* Neil Krepela *Additional Matte Cinematography* Michael Shannon *Animation Supervisor* John Bruno *Technical Animation Supervisor* Samuel Comstock *Animation Camera Supervisor* James C. Keefer *Animation Layout* Terry Windell *Laser and Cloud Effects* Gary Platek *Editor* Peter Amundson *Assistant Cameramen* Robert Hill, Peter Romano, Kim Marks, Garry Waller *Second Assistant Cameraman* Ray Gilberti *Additional Scenes Cinematographer* Jim Veilleux *Optical Printers* Donald Clark, James Lim, Mark Vargo *Optical Lineup* Ed L. Jones, Ralph Gordon, Tom Rosseter *Optical Technicians* Tim Geideman, Duncan Myers, Bob Chrisoulis *Miniaturists* Ease Owyeung, Barbara Gallucci, Larry Tan, Sean Casey, Toby Heindel, Jeff Mann, Marghi McMahon, Marc Thorpe, Scott Marshall, Charles Bailey, David Sosalla *Assistant Matte Cameraman* Craig Barron *Still Photographers* Terry Chostner, Roberto McGrath, Kerry Nordquist *Key Grip* Ted Moehnke *Grip Foreman* Patrick Fitzsimmons *Grips* Harold Cole, Rocky Paulson, Dick Dova, Bobby Finley III, Edward Hirsh, John McCleod, Peter Stolz, Thaine Morris, Dave Childers *Production Procurers* Ed Breed, Paula Karsh *Special Wardrobe* Lisa Jean Moore *Assistant Animation Supervisor* Renee Holt *Chief Animator* Art Villeto *Animators* Jose Abel, Milton Gray *Associate Animator* Noel Gray *Chief Assistant Animator* Michael Lessa *Assistant Animators* Jack Mongovan, Rob La Duca, Scott Caple, Ellen Lichtwardt *Matte Animation* Katherine Leighman, Kimberly Knowlton, Jan Davis, Judy Elkins *Administrative Supervisor* Chrissie England *Production Secretaries* Mary Lou Hale, Kathy Shine *Production Accountant* Laura Kaysen *Electronic Systems Designer* Jerry Jeffress *Electronic Systems Software* Kris Brown *Electronic Coordinator* Cristi McCarthy *Electronic Engineers* Mike Mackenzie, Marty Brenneis, Gary Leo *Electronic Technicians* Melissa Cargill, Bessie Wiley *Design Engineer* Michael Bolles *Draftsman* Ed Tennler *Equipment Engineering Supervisor* Gene Whiteman *Machinists* Udo Pampel, Conrad Bonderson *Apprentice Machinists* David Hanks, Chris Rand *Equipment Maintenance* Wade Childress, Michael Smith — *Mechanical Effects Supervisor* Michael Wood *Mechanical Effects Foreman* Jeff Jarvis *Mechanical Effects Technician* Jon G. Belyeu

A Steven Spielberg Production. A Tobe Hooper Film. A Metro-Goldwyn-Mayer Picture. A SLM Entertainment Enterprise. Made at MGM Studios and Industrial Light & Magic and on location in Simi Valley, California. Copyright 1982 by Metro-Goldwyn-Mayer Film Company and SLM Entertainment Ltd. 70mm. JDC Scope. Metrocolor. Dolby Stereo. 114 minutes. M.P.A.A. Rating: PG.

The Players: *Diane Freeling* Jobeth Williams *Steve Freeling* Craig T. Nelson *Dr. Lesh* Beatrice Straight *Dana Freeling* Dominique Dunn *Robbie Freeling* Oliver Robins *Carol Anne Freeling* Heather O'Rourke *Dr. Tangina* Zelda Rubinstein *Marty* Martin Casella *Ryan* Richard Lawson *Ben Tuthill* Michael McManus *Mrs. Tuthill* Virginia Kiser *Teague* James Karen *Bulldozer Operator* Clair Leucart *Woman Buyer* Helen Baron *Jeff Shaw* Dirk Blocker *Neighbors* Joseph R. Walsh, Allan Graf *Pugsley* Lou Perry *Husband* Noel Conlon *First Pool Worker* Robert Broyles *Second Pool Worker* Sonny Landham *Implosion Men* Jeffrey Bannister, William Bail, Greg Simmons *NBC-TV Sports Announcer* Phil Stone *Special Children* Dana Gendlan, James Gendlan *Female Ghost Special Wire Performance* Paula Kennedy Paulson *Stunts* Felix Silla, Chuck Waters, Bobbie Clark, Jeannie Epper, Cindy Folkerson, Beth Nufer, Donna Garrett, Bob Yerkes, Bobbie Herron *Dog* Rip

Additional Oscar Nominations: *Music — Original Score* (Jerry Goldsmith); *Sound Effects Editing* (Steven H. Flick, Richard L. Anderson)

Note: This bears some resemblance to the CBS telefeature *Something Evil* (Belford Productions, 1972), which was written by Robert Clouse and directed by Steven Spielberg. Visual effects filmed in VistaVision and converted to *Super*Scope 235 to match the anamorphic principal photography and blown up to 70mm. Sequel was *Poltergeist II* (MGM/UA Entertainment Co., 1986).

1983

Special Achievement Awards

Special Visual Effects Return of the Jedi
(Lucasfilm Ltd. production
20th Century-Fox)
Richard Edlund, Dennis Muren,
Ken Ralston, Phil Tippett
Scientific and Engineering Award Jonathan Erland
and Roger Dorney of Apogee Inc.
For the engineering and development of a reverse blue screen
traveling matte process for special effects photography
Technical Achievement Awards Elizabeth D. De La
Mare of De La Mare Engineering Inc.
For the progressive development and continuous research of
special effects pyrotechnics originally designed by Glenn W.
De La Mare for motion picture production
Douglas Fries, John Lacey
and Michael Sicrist
For the design and engineering of a 35mm reflex conversion
camera system for special effects photography

Comments

With *Return of the Jedi*, known as *Revenge of the Jedi* until just before
opening, Lucasfilm brought the middle trilogy of the purposed nine-part *Star
Wars* Saga to a most satisfying close. This was grand filmmaking at its best
and more than deserving of a Special Achievement Award for its trick work.
It was surprising that it did not also win for Sound and Sound Effects
Editing, for its audio track, when heard in full stereophonic surround, was
loud and overloaded with movement matching the busy screen action to a
tee. The main characters had matured very noticeably since their introduc-
tion in *Star Wars (A New Hope)*, and while there was some sadness at the death
of two characters, the story ended with a pleasing curtain call by all. The
audience had aged also, but this did not keep the film from becoming the
third-highest grossing feature yet released. While the title of the next entry
has not been announced, it will supposedly be the first installment in the
long-running series. Whatever the next tale is, it will be hard put to top

the spectacle of this one. There were expansive space vistas of literally hundreds of craft in action. (Some of the models were so small that chewing gum was used to represent flying ships.) The land battles incorporated perfectly matted-in-miniature machinery with full scale pyrotechnical effects. The stop-motion animation brought to terrifying life the stalking AT-ST tanks of the Empire. The high speed use of Steadicam photography and Industrial Light & Magic Inc.'s extraordinary employment of blue screen and models brought the speeder bike chase sequence to heart-pounding life. One scene that will surely be considered a hallmark in stop-motion work in coming years was in fact achieved not by that process but by puppetry: the Rancor Pit battle. This scene, while making the best use possible of its model monster, was marred by some rather poor traveling matte processing and was one of only two truly faulty aspects of the show. (The other problem was the too-cute overuse of huge puppets, all well crafted and operated, in Jabba the Hutt's domain. The alien creatures seemed too much like lovable Muppets to be a real threat to the story's heroes.) While the other *Star Wars* features had employed intricate effects shots, they had not used the moving camera within such scenes to the degree here. One shot tilted down from the sky into the forest to show a landing spacecraft and a moving AT-ST. This scene used literally every type of photographic trick: matte painting, stop motion, motion control, miniaturization, traveling matte, cartoon animation, etc. It alone was worth the price of admission. *Return of the Jedi* was a treat!

Credits

Return of the Jedi
(20th Century–Fox; May 25, 1983)

Executive Producer George Lucas *Producer* Howard Kazanjian *Co-Producers* Robert Watts, James Bloom *Director* Richard Marquand *Second Unit Directors* David Tomblin, George Lucas *Screenplay* Lawrence Kasden, George Lucas *Story* George Lucas *Cinematographer* Alan Hume *Music* John Williams *conducting* the London Symphony Orchestra *Film Editors* Sean Barton, Marcia Lucas, Duwayne Dunham *Costume Designers* Agnes Guerard Rodgers, Nilo Rodis-Jamero *Makeup Design* Phil Tippett, Stuart Freeborn *Sound Designer and Supervising Sound Effects and Dialogue Replacement Editor* Ben Burtt *Assistant Director* David Tomblin *Casting* Mary Selway Buckley *Location Cinematographer* Jim Glennon *Second Unit Cinematographer* Jack Lowin *Production Mixers* Tony Dawe, Randy Thom *Supervising Music Editor* Kenneth Wannberg *Music Mixer* Eric Tomlinson *Orchestration* Herbert W. Spencer *Production Designer* Norman Reynolds *Production Supervisor* Douglas Twiddy *Production Executive* Robert

Latham Brown *Production Manager* Miki Herman *Assistant Production Manager* Patricia Carr *Associate to the Producer* Louis G. Friedman *Conceptual Artist* Ralph McQuarrie *Art Directors* Fred Hole, James Schoppe *Set Decorators* Michael Ford, Harry Lange *Property Master* Peter Hancock *Chief Hairdresser* Patricia McDermott *Stunt Coordinator* Glenn Randall *Stunt Arranger* Peter Diamond *Production Controller* Arthur Carroll *Production Accountants* Margaret Mitchell, Colin Hurren *Second Assistant Directors* Roy Button, Michael Steele, Chris Newman, Russell Lodge, Eric Jewett *Production Assistant* Ian Bryce *Production Coordinator* Lata Ryan *Assistant Production Coordinators* Sunni Kerwin, Gail Samuelson *Script Supervisor* Pamela Mann Francis *Location Script Supervisor* Bob Forrest *Location Casting* Dave Eman, Bill Lytle *Assistant to the Producer* Kathleen Hartney Ross *Assistant to James Bloom* John Syrjamaki *Assistant to the Executive Producer* Jane Bay *Assistant Art Directors* Michael Lamont, John Fenner, Richard Dawking *Set Dresser* Doug von Koss *Construction Manager* Bill Welch *Assistant Construction Manager* Alan Booth *Construction Supervisor* Roger Irvin *General Construction Foreman* Bill Iiams *Construction Foremen* Greg Callas, Guy Clause, Doug Elliott, Stan Wakashige *Paint Foreman* Gary Clark *Production Illustrator* Roy Carnon *Scenic Artist* Ted Michell *Decor and Lettering Artist* Bob Walker *Set Designers* Reg Bream, Mark Billerman, Chris Campbell *Production Buyer* David Lusby *Construction Storeman* David Middleton *Camera Operators* Alec Mills, Thomas Laughridge, Michael Benson, Leo Napolitano *Additional Camera Operators* Steve Yaconelli, Jack Green, Rick Fichter, Scott Farrar *Assistant Cameramen* Michael Frift, Chris Tanner, Bob La Bonge *Second Assistant Cameramen* Simon Hume, Steve Tate, Martin Kenzie, Michael Glennon *Gaffers* Mike Pantages, Bob Bremmer *Rigging Gaffers* Clark Garland, Tommy Brown *Electrical Contractors* Lee Electric (Lighting) Ltd. *Key Grip* Dick Dova Spah *Best Boy Grip* Joe Crowley *Dolly Grips* Chunky Huse, Reg Hall *Supervising Set Operations Grip* Eddie Burke *Supervising Rigger* Red Lawrence *Aerial Cinematographers* Ron Goodman, Margaret Herron *Camera Helicopter Pilot* Mark Wolfe *Chief Makeup Artists* Tom Smith, Graham Freeborn *Makeup Artists* Peter Robb-King, Dickie Mills, Kay Freeborn, Nick Dudman, S. Bide, Stella Morris *Hairdressers* Mike Lockey, Paul Le Blanc *Costume Supervisor* Mary Elizabeth Still *Costume Shop Manager* Jenny Green *Jeweler* Richard Miller *Wardrobe Supervisor* Ron Beck *Wardrobe Mistress* Janet Tebrooke *Alien Wardrobe Mistresses* Barbara Kassal, Edwina Pellikka, Anne Polland, Elvira Angelinetta *Assistant Property Master* Charles Torbett *Property Supervisors* Dan Coangelo, Brian Lofthouse *Property Men* Holly Walker, Ivan van Perre *Property Makers* Bill Hargreaves, Richard Peters *Master Carpenter* Bert Long *Master Plasterer* Kenny Clarke *Master Painter* Eric Shirtcliffe *Sail Coordinators* Bill Kreysler, Warwick Tompkins *Sail Engineers* Derrick Baylis, Peggy Kashuba *Assistant Film Editors* Steve Starkey, Conrad Buff, Phil Sanderson, Nick Hosker, Debra McDermott, Clive Hartley *Sound Effects Editors* Richard Burrow, Teresa Eckton, Ken Fischer *Dialogue Replacement Editors* Laurel Ladevich, Curt Schulkey, Bonnie Koehler, Victoria Rose Sampson *Assistant Sound Effects and Dialogue Replacement Editors* Chris Weir,

Bill Mann, Gloria Borders, Suzanne Fox, Kathy Ryan, Nancy Jencks *Dubbing Mixers* Ben Burtt, Gary Summers, Roger Savage, Randy Thom *Dubbing Engineer* Tomlinson Holman *Boom Operators* David Batchelor, David Parker *Recorders* Shep Dawe, Jim Manson *Post Production Audio Engineers* T.M. Christopher, Catherine Coombs, Kris Handwerk, K.C. Hodenfield, Howie Hammerman, Tom Johnson, Brian Kelly, James Kessler, Susan Leahy, Robert Marty, Scott Robinson, Dennie Thorpe, John Watson *English Lyrics* Joseph Williams *Huttese Lyrics* Annie Arbogast *Ewokese Lyrics* Ben Burtt *Choreographer* Gillian Gregory *Location Choreographer* Wendy Rogers *Assistant Production Accountants* Sheala Daniell, Barbara Harley *Location Accountants* Diane Dankwardt, Dick Wright, Pinki Ragan *Transportation Coordinator* Gene Schwartz *Transportation Captains* John Feinblatt, H. Lee Noblitt *Studio Transportation Managers* Vic Minay, Mark La Bonge *Location Contact* Lennie Fike *Still Photographers* Albert Clarke, Ralph Nelson, Jr., Frank Connor *Unit Publicist* Gordon Arnell *Assistant Publicist* June Broom *Research* Deborah Fine *Greensmen* Fern Bros. *Financial Controller* Ron Hein *Chief Executive* Robert Greber *Paramedic* Sue Clarkson *Dialogue Replacement Recording* Mayflower Film Recording Ltd., Goldwyn Sound Facility *Music Recording* Anvil-Abbey Road Studio *Re-Recording* Sprocket Systems *a Division of* Lucasfilm Ltd. *Location Caterers* Michaelson's *Shipping Company* Renow Freight Ltd. *Negative Cutting* Sunrise Film Inc. *Negative Cutter* Bob Hart *Color Timers* Jim Schurmann, Bob Hagans *Marketing and Publicity Executive* Sidney Ganis *Marketing and Publicity Assistant* Susan Trembly *Merchandising Executive* Maggie Young *Film Librarians* Barbara Lakin, Kathy Wippert *Arriflex Cameras and JDC Anamorphic Lenses* Joe Dunton Cameras Ltd. *Production Cooperation* U.S. Department of Interior, Bureau of Land Management and National Park Service *Aerial Camera Systems* Wesscam Camera Systems (Europe) *Production Vehicles* GMC Truck, Oldsmobile *Mobile Unit* Cinemobile Systems Inc. *Air Transportation* Pan American Airlines *Visual Effects* Industrial Light & Magic Inc. *a Division of* Lucasfilm Ltd. *Visual Effects Unit—Supervisors* Richard Edlund, Dennis Muren, Ken Ralston *Matte Cinematography Consultant* Stanley Sayer *Art Directors* Joe Johnston, Nilo Rodis-Jamero *Optical Cinematographer* Bruce Nicholson *General Manager* Tom Smith *Production Supervisor* Patricia Rose Duignan *Supervising Matte Artist* Michael Pangrazio *Miniature Shop Supervisors* Lorne Peterson, Steve Gawley *Animation Supervisor* James Keefer *Supervising Editor* Arthur Repola *Camera Operators* Don Dow, Michael J. McAlister, Bill Neil, Scott Farrar, Selwyn Eddy III, Michael Owens, Robert Elswit, Rick Fichter, Stewart Barbee, Mark Gredell, David Hardburger *Assistant Camera Operators* Pat Sweeney, Kim Marks, Robert Hill, Ray Gilberti, Randy Johnson, Patrick McArdle, Peter Daulton, Bessie Wiley, Maryan Evans, Toby Heindel, David Fincher, Peter Romano *Production Coordinators* Warren Franklin, Laurie Vermont *Optical Printers* John Ellis, David Berry, Kenneth Smith, Donald Clark, Mark Vargo, James Lim *Optical Lineup* Tom Rosseter, Ed L. Jones, Ralph Gordon, Philip Barberio *Laboratory Technicians* Tim Geideman, Duncan Myers,

Michael S. Moore *Assistant Art Director* Dave Carson *Illustrator* George Jenson *Matte Artists* Chris Evans, Frank Ordaz *Matte Cinematography* Neil Krepela, Craig Barron *Stop Motion Animation* Tom St. Amand *Chief Miniaturists* Paul Huston, Charles Bailey, Michael Glenn Fulmer, Ease Owyeung *Miniaturists* William George, Marc Thorpe, Scott Marshall, Sean Casey, Larry Tan, Barbara Gallucci, Jeff Mann, Ira Keeler, Bill Beck, Mike Cochrane, Barbara Affonso, Bill Buttfield, Marghi McMahon, Randy Ottenberg, Chuck Wiley, Toby Heindel, Richard Davis *Chief Animators* Garry Waller, Kimberly Knowlton *Animators* Terry Windell, Renee Holt, Mike Lessa, Samuel Comstock, Rob La Duca, Annick Therrien, Suki Stern, Margot Pipkin *Editors* Howard Stein, Peter Amundson, Bill Kimberlin *Assistant Editors* Robert Chrisoulis, Michael Gleason, Jay Ignaszewski, Joe Class *Additional Animation Supervisor* Peter Kuran *Additional Optical Supervisor* Greg van der Veer *Key Grip* Ted Moehnke *Grip Foreman* Patrick Fitzsimmons *Grips* Bob Finley III, Ed Hirsh, John McCleod, Peter Stolz, Dave Childers, Harold Cole, Merlin Ohm, Joe Fulmer, Lance Brackett *Pyrotechnical Effects* Thaine Morris, Dave Pier, Peter Stolz *Still Photography Supervisor* Terry Chostner *Still Photographers* Roberto McGrath, Kerry Nordquist *Electronic System Designers* Jerry Jeffress, Kris Brown *Electronic Engineers* Mike MacKenzie, Marty Brenneis *Computer Graphics* William Reeves, Tom Duff *Equipment Engineering Supervisor* Gene Whiteman *Machinists* Udo Pampel, Conrad Bonderson *Apprentice Machinists* David Hanks, Chris Rand *Design Engineers* Mike Bolles, Ed Tennler *Equipment Maintenance* Wade Childress, Michael J. White, Cristi McCarthy, Ed Tennler *Administration* Chrissie England, Laura Kaysen, Paula Karsh, Karen Ayers, Sonja Paulsen, Karen Dube *Production Assistants* Susan Fritz-Monahan, Kathy Shine *Steadicam Plate Cinematography* Garrett Brown *Ultra High Speed Cinematography* Bruce Hill Productions *Additional Optical Effects* Lookout Montain Films, Pacific Title & Art Studio, Monaco Film Labs, California Film, Visual Concepts Engineering, Movie Magic, Van der Veer Photo Effects. *Mechanical Effects Staff — Supervisors* Kit West, Roy Arbogast *Foreman* William David Lee *Floor Controller* Ian Wingrove *Chief Technician* Peter Dawson *Technicians* John Baker, Joe Fitt, G. Clifford, David Beavis *Location Technicians* David Simmons, Gary Zink, Eddie Surkin, John Stirber, Bruno von Zeebroeck, John Chapot, William Klinger, Jr., Kevin Pike, Donald Chandler, Michael Wood *Chief Electronics Technician* Ron Hone *Wire Flying Technician* Bob Harman *Wire Flying Assistant* S. Miles *Creature Designers* Phil Tippett, Stuart Freeborn *Articulation Engineer* Stuart Ziff *Assistant Articulation Engineer* Eben Stromquist *Armature Designer* Peter Ronzani *Plastic Designer* Richard Davis *Sculptural Designers* Chuck Wiley, James Howard *Chief Sculptors* Dave Carson, Tony McVey, Dave Sosalla, Judy Elkins, Derek Howarth *Chief Moldmaker* Wesley Seeds *Moldmaker* Ron Young *Creature Technicians* Randy Dutra, Kirk Thatcher, Dan Howard, James Isaac, Brian Turner, Jeanne Lauren, Richard Spah, Jr., Ethan Wiley *Creature Consultants* Jon Berg, Chris Walas *Production Creature Coordinator* Patty Blau *Latex Foam Laboratory Supervisor* Tom McLaughlin *Animatronics Engineer*

John Coppinger *Jabba the Hutt Puppeteers* Toby Philpott, Mike Edmonds, David Barclay *Creature Puppeteers* Michael McCormick, Deep Roy, Simon Williamson, Hugh Spirit, Swim Lee, Michael Quinn, Richard Robinson

A Lucasfilm Ltd. Production. A Chapter III Productions Ltd. Picture. Copyright 1983 by Lucasfilm Ltd. Made at EMI-Elstree Studios and Industrial Light & Magic and on location in Buttercup Valley, Death Valley and Smith River, California. 70mm. JDC Scope. Color by Rank, Monaco and De Luxe. Print by De Luxe. Dolby Stereo. 133 minutes. M.P.A.A. Rating: PG.

The Players: *Luke Skywalker* Mark Hamill *Han Solo* Harrison Ford *Princess Leia Organa* Carrie Fisher *Lando Calrissian* Billy Dee Williams *C-3PO* Anthony Daniels *Chewbacca* Peter Mayhew *Anakin Skywalker* Sebastian Shaw *The Emperor* Ian McDiarmid *Yoda* Frank Oz *Lord Darth Vader* David Prowse *Voice Characterization for Lord Darth Vader* James Earl Jones *Ben (Obi-Wan) Kenobi* Alec Guinness *R2-D2 and Paploo* Kenny Baker *Moff Jerjerrod* Michael Pennington *Adm. Piett* Kenneth Colley *Bib Fortuna* Michael Carter *Wedge* Denis Lawson *Adm. Ackbar* Tim Rose *Gen. Madine* Dermot Crowley *Mon Mothma* Caroline Blakiston *Warwick W. Wicket* Warwick Davis *Boba Fett* Jeremy Bulloch *Oola* Femi Taylor *Sy Snootles* Annie Arbogast *Fat Dancer* Claire Davenport *Teebo* Jack Purvis *Logray* Mike Edmonds *Chief Chirpa* Jane Busby *Ewok Warrior Leaders* Malcolm Dixon, Mike Cottrell *Nicki* Nicki Reade *First Stardestoyer Controller* Adam Bareham *Second Stardestroyer Controller* Jonathan Oliver *First Stardestroyer Captain* Pip Miller *Second Stardestroyer Captain* Tom Mannion *Gamorrean Guards* Tony Star, Isaac Grand, Barry Robertson, George Miller *Voice Characterization for Jabba the Hutt* Larry Ward, Ben Burtt *Voice Characterization for EV-9D9* Richard Marquand *Ewoks* Margo Apostocos, Phil Fondacaro, Barbara O'Laughlin, Ray Armstrong, Sal Fondacaro, Brian Orenstein, Eileen Baker, Tony Friel, C. Harrell Parker, Jr., Michael Henbury-Badham, Dan Frishman, John Pedrick, Bobbie Bell, John Gavam, April Perkins, Patty Bell, Michael Gilden, Ronnie Phillips, Alan Bennett, Paul Grant, Katie Purvis, Sarah Bennett, Lydia Green, Carol Read, Pamela Betts, Lars Green, Nicholas Read, Dan Blackner, Pam Grizz, Diana Reynolds, Linda Bowley, Andrew Herd, Daniel Rodgers, Peter Burroughs, J.J. Jackson, Chris Romano, Debbie Carrington, Richard Jones, Dean Shackenford, Maureen Charlton, Trevor Jones, Kiran Shah, William Coppen, Glynn Jones, Felix Silla, Sadie Corrie, Karen Lay, Linda Spriggs, Tony Cox, John Lummiss, Gerald Staddon, John Cumming, Nancy MacLean, Josephine Staddon, Jean D'Agostino, Peter Mandell, Kevin Thompson, Luis de Jesus, Carole Morris, Kendra Wall, Debbie Dixon, Stacy Nichols, Brian Wheeler, Margarita Fernandez, Chris Nunn, Butch Wilhelm *Mimes* Franki Anderson, Ailsa Berk, Sean Crawford, Andy Cunningham, Tim Dry, Graeme Hattrick, Phil Herbert, Gerald Home, Paul Springer *Stuntmen* Bob Anderson, Dirk Yohan Beer, Marc Boyle, Mike

Cassidy, Tracy Eddon, Ted Grossman, Frank Henson, Larry Holt, Bill Horrigan, Alf Joint, Julius Leflore, Colin Skeaping, Malcolm Weaver, Paul Weston, Bob Yerkes, Dan Zormeier *Stuntwoman* Sandra Gross *Mark Hamill's Stand-in* Joe Gibson *Harrison Ford's Stand-in* Jack Dearlove *Carrie Fisher's Stand-in* Erica Simmons *Billy Dee Williams' Stand-in* Quentin Pierre *Anthony Daniels' Stand-in* Alan Harris *Peter Mayhew's Stand-in* Steven Meeks

Additional Oscar Nominations: *Music — Original Score* (John Williams); *Art Direction–Set Decoration* (Norman Reynolds, Fred Hole, James Schoppe, Michael Ford); *Sound* (Ben Burtt, Gary Summers, Randy Thom, Tony Dawe); *Sound Effects Editing* (Ben Burtt)

Note: Working title was *Revenge of the Jedi*. For publicity purposes a false working title, *Blue Harvest — Horror Beyond Imagination*, was used during location photography. Last of the middle trilogy of the *Star Wars* Saga. Principal photography was in 35mm 'scope with trick shots in VistaVision and converted to *Super*Scope 235. Some scenes may have been filmed in Todd-AO 35. The 35mm CRI was blown up to 70mm. Two sequels, *The Ewok Adventure* (November 25, 1984) and *Ewoks The Battle for Endor* (November 24, 1985), were made by LucasFilm for ABC-TV but are not considered part of *the* official *Star Wars* saga.

1984

Visual Effects Nominations

Ghostbusters . Richard Edlund
(Columbia) John Bruno, Mark
 Vargo, Chuck Gaspar
Indiana Jones and the Temple of Doom Dennis Muren
(Lucasfilm; Paramount) Michael McAlister, Lorne
 Peterson, George Gibbs
2010 . Richard Edlund
(Peter Hyams Film Productions, Neil Krepela, George
Metro-Goldwyn-Mayer; Jensen, Mark Stetson
MGM/UA)

Scientific or Technical Awards

Gordon A. Sawyer Award Linwood G. Dunn
For outstanding contributions toward advancement of the
science or technology of motion pictures
Scientific and Engineering Gunther Schaidt and
 Rosco Laboratories Inc.
For the development of an improved, nontoxic fluid for
creating fog and smoke for motion picture production
 Jon Whitney, Jr. and
 Gary Demos of Digital
 Productions Inc.
For the practical simulation of motion picture photography
by means of computer-generated images
Technical Achievement Donald Trumbull, Jonathan
 Erland, Stephen Fog and
 Paul Burk of Apogee Inc.
For design and development of the "Blue Max" high power
blue-flux projector for traveling matte composite photography
 Jonathan Erland and Robert
 Bealmear of Apogee Inc.
For an innovative design for front projection screens and an
improved method for their construction

Comments

The only surprise in this year's nominations was the exclusion of several titles, notably *Star Trek III: The Search for Spock* and *Dune*. Otherwise it was the usual folks standing in line. (This is not a slur on their work, just a notation that is justified by looking over the nominations for the last several years.) It is also of some interest that this year's films included a prequel, a sequel and the first entry in what is promised to be a series. And, of course, all were in 70mm and surround sound, which has become a commercial requirement for super-budgeted effects pictures.

Indiana Jones and the Temple of Doom won. Surely this surprised no one. Certainly not me, and probably not you! It was an extremely good-looking, polished, and exciting production. The 70mm blowup was topnotch; the sound loud and effective. It may have seemed almost claustrophobically staged at times when compared with its sequel, *Raiders of the Lost Ark*, but it delivered the goods as promised on a grand scale. In fact it made its offerings too good. At least one effects shot was removed due to gruesomeness, and in England and elsewhere it lost more footage because censorship boards were shocked by the all-too-real cult scenes. It is credited, justly or otherwise, for causing the Motion Picture Association of America to establish a PG-13 rating; and there seemed to be no end to the various watchdog groups who attacked the violence they claimed it contained. Violent to the point of harm or not, kids (and kids at heart) loved every second of it. The trick work was mostly incredible, especially the matte art and miniatures. Very few noticed the use of stop-motion puppets in the mine car chase or the full-size mechanical dummies on the bridge; and even fewer were aware that the sacrifical victims lowered into the volcano were not actors but articulated models. The effects people did their jobs and well deserved their Oscars.

Ghostbusters came as something of a surprise. It was a huge-budget picture, put together relatively fast, by a producer who had been associated with several popular but considerably less expensive efforts. It was funny, but less so than other efforts from the same creative team, and most definitely not the hilarious masterpiece many accepted it for. But the money spent showed in the effects scenes if not in the rest of the show. There were monsters, including costumed performers, mechanical contrivances, and stop-motion puppets, explosions, mattes galore, miniatures, cel animation, the whole array of trick technologies, and one of the cutest demons ever seen: the Staypuft Man. This funny, fat, living marshmallow was a delight. His demise, necessary because he was a villain after all, was really quite sad — funny, but sad. The special effects were all generally well executed, though some of the mattes seemed out of place, perhaps because the paintings depicting the haunted apartment building didn't quite convince. All in all, a good show, but not the best.

Once upon a time a real stinker of a movie was made called *2001: A Space Odyssey*. It had impressive visual effects and little else. It had no story. It did

have an undeserved reputation for greatness among a certain group of people. But all of that didn't matter, because Arthur C. Clarke, who wrote the original source material and co-scripted the feature, was able to produce a bestselling novel which served as a sequel, *2010: Odyssey Two.* Thank goodness Stanley Kubrick had no interest in doing the film version of that novel. Unfortunately, Peter Hyams did make a movie from it, the abysmal *2010.* (While every other producer seemed intent on attaching a "II" or "III" to their sequels, *2010,* which came with its own *Two* on the novel, was released without such.) To be fair, the miniatures and matte work were excellent, even though the design of the models, supposedly realistic, were laughable. But quality special effects do not a good picture make! There was nothing to recommend this picture. Oh sure, it was much better storywise than *2001,* but that's not saying it was good in any way. Like the first film, it was full of nonsense about intelligent monoliths and afterlife. The box office showed it for the misfire it was. The hippies who liked the first film had turned into yuppies and changed their minds about what was good and bad. The younger viewers, few of whom had ever seen *2001,* expected an exciting, uplifting space fantasy. They got space and they got fantasy. They didn't get uplifting. They got talk, nonsensical motives, talk, good but uninteresting special effects, talk, and nothing to entertain them. *2010* was just plain waste. Waste of time, talent (in some areas such as effects), money, effort.

For the record, I should also like to comment on the fact that *2010* was nominated for a Sound Oscar. Unbelievable! While the music and surround sound was good the dialogue was often incoherent, both in the sense of what was being spoken and in the sense the recording (or mixing) was muddled. And I heard it in a large Cinerama house equipped with a top-drawer audio processing system. The ads boasted "the year we make contact" and "life on Earth will never be the same!" Let's hope the entertainment industry makes no additional contacts like this.

Credits

Ghostbusters
(Columbia Pictures; May 1984)

Executive Producer Bernie Brillstein *Producer and Director* Ivan Reitman *Screenplay* Dan Aykroyd, Harold Ramis *Cinematographer* Laszlo Kovacs *New York Cinematographer* Herb Wagreitch *Production Designer* John De Cuir, Sr. *Film Editors* Sheldon Kahn, David Blewitt *Music* Elmer Bernstein *Associate Producers* Joe Medjuck, Michael C. Gross *Costume Designer* Theoni V. Aldredge *Casting* Karen Rea *New York Casting* Joy Todd *Production Manager* John G. Wilson *New York Unit Production Manager* Patrick McCormick *Assistant Director* Gary Daigler *Second Assistant Director* Katterli Frauenfelder *New*

York Assistant Director Peter Giuliano *New York Second Assistant Directors* John Pepper, Bill Eustace *Camera Operator* Bob Stevens *New York Steadicam Operators* Ted Churchill, Larry McConkey *Assistant Cameraman* Joe Thibo *Second Assistant Cameraman* Paul Mindrup *New York Assistant Cameraman* Vincent Gerardo *New York Second Assistant Cameraman* Patrick Capone *Script Supervisor* Trish Kinney *Art Director* John De Cuir, Jr. *New York Art Director* John Moore *Set Designer* George Eckert *Set Decorator* Marvin March *New York Set Decorator* Robert Drumheller *Property Master* Jack E. Ackerman *New York Property Master* Joseph Carracciola, Jr. *Wardrobe Supervisor* Bruce Erickson *Wardrobe Master* Dayton Anderson *Wardrobe Mistress* Peggy Thorin *New York Wardrobe Supervisors* Lee Austin, Debra Louise Katz *Makeup* Leonard Engelman *New York Makeup* Michael Thomas *Hairdressing* Dione Taylor, Paul LeBlanc *Gaffer* Colin Campbell *Best Boy* Robert Jason *New York Gaffer* Billy Ward *Key Grip* Gene Kearney *Best Boy Grip* Bob Munoz *New York Key Grip* Norman Buck *Construction Coordinator* Don Noble *Standby Painter* Paul Campanella *Transportation Coordinator* James Foote *Transportation Captain* John F. Curtis *New York Transportation Captain* Rocco Derasmo *Location Manager* Paul Pav *New York Location Managers* Lenny Vullo, Jeff Stolow *Production Coordinator* Rita Miller-Grant *Assistant Production Coordinator* Sherry Lynne *New York Production Coordinator* Kate Guinzburg *Apprentice Assistant Director* Patrick McKee *New York Apprentice Assistant Director* Carol Vitkey *Still Photographer* Gemma La Mana-Wills *New York Still Photographer* Michael Ginsberg *Unit Publicist* Nancy Willen *Stunt Coordinator* William Couch *Production Accountant* Kirk Borcherding *Producer-Director's Secretary* Joyce Y. Irby *Associate Producers' Secretary* Kathi Freeman *Hardware Consultants* Steven Dane, John Daveikis *Sound Designers* Richard Beggs, Tom McCarthy, Jr. *Assistant Film Editors* Saul Saladow, Jim Seidelman, Joe Mosca *Sound Effects* Effective Sound Unlimited *Sound Effects Editors* Don S. Walden, William L. Manger, Mike Redbourn, Joseph Holsen, Jim Bullock, John Colwell *Production Mixer* Gene S. Cantamessa *Boom Operator* Raul A. Bruce *Cableman* Jack Wolpa *Dubbing Mixers* Lester Fresholtz, Richard Alexander, Vern Poore *Music Mixer* Robert Fernandez *Orchestration* Peter Bernstein, David Spear *Supervising Music Editor* Kathy Durning *Music Editing* Segue Music *Re-Recording* The Burbank Studios *Main Title Animation* R/Greenberg Associates Inc. *Titles* Pacific Title & Art Studio *Songs* "Ghostbusters" *Writer and Performer* Ray Parker, Jr. "Savin' the Day" *Writers* Bobby Alessi, Dave Immer *Producer* Phil Ramone *Performer* Bobby Alessi "Hot Night" *Writers* Diane Warren, The Doctor *Producers* Jack White, Robbie Buchanan *Performer* Laura Branigan "Disco Inferno" *Writers* Leroy Green, Ron Kersey *Producer* Ron Kersey *Performers* The Trammps "Cleanin' Up the Town" *Writers* Kevin O'Neal, Brian O'Neal *Producers* Kevin O'Neal, Brian O'Neal, John Hug *Performers* The Bus Boys "In the Name of Love" *Writer* T. Bailey *Producer* Steve Lillywhite *Performers* Thompson Twins "I Can Wait Forever" *Writers* Graham Russell, David Foster, Jay Graydon *Producers* David Foster, Jay Graydon *Performers* Air Supply "Magic" *Writer and Performer* Mick Smiley *Producer* Keith Forsey; Laura Branigan *and* The Trammps

Courtesy of Atlantic Recording Corp. *by Arrangement with* Warner Special Products; Ray Parker, Jr., The Bus Boys, Thompson Twins *and* Air Supply *Courtesy of* Arista Records Inc. *Courtesy Credits* Suzy Benzinger, Will Fowler, Amy Friedman, Frank Krenz, Hal Landaker, Joanna Lipari, The Los Angeles Public Library, Peggy Semtob, Don Shay, Chris Stoia *Visual Effects* Entertainment Effects Group *Visual Effects Unit — Supervisor* Richard Edlund *Administrator* Leona Phillips *Art Director* John Bruno *Editor* Conrad Buff *Matte Supervisor* Neil Krepela *Mechanical Effects Supervisor* Thaine Morris *Cinematographer* Bill Neil *Special Projects Director* Gary Platek *Miniature Shop Supervisor* Mark Stetson *Optical Supervisor* Mark Vargo *Animation Supervisors* Garry Waller, Terry Windell *Chief Engineer* Gene Whiteman *Chief Matte Artist* Matthew Yuricich *Ghost Shop Head* Stuart Ziff *Production Adviser* Jim Nelson *Production Supervisor* Richard Kerrigan *Production Coordinator* Laura Buff *Camera Operators* Jim Aupperle, John Lambert *Assistant Cameramen* Pete Romano, Jody Westheimer, Clint Palmer *Still Photographer* Virgil Mirano *Optical Printers* Chuck Cowles, Bruno George, Bob Wilson *Optical Lineup* Phil Barberio, Mary E. Walter, Ronald B. Moore *Stop Motion Animator* Randall William Cook *Animators* Sean Newton, William Recinos, Bruce Woodside, Richard Coleman *Technical Animators* Annick Therrein, Peggy Regan, Sam Recinos, Pete Langton, Les Bernstein, Wendie Fischer *Additional Animation* Available Light Ltd. *Assistant Matte Cameraman* Alan Harding *Matte Artists* Michelle Moen, Constantine Ganakas *Mechanical Effects Technician* Robert Spurlock *Ghost Shop Adviser* Jon Berg *Sculptors* Steve Neill, Mike Hosch *Onion Head/Librarian Sculptor* Steve Johnson *Staypuft Man Sculptors* Linda Frobos, Bill Bryan *Chief Mold Maker* Gunnar Ferdinandsen *Chief Mechanism Designer* Steve Dunham *Mechanism Designers* Don Carner, John Alberti, Nicholas Alberti, Doug Beswick, Lance Anderson *Mechanism Builders* Joe Franke, Kevin Dixon, Tom Culnan, Bill Sturgeon, Larz Anderson *Miniaturists* Gary Bierend, Leslie Ekker, Kent Gebo, Pete Gerard, Bob Hoffman, Pat McClung, Don Pennington, Milius Romyn, Nick Seldon, Paul Skylar *Creature Design Consultants* Brent Boates, Terry Windell, Thom Enriquez, Berni Wrightson, Robert Kline, Kurt W. Conner *Design Engineers* Mike Bolles, Mark West *Electronics Engineers* Jerry Jeffress, Robin Leyden *Softward Programmer* Kris Brown *Production Secretaries* Laurel Walter, Leslie Falkinburg, Mary Mason *Special Optics Designers* David Grafton, Harold Johnson *Projector Manufacturer* George Randle Co. *Mechanical Effects — Supervisor* Chuck Gaspar *Foreman* Joe Day

A Black Rhino–Bernie Brillstein Production. A Columbia–Delphi Productions Picture. An Ivan Reitman Film. Copyright 1984 by Columbia Pictures Industries Inc. Panavision 70. Metrocolor. Dolby Stereo. Made at The Burbank Studios and EEG/BFC Facilities and on location in New York City. 107 minutes. M.P.A.A. Rating: PG.

The Players: *Dr. Peter Venkman* Bill Murray *Dr. Raymond Stantz* Dan Aykroyd *Dana Barrett* Sigourney Weaver *Dr. Egon Spengler* Harold Ramis *Louis Tully*

Rick Moranis *Janine Melnitz* Annie Potts *Walter Peck* William Atherton *Winston Zeddmore* Ernie Hudson *Mayor* David Margulies *Male Student Testee* Steven Tash *Female Studnt Testee* Jennifer Runyon *Gozer* Slavitza Jovan *Hotel Manager* Michael Ensign *Librarian* Alice Drummond *Dean Yeager* Jordan Charney *Violinist* Timothy Carhart *Library Administrator* John Rothman *Archbishop* Tom McDermott *Roger Grimsby* Himself *Larry King* Himself *Joe Franklin* Himself *Casey Kasem* Himself *Fire Commissioner* Norman Matlock *Police Captain* Joe Cirillo *Police Sergeant* Joe Schmieg *Jail Guard* Reggie Vel Johnson *Real Estate Agent* Rhoda Gemignani *Man at Elevator* Murray Rubin *Con Edison Man* Larry Dilg *Coachman* Danny Stone *Woman at Party* Patty Dworkin *Tall Woman at Party* Jean Kasem *Doorman* Lenny Del Genio *Chambermaid* Frances E. Nealy *Hot Dog Vendor* Sam Moses *Television Reporter* Christopher Wynkoop *Businessman in Taxi* Winston May *Mayor's Aide* Tommy Hollis *Louis' Neighbor* Eda Reiss Merin *Policeman at Apartment* Ric Mancini *Mrs. Van Hoffman* Kathryn Janssen *Reporters* Stanley Grover, Carol Ann Henry, James Hardie, Frantz Turner, Nancy Kelly *Ted Fleming* Paul Trafas *Annette Fleming* Cheryl Birchfield *Library Ghost* Ruth Oliver *Dream Ghost* Kym Herrin *Staypuft Man* Bill Bryan *Stuntman* Julius LeFlore

Additional Oscar Nomination: *Original Song* (title song by Ray Parker, Jr.)

Note: Working title was *Ghostsmashers* and was to have starred John Belushi in the Peter Venkman role. Visual effects filmed in 70mm using the BFC camera. The 70mm footage was reduced to 35mm and cut into the Panavision main footage then blown up to 70mm for release printing. A sequel has been announced for production.

Indiana Jones and the Temple of Doom
(Paramount Pictures; May 25, 1984)

Executive Producers George Lucas, Frank Marshall *Producer* Robert Watts *Associate Producer* Kathleen Kennedy *Director* Steven Spielberg *Screenplay* Gloria Katz Huyck, Willard Huyck *Story* George Lucas *U.S. and Asia Cinematographer* Douglas Slocombe *U.S. Cinematographer* Allen Daviau *Aerial Cinematographer* Jack Cooperman *U.K. Additional Cinematographer* Paul Beeson *U.S. Additional Cinematographer* Reed Smoot *Music* John Williams *Costume Designer* Anthony Powell *Production Designer* Elliot Scott *Film Editors* Michael Kahn, Peter Pitt *Casting* Michael Fenton, Jane Feinberg, Mary Selway Buckley, Marci Liroff *Asia Second Unit Director* Michael Moore *London Second Unit Director* Frank Marshall *Location Stunt Arranger and U.S. Second Unit Director* Glenn Randall *Aerial Second Unit Director* Kevin Donnelly *Choreography* Danny Daniels *Sound Designer and Supervising Sound Effects Editor* Benjamin Burtt *Studio Stunt Arranger* Vic Armstrong *U.S. Stunt Coordinator* Dean

Raphael Ferrandini *U.K. Assistant Director* David Tomblin *U.S. Assistant Director* Louis Race *Macau Assistant Directors* Carlos Gill, Patty Chan *Sri Lanka Assistant Directors* Carlos Gill, Ranjit H. Peiris *Marketing and Promotion Executive* Sidney Ganis *U.K. Production Supervisor* John Davis *Macau Production Supervisor* Vincent Winter *Sri Lanka Production Supervisor* Chandran Rutnam *London Second Unit Assistant Directors* David Bracknell, Michael Hook *U.K. Production Manager* Patricia Carr *U.S. Production Manager* Robert Latham Brown *Macau Production Manager* Pay Ling Wang *Sri Lanka Production Manager* Willie De Silva *Sri Lanka Unit Manager* Asoka Perera *U.K. Second Assistant Directors* Roy Button, Steve Harding *U.S. Second Assistant Director* Louis G. Friedman *Asia Second Assistant Director* Ian Bryce *Script Supervisors* Phyllis Townsend, Pamela Mann Francis *Asia Script Supervisor* Ceri Evans *U.K. Production Controller* Arthur Carroll *Production Secretary* Linda Rabin *Sri Lanka Production Secretary* Rita De Silva *U.K. and Asia Camera Operators* Chic Waterson, David Worley *U.S. Camera Operators* John Connor, John Stevens *Sri Lanka Steadicam Operator* Garrett Brown *London Second Unit Camera Operator* Walter Byatt *U.K. and Asia Assistant Cameramen* Robin Vidgeon, Chris Tanner *U.K. and Asia Second Assistant Cameramen* Tony Brown, Danny Shelmerdine *U.S. Assistant Cameraman* Eric Engler *London Second Unit Assistant Cameraman* Keith Blake *London Second Unit Second Assistant Cameraman* Martin Kenzie *U.K. and Asia Dolly Grips* Colin Manning, John Fleming *U.S. Key Grip* Ken Phelps *London Second Unit Dolly Grip* Jim Kane *U.K. Supervising Set Operations Grip* Micky Driscoll *U.K. Standby Set Operations Grip* George Gibbons *London Second Unit Standby Set Operations Grip* George King *U.K. and Asia Cinetechnician* Nobby Godden *U.K. Production Mixer* Simon Kaye *U.S. Production Mixer* David McMillan *Sri Lanka Production Mixer* Colin Charles *U.K. Boom Operator* David Sutton *U.S. Boom Operator* Stephen Powell *Sri Lanka Boom Operator* Gary Weir *U.K. Sound Engineer* Taffy Haines *Sri Lanka Sound Engineer* Colin Dandridge *Chief Art Director* Alan Cassie *U.K. Art Director* Roger Cain *U.S. Art Director* Joe Johnston *Sri Lanka Art Director* Errol Kelly *U.K. Set Decorator* Peter Howitt *Assistant Art Directors* Peter Russell, Stephen Scott *Production Illustrators* Edward Verreaux, Andrew G. Probert, Joe Johnston *Set Designers* Richard Holland, Stephen Scott *Construction Manager* Bill Welch *U.K. and Asia Property Master* Barry Wilkinson *U.S. Property Master* Danny Colangelo *Scenic Artist* Ted Michell *Property Buyer* John Lanzer *Chief Modeller* Derek Howarth *Modellers* Keith Short, Brian Muir, Valerie Charlton, Stuart Smith *Assistant Costume Designer* Joanna Johnston *U.K. and Asia Wardrobe Supervisor* Ron Beck *U.K. and Asia Wardrobe* Patrick Wheatley, Janet Tebrooke *U.S. Wardrobe* Barbara Kassel *U.K. and Asia Makeup Supervisor* Tom Smith *U.K. and Asia Chief Makeup Artist* Peter Robb-King *U.K. and Asia Makeup Artists* Linda De Vitta, Richard Mills, John Webber *U.S. Makeup* Yvonne Curry *U.K. and Asia Chief Hairdresser* Colin Jamison *U.K. and Asia Hairdresser* Janet Jamison *U.S. Hairdresser* Lynda Gurasich *London Second Unit Chief Makeup Artist* Connie Reeve *London Second Unit Chief Hairdresser* Hilary Haines *Unit Publicist* Susan D'Arcy *U.K. Still Photographers* Keith

Hamsphere, Eva Sereny *U.S. Still Photographer* Ralph Nelson, Jr. *Macau Still Photographer* Jeff Marks *Post Production Services* Sprocket Systems *a Division of* Lucasfilm Ltd. *Sprocket Systems Administration* James Kessler, Catherine Coombs, K.C. Hodenfield, Susan Leahy *Dubbing Mixers* Benjamin Burtt, Gary Summers, Randy Thom *Scoring Mixer* Lyle Burbridge *Score Recording Consultant* Bruce Botnick *Assistant Film Editors* Colin Wilson, Bruce Green, Steve Kemper *Supervising Dialogue Replacement Editor* Laurel Ladevich *Dialogue Replacement Editors* Gloria S. Borders, Richard Hymns *Sound Effects Editors* John Benson, Teresa Eckton, Ken Fischer, Suzanne Fox *Assistant Dialogue Replacement and Sound Effects Editors* Tom Christopher, Kathleen Korth, Mary Helen Leasman, John Watson, Christopher Weir *Post Production Sound Assistants* Karen Harding, Steve Klocksiem *Foley Artist* Dennie Thorpe *Audio Engineers* Howard W. Hammerman, Tomlinson Holman, Brian Kelly *Audio Technicians* Tom Johnson, Tom Martin, Gary Rydstrom, Dawn Warneking, Kris Handwerk Wiskes *Supervising Music Editor* Kenneth Wannberg *Orchestration* Herbert W. Spencer *Dance Music Playback Arranger* Peter Howard *Music Recording* Metro-Goldwyn-Mayer Studios *Dialogue Replacement Recording* Mayflower Recording Ltd., Warner Hollywood Studios *Assistant Choreographer* Caroline Hamilton *U.K. and Asia Production Accountant* George Marshall *U.K. and Asia Assistant Production Accountant* Tony Miller *U.S. Production Accountants* Bonne Radford, Diane Dankwardt *Location Accountant* Stefano Priori *Assistant to the U.K. Production Controller* Barbara Harley *Research* Deborah Fine *Indian Adviser* Cristi Janaki Rathod *Assistant to George Lucas* Jane Bay *Assistant to Frank Marshall* Mary T. Radford *U.K. and Asia Producer's Secretary and Assistant* Rebecca West *U.S. Producer's Secretary* Annie Berardini *U.S. Producer's Assistant* Patrick Crane *Associate Producer's Assistant* Kate Barker *Director's Secretaries and Assistants* Kathleen Switzer, Patsy De Lord *Studio Teachers* Adria Later, Janet Willis *U.K. and Asia Transportation Manager* Vic Minay *U.S. Transportation Coordinator* Dave Marder *Wrangler* Mike Culling *Insect Supplier* Andy Miller *Marketing Coordinator* Susan Trembly *U.K. Supervising Standby Property Men* Joe Dipple, Bernie Hearn *U.K. Standby Property Man* Martin Kingsley *London Second Unit Standby Property Men* Steve Short, Simon Wilkinson *U.K. Supervising Set Dressers* Charles Ixer, Peter Wallis *U.K. Property Storeman* Tommy Bacon *Assistant Construction Manager* Bert Long *U.K. Construction Storeman* Dave Middleton *U.K. Chief Carpenter* Anthony Youd *U.K Standby Carpenter* Stephen Hargreaves *London Second Unit Standby Carpenter* Roger Dawson *U.K. Supervising Chief Plasterer* Ray Staples *London Second Unit Standby Plasterer* Michael Quinn *U.K. Chief Painter* Bill Beecham *U.K. Standby Painter* Bob Betts *London Second Unit Standby Painter* Tony Caccavale *U.K. Supervising Rigger* Red Lawrence *U.K. Standby Rigger* Fred Crawford *London Second Unit Standby Rigger* Tom Parker *U.K. and Asia Gaffer* Martin Evans *U.K. and Asia Best Boy* Ray Meehan *U.K. and Asia Rigging Gaffer* Tommy Brown *U.K. and Asia Electrical Contractors* Lee Electric (Lighting) Ltd. *U.S. Gaffer* Pat Kirkwood *London Second Unit Gaffer* Eamonn Dunne *Drapesman* Barry Wilson *U.S. Location Manager* Richard Vane *Macau Location*

Manager May Leung *Sri Lanka Location Manager* Peter Bennett *U.S. Production Coordinator* Lata Ryan *Raft Camera Mounts* Art Vitarelli *Ski Unit Coordinator* Clifford Mann *Color Timers* Jim Schurmann, Terry Clayborn *Negative Cutters* Jack Hooper, Tom Hooper, Gary Burritt *Pilots* Art Scholl, Lennard Von Clemm, Ross Reynolds *Jump Master* Larry Lee Perkins *Song "Anything Goes"* Cole Porter *Titles* Modern Film Effects *Macau Facilities* Salon Films (H.K.) Ltd. *Sri Lanka Facilities* Sri Lanka Location Services Ltd. *Harrison Ford's Physical Conditioning* Body by Jake Inc., Jake Steinfeld *Metalwork* Norank Engineering Ltd. *Rafts* Maravia Corporation *Catering* Location Caterers *Auburn Duesenberg Builders* Specialty Cars *Production Vehicles* GMC Truck and Bus *Air Transportation* Pan Am, Air Lanka *Production Cooperation* Government of Macau, Government of Sri Lanka, Balfour Beatty Nuttal Victoria Project (Sri Lanka) *Special Visual Effects* Industrial Light & Magic Inc. *a Division of Lucasfilm Ltd. Visual Effects Unit — Supervisor* Dennis Muren *Chief Cinematographer* Mike McAlister *Optical Cinematography* Bruce Nicholson *General Manager* Tom Smith *Production Supervisor* Warren Franklin *Supervising Matte Artist* Michael Pangrazio *Miniature Shop Supervisor* Lorne Peterson *Stop Motion Animation* Tom St. Amand *Key Grip* Patrick Fitzsimmons *Animation Supervisor* Charles Mullen *Additional Animation Supervisor* Peter Kuran *Supervising Editor* Howard Stein *Cinematographer* Mike Owens *Camera Operator* Kim Marks *Assistant Cameramen* Pat Sweeney, Randy Johnson, Joe Fulmer *Additional Cinematography* Rick Fichter *Production Coordinator* Arthur Repola *Grip Coordinator* Edward Hirsh *Optical Printers* John Ellis, David Berry, Donald Clark *Optical Lineup* Tom Rosseter, Ed Jones, Peg Hunter *Additional Optical Effects* Modern Film Effects *Additional Optical Lineup* Jacques Protay *Laboratory Technicians* Tim Geideman, Jeff Doran, Louis Rivera *Creative Consultant* Phil Tippett *Stop Motion Technicians* David Sosalla, Randy Ottenberg, Sean Casey *Matte Artists* Christopher Evans, Frank Ordaz, Caroleen Green *Matte Camera Supervisor* Craig Barron *Matte Cinematography* David Fincher, Deborah Morgan *Illustrators* Stan Fleming, Phil Norwood *Chief Miniaturists* Paul Huston, Barbara Gallucci, Charlie Bailey, Ease Owyeung, Michael Fulmer *Miniaturists* Wesley Seeds, Barbara Affonso, Larry Tan, Marc Thorpe, Scott Marshall, Chuck Wiley, Pete Ronzani, Jeff Mann, Ira Keeler, Richard Davis, William George, Mike Cochrane *Chief Animator* Bruce Walters *Animators* Barbara Brennan, Jack Mongovan, Ellen Lichtwardt, Rebecca Petrulli, Sean Turner, Suki Stern *Additional Animation* Visual Concepts Engineering *Editor* Michael Gleason *Assistant Editor* Michael Moore *Grips* Bob Finley III, Dick Dova, John McCleod, Dave Childers, Harold Cole, Lance Brackett, Merlin Ohm, Mike Speakman, Don Watson *Pyrotechnical Effects* Ted Moehnke, Peter Stolz, Bob Finley, Jr. *Still Photographers* Terry Chostner, Kerry Nordquist, Roberto McGrath *Electronic Engineering* Michael MacKenzie, Wade Childress, Greg Beaumonte, Jerry Jeffress, Kris Brown *Machinists* Udo Pampel, Christopher Rand *Location Coordinator* Patty Blau *Administration* Chrissie England, Cheryl Durham, Susan Monahan, Paula Karsh, Kathy Shine, Karen Ayers, Karen Dube, Ned Gorman, Geoffrey de

Valois. *U.K. and Asia Mechanical Effects — Supervisor* George Gibbs *Chief Technician* Richard Conway *Floor Supervisor* David Watkins *London Second Unit Floor Supervisor* David Harris *Senior Technicians* Trevor Neighbour, David Watson *Technicians* Bob Hollow, Brian Morrison, Rodger Shaw *Assistant Technicians* Peter Davey, Stephen Hamilton, Joss Williams *Chief Wire Flying Technician* Bob Wiesinger. *U.S. Mechanical Effects* Kevin Pike

A Lucasfilm Ltd. Production. A Steven Spielberg Film. Copyright 1984 by Lucasfilm Ltd. Panavision 70. Color by Rank and Monaco. Prints by De Luxe. Dolby Stereo. Made at Thorn EMI–Elstree Studios, Borehamwood, England and Industrial Light & Magic and on location in Hong Kong, Macau, Sri Lanka, Idaho, Mammoth Mountain and on the Tuolomme and American rivers, California, and Glen Canyon, Utah. 121 minutes. M.P.A.A. Rating: PG.

The Players: *Dr. Indiana Jones* Harrison Ford *Willie Scott* Kate Capshaw *Short Round* Ke Huy Quan *Mola Ram* Amrish Puri *Chattar Lal* Roshan Seth *Capt. Blumburtt* Philip Stone *Lao Che* Roy Chiao *Wu Han* David Yip *Kao Kan* Ric Young *Chen* Chua Kah Joo *Maitre D'* Rex Ngui *Chief Henchman* Philip Tann *Weber* Dan Aykroyd *Chinese Pilot* Akio Mitamura *Chinese Co-Pilot* Michael Yama *Shaman* D.R. Nanayakkara *Chieftain* Dharmadasa Kuruppu *Sajnu* Stany De Silva *Village Women* Rudy De Miel, D.M. Denawake, I. Serasinghe *Village Child* Dharshana Panangala *Little Maharajah* Raj Singh *First Merchant* Frank Olegario *Second Merchant* Ahmed El-Shenawi *Eel Eater* Arthur Repola *Sacrifice Victim* Nizwar Karanj *Chief Guard* Pat Roach *Guard* Moti Makan *Temple Guards* Mellan Mitchell, Bhasker Patel *First Boy in Cell* Arjun Pandher *Second Boy in Cell* Zia Gelani *Dancers* Debbie Astell, Carol Bebbington, Marisa Campbell, Jan Colton, Vanessa Fieldwright, Sue Hadleigh, Julie Kirk, Nina McMahon, Lisa Mulidore, Clare Smalley, Maureen Bacchus, Sharon Boone, Christine Cartwright, Louise Dalgleish, Brenda Glassman, Sarah-Jane Hassell, Deirdre Laird, Julia Marstand, Dawn Reddall, Lee Sprintall, Ruth Welby, Corinne Barton, Elizabeth Burville, Andrea Chance, Lorraine Doyle, Elaine Gough, Samantha Hughes, Vicki McDonald, Gaynor Martine, Rebekkah Sekyi, Jenny Turnock *Stunts* Vic Armstrong, Roy Alon, Andrew Bradford, Dean Raphael Ferrandini, Ted Grossman, Nick Hobbs, Bronco McLaughlin, Greg Powell, Doug Robinson, Rocky Taylor, Chris Webb, Fred Washburn, Wendy Leech, Dickie Beer, Terry Cade, Terry Forrestal, Reg Harding, Billy Horrigan, Wayne Michaels, Glenn Randall, Denise Ryan, Tip Tipping, Jason White, Felix Silla, Peter Brace, Graeme Crowther, Marietta Gillman, Frank Henson, Donna Keegan, Gareth Milne, Bill Reed, Colin Skeaping, Malcolm Weaver, Chuck Waters *Extras* George Lucas, Steven Spielberg *Harrison Ford's Stand-in* Jack Dearlove

Additional Oscar Nominations: *Original Score* (John Williams)

Note: Working titles were *Indy II* and *Indiana Jones and the Temple of Death*. Prequel to *Raiders of the Lost Ark*. The last entry in this trilogy went into production in 1986. Special effects photography was in VistaVision and converted to *Super*Scope 235 to match the Panavision ratio employed on non-trick scenes. The 35mm anamorphic footage was blown up to 70mm.

2010

(MGM/UA Entertainment Co.; November 1984)

Producer, Screenwriter, Director and Cinematographer Peter Hyams *Based on the Novel* 2010: Odyssey Two *by* Arthur C. Clarke *Production Designer* Albert Brenner *Supervising Film Editor* James Mitchell *Music* David Shire *Casting* Penny Perry *Costume Designer* Patricia Norris *Associate Producers* Jonathan A. Zimbert, Neil A. Machlis *Unit Production Manager* Neil A. Machlis *Assistant Director* William S. Beasley *Second Assistant Director* Alan B. Curtiss *Set Decorator* Rick Simpson *Visual Futurist* Syd Mead *Film Editor* Mia Goldman *Associate Film Editors* Joanna Cappuccilli, Ross Albert *Assistant Film Editor* Barbara Dunning *Second Assistant Film Editor* Greg Gerlich *Third Assistant Film Editors* Craig Herring, Ann Martin *Makeup* Michael Westmore *Script Supervisor* Marshall Scholm *Camera Operator* Ralph R. Gerling *Assistant Cameraman* Don E. Fauntleroy *Second Assistant Cameraman* Michael Wheeler *Gaffer* John Baron *Key Grip* Tom May *Still Photographer* Bruce McBroom *Production Illustrator* Sherman Labby *Sound Designer* Dale Strumpell *Production Mixer* Gene S. Cantamessa *Boom Operator* Raul Bruce *Dubbing Mixers* Michael J. Kohut, Aaron Rochin, Carlos de Larios, Ray O'Reilly *Supervising Sound Effects Editor* Richard L. Anderson *Sound Effects Editors* Warren Hamilton, David Stone, Michael J. Benavente, Donald Flick, James Christopher *Apprentice Sound Effects Editor* John Pospisil *Dialogue Replacement Editor* Vince Melanari *Music Editor* William J. Saracino *Technical Adviser* Dr. Richard Terrile *Hairdressing* Vivian McAteer *Property Master* Martin Wunderlich *Men's Wardrobe Supervisor* Bruce Walkup *Men's Wardrobe* Jim Kessler *Women's Wardrobe Supervisor* Nancy McArdle *Transportation Coordinator* Randy Peters *Transportation Captain* Candace Wells *Stunt Coordinator* M. James Arnett *Production Coordinator* Katharine Ann Curtiss *Peter Hyams' Secretary* Barbara Allen *Production Controller* Steve Warner *Location Manager* Mario Iscovich *Unit Publicist* Don Levy *Graphics* Arthur Gelb *Marketing Director* Elliot Fischoff *Visual Displays and Graphics* Video-Image *Video Supervisor* Gregory L. McMurray *Video Playback Coordinator* Rhonda Gunner *Video Computer Graphics* Richard E. Hollander *Computer Graphics Supervisor* John C. Wash *Video Technician* Pete Martinez *Production Associate* Steven Jongeward *Marine Technical Adviser* Dr. Jay Sweeney *Electronic Music Producers* Craig Huxley, David Shire *Synthesizer Programmer* Craig Huxley *Additional Music: "Also Sprach Zarathustra!" by* Richard Strauss *"Lux Aeterna" by* Gyorgy Ligeti *Performed by*

The North German Radio Chorus *Conducted by* Helmut Franz *Courtesy of* Deutsche Grammophon, a Division of Polygram Classics *Lightning Sculpture* Bill Parker *Louma Crane and Camera Equipment* Panavision Inc. *Color Timer* Bob Kaiser *Titles and Opticals* MGM Laboratories *Courtesy Credits* The Very Large Array Radio Telescope, an operating activity of the National Radio Astronomy Observatory which is sponsored by the National Science Foundation; Marineland, Rancho Palos Verdes, California; Panasonic; Sheraton Hotels; Pan American Airlines; Ford Motor Company; Sanyo; 3M Company; Adidas; Physio Control; Mag Instruments; Yamaha International; Huffy; Carrera; Apple Computers Inc.; Convergence Corporation; Calma G.C. Co.; Heartrate Inc.; AT&T Systems; Aquarium World *Visual Effects* Entertainment Effects Group's Boss Film Company *Visual Effects Unit— Supervisor* Richard Edlund *Project Administrator* John James Jr. *Art Director* George Jenson *Cinematographer* Dave Stewart *Supervising Editor* Conrad Buff *Matte Supervisor* Neil Krepela *Mechanical Effects Supervisor* Thaine Morris *Special Projects* Gary Platek *Miniature Shop Supervisor* Mark Stetson *Optical Supervisor* Mark Vargo *Chief Engineer* Gene Whiteman *Animation Supervisors* Terry Windell, Garry Waller *Chief Matte Artist* Matthew Yuricich *Production Adviser* Jim Nelson *Business Manager* Laura Buff *Production Supervisors* Michael Kelly, Lynda Lemon *Camera Operators* John Fante, John Lambert, Mike Lawler, Bill Neil *Motion Control Technicians* David Hardberger, Michael F. Hoover, Jonathan Seay *Camera Assistants* Clint Palmer, Pete Romano, Jody Westheimer, Bess Wiley *Assistant Matte Cameraman* Alan Harding *Still Photographer* Virgil Mirano *Optical Printers* Chuck Cowles, Bruno George *Optical Lineup* Phil Barberio, Ronald B. Moore, Mary E. Walter *Animators* Peggy Regan, Richard Coleman, Eusebio Torres *Technical Animators* Annick Therrien, Samuel Recinos, Rebecca Petrulli, Margaret Craig-Chang, Windie Fischer, Juniko Moody *Stop Motion Animator* Randall William Cook *Matte Artist* Michelle Moen *Key Mechanical Effects Technician* Bob Spurlock *Key Grips* Pat Van Auken, Ben Haller *Gaffer* Robert Eyslee *Mechanical Effects Technicians* Bob Cole, Robin Kolb, Larz Anderson *Editor* Arthur Repola *Assistant Editors* Jack Hinkle, Marty November, Dennis Michelson *Miniaturists* Jarek Alfer, David Beasley, Gary Bierend, Leslie Ekker, Kent Gebo, Bryson Gerard, Patrick McClung, Thomas Pahk, Robin Reilly, Milius Romyn, Christopher Ross, Dennis Schultz, Nicholas Seldon, Tom Silveroli, Paul Skylar, Ken Swenson *Miniature Mechanical Effects* Bob Johnston *Chief Mold Maker* David Schwartz *Chief Miniature Painter* Ron Gress *Starchild Technicians* John Alberti, Lance Anderson, Jon Berg, Tom Culnan, Gunnar Ferdinandsen, Mike Hosch, Stuart Ziff *Artistic Consultants* Brent Boates, Adolph Schaller *Video Systems* Clark Higgins *Design Engineers* Mark West, Mike Bolles, Rick Perkins *Electronics Engineers* Jerry Jeffress, Robin Leyden, Bob Wilcox *Software Programmers* Kris Brown, Paul Van Kamp *Illustrator* Janet Kusnick *Cinetechnicians* George Polkinghorne, Mark Matthews, Ken Dudderar, Michael Nims, Joseph Ramos *Laboratory Technicians* Pat Repola, Brad Kuehn, Mike Lehman *Production Associates* Thomas Brown, Richard

Johnson, Dan Kuhn, Sam Longoria, L. Mark Medernach, Laurel Walter *Supervising Production Accountant* Claire Wilson *Production Accountants* Kayte Westheimer, Leslie Falkinburg, Kim Ybiernas *Apprentice Matte Artist* Tanya Lowe *Additional Miniaturists* Adam Gelbart, George Pryor, Bob Wilson, Cynthia Czuchaj, Leslie Stetson *Production Administrators* Jill Allen, Jamie Jardine, Mary Mason, Terry Platek *Digital Jupiter Simulation* Digital Productions *Additional Display Material* Bo Gehring Associates *Production Assistants* Carl Brodene, Allen Cappuccilli, Dan Hutten, Brian Lee, Guy Marsden, John Schreiber, Harry Zimmerman *Projectionist* Don McLaren *Additional Optical Effects* Cinema Research Corporation. *Mechanical Effects — Supervisor* Henry Millar *Technicians* Dave Blitstein, Andy Evans *Wire Flying Supervisor* Robert Harman

A Peter Hyams Film Production. A Metro-Goldwyn-Mayer Picture. Copyright 1984 by MGM/UA Entertainment Co. Panavision 70. Metrocolor. Dolby Stereo. Filmed at MGM Studios, Culver City and EEG/BFC Studios, Los Angeles and on location in Socorro, New Mexico and Washington, D.C. 114 minutes. M.P.A.A. rating: PG.

The Players: *Dr. Heywood Floyd* Roy Scheider *Dr. Walter Curnow* John Lithgow *Dr. Tanya Kirbuk* Helen Mirren *Dr. R.S. Chandra* Bob Balaban *Astronaut David Bowman* Keir Dullea *Voice of H.A.L. 9000* Douglas Rain *Carolyn Floyd* Madolyn Smith *Dr. Dimitri Moisevitch* Dana Elcar *Christopher Floyd* Taliesin Jaffe *National Council of Aeronautics Chairman Victor Milson* James McEachin *Betty Bowman Fernandez* Mary Jo Deschanel *Chief Engineer Maxim Brailovsky* Elya Baskin *Medical Ofr. Dr. Vladimir Rudenko* Savely Kramarov *Chief Science Ofr. Dr. Vasali Orlov* Oleg Rudnik *Medical Ofr. Dr. Irina Yakunina* Natasha Shneider *Yuri Svetlanov* Vladimir Skomarovksy *Mikolai Ternovsky* Victor Steinbach *Alexander Kovalev* Jan Triska *News Anchorman* Larry Carroll *Jessie Bowman* Herta Ware *Nurse* Cheryl Carter *Hospital Neurosurgeon* Ron Recasner *Dr. Hirsch* Robert Lesser *Voice of S.A.L. 9000* Olga Mallsnerd *Commercial Announcers* Delana Michaels, Gene McGarr *Man Feeding Pigeons Outside the White House* Arthur C. Clarke *Stuntmen* M. James Arnett, Jim Burk, Jim Halty, Robert Harman, Freddie Hice, John Meier, Gary Morgan, Mic Rodgers

Additional Oscar Nominations: *Art Direction–Set Decoration* (Albert Brenner, Rick Simpson); *Costume Design* (Patricia Norris); *Makeup* (Michael Westmore); *Sound* (Michael J. Kohut, Aaron Rochin, Carlos de Larios, Gene S. Cantamessa)

Note: Working title was *2010: Odyssey Two*. A sequel to *2001: A Space Odyssey*. Visual effects scenes involving live action were filmed in Super Panavision 70, with all other trick shots made with the BFC 70mm camera. The 70mm footage was reduced to 35mm anamorphic to match principal footage shot in Panavision, then blown back up. Dedicated to Chris, John and Nick.

Glossary

Note: I have selected various terms, trade names, and crew positions for definition here. This information is meant to assist the reader who is not fully aware of all aspects of film production. I have kept the descriptions short and not too technical in order not to add possible confusion to what is often a maze even to industry insiders.

Best Boy—Assistant to the crew chief, usually electrical or grip, though now the title is being applied to the assistant in any department. He is in charge of the equipment used by his department. When the title appears alone (that is, not as Best Boy Grip or Special Effects Best Boy, etc.) it refers to the assistant chief set electrician.

Blue Screen—See Traveling Matte.

Cableman—Sound technician in charge of running cables between microphone and recorder.

CinemaScope—35mm wide screen photographed with anamorphic lenses using a 2×1 optical compression and a 2.35×1 aspect ratio. Other lenses which deliver the same screen image include Panavision, Technovision, Todd-AO 35 and JDC Scope (after Joe Dunton Cameras Ltd.).

Cinetechnician—Camera maintenance man.

Craft Services Man—The individual on the crew who prepares coffee and tea and provides other soft beverages and snack foods for the technicians.

Dialogue Replacement Editor—Much dialogue has to be re-recorded or replaced in post production for various reasons. A loop is made of the scene that needs to be dubbed and the actor(s) repeat their dialogue in sync until a good sound take is made. The Dialogue Editor (also called a Loop Editor, Dubbing Editor [in Europe] and ADR [Automated Dialogue Replacement] Editor) cuts the new dialogue into the sound track. Some films also employ a Dialogue Editor to sync up original dialogue.

Dimension 150—70mm spherical wide screen meant for projection on a curved screen of 150°.

Dolby Stereo Sound—A 35mm optical stereo sound system using the RCA Photophone variable area format, except that the two Photophone tracks are separate sound channels. A center screen sound track is matrixed onto both right and left tracks and is electronically pulled out by the audio decoder reading it as "common information" (same on both tracks) and sending it to the center speaker. Surround sound is achieved by adding one or two (left-right-rear surround or a separate left and a separate right surround) sound tracks on the two Photophone tracks but having such information out of phase with the left screen and right screen channels. Separate left and separate right surround channels use the out-of-phase plus time delay frequencies which the Dolby sound processor decodes during projection. For 70mm release prints, the sound system employs magnetic strips with six separate sound tracks. Tracks one, three and five are for music, dialogue and effects. Track six is for surround information. Tracks two and four are for extra bass on explosions, crashes, etc. This is called "baby boom" format. On some 70mm Dolby Stereo prints a "split surround" system is used by taking information on tracks two and four and adding it to the surround sound. On some very limited prints (including *Logan's Run*, among others) all six tracks are employed for music, dialogue and effects. Three different Dolby 70mm sound processors are needed for each of the different formats.

Foley—Footsteps. Generally these are added in post-production. A Foley Artist (also called Foley Walker) performs the footfalls in sync with a loop of the scene being dubbed. A Foley Editor cuts the new sounds into the sound effects track.

Front Projection—See *Process Photography*.

Gaffer—Chief set electrician. The title is taken from gaff, the hooked poles used to adjust the hanging lights from the stage floor.

Glass Shot—See *Matte Paintings*.

Grips—The stage technicians in charge of setting up the camera and related equipment (dolly, reflectors, etc.) and handling minor construction duties, usually those limited to equipment rigging to the set. In Europe they are called Mechanics and Stagehands.

JDC Scope—See *CinemaScope*.

Key Grip, Best Boy Grip, Dolly Grip, Set Operations Grip—See *Grips*.

Leadman—The head (or lead) set dresser who is in charge of moving onto the set the larger props (furniture, vehicles, etc.). In the U.S. he works directly with the art department, but in Europe he is considered part of the property department and is called a Dressing Propman.

MagOptical Stereophonic Sound—Four-track stereophonic sound on magnetic strips along the side of the film. There is also a single-track optical sound channel in case there are problems with the magnetic reproducing unit. In some rare cases the optical track has been employed as a fifth channel.

Matte—The addition of elements to an already shot scene. A stationary matte may involve miniatures but usually means a painting has been added to expand the scenery. A traveling matte involves added information which moves over the original footage. This, of course, is usually actors but can be miniatures or anything else.

Matte Painting—The art of painting part of the scenery onto glass or some other surface and adding it to the scene photographed. In the first half of this century the matte artist would often paint onto glass, which would be positioned between the camera and the action being photographed during production. In recent years the most common practice is to shoot the scene normally and then have the matte painted and added in post production. This can be done on an optical printer (optical camera, see *Optical Photography*), or the original live action can be projected into the painted matte and rephotographed. In a few rare instances the matte supervisor is on the set and has a black area (into which the painted elements will later be added) placed on glass and set up between the camera and the action being photographed. The matte painting is then created and the original footage, which has not been processed, is rewound and exposed again with the painting filling in the area originally blacked out. This achieves the finest results but is also the most difficult technique to use and the most costly if there is a major error requiring the re-shooting of the live elements or the repainting of the matte.

MGM Camera 65—70mm wide screen photographed with an anamorphic lens having a 1.25 × 1 compression. As with all 70mm camera films the shooting stock was 65mm and the release prints 70mm (allowing extra space for soundtrack). The system was renamed Ultra Panavision 70 during the production of *Mutiny on the Bounty*.

Mixer—Sound recording technician. A Production Mixer records during shooting, Music Mixer records the score, Dubbing Mixer re-records all the final sound tracks (music, dialogue, effects). The Production Mixer is often assisted by a Recorder who loads the sound tape and in years past

operated the sound-recording (then optical) camera (actually a repro-
ducing machine that created sound as a photographic image).

Motion Control—Computer-controlled movement of models and photog-
raphy. The use of computers allows repeat action and movement. While
the method is extremely time consuming and costly and produces results
that can be achieved faster, cheaper and easier with other techniques, this
has become the industry standard for most miniature work. In the Visual
Effects credits in this book, such billings as Electronics Engineers and Soft-
ware Programmer refer to the motion control technicians.

Optical Photography—The various techniques used by the optical lab to add to
(and sometimes subtract from) already shot scenes. This covers all
traveling matte work, enlargements, reductions, etc. Literally anything
involving special processing and printing falls under this title.

Panavision 70—35mm anamorphic Panavision blown up to spherical 70mm.

Perspecta Stereophonic Sound—An optical sound system (Movietone, Photo-
phone or Westrex could be used) in which three-channel stereo was repro-
duced by using subaudible tones for each track. Developed by MGM and
used by Paramount and Warner Bros. The system was discontinued in the
U.S. in the early sixties.

Process Photography—The photographing of scenes in which performers stand
before a background which is projected—usually from the rear, occasion-
ally from the front—onto a screen. The final scene creates a married image
between the earlier shot background and the scene in front of the screen
(transparency). It is usually less effective than a traveling matte but con-
siderably cheaper and involves no special lab work.

Production Illustrator—A storyboard artist who sketches detailed drawings,
often in color, of camera setups, sets, action sequences and anything else
that needs vivid visualization before beginning of production. He is part
of the art department and is also known as a Production Artist, Con-
tinuity Artist and Sketch Artist.

RCA Photophone Sound—An optical sound system using a variable area track
which actually consists of the same sound track printed twice, side by side,
half size. This is the most common sound format now employed.

Rear Projection—See *Process Photography*.

Recorder—See *Mixer*. In Europe the Recorder is (was) called a Sound Camera
Operator.

Rigging Gaffer—Chief light-rigging electrician. In Europe this job falls not under the electrical department but under a separate group of technicians called Riggers.

Sensurround—A sound system, usually employed with three-track stereo, that created a surround feel by the use of subwoofers. On the several features released in Sensurround the system was altered slightly for each film, but basically the effect was the same: The viewer felt vibrations of explosions, earthquakes, etc. Developed by MCA and RCA.

Set Designer—The construction draftsman (though in Europe the term is interchangeable for an art director or a set decorator).

Set Dresser—See *Leadman*.

Sound Designer—Sound effects supervisor.

Sound Engineer—Production sound equipment maintenance man. In some cases the Production Mixer has been billed as Sound Engineer.

Spherical Panavision—Flat wide screen shot with Panavision spherical lenses or Panavision cameras. Aspect ratio can be from 1.33×1 to 1.85×1 in 35mm and when blown up to 70mm the ratio usually is 2×1.

Super Cinerama—Standard 70mm film optically squeezed slightly on extreme left and right sides of the frame and projected onto the Cinerama screen through an enlarging lens. This was the standard Cinerama process (starting with *It's A Mad, Mad, Mad, Mad World*) and replaced the three-camera, three-projector format formerly employed. The Cinerama screen was also reduced slightly in the amount of curvature.

Super Panavision 70—70mm wide screen photographed with spherical Panavision lenses.

SuperScope 235—The technique of taking spherical footage (which is usually framed for cropping) and optically scanning the top and bottom of the frame to a 2.35×1 aspect ratio, adding a 2×1 anamorphic compression and printing in 'scope format. In the truest sense a standard 35mm camera is employed with a widened aperture but for the sake of this book I have included such optical conversion of any (generally VistaVision) spherical film. Today the system is generally referred to as Super Techniscope.

Swingman—The set dresser who is in charge of cleaning up the sets, removing used items such as furniture, etc. He often works at night.

Techniscope—A wide screen system developed by Technicolor in which standard 35mm is exposed half frame (two perfs instead of four) using spherical lenses. This is then optically squeezed with a 2 × 1 compression and blown up to four perforation format for anamorphic projection in 2.35 × 1 aspect ratio.

Technovision—See *CinemaScope.* In addition to anamorphic lenses the Technovision trademark is also used on spherical lenses.

Todd-AO—70mm spherical wide screen. Originally the lenses were made by American Optical Company (the AO) but by the late fifties Panavision optics were generally employed. Developed by Michael Todd, Sr.

Todd-AO 35—See *CinemaScope.* Todd-AO 35 is also used on spherical lenses but generally refers to anamorphic format.

Transparencies—See *Process Photography.*

Traveling Matte—A photographic technique for introducing one or more images over already shot material. This is generally achieved by having the performer (or whatever is to be added) stand before a blue-lit screen (the screen can be colored or simply bathed in tinted light) and be photographed doing whatever action is necessary to the scene. In the laboratory, a silhouette image is created and printed onto the original background material by extracting a matte from the blue-screen shot footage. This is then reprinted with the new footage. The silhouette is filled in by the new material and the original background and new foreground are married into one scene. While a blue screen is generally employed a green background can also be used. Another technique for creating a traveling matte is the sodium vapor system in which a yellow screen is employed with a modified three-color (three individual strips of film in the camera) Technicolor camera. This process creates the hold-out matte (silhouette) in the camera and avoids one of the laboratory steps. It was used in England by Rank, who developed it, and in the U.S. by Disney. It cannot be used with anamorphic lenses, and while superior to blue-screen technique, it never has been accepted by the industry at large. It is seldom employed now. A third traveling matte system uses a front-light/back-light alternating setup to create an in-camera silhouette, but this can only be employed with models and is exposed in a stop-motion manner. It is considered far too time consuming to be generally used.

Ultra Panavision 70—See *MGM Camera 65.*

VistaVision—35mm spherical wide screen achieved by photographing over two frames running through the camera horizontally in the so-called "lazy

8″ (because 8 perforations per frame are used) format. This is optically re-duced to standard 35mm for projection. In most cases in this book the "lazy 8" image was cropped and optically printed via *Super*Scope 235 format.

Western Electric Mirrophonic Sound — See *Western Electric Movietone Sound.*

Western Electric Movietone Sound — An optical sound system employing a variable-density track. It was also trade-named Mirrophonic Sound from the late thirties to the late forties. The system is no longer employed in the U.S. except by small sound studios and for re-releases on which the sound-track has not been re-recorded.

Westrex Sound — An optical sound system using the same type variable area as RCA Photophone except that only one track is employed and it is twice the size of the Photophone format.

Yellow Screen — See *Traveling Matte.*

Index

This index lists all individuals, companies, film titles, working titles (nominated features are in boldface type), songs, etc., appearing in this book. In the case of identical or very similar names I have noted the occupation of the person: i.e., Ford, John (producer and director), Ford, John (musician). Film companies are listed under their full corporate name at the time of their involvement with the subject covered: for example, Paramount Famous Lasky Corp., Paramount Pictures Inc., Paramount Pictures Corp., Paramount Television. If a credit is for a specific studio department it is indexed as such and not simply under the studio: i.e., Goldwyn, Samuel, Studios Sound Department is separate from Goldwyn, Samuel, Studios. Film titles which are the same as nominated features are noted by the year of release. In some cases the spelling of names is variable in the text due to conflicts in source material, occasional changing of names by individuals, etc. This index lists all individuals under the most common spelling.

F